Speaking of FURNITURE

Speaking of FURNITURE
Conversations with 14 American Masters

Bebe Pritam Johnson
Warren Eames Johnson

ESSAYS BY
Edward S. Cooke, Jr.
Roger Holmes

THE ARTIST BOOK FOUNDATION

New York London Hong Kong

First Edition

© 2013 The Artist Book Foundation

All rights reserved under International and Pan-American Copyright Convention. Except for legitimate excerpts customary in review or scholarly publications, no part of this publication may be reproduced or transmitted in any form or by any means, electronic or mechanical, including photocopying, recording, or information storage or retrieval systems, without permission in writing from the publisher.

Published in the United States by The Artist Book Foundation
115 East 57th Street, 11th floor, New York, New York 10022

Distributed in the United States, its territories and possessions, and Canada by
ARTBOOK LLC D.A.P. | Distributed Art Publishers, Inc.
www.artbook.com
Distributed outside North America by ACC Distribution
www.accdistribution.com/uk

Publisher and Co-founder: Leslie Pell van Breen
Co-founder: H. Gibbs Taylor, Jr.
Production Manager: David Skolkin
Design: Irene Cole
Editor: Deborah Thompson
Proofreader: Marisa Crumb
Indexer: Barbara E. Smith
Printed and bound by Imago Publishing Limited

Manufactured in China

Library of Congress Cataloging-in-Publication Data
Johnson, Warren Eames and Johnson, Bebe Pritam
Speaking of Furniture / by Warren Eames Johnson and Bebe Pritam Johnson. — 1st ed.
p. cm.
Includes bibliographical references.
Library of Congress Control Number: Pritam & Eames: 1-662713461

Library of Congress Control Number: The Artist Book Foundation: 2013939213

ISBN 9780988855717 (alk. paper)(c)

p. 2. Wendell Castle, *More Is More*, 2011. Stained walnut, 30⅜ x 64½ x 26 in. (77.2 x 163.8 x 66 cm), Photograph: Jon Lam Photography.

p. 3. Jere Osgood, *Spring Desk*, 1996. Bubinga, wenge, cherry, and ash, 49 x 51 x 31 in. (124.46 x 129.54 x 78.74 cm). Photograph: Andrew Dean Powell.

p. 4. Judy Kensley McKie, *Pyramid Chest*, 2010. Carved and painted basswoood, 52 x 48 x 17 in. (132.08 x 121.92 x 43.18 cm). Photograph: David Caras.

p. 6. John Dunnigan, *Snakeback Settee*, 2001. Cherry and silk, 32 x 42 x 22 in. (81.28 x 106.68 x 55.88 cm). Photograph: Erik Gould.

thefurnituresociety
www.furnituresociety.org

CONTENTS

PREFACE 9
 Bebe Pritam Johnson and Warren Eames Johnson

FOREWORD 17
Defining the Field
 Edward S. Cooke, Jr.

INTRODUCTION 21
A Few Thoughts on What They Say
 Roger Holmes

CONVERSATIONS WITH 14 AMERICAN MASTERS
 James Krenov 28
 Wendell Castle 46
 Jere Osgood 68
 Judy Kensley McKie 88
 David Ebner 108
 Richard Scott Newman 126
 Hank Gilpin 148
 Alphonse Mattia 168
 John Dunnigan 190
 Wendy Maruyama 210
 James Schriber 232
 Timothy S. Philbrick 252
 Michael Hurwitz 272
 Thomas Hucker 290

ACKNOWLEDGMENTS 313

APPENDIX
 Stepping Stones 315

DEFINITION OF TERMS 329

INDEX 331

Thomas Hucker, *Settee*, 2011. Bubinga and cotton/linen-blend fabric, 36 x 88 x 24 in. (91.44 x 223.52 x 60.96 cm). Photograph: C.A. Smith.

PREFACE

WHY A BOOK OF INTERVIEWS?
Without a story, there is no record.

Bebe Pritam Johnson and Warren Eames Johnson

We were traveling in a rental truck toward the extreme eastern tip of Long Island, where the ferry at Orient Point would take us across to New England. It was 1981 and I was with my friend Elwood Howell, an East Hampton artist, who had offered to help me out on this trip. We were picking up pieces of furniture from a number of small studio workshops in New Hampshire, Boston, and Rhode Island for the opening of Pritam & Eames.

Elwood was driving; I was sitting there as a passenger, thinking. The filings for the new business had been minimal: no waiting, no examinations, no permits—just some simple papers filed in Riverhead, the county seat, and we were officially in existence. A snap, you could say. The hard work to ready the gallery interior was behind us—wiring, sheet rocking, painting—all done with the help of willing friends and local suppliers. We needed a truck with a 14-foot box, so we went to Budget in Southampton with a credit card and a license. Shouldn't all this be more difficult?

Bebe and I were creating a new business on a shoestring, essentially with no guidance. The idea was to represent custom furniture makers—people who had also chosen their career paths unrestrained by tradition, guild, or class. That this was actually happening left me sitting there astonished, thankful for our amazingly wide-open culture.

Warren Eames Johnson
Pritam & Eames

One of the hidden privileges of running a gallery is the firsthand view it affords of the creative process, the unfiltered exposure to the lives and thoughts and stories behind the work. During the first decade after we opened our furniture gallery, Pritam & Eames, in East Hampton, New York, in 1981, our modest house was often filled with visiting furniture makers who lived in a style similar to ours. Many shared a 1960s background fueled by the belief that you could make a living doing work that you loved and that such work would be valued by others. The beginning years were harrowing, but, before we knew it, it was time to celebrate our first 10 years. When we decided to write a book to mark the occasion, we wanted it to be in the form of interviews in which we would ask furniture makers to tell us why they do what they do and how they found their way into the field.

The 14 artist–furniture makers we selected to interview for the book were all makers whose work was integral to our gallery in that first decade. Because the makers' personalities are as distinctive as their furniture, readers of these illustrated interviews will have the double pleasure we have experienced over the years: seeing the work and hearing the stories behind it. The stories overlap and spill from one chapter to another because the studio furniture community is relatively compact, one in which teachers and schools of thought about furniture coincide and, sometimes, conflict. One maker's stories build on those of the maker before.

Michael Hurwitz, *Lattice Table*, 2007. Alaskan yellow cedar and epoxy resin, 30 x 37 x 37 in. (76.20 x 93.98 x 93.98 cm). Photograph: John Carlano.

In choosing the furniture that would illustrate each chapter, we selected pieces made before the interviews were conducted in 1991, as well as work that was done in the years since. We have arranged the chapters according to birth dates, an order that conveniently places James Krenov and Wendell Castle first, so that these two, who occupy opposite ends of studio furniture's aesthetic spectrum, set the table for the ensuing chapters.

Peter Joseph, a venture capitalist and early client who had become a passionate collector during our first decade, agreed to underwrite the book. By the time the interviews were completed, however, he had decided to open his own furniture gallery in Manhattan; he asked Pritam & Eames to partner with him in the venture. After a series of meetings, it was clear that the differences in approach between us were too difficult to bridge—and there was a parting of the ways. The transcripts stayed on the shelf through the 1990s as the Peter Joseph Gallery opened with fanfare on New York's Fifth Avenue in 1991, the year of P&E's 10th anniversary. Five years later, when it closed, Joseph returned to the East Hampton gallery and said, "I would rather be your client than your competitor." He also urged us to return to the book project. Sadly, he did not live to see its publication. In 1998, he died of cancer at age 47 and the interviews have remained unpublished until now.

WHY FURNITURE?

Furniture is often an unexamined fixture in our domestic landscape and to choose furniture making as a means of self-expression might seem puzzling to some. Why would a group of gifted individuals work with so much tenacity for so little acclaim and material return—especially in a culture so in love with its wealth? As observers of a field referred to as studio furniture, this has been a source of wonderment to us for more than 30 years.

WHY NOT?

Furniture has been part of the human experience ever since our forbearers gave up hunting and gathering in favor of cultivating the land and permanent settlements. They built simple huts of hides or wood and reed, perhaps clay or mud, and later of stone and baked-clay bricks, and these dwellings ultimately gave rise to the need for furniture: to elevate food, belongings, and people off the ground. Once the construction and use of furniture became part of human culture, when did furniture become something more than a platform at a remove from the ground? The answer is "almost immediately" because of furniture's fundamental tie to ritual and ceremony. Consider the ceremonies at the altars and offering stands of the Israelites, or the ancient Egyptians' set of beliefs that must have attended the Pharaoh and his furniture into the tomb, or the mythic proportion that the Emperor of China achieved while seated on his Dragon Throne. It is no coincidence that Zeus, the mythological Greek king of gods, is pictured by artists as either standing with a thunderbolt in his raised right hand or seated with majesty on his throne: furniture's connection to the human experience is elemental.

Jere Osgood, *Chest of Drawers*, 1984. Andaman padauk and ebony, 61 x 26 x 17 in. (154.94 x 66.04 x 43.18 cm). Photograph: Andrew Dean Powell.

In addition, many European languages have some version of the word *mobility* that refers to furniture: la mobilia, los muebles, les meubles—furniture as movable objects. As people moved from province to province and from country to country, what did they bring along to make them feel at home? Once placed, furniture is, as writer Rose Slivka observes, "both artifact and allegory; it anchors us in our chosen space and articulates that place and ourselves in it. On the whole, furniture, however much it considers its other options, possibilities, and contradictions, does what it promises to do—the chair provides seating…unlike art, which picks at its own identity like a sore it will not allow to heal."[1]

THE POWER OF PRESENCE

James Krenov said, "I've never gotten more enjoyment out of my work than when I've finished something and I can look at it and say, 'It's not bad; in fact, it's better than I can do.'"[2] What does Krenov mean by that? He does not mean that the drawers of one cabinet function better than those of another, or that the dovetails in one cabinet are tighter than those in another. He means that the cabinet has become something more than the sum of the pieces of wood he has put together; he is referring to the impact of the whole. The object has a presence that seizes our attention in a way that has little to do with its utility.

Wendy Maruyama, *Men in Kimonos III*, 2005. Wall-hung cabinet, curly maple, ultrachrome digital collage, and handmade paper, 40 x 72 x 8 in. (101.60 x 182.88 x 20.32 cm). Photograph: Larry Stanley.

All of the artisans interviewed in this book strive for the power of presence in their work. And like the opening chord in a symphony, or a characteristic quality of line in a drawing, that presence is found in the best furniture: the indelible voice of the maker. The language here is silent but captivating nonetheless.

SLOW CRAFT

This sense of presence leads us to think about the makers and how their authorship can be established in the skillful handling of material. About these difficult-to-literalize qualities and the immersion of the maker in his or her material, British writer and critic Paul Harper, a woodworker himself, describes his own process:

> When I consider my pleasure in making, I realize that it is quite bound up with different experiences of time, of time slowing down and of time passing suddenly and unexpectedly. Work settles into a rhythm, ostensibly mechanical: you pick up the wood from one pile and pass it over a rotating blade of the planer in order to create a flat surface, then you place it onto another pile. In fact, as you pick up each piece of timber you assess the direction of the grain, the flatness or curve of the unplaned surface. And while you are using the machine to delicately shave material from the surface, you are aware it is a powerful machine. You are aiming to use it fluently and carefully, respectfully. So you are extremely focused and responsive, to the machine, to the process, and to the material. As the rhythm imposes itself, you are working quickly with an almost intuitive sureness, not questioning. All of your knowledge and experience flows together and coheres in the act of making.[3]

At this point, we say, things are just right.

SETTING THE TABLE

The studio furniture movement traces its beginnings to the early twentieth century and the visionary authorship of Wharton Esherick, a painter, sculptor, woodcut artist, and furniture maker, who built his home in Paoli, Pennsylvania, where it is now a museum. Esherick gave others in the field, according to Jere Osgood, "de facto permission to make things that didn't look like they came out of the furniture factories in Grand Rapids."[4] Esherick also embodied the notion of the artisan—a person who both conceives and builds his or her pieces—that became the defining characteristic of the studio furniture maker. Other notable makers associated with the studio furniture movement followed Esherick: George Nakashima, Sam Maloof, Art Espernet Carpenter, James Krenov, and Walker Weed.

In 1944, Dartmouth College, in Hanover, New Hampshire, established the first college program to teach furniture making; it was designed to provide returning World War II vets with manual skills. Over the next four decades, at colleges and in stand-alone professional training schools, dozens of programs sprang up that offered intensive instruction in both hand and machine woodworking skills. As a result, college programs became the primary training ground for several generations of American furniture makers.

THE SIXTIES ADDED FUEL

The 1960s proved to be a decisive time in the evolution of American crafts. The cross-fertilization of ideas at college-based programs spurred on the revolution already brewing within traditional crafts: makers in mediums such as glass, clay, and fiber plunged into more sculptural realms, quickly accepting the functional/nonfunctional duality of their disciplines. Furniture, however, was the last craft medium to embrace the compact with contemporary art—the last to question the beauty of utility.

But studio furniture was not at home in the contemporary art world. Unlike glass, which adapted easily to art-world prices and practices, furniture did not fit in and did not feel welcome. Poet and essayist Joan Retallack points out that furniture's uncertain standing in relation to fine art "is not surprising in a culture that has tended to keep art and the everyday at a nervous remove. That remove," Retallack says, stems from "the peculiarly Western legacy (coming directly out of our religious forms) of a transcendental aesthetic" and "an art whose chief purpose has been to transport us beyond the limitations of our lives, to not invite us to inhabit the quotidian joyfully."[5]

The accomplishment of the 14 makers in this book is just that: they make it possible for us to inhabit the quotidian joyfully.

AFTERWORD

Although we intended these interviews to be published closer to the time the conversations took place, that aim was not realized. However, when we returned to the manuscript, we found these 20-year-old stories as engaging as if they had been told yesterday, and perhaps richer for the passage of time.

As we put the book together, we decided to return to the artisans (except for James Krenov, who died in 2009) and ask them a few new questions: how their way of working has changed over the years; what are their views on furniture as a vehicle for creative expression; and what trends they have noticed in the last 20 years in the studio furniture field? Their 2011 observations can be found in the afterword at the end of their interviews.

Almost every one of these makers is still at work, continuing to do what they do despite the obvious hazards of the workshop and the difficulty of making a living doing handwork in a high-tech age. There must be some reason for their longevity in the craft. Perhaps the answers can be found in the stories they tell.

East Hampton, New York
November 2010

1. Rose Slivka, "Meaning of Furniture/Furniture as Meaning," unpublished essay, 1990.
2. James Krenov, this volume.
3. Paul Harper, "A New Post from Paul Harper," *Making a Slow Revolution*, http://makingaslowrevolution.wordpress.com/a-summer-season-of-discussion/a-summer-season-post-from-paul-harper/a-new-post-from-paul-harper/ (accessed April 2, 2012).
4. Jere Osgood, this volume.
5. Joan Retallack, "The Chair within the Chair with 'In the Chair': The Art of Furniture as Craft/The Craft of Furniture as Art," unpublished essay, 1991.

Alphone Mattia, *Architect's Valet*, 1985. Painted wood, ebonized walnut, and assorted exotic and domestic hardwoods, 76 x 22 x 18 in. (193.04 x 55.88 x 45.72 cm). Photograph: Andrew Dean Powell.

FOREWORD

DEFINING THE FIELD

Edward S. Cooke, Jr.

Speaking of Furniture offers a rich and revealing view of studio furniture—an important segment of the contemporary furniture world. A wide range of work is chronicled here, from the direct-joinery furniture of Hank Gilpin to the witty creations of Alphonse Mattia and the sculptural aspirations of Wendell Castle. Such aesthetic pluralism is endemic to our age of rapid information exchange, of an oversaturated market for domestic goods, and of a heightened interest in art and design. Yet there are, I believe, relationships between all of these pieces, for they are specific products of a particular time. But to see their coherence as a field, it is essential to understand the people who made them.

Furniture historians typically organize furniture according to formal stylistic categories, using the names of seminal designers or monarchs or nomenclature that describes aesthetic intent. Thus, eighteenth-century furniture has been called all of the following: Chippendale or Hepplewhite, referring to the designers who most influenced that period's style; Louis XVI or Georgian, in honor of the kings and queens who ruled during the time of the style's popularity; and Baroque or Rococo, to signify the dominant aesthetic in Europe.

But we cannot adequately describe the furniture presented in this volume by invoking major designers. The furniture of James Krenov, though widely emulated, hardly reflects enough of the field for the term "Krenovian" to have broad currency. Wendell Castle, though known for three or four powerfully influential styles, still might lend his name to only a portion of the story.

References to the political era, such as "Bushian" or "Clintonian," are equally inappropriate because the furniture displays little direct connection to the political culture. Defining the furniture illustrated in these pages with an aesthetic term, such as post-Minimalist, would do a disservice to most of it. Other aesthetic terms, such as "California roundover" or "Northeast academic," may be appropriate for certain regional work at a particular time, but they do not provide a cohesive description. They merely fragment the field further.

What really distinguishes the furniture illustrated and discussed in these pages is the background of the furniture makers; their expertise in both making and designing their pieces by linking concept, materials, and technique; and the small shops in which they work. Nearly all of these furniture makers have learned their skills not through traditional apprenticeship systems but rather have mastered furniture design and construction in college (either in dedicated college art programs such as the California College of Arts and Crafts or the Rhode Island School of Design, or in college woodworking shops such as those at Dartmouth or Michigan), or they are self-taught. The latter, as well as many of the academically trained, have learned through reading periodicals and books, attending workshops or short-term courses, constant experimentation, and comparing notes with other furniture makers.

In contrast to the wage-based, task-specialized, restrictive training typical of the furniture trade, most studio furniture makers experience a longer, self-directed, and less constrained learning period. They also exhibit a high

degree of visual literacy and a vigorous conceptual approach to design and construction. Many of the makers featured in this book have had some education in art or design and draw inspiration from a vast stock of images and ideas—traditional furniture or new industrial design, fine arts or popular culture, the familiarity of wood and joinery, the excitement of new materials and techniques, and common notions or private dreams. Constant throughout the design and fabrication process is an intellectual rigor in which a maker fully invests him- or herself in order to realize an idea.

These furniture makers use a variety of machinery and hand tools, and often assistants or specialists, but they tend to work in smaller spaces set up to maximize the effective work of the individual and their level of production remains relatively low, occupying the middle and upper levels of the furniture market. Their spaces, approaches to work, and final products lack the scale of factory production.

American and Canadian furniture makers are leaders in the field, and understanding the essence of today's studio furniture helps to explain why. In most countries, the furniture field is more hierarchical, with a clear separation of design and production. Design schools, and the intellectual processes taught in them, are distinct from technical schools and apprenticeship programs, and the skills taught there. In America and Canada, the emphasis on academic training or self-education, a professional identity, and a dynamic, multilayered market have made studio furniture making more diverse, more energetic, and more prominent.

To appreciate the distinctive characteristics of studio furniture, we must go beyond traditional formal or aesthetic analysis based on the concept of stylistic unity and the existence of an idealized type within that style. It is also not sufficient to focus only on craftsmanship or the concept behind a piece of furniture. Instead, it is important to examine all aspects of the maker's intent and performance.

Critical to this endeavor is a thorough understanding of the individual furniture maker. By offering insights into the varied backgrounds and approaches of the makers, the synergy between idea and technique, and the multifaceted meanings of the final product, the interviews in this book attest to the long and serious commitment to the field of studio furniture by Warren and Bebe Johnson. Their gallery, Pritam & Eames, has played a prominent role in enriching our understanding of these individual makers and shaping contemporary studio furniture as a whole.

Edward S. Cooke
Newtonville, Massachusetts
1991

Edward S. Cooke, Jr., is Charles F. Montgomery Professor of the History of Art, American Decorative Arts, and Material Culture at Yale University. As a curator, he has produced some of the most influential exhibitions of studio furniture to date, including New American Furniture (1989) *and* The Maker's Hand (2003), *both at the Museum of Fine Arts, Boston; and* Inspired by China (2007), *at the Peabody Essex Museum in Salem, MA.*

This essay, "Defining the Field," is the first iteration of two extended definitional essays of the same title by Edward S. Cooke that appeared in 2002 in the Furniture Society's journal, Furniture Studio, *and in 2003, in the accompanying catalogue for the Museum of Fine Arts, Boston, exhibition,* The Maker's Hand.

Michael Hurwitz, *Dressing Table*, 1996–1967. Figured ash and marble mosaic with silver/copper pulls, 55 x 45 x 21½ in. (139.70 x 114.30 x 54.61 cm). Photograph: Tom Brummett.

Judy Kensley McKie, *Mirror with Birds*, 1994. Carved and polychromed lime wood, 30 x 28 x 1¹/₂ in. (76.20 x 71.12 x 3.81 cm). Photograph: David Caras.

INTRODUCTION

A FEW THOUGHTS ON WHAT THEY SAY

Roger Holmes

"All I can remember as a little kid was just wanting to make stuff."
 —Richard Scott Newman, page 129

You don't have to be an aficionado of contemporary furniture to realize that the pieces shown in this book are something special. Imaginative, exquisitely made, they have great presence even when flattened out on the printed page. As a furniture maker myself, I've admired this work for a long time and have great respect for what each of these makers has accomplished.

Over the years, I've talked with many woodworkers in the United States and Britain. There have been thoughtful discussions and passionate arguments about design, technique, art, craft, and life. It is always instructive and frequently fascinating to hear these people talk about how they came to do what they do and to glimpse the thoughts, feelings, and experience that lie behind their efforts.

There is much heartfelt and perceptive talk in this book, but if I had to pick one sentence to explain this work and the people who made it, it would be the statement that leads off this piece. Of all the motivations driving these folks, I have little doubt that the strongest one is the simplest. These people all love to make stuff. They need to make stuff.

"Skill is the beginning of freedom."
 —James Krenov, page 36

Knowing that you want to make things from wood is one thing; finding out how to do it is another. For centuries, the apprenticeship system passed knowledge and skills from generation to generation, but by the 1950s, the demand for traditionally trained craftsmen had just about disappeared in the United States. As an aspiring maker, if you wanted to expand beyond factory furniture and plywood kitchen cabinets, you had to figure it out yourself, enroll in one of a very few college craft programs or, if you were lucky, unearth an old European craftsman to teach you.

Many, like Wendell Castle and Judy McKie, found their own way. Some, like me, set off for Europe in search of a master craftsman with a spare bench in his shop. A few found their European craftsman in an American college. Tage Frid, traditionally trained as a furniture maker in Denmark, taught for more than 30 years in the United States, first at the School for American Craftsmen at the Rochester Institute of Technology, then at the Rhode Island School of Design. Almost everyone in this book has been, at one time or another, a student or teaching colleague of Frid's, and he provided many of them with the means to bring their ideas to life.

Woodworkers, perhaps more than other craftspeople, tend to become obsessed with technique. This is understandable, given the vast number of techniques to explore and tools to master. Traditionally, five to seven years of apprenticeship provided enough skills to get a job, but even years of journeyman work wouldn't expose a craftsman to anything like the full range of construction possibilities.

The importance of technique has been a contentious subject among contemporary woodworkers. Battles between design divas and joint junkies erupted sporadically in the 1970s and early 1980s. The former believed that too much emphasis on technique was stifling creativity; the latter thought too little emphasis encouraged self-indulgent or shallow work. A crescendo of sorts was reached when Garry Knox Bennett, a talented Californian, as technically proficient as he is imaginative, drove a large nail into the door of a flawlessly executed cabinet (see p. 96) that he'd apparently made just for that purpose.

Looking at the work shown here and reading the makers' comments, it seems that technique and creativity now reside together more comfortably. I'm reminded of seasoned musicians who have mastered their instruments and now concentrate on the range and subtleties of making music. James Krenov constructed sonatas with fine handsaws and handmade planes, while Judy McKie carves a sort of wooden jazz with a chainsaw and gouges. Today, few woodworkers would dispute that the one is as skillful as the other, and that both have expanded and enriched our vision of furniture.

"What I admired was that…fine art and craft were the same thing."
 —Wendell Castle, page 53

"I'm not making art; I'm making furniture."
 —Richard Scott Newman, page 135

Clearly, this is mature, confident, self-assured work. But on one front, at least, there is still uncertainty. Is this exquisite stuff the pinnacle of craft, or is it instead superbly crafted art? This question has plagued contemporary craftwork for decades, and it seems unlikely ever to be resolved.

In my experience, craftspeople are far more comfortable making things than they are trying to categorize what they make (though this doesn't stop them from strong opinions). Some of the makers in this book think of themselves as artists, some as craftsmen, and some make no distinction at all. I suspect that there are differences among them about what those terms mean. On a personal level, I don't think it matters. If one were to produce some sort of scientific proof that a self-described artist was, in fact, a craftsman, would it change his or her work?

The art/craft question lives on, I believe, largely for institutional and commercial reasons. A great deal is made of art in our society; successful artists are anointed with celebrity and, recently anyway, large sums of money. Mainstream publications such as *Time* magazine cover art regularly. Governments and universities fund grants and art departments to keep the pot boiling. Craft, on the other hand, has long been art's country cousin. While artists busy themselves revealing the inner workings of the psyche or the spirit of the age, craftsmen and women attend to more mundane needs—a bowl to hold the soup, a table to support the bowl. Artists, the conventional wisdom goes, are creative, while craftsmen are skilled. And if the difference isn't immediately evident in the work, it is on the price tag. The value of contemporary art is a function of, for want of a better term, its collectability. The sticker on a table or chair depends far more on how many hours it took to make.

Wendell Castle, *Silver Leaf Desk*, 1967. Mahogany, cherry, plywood, gesso, and silver leaf, 40½ x 96 x 72 in. (102.9 x 243.8 x 182.9 cm). Photograph: Jon Bolton. © Racine Art Museum.

Given what is at stake, it isn't surprising that some craftspeople, craft institutions, and craft galleries have labored long and hard to clothe craftwork in the same glittering cloak as fine art. Others have worked equally hard to maintain a distinction between the two while lobbying for equal status for the perennially junior member. It's hard to say what these efforts have wrought for woodworkers. There has never been a lot of grant money around and college-level woodworking programs have hit hard times after a spurt of growth in the 1970s and early 1980s. Most tellingly, I think, the few attempts by furniture makers to crack the art world have been largely unsuccessful, financially and critically. On the other hand, there are far more craftspeople making furniture and other wooden objects, and making a living at it than there were 25 years ago.

"The only reason for doing any of this is to get at what's inside you. Otherwise, every table has already been made, every chair has already been made. The only one that hasn't been made is the one that I do or you do."
—John Dunnigan, page 200

Art or craft, this is very personal work. From time to time, comparisons are made between contemporary studio furniture makers and past masters such as Chippendale and Ruhlmann. I've snooped around enough museums to believe, firmly, that some of this newer furniture is every bit the equal of period masterpieces. Granted, it is seldom as elaborate as the high-style furniture of the eighteenth and early nineteenth centuries. And few, if any, of today's cabinetmakers command the range of skills possessed by the late Victorian craftsmen who produced those towering neo-Gothic sideboards or sweeping Art Nouveau cabinets. But at its best, this furniture has the same presence as the work of Chippendale, Sheraton, or Ruhlmann, and its construction couldn't be improved upon by any craftsman of the past.

That said, I don't see a lot of point to continuing the comparison. Chippendale's shop, for its time, was a factory; so was Ruhlmann's. Did these men struggle to express their inner selves in their work? Did it matter to them that they didn't make the pieces themselves? Did either of these things matter to their customers? The interviews in this book make it clear how much these personal things matter to contemporary makers.

There is a great deal of anguish in these pages over how much work to cede to assistants—if you're managing employees and running a business, the time to make stuff yourself disappears and the nature of your work changes. For many years, Wendell Castle, a vigorously imaginative and restless craftsman, directed a fairly large shop employing half-a-dozen or more highly skilled makers who produced a slew of technically daunting pieces. Now, in his comments here, he seems to feel this reliance on others led him astray. I'm reminded of a conversation I had with Edward Barnsley, England's preeminent craft furniture maker for 60 years. Barnsley, who also ran a large shop, said he sometimes regretted moving from the sturdy Arts and Crafts style of his early years to the more complex and refined work he produced after World War II. He felt he owed it to his craftsmen, he told me, to keep providing them with new challenges. I find it fascinating that Barnsley, a resolutely old-fashioned craftsman, should share with Castle, a sculptor at heart, uneasiness about losing personal control over his work.

John Dunnigan, *Floor Lamp*, 1986. Maple and hand-blown glass, 74 in. high x 20 in. diameter (187.96 x 50.80 cm). Photograph: Ric Murray.

"I just decided that it would be a nice life…to open up this little shop and learn to make furniture. So that's what I did."

—John Dunnigan, page 195

About 100 years ago, Ernest Gimson and the brothers Sidney and Ernest Barnsley set up workshops in England's picturesque Cotswold Hills and began making furniture by hand. Men of independent means, trained as architects, they were inspired by William Morris, who saw in craftwork an antidote to the twin ills of the industrial revolution— shoddy goods and the devalued lives of the workers who made them.

24

Morris and his Arts and Crafts followers didn't effect a revolution in mass taste or noticeably improve the lot of the average factory hand. But, in a world in which people were increasingly divorced from the production of goods, they succeeded in reasserting the fundamental connection between hand, mind, heart, and the making of things. And, in the process, they fashioned richly rewarding lives for themselves.

The people in this book came to craftwork for many reasons, but I suspect more than a few of them would recognize Gimson and the brothers Barnsley as kindred souls. In the 1960s and 1970s, when most of these makers were getting started, craftwork was once again part of a larger upheaval. Once again, it offered an alternative to a social order perceived by many as exploitative and corrupt. And, once again, despite much publicity about wholesome craftspeople and a healthy (for craftspeople anyway) jump in craft purchases, society remained largely unreformed.

These days, there's not nearly as much talk about the redemptive qualities of craft. William Morris might frown on the degree of self-absorption in these pages, but I think this book would still please him. Ethan Allen and IKEA may supply the needs of 99.9% of the population, but studio furniture supplies something important to more than the few who can afford it. Whether we judge it beautiful or merely audacious, this furniture reassures us that people are still capable of creating extraordinary things with no more than a bit of material and their hands. Morris would like that. He was, after all, a man who took great pleasure in just making stuff.

Roger Holmes
Lincoln, Nebraska
1993

Roger Holmes has designed and made furniture since 1971. Trained in an English workshop steeped in the English Arts and Crafts tradition, he maintains a workshop in Lincoln, Nebraska, where he combines traditional handwork and contemporary technology in his commissioned work. Author of The Woodworker's Companion, *Holmes has been an editor for* Fine Woodworking *magazine and has written extensively on furniture and furniture making.*

Conversations

JAMES KRENOV

b. Siberia, Russia, 1920–2009

James Krenov, an unflinching advocate for personal expression in one's work, was born on October 31, 1920, in Wellen, Siberia, a Chukchi village on the Arctic Circle. Soon afterward, his parents fled Russia and the revolution, traveling first to Shanghai, where they lived for two years with Krenov's grandfather, an architect. From there, they moved to Seattle and then on to Alaska, where they found work with the Bureau of Indian Affairs as teachers. Krenov was raised among Eskimos and the indigenous peoples of the Pacific Northwest, and he developed a lifetime admiration for handcrafted articles made "with integrity and skill." This period would have a lasting effect on Krenov—a time when he began to take an interest in Native American craftsmanship in wood and when he made carved bows and arrows and model sailboats. The word *genuine* became deeply ingrained in his thought and in his work.

In 1932, his parents separated, and Krenov and his mother moved to Seattle. As a young man, Krenov worked in Seattle's shipyards and, during World War II, he became a Russian–English interpreter for the U.S. Lend-Lease program, whose cargo ships made the wartime passage from Alaska to Vladivostok.

In 1947, Krenov traveled to Europe and ultimately settled in Sweden, where he lived for the next 30 years and where he would begin to make his trademark small cabinets. In Stockholm, he came upon the showroom of leading Scandinavian furniture designer, Carl Malmsten. Discovering that Malmsten ran a cabinetmaking school, Krenov enrolled. After graduation, he set up his own small workshop in the basement of his home in Bromma, a suburb of Stockholm. By this time, he had met Britta, who would be his wife for more than 60 years.

In 1975, Krenov wrote *A Cabinetmaker's Notebook*, the first of his four books. With its lambent prose and thoughtful reflection on the fulfillment to be found in handwork, *Notebook* earned him an international audience; the four books together sold more than 500,000 copies and inspired a generation of woodworkers worldwide.[1] After brief stints teaching at American schools, including the Rochester Institute of Technology and Boston University, Krenov was invited by the Mendocino Woodworkers Association and Guild to give a series of lectures in California from 1978 to 1980. In 1980, Krenov moved his family from Sweden and established the furniture-making program at the College of the Redwoods in Fort Bragg, California, where he taught until his retirement in 2002.

Krenov was a controversial figure during his lifetime—his mercurial personality and harsh criticism of current trends in art and design created legions of detractors to go along with his many admirers. Well aware of the animosity he could elicit, Krenov, with a wink, referred to his critics as simply "an absence of well-wishers." In 1992, a year after the interview below, he became the first non-British recipient of The Society of Designer-Craftsmen's Centennial Silver Medal; his acceptance speech in London drew the largest audience in the society's annual lecture series. That same year, the Philadelphia Museum of Art purchased the kwila, hickory, and cedar of Lebanon cabinet pictured on page 40. In 2000, he was elected a Fellow of the American Craft Council and, in 2001, he received The Furniture Society's Award of Distinction.

In his last years, his eyesight dimming, Krenov stopped making cabinets and concentrated on making wooden hand planes. He died on September 9, 2009, in his home in Fort Bragg, California, at age 88, with his wife, Britta and two daughters at his bedside. The obituary that appeared in London's *The Times /NI Syndication* said of Krenov, "In outline, James Krenov's cabinets are conventional. It is the way in which they display a creator in total harmony with his raw material—wood in all its vitality and variety—that they are extraordinary."[2]

I have a good friend who, like me, is a struggling woodworker. He is a good thinker, too, but when we get together there is this tension in our talks, this lost energy between us. He says that craftsmen like us have no place today. We have outlived ourselves; we are an anachronism. We are no longer the village craftsmen doing the simple, straightforward, utilitarian things, supplying everyday things to everyday people. That's gone. He believes that in the art world we are misplaced. True craft is not necessarily at home in the art world. Sometimes in the midst of our little bouts I will almost explode and say, "You know, there is one last defense for people like us, one last reason that will always be there, and that is the emotional content of what we do. Nevermind the village crafts thing, that is gone; but we have one defense, and that is we bring together the essence of ourselves in our work, for better or for worse, whatever it is that we are. If we have integrity, a certain amount of skill, and perhaps even a bit of talent, then some very interesting things can happen."

I was brought up in an old European culture. Words like "genuine" soaked into me at an early time in my life—and "artistic." I grew up among primitive people in Siberia and the natives in various parts of Alaska. My old mother often used the word "genuine" in relation to their ethnic things and the way they were made, utensils or clothing or other objects. Ethnic people are artistic intuitively; none of them would say they are an artist. They don't. "Genuine" had and still has significance for me, and so does "artistic." It's more important to be artistic than to do art. If you are artistic, then time will determine whether or not it's art.

I inherited those few very durable values that transcend time and transcend everything else. When my mother had sable and brocade, it was not imitation. It was the real thing. I don't like imitation leather. I don't like quasi-silk. Some people call that conservative: "You are not living with your time." My answer to that is that some of these times are not worth living with. I've got a bag that I wouldn't trade for a Gucci 20 times its cost and that might look great on the steps of the Concorde. My bag looks and feels good right across my shoulder and it will wear forever and I bought it for $32.00 in Seattle 12 years ago. I bought moccasins from Walter Dyer in Boston because he made the real thing. Britta would say, "Every time you come back from America, you've got these moccasins. What are you going to do with them? You've got four pairs already." I'd say, "Britta, look at the stitching. Look at the insides of these moccasins."

As I said, I grew up in those primitive places in the north in Alaska, before the choppers, before the scooters, before the radios. It was semiprimitive. I grew up on legends. It's all rubbed off. If you were to sum me up, you'd probably say that this guy is an incurable romantic without being a poet. I like big country. I like to be out alone up on a mountain or in the woods. I don't want any claptrap.

It's just that combination of all those things that I continue to value without really feeling bound by them. They are so much a part of your life. That's what you build on. That's what you are. That explains some things that I do believe.

After World War II, you went to Europe and ended up settling in Stockholm. What was it like starting out as a craftsman there?

In the early years of being a craftsman, I went through great humiliation. I went through the dark struggle and bouts of desperation that a lot

Flared Panel Cabinet, 1992 (detail; see p. 40).

Music Stand, 1963. Lemon wood, 17½ x 24 x 28½ in., closed (44.45 x 60.96 x 72.39 cm). Photograph: Bengt Carlén.

Krenov, Sweden, 1971. Photograph: Unknown.

of craftsmen have to go through. I was an outsider from the beginning. In Sweden, there was the Crafts Guild and the established craftsmen frowned upon me.

Then some of them began to say, "Well, there may be something to what he does even though it's not according to the traditions and the habits of the established craftsmen." Then the museums started to appreciate it, and a few individuals did, too.

I had things at the Guild Gallery of Arts and Crafts in Stockholm, which is a continuation of the old guild system where everyone—the painter, the people who do the plaster work, the brick layers, everyone—belonged to the guild. You had the cabinetmakers and the potters and everyone else. They had a very nice showroom and one could have pieces there.

A friend of mine had a very tiny gallery and he was quite choosy about what he showed. You know, fine bookbinders' work or whatever—little artisan things. I had one show that I called *Five Not So Easy Pieces*.

I'm working alone in Stockholm when I get an invitation to come to America. I begin teaching in various universities and colleges where I am invited. I visit European countries as a guest. Then somebody twists my arm, a good friend, Craig McArt, and I write *A Cabinetmaker's Notebook*. Within a short time, I find myself with about 500 letters on my workbench in Stockholm. Fundamentally, to sum them up, each one is saying, "Well, I thought I was the only one on the planet silly enough or unrealistic enough to believe in these things, and now I know that there are more of us. So, thank you, Mr. Krenov." *Notebook* did strike a chord. It rang a bell. It wasn't my bell. The bell was already there; I just happened to strike it passing by. But it did ring and there was a response.

Now *Notebook* is, what—17 years old? Something like that. I must have come to Rochester Institute of Technology [RIT] a

Pagoda Cabinet, 1973. Cherry, 61 x 24½ x 10 in. (154.94 x 62.23 x 25.4 cm). Photograph: Bengt Carlén.

couple of years before that because it took two or three years for Craig to pressure me to write *Notebook*. He was a Fulbright student in Sweden studying at the School of Arts and Crafts, and he happened to hear about me and we became friends. Then he was a professor in the Department of Environmental Design at RIT. He was a part of that original nucleus of people—Dan [Jackson], Jere [Osgood], Bill [Keyser], Wendell [Castle], and Craig. They all went to teach at the original RIT when it was down in the slums in those brick buildings with the bars on the windows and all the rest of it. He was a close friend of Wendell's, and he arranged for me to come to RIT.

When Craig McArt came along and I came to America, gradually life changed. Had I stayed in Sweden, I don't think that I would ever have gotten the satisfactions and the chance to help people and share in the way that I'm doing.

I taught at RIT two or three times. I did one or two summers and I was supposed to stay a year, but that didn't pan out. Long before me, there was already some tension in the air there. Then along came this person with a different kind of message that didn't call for pressure. He didn't call for self-assertiveness and inventiveness. His accent was on emotion and method, on expressing the emotion towards your craft as a whole. Not just emotion towards the piece that you're making, but towards your life as a craftsman. It struck a chord and students there were saying that it wasn't bad. It caused a stir and it added to the commotion—and I left before I got killed.

Notebook led to additional travels and invitations. Finally, I was asked by the University of California to do a course in Santa Cruz. There were three students from Mendocino in the class and they invited me and my wife, Britta,

Cabinet, 1982. Mahogany and yaka, 52 x 29 x 15 in. (132.08 x 73.66 x 38.1 cm). Photograph: Rameshwar Das.

Cabinet on Stand, 1982. Spalted maple, oak, partridge wood, cedar of Lebanon, 67 x 27 x 11 in. (170.18 x 68.58 x 29.74 cm). Photograph: Jonathan Binzen.

Cabinet on Stand, 1982 (detail).

Krenov and Redwood's student, Cecilia Onn, 1992. Photograph: Kevin Shea.

up there. We had a wonderful time. We had some salmon. Not only was the salmon hooked, but we were, too.

The College of the Redwoods sponsored three summer courses that I did in Mendocino Village. And then they said, "Look, if this old geezer is willing to move from Stockholm, why don't we build a school and make it part of the College of the Redwoods?" This was before Proposition 19 lowered the boom on finances. Miraculously, the school emerged. [The woodworking program at the College of the Redwoods was established in 1981.]

The old geezer sold his home in Stockholm and came back to America. People regarded us as oddballs, out in left field, dreamers. We lived through other peoples' doubts and, let's just say, lack of well-wishes. We survived. Now, I think, those who detracted, along with a lot of other people, realize that we are a good crafts school

Cabinet, 1983. Japanese white oak, 54 x 23 x 10 in. (137.16 x 58.42 x 25.4 cm). Photograph: Sean Sprague.

—and a fine human experience for would-be craftsmen, young and old, men and women.

I sometimes refer to our school as a refugee camp for some very fine people. So many people are unhappy in their work, regardless of what that work is. We give people a chance to find out that they can be craftsmen and they can be happy.

We believe that skill is the beginning of freedom. Skill comes first. It gives you the possibility to express whatever it is that is in you. Skill is not necessarily dexterity and it's not necessarily efficiency. Of course, a skilled person works efficiently. But efficiency is the kind of skill that relies on mechanical means and shortcuts and all kinds of novelties—where the sensitivities of a person are secondary to the powers of organization and engineering. It is a danger when we become very, very efficient; probably we succeed financially and we start to cater to public tastes.

I have knocked around America and many other countries these last 20 or 30 years. I have watched the emergence of woodworking as a major facet of arts and crafts in America. What I do remain aware of is that there are some warning signals, there are some red lights—and art is one of them. A lot of things survive with the help of that word "art" that would not survive as fine craft. I try to keep my students from being too concerned with art. In an art school, you have to create things that mankind has never seen before. With us, you just express what is within you.

To people like me, art and design are separate from the process I imagine craft to be. Craft is an intimate connection between material, tools, hands, eyes, and ideas. And then, there is something that is even more important than the ideas. It is something somewhere inside the person. We weave into our teaching a great many things that are not really woodworking. We talk about music. We talk about literature. We discover articles about people—potters, weavers, authors, people who have gone into themselves, made discoveries,

Krenov's trademark signature. Photograph: Warren Johnson.

Detail of 1985 ash *Cabinet*. Photograph: David Welter.

Cabinet, 1985. Ash, 55 x 20 x 10 in. (139.70 x 50.8 x 25.4 cm). Photograph: David Welter.

opened up things, and then shared them with the rest of the world.

Take the lady potter [Eva Zeisel in an article from *The New Yorker*].[3] She is old now and, after an absence, she is back at work and she says, "My hands are remembering things that my mind has forgotten." That sense of the hands being a projection of what is inside you, of the things that you feel, and the intangible sense of seeing things that are really not quite that obvious or visible. The creative process is marvelous. There are transcending moments and values that are wonderful to share.

There is also a physical relationship to a crafted object. If you make functional objects, you do it with a lot of responsibility. You consider how those things will be used and how long they will last. You make friendly and, hopefully, beautiful functional objects.

What I'm trying to say is very difficult to define. It is essentially about a person who wants the life of a craftsman; who is willing to acquire the quiet, intimate skills; one who really cares about his or her material, listening to it and learning about it. A material like wood is not only light or dark or hard or soft. To some craftsmen, different woods call for different methods. They coax out of the craftsman different combinations of color, rhythm, texture, and an inner sense, an awareness of the kind of touch these materials require—the way that one will work with one's hands and one's tools.

At first glance, your work seems familiar; it is available. Your admirers would argue that it retains its real qualities for a quieter, more prolonged study. But that immediate quality of recognition has led others to criticize your work as unoriginal.

Well, a lot has been said and written about my work. Now and then someone will talk about limitations and lack of fantasy and lack of imagination. You know, "the fellow isn't very original." Well, I don't think the Barnsleys or Gimson or Greene and Greene or even the Shakers were all that original in the modern sense of the word, so that has never really bothered me. I have accepted my limitations and try to do my best within those not quite precisely defined lines.

In looking back over your lifetime of work, is there one cabinet that completely embodies what you have to say?

I don't think so, because there is no ultimate goal; it keeps changing and you can't, or at least I can't, clearly define it. There are a few pieces that I may have more emotional affinity for, just as when you meet certain people, you remember them longer and your emotions are stirred more at the memory of them. I've done pieces I wouldn't change.

You've given us a much fuller understanding of how you see the role of craft, and furniture making specifically, in the world. What we'd like to do now is discuss a couple of your pieces in particular. Let's start with the doussie cabinet [see fig. 1, opposite].

From the beginning, when I chose those planks, I said to myself, "It's going to be a heavy cabinet." Heavy not just in the visual sense, but actually heavy. Doussie is not a feminine wood like pearwood or maybe even maple or boxwood or satinwood. It's a masculine wood, which doesn't mean you have to make clumsy things out of it. Maybe that sense of weight had a relationship later on to some of the dimensions, because it is not a delicate cabinet. I didn't start out with the feeling, delicate, in me. I wanted to make something sturdy. Sturdy but not awkward is what I was hoping for.

The legs seem to change their stance when you walk around that cabinet.

That was a real problem. It's a problem that some of my students discovered. When you do something oval or slightly rounded from one side and you follow that shape down in a post or a leg, then you find it's flat in one direction. There is, despite what you can do on the inside—beveling it or something else—there is going to be an angle at which there is more

Walkabout Cabinet, 1986. Pearwood, 54 x 34 x 16 in. (137.16 x 86.36 x 40.64 cm). Photograph: Jonathan Binzen.

of it. You try to counteract that. I was almost desperate because I saw that and realized what the problem was. That line going down the middle was the only thing I could think of. I drew a line with a magic marker and it divided that wide, curved surface in two. It registered as two halves and one unbroken field. Anyhow, it started to work.

Before you start a piece, do you sometimes see the doors—for example, in a plank—and it begins from there?

If I don't get beautiful doors, I can't build a beautiful cabinet around them. Nothing else will work. There is a process of elimination in regard to the way that we work. You say to yourself, "If I get this right, the rest will fall

Fig. 1. *Cabinet*, 1991. Doussie and bird's-eye maple, 58$\frac{1}{2}$ x 19$\frac{1}{2}$ x 12 in. (148.59 x 49.53 x 30.48 cm). Photograph: Jon Reed.

Flared Panel Cabinet, 1992. Kwila, hickory, and cedar of Lebanon, 61 x 19½ x 11¼ in. (154.94 x 49.53 x 28.57 cm). Photograph: Kevin Shea.

Fig. 2. *Cabinet*, 1994. Pearwood, yaka, and cedar of Lebanon, 50 x 23 x 14 in. (127 x 58.42 x 35.56 cm). Photograph: David Welter.

into place." It's almost like saying, if I get the light properly on this object, I'll get a good photograph. Without good lighting—even with a Leica or Hasselblad—you're not going to get a good photograph. You gradually learn what your starting points need to be. I don't fall down on my knees and ask the plank what it wants to be, but there is a dialogue from the beginning, there is an emotional relationship there and a very physical one in terms of "this is the way it should be worked."

I think this process is the same in a lot of media—the painter or the graphic artist who backs off and sits there looking at the partly completed painting or sketch or whatever and soaks up the sunshine or waits for the light to change and asks themselves if they should start all over again and will this be all right. Anybody that is too certain about what they're doing bothers me.

40

Cabinet, 1999. Claro walnut, 57 x 24 x 14 in. (144.78 x 60.96 x 35.56 cm). Photograph: Kevin Shea.

How do you know when it's right?

I think you just keep it a guess and enjoy the fact that you really don't know. I've never gotten more enjoyment out of my work than when I've finished something and I can look at it and say, "It's not bad. In fact, it's better than I can do." And that's not contrived. It's not an invention. It's a real feeling and it's a great feeling. You have to be very careful because right there you could say, "Because I'm a genius, these forces and these vibes are affecting me but no one else on the planet." That's B.S.! When it's good, you're lucky. Because at any time you could have made a wrong turn—it's human.

So, the doussie cabinet had nothing to do with any request. It was just a feeling on your part that there was a need for that kind of cabinet at that time.

Well, for one thing, I can't be idle. I'm a nuisance to everybody if I'm idle. I have to work. I want to work. And it's not an escape. Some people work to get away from things. I think I work to get to something. In the last eight or nine years since I've met you both, I've done quite a bit of work and a lot of my Swedish friends or the people at the National Museum in Stockholm might be surprised at how far afield I've gone without losing myself.

What about that pearwood cabinet [fig. 2] over there? The impression of that cabinet is quite different from the one in doussie; it reminds us of a long-legged girl.

It was different from the beginning—from the little doodle that I did. It occurred to me that it needed to be a small horizontal box on fairly long legs. It curves out and tapers and it stands on its toes in a different way. But you're right; it's a long-legged whatever—and delicate.

What is the perfume inside?

It's a combination of cedar of Lebanon and polish. It beats Chanel No. 5. That's the way some of us work—more with a feeling than anything else. A feeling of wanting a result that's light or heavy, delicate or not—and just searching for it.

Why aren't the drawers even?

I'm off center. I confessed to Warren that I was sorely tempted to move that vase you put in it three inches to the right or to the left and put another one down below in the other direction. Something right on center just does something to me. It's partly inherited and partly instinct; some people are that way. Others tend just by their nature to want to center things, right in the middle of the shelf, straight up and down and that's it. It's unpremeditative for both.

It would seem that you should be satisfied at this point in your life, or be reasonably content, when reflecting on the work that you've done—and yet these strong pieces keep coming.

Maybe I'm a little more relaxed in the last five or whatever years. I haven't taken myself quite as seriously as I once did. I don't think I'm satisfied in the sense that I've done it all. I've never been preoccupied or engrossed by the word *success*. I'm just a craftsman continuing to do my best. I'm vain. I'm just as vain as the next person. I enjoy someone saying, "That's nice work." Fine, but I'm not changing the size of my hat and that helps me to keep the friends I have. The people who knew me 20 or 30 years ago in the middle of the darkest struggle are still my friends and I cherish that. I cherish the fact that whatever it is that I've done—the books or my work—hasn't changed me.

Fire & Smoke Cabinet, 1995. Pearwood, alerice, and pernambuco, 54 x 22½ x 13½ in. (137.16 x 57.15 x 34.29 cm). Photograph: Warren Johnson.

But I worry about these young people, and I have this one last task: to build a bridge between fine workmanship done by generous, sincere, and responsible people who have a sense of adventure in their work, and the relatively small but very durable public that must be out there. It's a real chore, because with many

Cabinet, 1995. Honduran rosewood and pearwood, 54 x 30½ x 14½ in. (137.16 x 77.47 x 36.83 cm). Photograph: Seth Janofsky.

Krenov with the 1995 Honduran rosewood and pearwood cabinet. Photograph: Unknown.

of the people with means, there is no relationship between their wealth and their taste.

I've never been quite stupid enough to think that there should only be quiet expressions in craft—that there shouldn't be the painted and the carved and the glass and the chrome and all these other things. America is a kaleidoscope politically, emotionally, in every respect, so there always is going to be that; but I think that those doing this uncompromising, sensitive, responsible work have drawn the short straw, and that's a shame.

And there is an element here that bothers me in the sense that people are making more of themselves and what they're doing than is there, creating this "I'm an artist" stance. I remember a brochure by some young man in Los Angeles, I think he was 21 or 20: "The reason why my work makes such an impact on contemporary American crafts is blah, blah, blah, blah, blah." And then you see this neon-lighted stuff and it's ho-hum, just another light along the road. So, I can be pretty negative, as you hear, but I'm just not wasting my energy anymore trying to prove any of these things. There is no proof. There is only the reaction between the receiver of a certain craft and the creator of that craft.

I don't travel as much as I used to. But if I were to travel to, say, the Victoria and Albert in London, or the Metropolitan Museum in New York, and just stare at some little thing, it will

Cabinet, 2004 (Krenov's last cabinet). Spalted maple and kwila, 43 x 17 x 10 in. (109.22 x 43.18 x 25.4 cm). Photograph: David Welter.

be with me forever. That will never end, and the person who did it is anonymous, and I don't even want to know his or her name. It is just a lovely object that I enjoy. Somebody else might disagree; the curator might say, "No, no, the other thing is more precious, more important," but to me there; it all is, the rhythm, everything. This one sings, the rest don't. They just talk, like I do.

What we are doing is asking people to look at our work and to imagine what it would be like to live with it. It is honest work. The integrity of craft that transcends time in a quiet way without self-assertion, without really contradicting someone else. It is what it is and it endures.

I like the D. H. Lawrence quote that ended your talk at Pritam & Eames yesterday. Will you end this interview with those words?

I can try. I have read them a hundred times and they always move me:

Things men have made with wakened hands,
and put soft life into are awake through the years
with transferred touch and go on glowing for
long years.

And for this reason, some old things are lovely
warm still with the life of forgotten men
who made them.

East Hampton, New York
May 1991

1. James Krenov, *A Cabinetmaker's Notebook* (New York: Prentice Hall, 1975); James Krenov, *James Krenov: Worker in Wood* (New York: Sterling Publishing Company, 1997); James Krenov, *The Impractical Cabinetmaker: Krenov on Composing, Making and Detailing* (Fresno, CA: Linden Publishing, 1999); and James Krenov, *The Fine Art of Cabinetmaking* (Fresno, CA: 2007).
2. Obituary, *The Times /NI Syndication*, September 11, 2009.
3. Susannah Lessard, Profiles, "The Present Moment," *The New Yorker*, April 13, 1987: 36.

WENDELL CASTLE
b. Emporia, Kansas, 1932

Wendell Castle has challenged the boundaries separating sculpture and furniture for nearly five decades, and he is the most prominent figure in twentieth-century art furniture. Trained as a sculptor, he has treated furniture as a fine art medium and has established an international reputation in the process. *New York Times* art critic John Russell, writing in 1979, said Castle belonged to that "handful of outstanding artists who give character to a style and direction to the production of others."[1]

Born in Emporia, Kansas in 1932, Castle received a bachelor of fine arts in industrial design in 1958 from the University of Kansas, and a master of fine arts in sculpture from the same university in 1961. That year, Castle moved to New York and, after struggling to gain a foothold in the New York art world, accepted a teaching position at the School for American Craftsmen at Rochester Institute of Technology in 1963. He held that post until 1969. He also taught at the University of Kansas, 1959 to 1961, and at State University of New York at Brockport, 1969 to 1980. In 1980, he established The Wendell Castle Studio School in Scottsville, New York, a suburb of Rochester, which operated for eight years. In 1984, he was appointed Artist-in-Residence at RIT.

A strategic thinker, Castle's work straddled the worlds of art, craft, and design, and this made him prominent but also polarizing. Throughout the 1960s and 1970s, he made biomorphic furniture carved from wood, using his signature stack-lamination process, work that underscored his close ties to sculpture. He also experimented with materials such as fiberglass, Styrofoam, neon, and plastic. By the late 1970s, in a radical turn, Castle designed a series of trompe l'oeil works—pieces that resembled impeccably reproduced period furniture but with realistically rendered objects (hats, gloves, keys) carved right onto the piece. This work led him, in another turnabout, to consider historical furniture and, together with his New York dealer, Alexander Milliken, he presented the "Fine Furniture" series in 1983, emulating the showmanship of court furniture that combined extraordinary period-derived forms, exotic materials, and superb traditional craftsmanship. Milliken aggressively promoted the work, raising published prices for studio furniture to new highs.

In 1989, the Detroit Institute of Arts organized a Castle retrospective with a scholarly catalogue: *Furniture by Wendell Castle*, by Davira S. Taragin, Edward S. Cooke, Jr., and Joseph Giovannini.[2] Castle's work is in the permanent collections of The Metropolitan Museum of Art, New York; the Museum of Fine Arts, Boston; the Museum of Fine Arts, Houston; the Detroit Institute of Arts; the Philadelphia Museum of Art; and the Art Institute of Chicago. His work is also in a number of public and private collections, including those of American Express, Johnson Wax, *Forbes* magazine, Philippe de Montebello, Lee Nordness, Jim Henson, and Martin Margulies.

Wendell Castle received a Visual Artists Fellowship grant from the National Endowment for the Arts in 1988; the Golden Plate Award from the American Academy of Achievement in 1988; a fellowship from the New York Foundation for the Arts in 1986; and, in 1979, an honorary doctor of fine arts from the Maryland Institute of Fine Arts in Baltimore.

There are numerous publications on Castle's work, including *New Furniture: Trends + Traditions*, by Peter Dormer, and *The Fine Art of the Furniture Maker: Conversations with Wendell Castle, Artist, and Penelope Hunter-Stiebel, Curator*, edited by Patricia Bayer.[3] In 1991, the year of this interview, Castle's work was featured in the first solo show at the newly opened Peter Joseph Gallery in New York. He and his wife, ceramist Nancy Jurs, have lived and maintained their studios in Scottsville since 1978.

Castle's approach contrasts sharply with that of James Krenov, who described himself as a craftsman and spurned the fine art label. Krenov and Castle come first in this book because the interviews are arranged chronologically by the makers' ages, but their primary position might also stand for the formative influence that their competing philosophies have exerted on those studio furniture makers who followed. In his afterword, written as he approached his 80th birthday, still working in the Scottsville studio and still seeing his furniture drawing attention around the world, Castle can legitimately claim that he has succeeded on his own terms.

I drew as a child and I probably drew better than most kids, but it didn't mean anything. So what if you could draw better than the neighbor kids? I mean that's not good for anything. I drew cars particularly. I saw myself at that point in my life—and I think one of the key issues is how you see yourself—as being a car designer. I had romanticized the idea of what a car designer was. I didn't really know how impossible it was—that there were only a few people in the world who actually got to dream up a whole new car design. It wasn't until much later I learned that teams of hundreds of people worked on cars and that one person worked on hubcaps for years. It was not as simple a concept as I imagined.

There were competitions to encourage kids to be interested in designing cars, which I never entered. But I always kind of fantasized about them. I could never get my act together, maybe because I never got the encouragement from my parents, and because you had to follow a strict line—you had to do the car on a certain scale, you had to get it in at a certain time. Somehow I never knew what the scale was supposed to be or when it was supposed to be there.

You were born in Kansas, right? What was your father's work? Any brothers or sisters?

He was a vocational agriculture teacher, and yes, I have a brother and a sister; I'm the oldest.

Did you recognize your ability with tools early on?

Probably. I think I had a natural ability to be facile. I was around the farm where they built things and my dad built some things.

Didn't you say once that if you hadn't become an artist you would have considered becoming a basketball player?

Well, not a basketball player. There are things you romanticize about, but I knew I had no ability. When I was a kid, I thought the only thing that brought you any fame or fortune or respect from your peers was being an athlete. Early on, I tried to play basketball, but I wasn't very good at it. I was too skinny to be a football player. I didn't like to run. I couldn't play baseball very well. Once I understood the criteria, none of those were possibilities. Had tennis been a possibility, I might have done better—it being an individual sport where you didn't have to be part of a team. I had trouble with the team idea. I was interested in music and thought maybe I could be a musician.

What kind of music?

I played the trumpet. I was one of the better players but that didn't mean anything. I mean the better players in my high school probably couldn't have made the band in a big high school. It seems that everything I thought might be possible never worked out.

But I was very good at daydreaming. I think that was a good thing because what daydreaming does—and I think it is important in any field—is you picture yourself achieving certain things. In your mind's eye, you actually are doing it. People are all applauding and thinking you're wonderful, and if you can actually hook that up with something, then maybe it stands a chance of happening; it stands a bigger chance of happening because you're sort of prepared for it. You've already imagined it and you know what it's like, or you think you do anyway. And I was able to transfer

More Is More, 2011 (detail; see p. 6).

that at some point in college to something I could do. I actually imagined myself being good at something and then I was good at it.

And that was art.

Yes. That was art.

The sketching and daydreaming must have connected for you.

Sketching actually became a way of inventorying and keeping track so you don't lose ideas, as well as a way of combining ideas. There are some very creative people, like Garry Bennett for example, who come up with marvelous pieces of furniture without having this ability to set it down on paper. But I think it is so important to have had the chance to make several hundred of them in your mind and on paper before you decide which one you might actually do, and to have looked at it from every single angle, and to have looked at it in good light and in poor light, and to have looked at it upside down until you totally understand it, every bit of it, exactly what it looks like.

There is another side of drawing and, in some cases, of the actual creation where something is happening and you don't understand what it is. It's probably a mistake to even try to understand. If you're sitting down and you know what you're drawing, that's one thing, that's a type of design—development drawing. There is another kind of drawing where you are just sort of drawing things; they aren't anything in particular. It may start with a shape. I remember sitting in some place and a chair cast a very weird shadow on the floor; I drew that shadow. It didn't look like a chair shadow at all. It was just kind of a neat shape. Then you try to figure out what in the world it is. You look at it for hours; just look at the shape and then change it and redraw it and eliminate part of it or add to it and see if it becomes something. With no conscious effort to develop it into any particular thing, you just see what it might want to be.

If you do that, then I think you've really got something—at least you're hoping something from the right side of your brain will kick in and make it into something. Because the minute you say, "Okay, I'll put some legs under it and make it into a table," then you've switched it to the left side of your brain. You have to resist doing that.

And speaking of resisting, what you also have to resist is making judgments about what you are doing by thinking, "Oh, I'm on a good track or I'm on a bad track or I've got the answer now." That's the most dangerous one of all because then you're likely to stop and say, "Okay, I've got it figured out now. This is the good one. I want to do this one." How do you know that? You don't have any idea about that. The next one might be better or 50 from now might be a whole lot better. When time's up, when practical considerations come into play and whatever you got is what you got, then you do have to go back and make decisions, but you put that off absolutely until time is up. Also, you've got to remain neutral—not getting in love with your own ideas and not getting down on yourself, thinking you haven't got any good ideas—and that's so hard to do, to be neutral.

The other thing is when you're trying to solve a problem creatively, try and avoid the problem, try to think of a way around it, not to face up to it. That's very helpful. Eventually, of course, you have to face up to it. But if you don't try to sneak around it and find a back door first, then you've missed a whole possible avenue of approaching it. I don't think it's possible to focus on a problem or project and solve it creatively by looking at it directly or

Wendell Castle working in his studio in Scottsville, NY, c. 1970–1971. Photograph: Wendell Castle Studio.

head-on. You may solve it and you may think of ways to do it, but they won't be creative.

Do you think you sometimes create problems just to solve them?

No, I don't think so. I'm just saying that I don't think it's possible to focus on a problem or project and solve it creatively by looking at it directly or head-on. You may solve it and you may think of ways to do it, but they won't be creative. I think the only way you solve problems is by seeing solutions. It is really not possible to learn anything you don't already know. You just need to be reminded. I find everything. I don't really invent anything; if I find two words together and I take them out of context, they'll have this weird meaning. I find shapes the same way, whether I'm driving down a road or reading a magazine. Take an art magazine or a design magazine that might have something interesting in it. You can look at it so fast that you can't be sure what you've seen, or you look at it in poor light so that you can't be sure what you've seen, and frequently you can think you just saw the most amazing thing. And you go back and look later—it wasn't that at all. It was something different. Just see if anything catches your eye, anything. Just dig out your old sketchbooks and look at those maybe upside down and see if there's anything there that catches your eye. It helps to have a place to go where it is more likely to work than in other places. My office, for example, has generally been a pretty good spot for me to do that, or even in the shop. At home, less likely.

Is your office out of bounds?

Well, somebody knocks before they come in. Having other things that create an atmosphere around you that is yourself is important.

For example?

Other drawings on the wall. Not that they have anything to do with what you're doing, but if you glanced over there you might get a good feeling and say, "That was a good day." Or, "That means something." Or it's one you are still trying to figure out; you don't know if it's a good one or not. I think too many people are making judgments about things and they think they know how to do that, they know what the difference between good or bad is. I don't; it's not that clear to me. I don't know that I know the difference. I'm not even convinced that ugly is worse than beautiful. Maybe it's the other way around. I'm not convinced of any of those things.

That's a lot of freedom.

Well, that's what it's about.

Protecting yourself from being tied down by certain considerations so that you're open?

I suppose, if you wanted to psychoanalyze this, maybe it has to do with trying to put yourself in a position where you can't be judged, where people won't be able to say it's good or it's bad. I don't really approach it with that idea in mind. I think you have to approach it with the idea

Chest of Drawers, 1962. Oak, walnut, and birch, 47¼ x 52⅛ x 20⁷⁄₁₆ in. (120.01 x 133.03 x 51.91 cm). Photograph: Wendell Castle Studio.

that you're not concerned about what other people think, because that would be an outside influence creeping in on you. As soon as you think, "Well, nobody's gonna like this," or the opposite, where you think, "Boy, this is gonna be a winner—everybody's gonna love this." Well, that's just as bad.

But it's almost as if you're saying you don't commit yourself, that you do all of your contextual inspection at another time.

Yes, just keep moving. Go on to the next page. But that only works now and then. You can't make it work regularly. I have had, for example, an experience where in maybe 10 minutes I've gotten more ideas than I might get in 10 weeks, and good ones. You just have to count on it being that way so you're not too concerned if maybe things haven't been falling together for the last month or whatever.

A number of people we interviewed for this book have referred to the 1972 *Woodenworks* exhibit at the Smithsonian's Renwick Gallery as a pivotal event in their lives. You were in that show, along with Sam Maloof, George Nakashima, Wharton Esherick, and Art Carpenter. Was there an event or person who represented this sort of connection for you? Where you said to yourself, "He or she is doing what I want to do"?

I never had a mentor, anybody that I worked with and looked up to and wanted to be like. Sometimes Wharton Esherick gets that credit, but in a sense he doesn't really deserve it because that's not the case. I did admire his work, but I didn't admire the whole situation

from what I knew of it. I didn't admire him personally and I didn't admire the way the work got done. What I admired was the fact that there was sort of no definition for him—how do I explain this? Fine art and craft were the same thing. If he did a woodcut one day or a wood carving the next, I don't think he felt differently about them. His life also seemed very unified because he made things he lived with, so they were all very special and very personal. That part of it I thought about a great deal. He wasn't articulate: you couldn't talk to him about his work at all. He didn't have anything to say of any interest.

I don't know if I told you this story about the first meeting with him. It was 1958. I was going to school in Kansas and I had come east with a roommate of mine who had relatives here. We wanted to visit New York City primarily. We went to the museums and things. My roommate had a relative in Delaware he wanted to visit and he had a relative in Connecticut he wanted to visit. Well, it turns out that the relative in Connecticut lived in Roxbury, and I remembered from a book on Alexander Calder that Calder lived in Roxbury. So we went to visit him. We were just a couple of naive college kids from Kansas who didn't know the etiquette of visiting famous people, and we just showed up. Someone at the corner gas station told us how to get there, and we knocked on his door and Alexander Calder was wonderful. He showed us around his studio and asked us to have a glass of wine. We thought visiting artists was great. I knew that Wharton Esherick lived in Paoli, Pennsylvania, which wasn't that far from Delaware, so we showed up at Wharton Esherick's place the same way and knocked on his door. He wouldn't talk to us or let us in or anything. He said, "Get out of here!" But I could see it was interesting in there.

Music Rack, 1964. Oak and rosewood, 55¹/₂ x 18 x 21 in. (140.97 x 45.72 x 53.34 cm). Photograph: Rameshwar Das.

So you never got into his studio?

No, not then. I did get back there at a later time and spent a whole day with him. He was very receptive at that point. I don't think he ever liked my work, but he knew I was somebody serious. He had respect for what I was doing even if he didn't like it. We spent a pleasant

Game Table & Zephyr Chairs, 1979. Table: Walnut and Carpathian elm burl, 29 x 39 x 39 in. (73.66 x 99.06 x 99.06 cm); chairs: walnut, 28½ x 28½ in. (72.39 x 72.39 cm). Photograph: Unknown.

day there, but he wasn't the kind of guy who had anything interesting to say about his work. He'd answer questions, but not with any kind of answer that would give you any real insight about design. I think actually that he didn't have many feelings about design. It wasn't that he was trying to be secretive about it; he just liked to make things and he was a pretty simple guy.

When did you make the connection between sculpture and furniture?

Early on, I didn't know how to make furniture, and I'd never been around anyone who knew how to make furniture. I had some design courses in school so I knew a little about basic chair and table heights. But I had to study industrial design in spite of the fact that I didn't want to; painting and sculpture, which I really wanted to do, weren't possibilities for me at that time.

I discovered through people I worked with in Kansas some ways of working that avoided learning how to be a furniture maker. Sculptors before me used the lamination techniques that I used. One of my instructors in Kansas did bent lamination, although very crudely, compared to the way we do it today. They tried to bend things that were too stiff to bend so they'd soak them in water for weeks and then, of course, they never really glued together very nicely. But for sculpture they didn't need to.

Obviously, sculptors for hundreds of years—in fact, in medieval times, if they wanted a board bigger than the board they had, they glued two boards together. Those two methods seemed to me the way to make furniture; that's all I needed to know. You glued two boards together if you wanted a bigger board. If you wanted to bend a board, you

Leonard Baskin, *Oppressed Man*, 1960. Photograph: Unknown.

sawed it into strips and bent them. That was enough—and it is, actually.

You do two things when you are sculpting: you either add or subtract. You can do it in either order—it doesn't make a bit of difference—or you can intermix them. That's the good thing about lamination. Basically you add first, then subtract; if you subtract too much, you can always add some more back on. It's perfect. It's forgiving. You get to do exactly what sculptors have always done, but with a little more freedom because you don't have the restrictions of working with a block of any particular size.

I very quickly learned what grain direction meant in terms of strength. You would orient the grain direction in whatever way seemed to best provide the strength. So, it was the perfect solution.

Leonard Baskin was certainly the person whose work I most admired and paid most attention to at that point in my life, and he laminated. But he didn't laminate the same way. He'd laminate a great big block of wood and then carve. I thought this was silly. He could have just band-sawed off the bulk and gotten rid of all that, and sawed out the center and reduced the weight.

That method would also reduce a lot of internal pressure.

Yes, and the other thing that I was certainly well aware of as a child growing up was model airplanes—the nonflying type—solid balsa wood ones that you could buy kits for during World War II. They printed on the eighth-inch-thick pieces of balsa wood the various sections of the plane, and you'd cut them out and you'd glue A to B and B to C. You'd end up with this stair-step version of the fuselage and with sandpaper or an Exacto knife, you'd whittle off the corners and you had the basic shape. It was a great help for somebody who didn't have sculptural ability to get at the form. I had those models when I was in grade school and so when I wanted to laminate wood, I figured I'd do it the same way. You just have to plan your own cross sections, and I found that quite easy to do. That was probably one of the things I could do better than other people because I could visualize the sections.

It seems to us that you use wood like paint to get at form, and it's somewhat beside the point to talk about "Wendell Castle, woodworker."

As far as I'm concerned, it is. When I graduated from college with a master's degree in sculpture, if I could have gone right out and done whatever I wanted at that time material-wise, I

would have been modeling in clay and casting in bronze. That was what I liked best. We had a bronze foundry in college, and it was wonderful because you could cast things so cheaply in those days—you'd just find scrap bronze. In fact, it really helped pay my way through graduate school. I had made some contacts in Kansas City with people in society who got me commissions doing portraits. I did a lot of portrait heads—some that were absolutely lifelike—and cast them. I'd do a portrait head for 100, cast in bronze, and I got college credit for doing it.

We want your opinion on the exhibit organized in 1989 by the Museum of Fine Arts, Boston, titled *New American Furniture: The Second Generation of Studio Furnituremakers*. That show introduced a lot of people to studio craft furniture and people seemed to like the idea of artist-craftsmen replying to a historical piece.

The show was an odd one for my tastes, much too conservative. I have to admit some real problems with it from an historical standpoint. I thought it was a great error calling it a second-generation show since I don't know that there was more than one second-generation person in the whole show. And I didn't think it was representative of what was happening in the country in 1989 or whenever it was. It wasn't a true image at all. It was an image of what would happen more or less if you didn't go very much out of Boston. It emphasized New England furniture making.

The second thing that set it off on a really bad foot is that you were asked to reinterpret something from the museum's permanent collection. Well, that made no sense for some people: I mean if that's not the way you work, then that's not the way you work. It's asking somebody to do something that they might otherwise have never done. It's out of character.

Early sculptures by Wendell Castle; top: *Untitled*, 1959. Walnut; wall piece: 11 x 8 x 3 in. (27.94 x 20.32 x 7.62 cm); bottom: *Untitled*, 1960. Soldered copper sheet with walnut base; sculpture: 14^1/$_4$ x 6^1/$_2$ x 3^1/$_4$ in. (36.19 x 16.51 x 8.25 cm); base: 3^1/$_2$ x 11 x 9^3/$_4$ in. (8.89 x 27.94 x 24.76 cm). Photographs: Wendell Castle Studio.

56

Fig. 3. *Scribe Stool,* 1962. Walnut and ebony, 54 x 26 x 26 in. (137.16 x 66.04 x 66.04 cm). Photograph: Wendell Castle Studio.

Fig. 4. *Stool Sculpture,* 1959. Walnut and ivory, 61 x 23 1/4 x 37 in. (154.94 x 59.05 x 93.98 cm). Photograph: Wendell Castle Studio.

I don't think an artist should ever be asked to do that. Craftsmen are asked to do this frequently, but no one would ever ask a painter to do that. No painting show would happen where someone asked a bunch of painters to reinterpret some old paintings; painters may do that now and then, and if that's the thing you do, then that's the thing you do. Some of the furniture makers in that show do that. It was right down their alley. But I don't think you can tell by going through the show which ones are which. Nothing ever came out in the catalogue that indicated some were comfortable with this and some weren't.

Few people in their lifetimes have had the chance to view their work assembled in one place as you did in your retrospective organized by The Detroit Institute of Art in 1990. Few people in our field have had such distinct periods as you: the plastic work, the stacked carved work, the trompe l'oeil series, the fine furniture, the clocks, the warped-tabletop series, and now the *Angel* chairs [see fig. 9, p. 62] and *Pedestals*. Did you recognize yourself in all of the work?

Well, some more than others. Before I ever saw the retrospective, I knew exactly how I

57

Fig. 5. *Chair*, 1959. Walnut and nylon, 3½ x 23¾ x 31 in. (95.25 x 60.32 x 78.74 cm). Photograph: Wendell Castle Studio.

Blanket Chest, 1963. Cherry, 36 x 34 x 13 in. (91.44 x 86.36 x 33.02 cm). Photograph: Wendell Castle Studio.

was going to feel about it. It confirmed what I suspected or what I felt was important about my work. If I could analyze my own career in that way by walking through the retrospective and looking at the parts, the part that interests me the most now is in the very beginning—with the exception of the *Stool Sculpture*, which is not an interesting or great piece, though it's a great statement for having been done in 1959.

The *Stool Sculpture* [see fig. 4, p. 57] and the *Scribe Stool* [see fig. 3, p. 57] were built at the same time. They were very early pieces. When I started making furniture, I made a chair with string on it that was also in the retrospective. For me, there was no big difference between the *Chair* [fig. 5] and the *Scribe Stool*. I made the *Chair* because I needed a chair in my apartment. It was a chair, and I would have never thought of it ending up in a show. The other piece was made strictly because I thought I was making art. Art and craft were two entirely different things, and it wasn't until a little later that I thought of putting them together and making a connection. It was kind of trying to beat the system, I guess. I entered the *Scribe Stool* in a painting and sculpture show in Kansas that had no category for crafts, and I got into the show. That was kind of significant, I thought.

But I didn't know how to go ahead. That was a big problem. I thought the piece was good—but then how to take it further? I was suffering from what a lot of artists were experiencing in the 1950s. For the painters, what do you paint? There was confusion in the art world—there wasn't a clear way to go. The art school I went to was still having classes in antique drawing and drawing from plaster casts, but everyone knew about Abstract Expressionism. Everybody was wondering if they should be dealing with old-fashioned ideas about allegory and the figure or whether abstraction was the way to go. I was confused

Fig. 6. *Metropolitan Settee*, 1973. Cherry, 36 x 58 x 24 in. (91.44 x 147.32 x 60.96 cm). Photograph: Dirk Bakker.

by all of that and, in a sense, liked all of the choices. I think making furniture was a clear way to avoid having to deal with that decision because here was something you could do that was definite; it seemed outside of the confusion.

One of the things I asked myself about the time of the retrospective was what would I want to do with my work if I had to do it by myself, like I had to do early on? If you take away all of the skilled help I have had over the years and if I had to physically do it myself, what would I do? Well, it was really clear to me what I wanted to do. I'd go right back to where I was when I had to do the work myself.

The "me-ness"?

It was me all the way. I did what I wanted to do at a time when nobody was paying me to do anything because there weren't any customers for it and I enjoyed doing it.

The mid-1960s and through the late '60s was a wonderful time when the pieces got a little more complex, got bigger. That period I find very exciting—that aspect of my work that was taking full advantage of the lamination process [see p. 23].

You've made three two-seaters. The one that is at the Metropolitan Museum of Art in New York was done in 1973. Did you make the last one before you moved to teach in the furniture program at Rochester Institute of Technology in 1979?

No, I made that in Rochester. When I came to Rochester, I really had not made a decision that I wanted to be involved in furniture making. I'd only made a decision I needed a job.

Coat on a Chair, 1978. Maple, 36 ¼ x 18 ½ 27 ¼ in. (92.07 x 46.99 x 69.21 cm). Photograph: Wendell Castle Studio.

Fig. 7. *Tablecloth without Table*, 1979. Cherry, 24 x 28 x 42 in. (60.96 x 71.12 x 106.68 cm). Photograph: Wendell Castle Studio.

Was the shop there an attraction?

Not really. A very weird thing happened or else I wouldn't have ever been considered as a candidate for that job. Harold Brennen, who was the dean there at that time, had become dissatisfied with Danish-looking things so he let Tage Frid go. His idea was to get a sculptor in there. I think I may have gotten the job by default because I may have been the only sculptor in the United States who had made a piece of furniture.

 In sympathy for Tage Frid getting fired, Michael Harmon quit. He was the other teacher there and actually a far better craftsman than Tage technically. He'd gone through the English system that, as far as I'm concerned, has provided some of the very best craftsmanship. The part of the job that maintained some technical credibility went to Bill Keyser, and I was hired as a sculptor. But then the job descriptions tended to get blurred because actually I became more interested in technical things and sometimes my work became very much like furniture. Both bodies of work you just mentioned—the trompe l'oeil and the fine furniture—were works that depended a great deal upon skill. I decided I didn't really want to do things that depend on skill because skill is not what it is about.

It's not what you are about?

I don't think it's what art is about and that is one of the big dividing lines between art and craft. Craft is often about craft, whereas art is almost never about craft; it is unimportant.

 The trompe l'oeil does have its basis in some traditional art forms. There is great precedent for doing that. I thought it would be difficult to do, that you'd have to really fine-tune your skills. You just don't go out there and do it the first time, but it was easy. It was very easy to do. Four or five pieces later, it was no problem carving anything. The trompe l'oeil is about fooling the eye, and it's partly done with skill and partly done with the subject matter.

 Obviously, the way to fool people depended upon setting up a still life that was believable

Lady's Writing Desk with Chairs, 1981. Curly English sycamore, purpleheart, ebony and Baltic birch plywood with ebony and plastic inlay; table: 40⅛ x 41½ x 22¼ in. (102.55 x 105.41 x 56.51 cm); chairs, originally upholstered in Jack Lenor Larsen cream brocade, 34¾ x 21 x 26 in. (88.26 x 53.34 x 66.04 cm). Photograph: Wendell Castle Studio.

Fig. 8. *Ghost Clock*, 1985. Mahogany and bleached mahogany, 87½ x 24½ x 15 in. (222.25 x 62.23 x 38.10 cm). Photograph: Bruce Miller.

and simple and understandable, something that anyone might have seen at some point in life—a table with a hat on it, a chair with a coat on it. The table or chair doesn't look particularly weird; there is nothing to set you on guard that anything unusual is happening. You accept it and believe it. And you don't necessarily have to have great carving; it's not that important.

The kind of detail I put into the carving was, in a sense, unimportant, although there was a second level I was trying to challenge myself on and that was accurate carving. But neither thing in the end seemed to be very important because it was such an easy thing to do.

We wonder if the illusion would have been complete without that accuracy in carvng.

You're right on that—and that is why I had to do one more.

You mean the *Ghost Clock* [left]?

Yes. The other trompe l'oeil work wouldn't fool you upon close inspection and I wondered if you could fool somebody on close examination. But, again, that was kind of meaningless too. If you had the formula, it isn't fun anymore. You know when I give a talk on creativity, I like to make short statements and one of them is, "If you hit the bull's eye every time, then you're standing too close to the target."

There wasn't any doubt in my mind that I could do that and, so, where was the challenge

Fig. 9. *Angel of Blind Justice*, 1990. Ebonized mahogany, bird's-eye maple veneer, and poplar, 46 x 60 x 28 in. (116.84 x 152.40 x 71.12 cm). Photograph: Michael Galatis.

in this? In hindsight, a direction that I should have gone with that work was the surrealistic aspect.

The piece that Barbara Fendrick owns [see fig. 7, p. 60] is one of the earlier trompe l'oeil pieces where the carving is not anywhere as skillfully done as the later ones—that's the one that's a tablecloth with no table under it. It's this sort of drape hanging in mid-air that offered a far more interesting direction than the one I took.

A direction you took that mystifies us was turning to historical periods.

It doesn't interest me now at all. Obviously, it did then, but I made some mistakes in judging

Dr. Caligari Desk, 1986. Painted yorkite, solid maple, rosewood veneer, ebonized cherry, and silver-plated steel, 29 1/2 x 63 x 41 1/2 in. (74.93 x 160.02 x 105.41 cm). *Dr. Caligari Chair*, 1986. Painted yorkite, maple, and flakeboard, 31 1/2 x 24 x 24 in. (80.01 x 60.96 x 60.96 cm). Photograph: Dirk Bakker.

what was happening in the larger picture. There was a time in the later 1970s when painting and architecture were looking at postmodern kinds of ideas, and I saw a lot of possibilities there. Because of some circumstances in my life—the book I did with Penelope Hunter-Stiebel was one of them—and being sort of thrown in with a bunch of historical things, I learned about them and was impressed by them.[4] Like everything else I have passed by in my life, it might enter my work and it did. In hindsight, I don't think anything particularly great came out of that, the reason being that anybody might have done that. I had some skill and I could put things together in interesting ways, but it's got to be a lot more than that.

We heard that you were exhausted after the fine furniture and clocks. True?

Exhausted is the wrong word. The clocks were a part of the fine furniture period in a sense, although some of the clocks broke away from that a little. That was the time when I became enamored with the abilities that were available and took advantage of the situation. Nobody got that burned out because there was a team involved and that was fascinating. But there was a time later when I said, "No, this is silly, too. What's the point in any of this? It's not really what I want to be known for." It's back to the issue, if everyone went away and I was left in the studio by myself, would I make any of these pieces? No way. I wouldn't do that for anything. Those pieces, starting with the clocks and even before the clocks, became pieces that were designed. You sat down and figured out how they were going to be made, what the details were, and you did it. In the end, you weren't particularly surprised about what happened.

Were you personally connected with the work that followed the clocks, the *Caligari* series?

No, it falls into the same category. I developed the painting style, but Don Sottile did 90 percent of the painting and he really had a good feel for black-and-white painting. He's colorblind so if you ever need to decide who painted what in my studio, you'll know. If it's got color on it, I did it; if it's black and white, Don did it.

The next body of work was the *Angel Chairs* and the *Pedestals* that you introduced at the Peter Joseph Gallery in 1991. There's great ambivalence to the chairs—you can see them as dark forces from the ground or as wings.

Or whale's tails—I've stopped trying to make anything out of it myself. You are better off trying not to analyze it because you run the risk of turning what had been a right-brain activity into a left-brain activity. You really want to learn from the work in some kind of nonliteral

Tipsy Osbourne, 2010. Cast concrete, 18 3/8 x 55 x 24 in. (46.67 x 139.70 x 60.96 cm). Photograph: Lucas Knipsher.

or nonlogical way. I might mention that I'm actually doing a lot of painting now and less woodwork. I'm sort of coming full circle.

What kind of painting?

Painting painting—an actual picture, not just decoration. It's furniture-related but it's a complete composition in a square or rectangle. I've painted on furniture for years but that becomes a kind of decorative thing; this is different—I wanted to take it one step further and deal with a composition.

Are the paintings representational?

No, there is nothing recognizable in the paintings, except abstractly you might think, "Oh, that looks like a cloud or that looks like a watermelon." You might superficially pick out something like that.

Watermelons figure in your work. Is that your Kansas history speaking?

Well, watermelons are a good source of imagery. Their shape, their color, the way they're sliced, the way they're plugged.

We never thought of them like that.

I think of a watermelon as a sculptural thing, not just because of its shape but because of everything about it. The way it looks when you finish eating it, the way the seeds look and all that. They're great.

You've talked about fence posts.

It was early on and I made that analogy to farmers when they opened up the West. They'd let everybody go out and however much land you could put a fence around, you got to keep. I think in art it's the same thing: once you've fenced a territory, it becomes your territory, but

if you don't get the fence up before somebody else gets it up around the same territory, it won't be your territory. I felt pressure early on to get a lot of pieces made and to cover a fairly wide territory. I had so many ideas that I wanted to fence in—it prevented me from focusing a little.

You've said that you're immune to criticism. Is that why you named a dining table *Never Complain, Never Explain*?

I learned to be that way in college. There was a point when I was a good student, and really thought I was a good student. Then some things happened and I didn't get the grade I thought I should get. I got some criticism for a bunch of things. I got offended and tried to defend myself against somebody who had been brought in as a pro to criticize the work. I learned what a big mistake that was.

Was this a sculpture project?

Yeah, sculpture projects, so there weren't any right or wrong answers. I decided that I just was not going to let something like that bother me again. It just makes it worse. I'm not going to defend anything that someone is critical of. And I developed the ability to not let it bother me.

That's a valuable lesson learned early on. Now what about the many directions in your work?

I have fluctuated back and forth, and I know that. I think it's a mistake, and, if I could, I would go back and correct my own career. I think I have had a boundary on either side, like walls in a corridor that I am walking down. One wall is the more conservative, practical, make-sense side; the other doesn't make any sense, the who-knows-where-it-will-lead side. I've been afraid of both of these, and might get too close to one of them. I might not realize for a little while that I've gotten too close to the comfortable situation, and then I'll shy away. Then go away and think, "Well, this doesn't make any sense. Nobody is gonna buy any of these things. Where am I going with this crazy stuff?" And I wander back the other way. I've done that a lot. I'm going to do it a lot less.

I think when you get older, having covered lots of territory, it's a bit like Alice in Wonderland. I can't remember the exact quote but she's talking to the cat and asking, "Where do I go from here?" And he says, "Where do you want to go?" She says, "It doesn't matter much." And he says, "Well, then! It doesn't matter much which way you go!"

East Hampton, New York
September 1991

Concrete Chairs, 2009. Cast concrete, 26 ½ x 53 x 32 ½ in. (67.3 x 134.6 x 82.6 cm). Photograph: Rolant Dafis.

AFTERWORD

I still design with a pencil, and that will likely never change. Today we make furniture in a variety of materials—cast iron, bronze, aluminum, steel, concrete, plastic, and, of course, wood. We have joined the digital age in our production methods by using 3-D modeling, scanning, 3-D printing and SLR. We now have some laminated wood pieces carved on a 3-axis lathe and a 6-axis robot, although there are still many wooden works that we carve in very much the same way as I have done them since the 1960s.

I believe the field has changed dramatically in the last twenty years, with most of the changes occurring in the past ten. These changes have been good for a few, but I believe for the majority of furniture makers it has been to their detriment. The international fairs, like Design Miami and Art Basel, have changed everything. Today, it is absolutely essential to be represented internationally. Dealers from all over the world participate. The fairs are highly selective, with only the most important dealers being accepted to exhibit. Approximately 90 percent of the work shown will be European. I am typically the only living American designer exhibited. The fairs often celebrate design without regard for how something is made or what it is made out of. This fits my thinking, but not that of most American furniture makers.

Also, there has been a change in the collector base. The collectors from the 1990s are now older and less active. Prices are also dramatically higher than in the '90s, with Ron Arad and Marc Newson getting over a million dollars for a single piece of furniture. The collectors now are the same people you would find purchasing paintings and sculpture. There are so many differences I have watched unfold over the last twenty years, I could talk about it for hours.

I would never have given up on being a sculptor if I had not believed in the value of furniture as a vehicle for creative expression. The fine arts are finally embracing "Design as Art."

Scottsville, New York
September 2011

1. John Russell, "Gallery View: The Met Salutes the Decorative," *New York Times*, February 19, 1978.
2. Davira S. Taragin, Edward S. Cooke, Jr., and Joseph Giovannini, *Furniture by Wendell Castle* (New York: Hudson Hills Press in association with the Founders Society, Detroit Institute of Arts, 1989).
3. Peter Dormer, *New Furniture: Trends + Traditions* (London: Thames & Hudson, 1987); and Wendell Castle, *The Fine Art of the Furniture Maker: Conversations with Wendell Castle, Artist, and Penelope Hunter-Stiebel, Curator, about Selected Works from the Metropolitan Museum of Art* (Rochester, NY: Memorial Art Gallery of the University of Rochester, 1981).
4. Wendell Castle, *The Fine Art of the Furniture Maker: Conversations with Wendell Castle, Artist, and Penelope Hunter-Stiebel, Curator, about Selected Works from the Metropolitan Museum of Art* (Rochester, NY: Memorial Art Gallery of the University of Rochester, 1981).

JERE OSGOOD

b. Staten Island, New York, 1936

Jere Osgood has enjoyed a distinguished career as a teacher, but he considers himself, first and foremost, an artist–craftsman. Born in 1936 on Staten Island, New York, he was acting director of the Program in Artisanry, the legendary woodworking and furniture design school at Boston University, from 1975 to 1985. He is credited with training an exceptional group of furniture makers—including Rich Tannen, James Schriber, Tim Philbrick, Wendy Maruyama, Tom Loeser, Michael Hurwitz, Tom Hucker, Mitch Ryerson, and Jon Everdale—who have gone on to distinguished careers as teachers and artist-craftsmen.

Osgood also taught at the University of the Arts (formerly Philadelphia College of Art), Philadelphia, Pennsylvania, from 1970 to 1972; the School for American Craftsmen, Rochester Institute of Technology, Rochester, New York, from 1972 to 1975; and Rhode Island School of Design, Providence, Rhode Island, 1999. He has given numerous workshops on technique and design, teaching at Peters Valley, Layton, New Jersey; Haystack Mountain School of Crafts, Deer Isle, Maine; Brookfield Craft Center, Brookfield, Connecticut; Anderson Ranch, Aspen, Colorado; Virginia Commonwealth University, Richmond, Virginia; Penland School of Crafts, Penland, North Carolina; and at various conferences of The Furniture Society.

Initially trained as an architect, Osgood attended the University of Illinois–Champaign-Urbana, from 1955 to 1957. He found his interest drawn first to architectural details and then to furniture. He received his bachelor of fine arts in furniture design from RIT in 1960 and continued his graduate studies in Denmark under the Scandinavian Seminar program from 1960 to 1961.

His furniture is included in the permanent collections of the Mint Museum of Art & Craft, Charlotte, North Carolina; the Museum of Art, Rhode Island School of Design, Providence; the Museum of Fine Arts, Boston; the Museum of Arts and Design (formerly the American Craft Museum) New York City; the Renwick Gallery, Smithsonian Institution of American Art, Washington, DC; the Currier Museum of Art, Manchester, New Hampshire; the New Hampshire Historical Society, Concord, New Hampshire; and S.C. Johnson, A Family Company, Racine, Wisconsin.

Osgood received grants from the National Endowment for the Arts in 1980 and 1988, and he became a fellow of the American Craft Council in 1993. In 2002, he received the Furniture Society's Award of Distinction.

Osgood's work was included in two important exhibits at the Museum of Fine Arts, Boston, and in their accompanying catalogues: in 1989, *New American Furniture: The Second Generation of Studio Furnituremakers* and, in 2003, *The Maker's Hand: American Studio Furniture, 1940–1990*.

His furniture has been featured in many books, including Patricia Conway's *Art for Everyday: The New Craft Movement*; Michael Stone's *Contemporary American Woodworkers*; and on the cover of *The Penland Book of Woodworking*.[1] Magazine profiles include "Jere Osgood and Tom Hucker," by Amy Forsyth in *Woodwork* magazine and the cover story, "Perfect Sweep," by Rosanne Somerson, *American Craft* magazine.[2]

In the early 1970s, Osgood developed new methods for bending wood that transformed his furniture and influenced the work of many other makers. He devised systems of tapered lamination and compound stave and shell construction that enabled him to produce the complex curved forms that became the hallmark of his furniture. In the late 1970s, Osgood wrote a series of articles in *Fine Woodworking* magazine detailing the wood-bending techniques he developed.[3]

From his rural New Hampshire studio, Osgood strives to attain in his furniture a feeling familiar to us from organic forms. Observing that nature has no straight lines—in the flow of water, the growth of trees, and the movement of air currents—he aims to create furniture that is sympathetic to organic form. Osgood's mastery of his craft—and his ability to communicate this knowledge through his teaching and writing, coupled with his quiet manner and wry sense of humor—has earned him universal respect and affection.

You've said that Wharton Esherick was an early influence; how old were you when you first encountered his work?

Nineteen or twenty. I was in a ready-to-be-influenced stage, about to enter the School for American Craftsmen at RIT, when I ran into Esherick's work in New York. What he did was make me see that it was all right to design things your own way. It was de facto permission to do things that didn't look like Grand Rapids furniture. I wanted the freedom I saw in Esherick's work and I didn't want the restrictions that I saw in commercial furniture.

Did you expect to find that kind of freedom studying at RIT under Tage Frid?

I didn't know for sure. Although I was at an impressionable stage, I wasn't overly impressed with Tage Frid's work. Tage Frid, for all his greatness, was a catalyst, but he was never as sensitive a person as Wharton Esherick.

How did you get involved in woodworking in the first place?

My grandfather had a workshop on Staten Island and my memories of him were that he was always working in his shop. I was always going by there to see what he was making. Most of what he was doing was turning. I still have a few of his things around here somewhere. Now I know it was very simple woodwork, but I think what's important is that I saw him doing this and he was very involved in it.

As early as I can remember, my father always had a shop and his brother, my uncle, also had a workshop, and the other brother in Lawrence had a workshop. So, everywhere we went—the family, I mean—it was an expected thing in the eyes of a 10-year-old to see the workshop.

The concept I got from my father was that if you want something or need something, you just make it; you don't wonder about it or look for it in the market. You just make some simple version of it. I remember years later reading that Alexander Calder said this also. I think he had all handmade kitchen utensils. I don't want to go that far.

My father wanted to go to engineering school, but instead he had to go to work. He ended up working for a chemical factory as an industrial traffic manager. All these years, I was impressed by the fact that my father was doing a job he didn't like at all—he lived for summer vacations in Vermont. It was a reverse recommendation: be sure you find a career that you like. I made up my mind that I was going to do something that I liked.

Early on in high school, I started doing repair work for people in the neighborhood, like refinishing good pieces of furniture or repairing what was broken. They called me because they knew that I could make things that needed to be made or repair things—broken hinges or whatever. I'd figure out how to do it. My bench was right across from my father's bench.

I eventually got more elaborate, making bigger bookcases and making parts of kitchens. In college, I learned more about doing drawings and dimensioning and kitchen planning, so when I worked those summers, the stuff would go up another notch. I moved on to more elaborate kitchens. It would have been a four-, five-, or six-year period where I was running this business in the family basement off and on.

After high school, you spent a couple of years studying architecture. How did you find your way to the woodworking program at RIT?

I was always listening to stories from my grandfather about what he had done when he was

Shell Desk, 2001 (detail; see p. 86).

working as an architect. That got me wanting to go to architectural school at the University of Illinois. But then I realized I was focusing more on the detailing of the buildings—accessories like benches, door frames, handles, the smaller detail work. And somewhere along there I saw an advertisement in *Craft Horizons* for the School for American Craftsmen at the Rochester Institute of Technology.

At the same time, I took an aptitude test that said I would make a good watchmaker! Maybe because I'm ambidextrous—I can use tools in both hands. I'm glad I didn't do that.

I waited a year to get into RIT. I was lucky to get out of high school, and I had to work very hard in college. I mean it was a terrible strain. It's only the stuff that goes through my hands that comes out alright. I graduated with honors from RIT because my shop grades overpowered the low academic grades. I probably had three years of As. I thought that was really funny—that people's abilities lie in different areas, that you could be low on your scholastic scores but yet do very well once you got out in a career.

Somewhere in there, I started making things for America House. My father was on the way to the dentist one day and stumbled over the old America House. It was the major place for sales for American craftsmen in New York City. He started turning things for them and making things, and he said to me, "Stop in there and see Mrs. Eastmeade." She was a very famous figure there. She's really the one who helped me with product development—I guess that's what you'd call it—all these accessories that kept me going for 10 or 12 years after I finished college. It was my means of support. It got me into Manhattan, too, and that led me to go over to the museum [the Museum of Arts and Design, formerly the American Craft Museum] to see shows. Esherick's stuff was in America House then.

Easy Chair, 1965. Curly maple, 35 x 24 x 32 in. (88.9 x 60.96 x 81.28 cm). Photograph: Jere Osgood.

Small wooden objects for America House, 1960s. Photograph: Warren Johnson.

An interesting thing happened when I was making turned bowls for America House. I had a lot of math courses at the University of Illinois, and I had it in my head that to get a perfect form in a bowl or plate, you needed a mathematical formula. I was plotting these parabolic curves for the bowls and shallower parabolic curves for the plates. They came out all right, but something happened somewhere along the way. I don't know who said it or how I got the message, but I realized that I'd get better and more sensitive work if I didn't do that—that I needed my personal, irrational eye rather than a perfect mathematical form. You

Fig. 10. *Dining Chair*, 1962. Brazilian rosewood, 34 x 17 x 17 in. (86.36 x 43.18 x 43.18 cm). Photograph: Unknown.

get these personal idiosyncrasies into curves if you draw them freehand. The little aberrations or harmonic overtones wouldn't be gotten as easily from a mathematical formula. As soon as that hit me, I've never touched another formula. I've also been turned off to the "golden mean" because of that experience. I always thought that was a really strong message, that there was a personal feeling that you could put into your work.

At RIT, I was inventing joinery, which drove Frid up the wall. When I got up to the school, he said, "You've got to unlearn all this stuff; what you've been inventing is no good. I've got to teach you the right way to do this joinery, and then you've got to start over." Also, I had this stigma of entering RIT with two pieces of furniture in the *Young Americans* show before coming in as a first-year student. At the time, that was a very important exhibition for people under 30. It was at the Museum of Contemporary Crafts. One piece was a walnut desk that had some peculiar joints in it with silver inlay in the front. I had this kind of sliding dovetail for the legs instead of mortise and tenons. The other piece was a rosewood chair (Fig. 10).

In terms of technique, were you already going in one direction and Tage in another?

Well, it wasn't such a big problem. We got over it. There was a point where we were going at opposite things, but somehow we resolved it. I guess I said that I understood what he was trying to help me with and he said that he could live with what I was trying to do. We came to a peaceful solution, but up to a certain point it was real touchy because he felt I was too strong on wanting to do my own thing.

It was a four-year program. I did it in two and worked toward my graduate degree in my third year. They ran out of stuff. He doubled up the curriculum. It was really amazing. It was like pouring water into a sponge. I had a great time there. I mean, things moved really fast for me. I have reviewed in my mind the number of pieces I did in a school year, and I don't think we ever had a student through Boston University's Program in Artisanry [PIA] who did that much. I was very productive and I guess he had to hold me back to make sure things were right.

I exhibited all over the place. The dean or Tage was always coming in the shop and saying there's this show coming up, what have you got? I had an old station wagon that eventually got so bad there was no floor under the back seat. The floor by the clutch pedal disappeared, and the starter didn't work right a lot of the time. I had to get out and stick a screwdriver in

whatever it is in the front by the engine. But I can remember driving around with this thing full of furniture. And it wasn't just one show; they were one after another. That was the time when the rest of the world or the museums or the libraries were waking up to the fact that there was a craft movement underway.

I got some scholarships, and my parents sent me as much money as they could, but I needed more money, so I was filling orders for America House. I was sneaking around trying to make bookends or other small wooden objects. I was always pulling the stuff out and working on it when no one was looking. They'd let the students work in the bench room after hours but not in the machine room. We had this janitor who wasn't too attentive, so I would, at the end of the afternoon, use tape on the machine room doors so they wouldn't lock. I could only work in there 'til it got dark outside because I couldn't turn the lights on. I had to run the table saw in the dark and hope that the security people outside didn't hear machinery going. I had about three years of sneaking around trying to fill orders. My bed had all this stuff underneath it. I was carrying parts back to my room for this or that, and I'd work on them in odd moments.

They were jumping up and down for things like bookends and paper weights. They would be nicely sanded rosewood or walnut. It paid well. You'd get a check for $600. I know Mrs. Webb [Aileen Osborn Webb, art patron, philanthropist, and principal in the creation of the American Craft Museum] okayed scholarships for me, but you still needed money to live on.

Were there any relationships out of that period that stayed with you?

Well, the most important one was Dan Jackson, who came in my second year. We did a lot of

Peder Moos, *Occasional Table*, 1948. Mahogany, oak, and maple, 22 x 32½ in. diameter (56 x 82.5 cm). Photograph: Unknown.

work together and he would be with me when I was delivering things. He already had his engineering degree. At the time, he was doing smaller sculptural things.

You got your RIT degree in 1960. What did you do after that?

Tage Frid had recommended that Dan Jackson go to Denmark, so Dan left during my junior year. I'd get these great letters from him and then, one day in spring, he suddenly turned up walking up Washington Street with his knapsack and talking me into going to Denmark. I left for Denmark for a year; it was officially written down as "continuing work for my graduate degree." Anyway, Dan returned for a second year to Denmark to study with Peder Moos, the Danish woodworker. Peder Moos is the equivalent of a Krenov who never got as well known, except among us.

I went to Denmark through the Scandinavian Seminar program. I know now that it was the fading years of the heyday of Scandinavian furniture, but I didn't know that at the time. While I was there, I checked out different shops to see what they were making.

Chest of Chair, 1971. Curly maple, 72 x 74 x 30 in. (182.88 x 187.96 x 76.20 cm). Photograph: Unknown.

What were the sizes of the shops that you were visiting?

The places I went to would have had one or a couple of people or four or five people.

So, it relates to the studio shops here?

Yeah, it was equivalent to the stuff Tage Frid was always talking about—small shops. And many of them, if you're in a city, would be a room this size, absolutely jammed and barely any room to work. I made a chair there, and that was interesting because I had to go to two or three small shops in town to either get supplies or get some help with the joints I couldn't cut or didn't want to try with hand tools. So, that was a nice introduction. They let me use their machines.

Did you pick up any techniques?

I have a machine in the other room—a slot mortiser. The first time I'd ever used one of them was in Denmark. When I got back to the United States, I had a deposit from America House that I mailed right over to Denmark and got that machine. Soon after that, Dan came back and he got one. Now those machines are all over the place. Who knows how strong our influence was.

Denmark was great—very hard to put into words. There is sensitivity for form and materials in Denmark and in the other Scandinavian countries that just isn't here. You can't explain it to somebody—you've got to be in it. Walk around and look at it, talk about it, and feel it, and see the people doing it. It's a different viewpoint over there. Denmark opened my eyes to see that this sensitivity was possible.

I came back to New York and then started putting stuff together in my parents' basement. I got more machinery and every once in a while a cabinet job would come along that would be a big shot in the arm.

The basement was small, and there was no way to assemble a big series of cabinets side by side. So, I made this wooden railroad track and waxed it. I'd set one cabinet up on the track, hang the doors, and then screw the next cabinet to it and match the doors, hinges, and so forth. Then I'd shove the thing along and unscrew the first cabinet so I could keep adding onto the line of cabinets. I did 85 feet of cabinets for America House in Michigan this way.

I didn't want to stay in Staten Island. I didn't like it there. It was cramped in my parents' basement, and I knew it was just a matter of time before their insurance would go crazy. I started looking in a circle around New York, and I eventually found a place about 85 miles away in New Milford, Connecticut, near where James Schriber is now. Six thousand dollars for an old dairy—hard to believe these days.

Jere, this is the 1960s now. What's going on in your life that reflects this tumultuous time?

I think a lot of the success I had was because of the freedom that was going on in the '60s. It was a real opening up. I was busy doing what I wanted to do. I moved to Connecticut, got married; we had some wild friends. There's Woodstock going on over there, though it didn't hit Connecticut the way it hit other places. But I knew it was history at the time.

The 1960s were a really good time to start up anything. It was an important time, particularly for people like me because things were expanding. It was luck in a way.

When did you start teaching?

I taught at the Craft Students League starting in 1962 and taught there until 1970, one day a week and sometimes two. That was my day off out of the shop. I got on the train and went to New York. The teaching job came through Paul Smith, who was just starting out at the American Craft Museum. I was hired to teach woodcarving, and I evolved that into furniture because I didn't like doing woodcarving much. That was what gave me the opportunity, or the confidence, to take on the thing at Philadelphia.

When I started teaching at Philadelphia College of Art [PCA], I remember going into the office and they couldn't figure out what to

Desk Chair, 1974. Walnut and leather, 36 x 23 x 19 in. (91.44 x 58.42 x 48.26 cm). Photograph: Jere Osgood.

do because I didn't have the credentials. They gave me the title "assistant professor," which is before associate. So when I got to RIT in 1970, they couldn't put me in lower than that. Alphonse Mattia was a student at PCA when I was teaching. He was in the shop doing a lot of things.

So, you went off to teach at RIT with an assistant professorship.

I taught in Rochester for three years; it was a very busy academic situation and I jumped right into it. I didn't mind organizing things. I could sit down and figure out lists for curriculum and go to meetings. It was in that three-year period that Tom Hucker worked with Dan in Philadelphia—or tried to work with Dan. They're too headstrong. They couldn't cooperate with each other too well.

My son Mark was born and we left Rochester soon after that. The school year

ended, I managed to sell the house, and I retired from teaching and was going to work. Fortunately, I hadn't sold the old place in Connecticut, so we just moved back there. We hadn't been back very long when Neal Hoffman, an assistant dean at Boston University, started calling me about the Program in Artisanry [PIA] there. He called me so many times and I'd say, "No, I don't want to teach." And I finally thought, "Every time he calls, the salary goes up a little bit. If he's still interested next month, maybe I'll consider it."

I finally agreed to work part time with Jim Krenov at PIA. I've always liked Jim's work, but always wished that somebody else made it—he's been such a hazard over the years. PIA started in a spring term and Jim never organized much in the woodshop. He got some things together and other things were gotten together for him by John Tierney, who was a woodworker who knew what to get him. You'll never know the full story exactly, but apparently Jim was so difficult to get along with that he either quit or was fired. They said to me, "You no longer can have the part-time job. We have to have you full time because we don't have anyone else lined up."

I agreed to the teaching position at PIA, and Dan Jackson agreed to take a sabbatical so he would be with me at the beginning of the school year. Over the summer, he came up a number of times, as I did, to organize the whole shop there, to get it ready for the fall. Most of the curriculum and most of the Certificate of Mastery guidelines were written by him in his shaky handwriting. He would work on them and then go over them with me and then we'd maybe make a few changes. A lot of it was based on the way we had been taught at the School for American Craftsmen and what he had used when setting up the shop structure at PCA. At PCA, though, he didn't have as much latitude because it was part of a running craft department. At BU, we had the opportunity to set it up any way we wanted it. We couldn't offer a genuine graduate degree. It had to be an equivalency in the field to give people the status of a graduate degree without the academic backing. They weren't ready to let us offer a graduate degree.

I always tried to tell my students that what I'm after as a teacher is getting your strong personal feelings into your work. I don't want you copying things or combining associative forms that you see. I want your own personal inner interpretation. I think it worked because we had high expectations for the students, and we expected them to live up to them. And they, for the most part, did.

It's hard for me to describe those days other than that they were good. It was remarkable the way things clicked together. We had support from the administration. It wasn't reckless, but if you needed stuff, you could get it.

The other thing that's interesting about the Program in Artisanry is that it was always run by the faculty as a group. The place was basically a community organization. I was acting director and I had to make decisions myself, but I insisted on trying to get a consensus from the faculty.

So, Alphonse came by at the start of the second year?

We interviewed a lot of people. Alphonse had made a good impression on the students, and Dan and I knew he could do the job. He had a clear track record from Virginia Commonwealth. We felt we needed somebody directly from our field. We wanted somebody compatible with what we had started to set up.

Were you doing any of your own work at this time?

Some, but not much. I did next to nothing of my work in the summer before we started PIA, because there was so much work to get the place ready to run. It was peculiar— Jim Krenov left no curriculum behind.

I commuted from New Milford for at least three years—in an orange Bug through all weather on the Massachusetts Turnpike. I don't recommend that to anybody. I had a succession of apartments and it was terrible. Then eventually the marriage deteriorated to the point where we had to sell the place in Connecticut and that's when I moved the equipment into storage in Boston. I kept stuff at the building. There was a shop on the third floor that I shared with Alphonse. When he came along, I punched a hole into the elevator shaft and I moved my bench into it. I was just looking forward to the day when I could move out of Boston.

When did you build your first *Elliptical Desk*?

That was 1970. It was the first time I used tapered laminations. I remember making test models of the legs using the normal lamination process and it didn't work. When you laminate in the normal manner, you have an S curve that's two-and-one-half inches thick. Then you cut through the laminations on a long, gentle slope to create the leg's taper. When you do that, you weaken the thing considerably. After you've sawn the tapers, it's as if a lot of those laminations weren't there.

What came to me was that if I've got 11 laminations at the top and I can end up with 11 laminations at the bottom—instead of 4—then I'm going to maintain that strength so it's one continuous wood line [a wood line can be

Fig. 11. *Chest of Drawers*, 1969. Fiddleback Honduran mahogany, 59 x 33 x 17 in. (149.86 x 83.82 x 43.18 cm). Photograph: Hugh Laing.

understood as a continuous grain line, as in the growth lines of a branch]. All I had to do was invent some way of tapering the individual laminates. To me, it is important to reassemble the wood in a form relative to its growing form. That's part of a romantic concept you hear about in three-dimensional design classes.

The mahogany *Chest of Drawers* [fig. 11] in *Objects USA* and the *Elliptical Shell Desk* [fig. 12] are important early pieces because that's where I was starting to get a feeling for three-dimensional form. Somewhere, way back there, I had gotten dissatisfied with the square furniture

Fig. 12. *Elliptical Shell Desk*, 1970. Walnut, 34 x 48 x 50 in. (86.36 x 121.92 x 127.0 cm). Photograph: Unknown.

form, which was a logical outcome from our manufacturing processes.

You can fulfill your functional needs alright with square furniture, but that *Elliptical Desk* and the succession of things that followed are based on thinking about movement in all forms. In nature—your flow of water, your movement of air, even your growth of trees—there aren't any square, right-angle turns. There aren't too many flat planes. You get all these compound forms that are going on all the time in the natural world, and I felt that was a way to relate to the furniture—to try to get back to these forms.

When I was a student—and also when I was teaching at RIT—I was exposed to shaped and carved forms. There would be carcasses that were laminated up with heavy stock and then formed down into curves and bulges with a body grinder and so forth, and I didn't want any part of that because I felt that technology or that aesthetic was too foreign to the material. It was also too heavy and costly. I felt that if I could bend five-eighths or one-half-inch material to form this compound shape, well, that was better for me.

On the low chest, the staves in the sides were individually bent first and then they were joined. And it was the joining of the staves—as in a barrel—that created the second curve?

Yes. I was trying to get some kind of feeling into this three-dimensional mass. Each stave is different. The back one is straighter because it usually would be against the wall with those designs, and then they move out a little bit and the one in the front relates to the edges of the drawers. As far as I know, I developed that process. You would see similar forms in the side of a boat, but it would have been formed over the ribs of the boat.

I work out the use in things, but then the piece has to create its own form that will be in harmony with those functional aspects. If, in later stages, I'm going to sacrifice anything, I may chip away at the edges of

Fig. 13. *Rosewood Desk*, 1985. Rosewood, ash, and leather, 45 x 80 x 34 in. (114.30 x 203.20 x 86.36 cm). Photograph: Andrew Dean Powell.

Fig. 14. *Ebony Desk*, 1989. Ebony, lacewood, pearwood, ash, and leather, 41 x 69 x 50 in. (104.14 x 175.26 x 127.0 cm). Photographs: Andrew Dean Powell.

function—though not much. But I wouldn't chip away at the form concepts to try to get the function perfect.

You've made strong pieces in the three major furniture forms—the chair, the carcass, and the table and desks. In the chair, does function have to take over a little more?

I'm freer in the desks because in a chair you've got to drape your body over it and support yourself—without collapsing, hopefully.

Was your experience with draftsmanship in the study of architecture any help?

I couldn't have done without it. The drawings for those big pieces—they're killers. If I were to do them correctly, they'd take forever. I do them to the point where I can understand them and then stop. A big piece like the *Rosewood Desk* [fig. 13] or that *Ebony Desk* [fig. 14] that you have now, may be the result of 35 or 45 different drawings. There's got to be sections and rotated sections and overlaid top views superimposed on side views. It's just a mess. I don't like to hurt my brain that much.

You've talked about trying to get movement into three-dimensional mass and about the complexity of the drawing and planning stages of your design process. To us, it's still alchemy that you've been able to bring the first together with the second. Can you give us insight into what goes on? Is there some kind of visionary stage?

I was thinking about that relative to the desk I made in 1987 [fig. 15] and several others like it since then. I see the furniture form on a functional plane when talking about the top, and I see the legs that support the top as a gesture on my part. While sketching, I'm also

80

Fig. 15. *Desk*, 1987. Ash and leather, 32 x 72 x 26 in. (81.28 x 182.88 x 66.04 cm). Photographs: Andrew Dean Powell.

thinking three-dimensionally. I don't think or remember in words. I remember images. So, I can be doing sketches while at the same time making this curve in space that might be the legs. I'm making a positive gesture in space when I put these lines down on the sketchbook. That has to go on to a certain point until the piece of furniture becomes strong enough to make its own positive gesture back to me. Then, basically, the piece is almost done. If I push it far enough, by visualizing these lines in space, then the piece will take over and it will make its own suggestions back. This may sound kind of crazy, but they do develop in that way. I have to project the piece for a while until it's strong enough to stand on its own and suggest the rest of its form.

There is a particularly aerodynamic or wind-blown quality to that '87 *Desk*.

There's a lot of flow to it. I'm deliberately trying to get the feeling of…not water specifically, not air movement specifically, and not bending wood specifically, but a combination of things relating to organic form that we can be comfortable with as human beings. I feel the '87 *Desk* is probably the most easily understood statement I've made thus far regarding the forms I'm working with.

I also spent a long time working on the *Ebony Desk* very carefully from all five views, and I think it is a definitive statement. I wanted a strong counterpoint to the large sweeping planes of the doors, and I felt it was important to get these curves in there, these scallops, so that they would work as a counter to the long, restful curves of the rest of the piece. That desk was big enough to do this, whereas the '87 *Desk* was meant to be a simpler piece.

I took a drawer out of one of your desks and saw how it changes shape so many times. It's a complete composition unto itself.

I always felt that was very important. When I was a student, I made a mahogany box. I veneered up rosewood drawer bottoms. This is before Tage Frid and I were getting along well. He got really mad. "What a real stupid thing to do. You don't put really fine veneer in there." He said, "It's just not done. You use inexpensive drawer bottoms." I didn't see it that way. I was seeing this three-drawer unit, taking each part of it as important. It didn't bother me—it didn't even occur to me—that people might put stuff on top of the rosewood. Dan Jackson and I had an expression that some things were better hidden, meaning it was nice to be surprised when you discovered them later.

Elliptical Shell Desk, 1993. Bubinga, wenge, bird's-eye maple, and leather, 48 x 53 x 38 in. (121.92 x 134.62 x 96.52 cm). Photograph: Andrew Dean Powell.

Easy Chair, 1994. Cherry and upholstery, 34 x 33 x 33 in. (86.36 x 83.82 x 83.82 cm). Photograph: Warren Johnson.

How do you feel about the way your work is going now?

I wish I had the physical strength and energy that I had in the 10 years I spent teaching at PIA. I get tired now and it's a bit harder to work

Summer Chest, 1994. Claro walnut, ebony, and ash, 34 x 43 x 20 in. (86.36 x 109.22 x 50.8 cm). Photograph: Warren Johnson.

Side Chairs, 2003. English hornbeam and leather, 36 x 18 x 18 in. (91.44 x 45.72 x 45.72 cm). Photograph: Warren Johnson.

from eight in the morning until six, six days a week. I can maintain it for a long time the way I am, but I'm conscious of my physical mortality and that's bothersome. I'm really getting a little jittery, too, about my helper getting married at the end of the summer and that I may have to get somebody to replace her. It's hard to get people that will be compatible with the way I think.

But I'm just hitting my stride and getting a better and better sense of form—the way I want to handle it in furniture—and that feels good. I'm surprised when a museum wants a piece; I always see this as a bit of wonder.

I am worried about the economic consequences of spending three or four months on a piece, but the work that I do is expensive no matter what. Even a piece that takes a month adds up. I should either double my prices or at least move them up, because I'm just not earning very much. But I'm not going to do that, because it's more important to me to be making pieces. I just want to have my freedom to keep working by myself. I've got some mysterious driving force, I guess, whatever you want to call it, so I'll manage the economics of it somehow. If I were instantly to become very famous, the pieces would escalate in price and that would probably make things a little easier.

Do you feel a vacuum when you spend four months on a piece and then it's gone?

No. It's really a great adventure making a piece. There are things that go on in my brain and in my world. I have this time visualizing while I'm sketching and converting the sketches into working drawings. If the working drawings don't complete the visualization, I make cardboard mock-ups. Then the material has to be moved into position. I enjoy selecting the wood. Then the building process begins—some pieces a short time, others four or five months. I have a lifetime with a piece. You can't sell that.

Talk about why you built this shop the way you did—we're thinking, of course, about the three tiers of vaulted windows.

I knew it was kind of stupid; I could have put a storage area above there, but I would never do that. I found out from the Connecticut place

Tall Desk with Pocket Doors, 1995. Cherry and maple, 77 x 34 x 26 in. (195.58 x 86.36 x 66.04 cm). Photograph: Andrew Dean Powell.

Wave Table, 1999. Sycamore, 28 x 62 x 20 in. (71.12 x 157.48 x 50.8 cm). Photograph: Andrew Dean Powell.

about what happens with your thinking when you have 17-foot ceilings. You become much more unlimited. The thinking enlarges. So, the high ceiling here was very deliberate. It's really a soaring space.

That's what cathedrals are about—soaring verticality.

You're right. You go in there and it's like a mist or fog overhead that is forever. The bigger the cathedral, the more forever it is. I like that.

Wilton, New Hampshire
September 1991

Layton Table, 2000. Bubinga and wenge, 21 x 24 x 14 in. (53.34 x 60.96 x 35.56 cm). Photograph: Andrew Dean Powell.

Shell Desk, 2001. Macassar ebony, wenge, pearwood, and leather, 61 x 42 x 30 in. (154.94 x 106.68 x 76.20 cm). Photograph: Andrew Dean Powell.

AFTERWORD

My ways of working have changed over the years. Originally, after starting a design with sketches to help visualize what I wanted to accomplish, I would make full-size drawings on heavy brown paper. Occasionally, I would do scale drawings to verify dimensions before doing the final drawing. Also, I might make a test leg of pine. I used this method of working for years, but along the way I felt I wasn't getting a clear understanding of the form. So, I did two things. I started doing my full-size drawings on tracing paper, and I made full-size models. With tracing paper, it's easy to change a line by overlaying another piece of paper. You can see the original line and save it—you may go back to it later. I make the full-size models of pine and cardboard. Usually there's no joinery, just drywall screws. My visualization abilities have gotten much better over the years, but I feel a full-size model gives me a critical review.

The idea of furniture as a vehicle for creative expression certainly has a lot of meaning to me personally. Designing now is a great adventure. I need all sorts of sketches from various moods. I listen for the wind and the light. There is literally a forest of forms in trees. We can achieve many amazing forms, but I look for furniture forms that in the final analysis are functional. I don't do this too early in the design stage or I may miss something. All bets are off concerning technique—I live through the design and then find a technique that will make the piece possible.

Many years back, I put on an application form that I felt there was nothing new, just a rearrangement of forms. I've been doing this rearrangement for more than 50 years now and plan to continue a while longer. I think we've barely scratched the surface with design forms for furniture.

The trend over the last 25 years seems to be toward more abstract work. Many pieces seem to be "inspired by" furniture rather than actually being furniture. Is it artiture? I'd prefer to have a clean break so that the "inspired by" pieces would not be called furniture.

Wilton, New Hampshire
September 2011

1. Patricia Conway, *Art for Everyday: The New Craft Movement* (New York: Clarkson Potter Publishers, 1990); Michael A. Stone, *Contemporary American Woodworkers* (Salt Lake City, UT: Gibbs M. Smith, 1986); and *The Penland Book of Woodworking* (Asheville, NC: Lark Books, 2006).
2. Amy Forsyth, "Jere Osgood and Tom Hucker," *Woodwork*, June 2001; and Rosanne Somerson, "Perfect Sweep," *American Craft* 45, no. 3 (June/July 1985): 30–34.
3. Jere Osgood, "Tapered Lamination," *Fine Woodworking* 14 (January/February 1979): 48–51; Jere Osgood, "Bending Compound Curves," *Fine Woodworking* 17 (July/August 1979): 57–60.

JUDY KENSLEY McKIE
b. Boston, Massachusetts, 1944

Judy McKie, a self-taught furniture maker, has produced some of the strongest and most original work to come out of the studio furniture field. Her bronzes emit a powerful ambiguity: Are these creatures friendly or not? Her stone pieces evoke the directness of Inuit carvings or Sumerian relics, and her carved and painted wood tables, chests, and chairs can emanate the freshness of a "just done" watercolor. It is difficult to be simple, and therein lies McKie's genius.

Both decidedly sculptural and determinedly practical, McKie's work moves effortlessly across the boundaries between fine art and furniture. Above all else, the Boston native's work demonstrates the power of furniture as a means of personal expression.

Judy Kensley McKie was born in Boston, Massachusetts, in 1944 and lives with her husband, the painter Todd McKie, in neighboring Cambridge. McKie studied painting at the Rhode Island School of Design, where she received a bachelor of fine arts in 1966. It was her practical nature, she says, that led her to question whether she had something important enough to say in painting, a requirement she felt the fine arts demanded. By contrast, making practical things that she and her family and friends needed came easily.

McKie's use of animal, bird, and fish imagery in her furniture is well established. Equally compelling, however, are her carved, abstract-pattern pieces, which date back to the early 1970s and her days as a beginning woodworker.

Her work is in the permanent collections of the Fine Arts Museum of San Francisco; the Frederick Weisman Art Foundation, Los Angeles; the Philadelphia Museum of Art, Philadelphia; the Museum of Art & Design, New York City; the Museum of Fine Arts, Boston; the De Cordova Museum, Lincoln, Massachusetts; the Toledo Museum of Art, Toledo, Ohio; the Renwick Gallery, Smithsonian Institution, Washington, DC; the Vice President's Residence, Washington, DC; Jack Lenor Larsen's LongHouse Foundation, East Hampton, New York; the Museum of Art, Rhode Island School of Design, Providence; and the Yale University Art Gallery, New Haven, Connecticut. McKie's public outdoor pieces include a bronze sculpture, *Ibis Ascending*, in the Garden of Peace, Boston, Massachusetts; and five bronze jaguar benches in a small park in the 5th Arrondissement in Paris.

McKie has had many solo gallery shows. Her first was at The Elements Gallery, in New York City, in 1984. Since then, she has regularly had solo shows at Pritam & Eames in East Hampton, New York, and at Gallery NAGA in Boston. Her group exhibitions include *Inspired by China: Contemporary Furniture Makers Explore Chinese Traditions*, Peabody Essex Museum, Peabody, Massachusetts, 2006; *Shy Boy, She Devil, and Isis: The Art of Conceptual Craft, Selections from the Wornick Collection*, Museum of Fine Arts, Boston, 2007; *The Scale of Things to Come*, Fuller Craft Museum, Brockton, Massachusetts, 2006; *Dual Vision: The Chazen Collection*, Museum of Art and Design, New York City, 2005; the opening of the de Young Museum, The de Young Museum, Golden Gate Park, San Francisco, 2005; *The Maker's Hand: American Studio Furniture, 1940–1990*, Museum of Fine Arts, Boston, 2003; and *Please Be Seated*, Yale University Art Gallery, New Haven, 1999; and *New American Furniture*, Museum of Fine Arts, Boston, 1989.

McKie, who was named a fellow of the American Craft Council in 1998, received the Luminary Award from the Fuller Craft Museum in 2008; the Award of Distinction from The Furniture Society in 2005; the Master of the Medium Award from the James Renwick Alliance in 2005; and the Louis Comfort Tiffany Foundation Award in 1989. She received a National Endowment for the Arts fellowship in 1979; a Massachusetts Artist Foundation Fellowship in 1980; and a National Endowment for the Arts Craftsman's Fellowship in 1982.

Selected publications on McKie include David Savage, *Furniture with Soul: Master Woodworkers and Their Craft*; Oscar P. Fitzgerald, *Studio Furniture of the Renwick Gallery*; Jo Lauria and Steve Fenton, *Craft in America: Celebrating Two Centuries of Artists and Objects*; Pat Kirkham, *Women Designers in the USA 1900–2000*; and Jonathan Binzen, "A Conversation with Judy Kensley McKie," *Woodwork* magazine.

My parents were both artists. My father was an art director when I was growing up outside Boston, and he worked for a greeting card company. My mother was a graphic artist, and she did a lot of illustration and greeting cards and graphic design at home. She had a little studio at the back of the house. She was attentive as a mother, but she always had this work that she was doing. I just assumed that women had something that they were very devoted to besides raising their children. When we would come home from school, always that door was closed and she was in there working. She'd make us a snack or something and then she'd send us outside to play. She was an example to me.

My father loved to teach and he loved to show. He was mostly interested in showing my brother how to use tools, but I was the one who was more interested, so when there was a little project to be done, he took great pleasure in teaching me how to use a hammer and a saw. There are still phrases that ring in my mind that were my father's, like, "Let the saw do the work." It was a way of learning how to use tools naturally. Because of that, I never had any fear of wielding a hammer or anything.

My father had been an industrial designer before he became an art director. He and a friend went into a partnership, and they floundered around and it kind of died out. He always was a frustrated designer because he was talented, but he couldn't make that business work. He could see that I had those skills and was always encouraging me to pursue industrial design at Rhode Island School of Design, telling me how good I would be at it—just the kind of parental push that was enough to make me gravitate far from what he encouraged me to do. It's ironic that eventually I came full circle and came back to what I was meant to be doing, given my skills.

Did you go to RISD because of your parent's expectations?

In high school, I thought I would become a graphic artist. I think I probably pictured that I would have a little place where I would work at home and raise my kids, do exactly what my mother did. I think somewhere that was in the back of my mind. My parents were encouraging me to go to a liberal arts school and take some art courses on the side because, as artists, they had struggled. When I got into RISD (which was where my mother had gone; my father had gone to art school in Boston), they were perfectly happy. Even though they weren't really encouraging an art career, they also weren't discouraging it.

I transferred into the painting department, which was slightly upsetting to my parents because they just couldn't imagine how I would support myself as a painter. My intention was to maybe teach when I got out of school. Generally, among the students at school, it seemed that the most talented or the most interesting and the most energized people were in the painting department. Todd [McKie] and I were in the same class. As sophomores, he and I ended up living in the same apartment building. He was the boy next door. We spent a lot of time just hanging out together.

What was the content of your canvases during those RISD years? When you look back, do you recognize the work?

No, I was so lost as a painter; I mean it was such a struggle. I never got it. I think I get it now, and if I were to go back, I would be better equipped. For some reason, I had an attitude

Jaguar Bench, 1991 (detail; see p. 99).

Wall Hanging, 1968. Appliquéd cloth. Photograph: Todd McKie.

about painting that, because it was a fine art, the subject matter should be very important. I intimidated myself with the importance of what the work had to convey and I never got into the process of just making paintings. I never could figure out what I was doing and I didn't have an understanding of how to make colors work. I didn't understand the media, whereas when I went to build something, it was a completely natural experience. I didn't attach this importance to it.

It was my own glitch. It's just a lack of understanding. Possibly it even stemmed from the fact that my parents did commercial art and I considered that there was this huge leap between doing commercial and fine art. I made it even bigger than it had to be. Also, I felt as though I needed a very strong point of view to be coming from my work—and I hadn't discovered what it was. I didn't have the impulse to paint the way Todd did. It was clear to me, being around Todd, what an obsession with painting was about. Another problem was that I have such a pragmatic side, such a practical approach to things, that it bothered me to be making things that had no practical use.

While we were still at RISD, I had worked for this man, Norman LaLiberte, during the summers, making banners. They were appliquéd cloth wall hangings. I made a few presents for people and somebody saw them and found them interesting. Todd made a couple. We put them in a bank window in Harvard Square in Cambridge. You could rent a little window in a bank right in Cambridge and put in a display. So, we showed a couple of these wall hangings and that led to some jobs and to a little show at a gallery in town. We sold enough to get by on. Eventually, we found ourselves working almost full time making these banners, which was not what either one of us intended to do for a living, so we just stopped.

When Todd and I got out of college, we didn't have any money or furniture. It just seemed natural that I should build a few of the things that we needed. It had nothing to do with an interest in furniture making. It was just a totally practical impulse. This was the first thing I made [knocks on wooden table]. I made it in the garage at my parents' house. It's just because we needed a table and nothing more.

Those early years after school—the 1960s— must have been great years.

Yeah, they were great years. We were living a very loose kind of lifestyle and everybody was doing exactly what he or she wanted to be doing for a living. It definitely was a struggle, but it was a very pleasant, exciting struggle. We would have relaxed times at this table with our friends. After dinner, we would all be drawing on our napkins and discussing art and making plans. All of our friends were fresh out of art school—trying to do their own thing, trying to paint for a living or be photographers. It was the '60s and we didn't need very much money to live on, and the idea of a 9-to-5 job for some company had about as much appeal as...there is a big difference between not having money

New Hamburger Cabinetworks (McKie center in apron), Roxbury, MA, 1975. Photograph: Unknown.

and feeling that's your destiny, and choosing not to have money because you prefer to live a different way, which was very much our choice.

I found myself building shelves or little projects to do around the apartment or making toys for our son, Jesse. One thing led to another and I made a couch for us and somebody saw it and said, "Hey, would you make one for us?" because they liked it. I realized that I was spending a lot of my time making coffee tables and couches and things like that, and that people were coming and asking me to make one for them. That's what I loved doing. It was very easy for me to spend a solid week working on something in the basement, but it was a struggle for me to get myself into the studio to work on a painting.

When I went to build something, it was a completely natural experience. I didn't attach this importance to it. Whatever I made was just fine and one day it clicked that that's what I should be doing, that that's what I got pleasure from. I took a long time to discover that, and then I decided to see if I could make furniture for a living—just make some practical things that I liked designing, something that was simple and practical and straightforward, and then figuring out how to build it. I didn't really know how to put anything together. Some of the things that I did were so backwards and ill constructed and wrong that they fell apart immediately. Some things, by miracle, worked. I didn't have any tools. I had a saw, a handsaw, and after I made this table for Todd, he gave me a jigsaw. I went out and bought a hand drill. The jigsaw had a motor. The drill had a motor. That was it. I put everything together using dowels because I could make holes. It worked—for a while, anyway. I designed around having those three tools. I'd go down to the lumberyard, figure out what I needed, and would have them cut it to length. I'd go and say, "What do you have for wood that would be around two inches thick and five inches wide, and could you cut it to length?"

I had more of a will to make things than an eye to the future. I had a need and a desire to make a table for the kitchen. That was it. Then it was a couch because making the table was fun. And then it was a go-cart for Jesse or a tricycle. I was just doing it for the fun of it until I realized, "Yes, this really is fun. Maybe I could do more of this." I built this real simple sling chair and this table and a couch, and I took pictures and I put them in a bank window thinking, "Well, maybe I could get some orders and get a little production going down in the basement." During the two or three weeks that those things were in the window, I got two calls. One was from somebody who wanted to know where I'd purchased the leather that was in the sling seat and the other one wanted a job. That was how that went, but friends came along and offered me encouragement. I had made this couch in the basement, and Design Research was showing all kinds of Swedish furniture at the time. They actually bought the one that I had made and displayed it in

Box with Toads, 1975. Carved white pine, 3 x 8½ x 5½ in. (7.62 x 21.59 x 13.97 cm). Photograph: Judy McKie.

Grinning Beast Table, 1986. Carved and bleached maple, 30 x 60 in. diameter (76.20 x 152.40 cm). Photograph: David Caras.

Dragonfly Chest, 1987. Carved lime wood, 60 x 48 x 20 in. (152.40 x 121.92 x 50.80 cm). Photograph: David Caras.

the store. They never reordered it, but now I was sure that I could design things that were as nice as anything in that store.

It's embarrassing on some level to have all this stuff around that's old work, but I never had time to build anything for myself after I made these things. That's why there is a lot of stuff around that goes way back. It also functions well. In some ways, I'm more comfortable with the early things than the more refined things that I've come to make because I don't have that kind of a lifestyle. We treat our furniture so badly that it's almost a waste for me to have things around the house that need to be handled with care.

The real turning point for me was when a friend of mine saw that I had this interest in furniture making. He had just become connected with this cooperative shop in Roxbury. He casually mentioned that one day if I wanted see this shop, he'd be happy to take me over there. So, he did, and at the time, they had a policy of allowing people to come in and work on the weekends and pay an hourly fee. It was a very socialist shop set-up—a group of people who had set up this cooperative.

Originally, one person had set the shop up and advertised for people to come and rent the space in his shop. The people who came and rented the space were a group of young college graduates who had decided that they wanted to work with their hands. They wanted blue-collar instead of white-collar working lives. It was all in keeping with the 1960s thinking. So, they rented space, and they had a huge influence on the way that the shop developed. Instead of becoming a shop where someone owns all the equipment and rents space, it became a shop where everyone collectively participated in all the decisions, and eventually they bought the machinery from the original investor. They

Leopard Chest, 1989. Basswood, oil paint, and gold leaf, 33½ x 49½ x 18 in. (85.09 x 125.73 x 45.72 cm). Photograph: David Caras.

made it available to people on weekends at a very reasonable rate to come in and work there if you were serious about your work. The very next Saturday, I called and asked if I could come and make a couple of cuts on their table saw. They were happy to let me do that, and I never left. I kept coming back until eventually they made me a member of the co-op. They were so liberal they couldn't say, "Lady, you really don't belong."

I began to read about woodworking. There was only one person in the shop with experience, so everybody watched him and read books. It was mostly kitchen cabinets that were being built. That's how I worked for at least five years, just learning from other people in that shop. I had no idea there were schools where people were thinking about woodworking in any other way. After about three years, somebody brought in a brochure that Nakashima put

out and a catalogue on Wendell Castle. That was the first time any of us had seen anything that wasn't a straight contemporary butcher-block approach to woodworking.

Was there talk about William Morris and his kind of utopian ideas?

Certain members of our cooperative felt strongly that we could be like the Shaker Village of working shops in which you work toward a design goal collectively and the work you did had some meaning and purpose in terms of the total concept.

But individual, decorative input would have been quasi-immoral?

Very immoral—it was not necessary. When I started to work in the shop, we shared everything: jobs, information, and wages. Whatever jobs came into the shop would be portioned out at a meeting. We'd sit down and decide who had time to work on what and who wanted to work with whom. It suited everybody as long as everybody was learning.

Once everybody learned sufficiently how to build things and no longer needed learning skills, then each member started to go in a slightly different direction in terms of what they wanted to do. Discord began because there were certain members who wanted to go the direction of contracting, while others wanted to go in the direction of furniture making. I wanted to start carving and I knew that, if we were sharing wages, I would pull everybody else's wage down and people would resent that. There was discussion about whether the whole system had become obsolete.

I had been doing woodworking in this very straightforward manner long enough to start to get bored with it. I felt as if I needed to challenge myself in some way. I looked around and

Tall Cupboard, 1983. Maple with milk paint, 77½ x 34 x 19 in. (196.85 x 86.36 x 48.26 cm). Photograph: David Caras.

what I saw for furniture was masses of butcher-block furniture in every store in Cambridge. It was all very cold, very machined-looking.

Something in me was craving to give the work a different kind of purpose, not to make objects that were too impersonal. I had learned in a shop full of heavy industrial machinery, and I was using those machines before I learned how to use hand tools. It was limiting the way I conceived of putting something together because it's so efficient to shove all that wood

through machines and deal with straight lines and flat surfaces. I was craving a way of personalizing what I was making.

I decided that if I was to go on making furniture, it was going to have to change dramatically. I tried to discover what had meaning for me. The furniture would have to have a certain feeling to it and could no longer be that straightforward or that machined. It was necessary that it be almost an integral part of the object so you could see that it was made by a human being who thought a certain way. I started gravitating toward objects that had that feeling.

I went to the museums. What I would find would be a little Pennsylvania Dutch box that was carved with a daughter's name on it—very, very personal objects. I said, "This is what is needed, this is what I have to aspire to in object making, this feeling rather than a defined concept." I spent a lot of time drawing, and I had to rediscover drawing and I had to rediscover my way of conveying an idea. I had been doing what were essentially architectural drawings that I could make with a ruler and a protractor. I had to rediscover what my own mind was and what or how to bring my work back to life again, because it felt dead.

The very first project I gave myself was making boxes and decorating them and carving them. I built up gradually to something that was more three-dimensional. I just made plain, simple pine boxes, and then carved into the tops. That was the first time I took something that was essentially inanimate and animated some part of it.

The minute I carved into the top, it began to change and be more like what I imagined was necessary. The first box literally was little lines carved into the surface, and then there were little lines with the background. They

Tall Black Cabinet, 1987. Limewood and milk paint, 86 x 23 x 11 in. (218.44 x 58.42 x 27.94 cm). Photograph: David Caras.

went from a line drawing to a three-dimensional depiction in relief with some depth to it. Each box got a little more complicated and a little more dimensional, and then I jumped to the table that is out in your room, and that was the beginning. The apron was starting to be three-dimensional, but everything else wasn't really. It was going from some depth on a surface to trying to become a little three-dimensional in a part of a piece of furniture.

From that table, I progressed further in terms of achieving a sense of depth and three-dimensionality in an integrated way, so that the three-dimensional carving continued down the leg and it continued to the top, instead of being in one place on a table where it works, but it's not quite connected to the rest of the table.

One day after I decided that I wanted to change the way I was working, I sat down with a piece of paper and wrote down a list of all the possible ways I could alter and add to and change the furniture. I said, "I could pound nails into it. I could cut holes in it. I could shape it. I could carve it. I could paint it."

I made a list of all the ways possible to decorate or alter or enhance the object, and I was just going to try all those things one at a time. I still have a number of things on that list that I haven't gotten to. It was a chance to experiment and in that way make the work exciting again. I felt like everything had become automatic. I could do it with my eyes closed. I was never on the edge where I didn't know whether it would work or not, which is when working is the most exciting. You have that feeling that you could possibly fail in a big way and I no longer felt that way. Why even bother if there is no sense that it might not work?

That is part of the problem that I have with commissions—that feeling that you have to work because someone has paid for it and is

Fig. 17. *Table with Kissing Fish*, 1975. Pine, 29 x 60 x 30 in. (73.66 x 152.40 x 76.20 cm). Photograph: Judy McKie.

expecting it. There is no time built in to fail, to make something that doesn't work so it leads you somewhere else and you learn something from it and you discover something from it.

I remember coming into the living room and sitting in a chair and looking at this butcher-block couch that I made that was completely rectangular. I stared at it long enough—sort of like watching clouds—to transform it in my mind into an object where there were two figures, dogs, on either side. I could see the structure of the legs and the body, and suddenly that couch came to life for me. It became an object that wasn't just something that you sat on, but it was something lively and had its own personality. I knew what the couch would look like, and I put it together in the shop.

Did you have a model or historical antecedent for this approach?

I couldn't find a complete object of furniture that did what I wanted to do in my own work. I didn't discover until after I started carving that Egyptian furniture really did incorporate animal forms in the ways I was thinking about. I could see decoration in furniture used in little bits and pieces on things and then

Fig. 18. *Table with Cats*, 1977. Poplar and maple, 30 x 45 x 30 in. (76.20 x 114.30 x 76.20 cm). Photograph: Greg Heins.

Jaguar Bench, 1991. Cast bronze, 27 x 56 x 17½ in. (68.58 x 142.24 x 44.45 cm). Photograph: Eva Heyd.

three-dimensional objects that I coveted that did it completely aside from function. What I wanted to do was put those two things together and have an object function and be completely integrated in terms of its three-dimensional character.

The *Table with Kissing Fish* [fig. 17] was my first attempt to do this. There was also a great concern with making sure that every mark be very much apparent—that nothing be machined. When I shaped the legs, I shaped them with a spokeshave, and I didn't want to turn them or machine any part of them. Every carving mark was meant to show, and I rasped and used a spokeshave around the edge of the table so that it wouldn't have a smoothness that would belie that it was handmade. There were things proportionally wrong with it, but with the next table, *Table with Cats* [fig. 18], I managed to much more successfully integrate the parts and have them flow into each other.

Going back to your training as an artist, do you feel that the gouge had become your pencil?

It has become that way, but I couldn't say it was that natural in the beginning. It felt like a foreign object that I couldn't make work for a long time. In fact, the early attempts to decorate and embellish and alter what I was doing were so awkward that it was discouraging. I thought, "Just add a gentle, graceful curve somewhere." I couldn't believe how hard it was to actually draw a gentle, graceful curve with a gouge. It felt that every line I made was awkward in every way. It took an enormous amount of trying and making very ugly, awkward things to break through that. My first attempts at carving were pathetic. I had some figure in the basement that I tried to carve and finally gave up on; I uncovered it later and it was ghastly.

No one in the shop where I worked was doing any carving. I'm sure I still do it wrong. I just get rid of the wood any way I can figure out how to do it. Unlike someone like Krenov, who really knows what he's doing, I don't. I have in my mind what I want it to look like when I am done and any way I can get there is fine. I use a chain saw and routers—anything to pare away the wood so I get closer and closer to the final shape.

I don't feel there is any difference between a gouge and a chain saw when it comes to working with it and being comfortable with it and making it work for you. It's a rhythm and kind of a dance that you do with the tool. It doesn't matter really what the tool is if you have a relationship with the tool and it works for you. To me, it doesn't matter if it's powered

Fig. 20. *Leopard Couch*, 1983. Mahogany, bleached and burned, 30½ x 90 x 25 in. (77.47 x 228.60 x 63.50 cm). Photograph: David Caras.

or not powered. It's much sweeter doing the same thing with a gouge because it's quiet and, romantically, there is kind of an association that you make, but there are times when I am roughing things out with a chain saw and I get into that process where I just watch the wood disappearing, and I know that I'm holding it right and nothing is getting caught and it's for me the same as getting into a rhythm with a hand tool. I guess the difference from Krenov is that I'm not much of a purist. Anything that works in terms of tools and process is okay. I do think intuition enters into the way that I work and the way that Krenov works in a major way. It comes out differently. The process of using hand tools and feeling every part of it is the intuitive part that Krenov talks about a lot. That's a very important aspect of my own work and my own process. There's a difference probably in the way we go about it and in the end result, but it involves feeling things out and not figuring them out. A major part of getting it right is just trying things until they work. It's never a mathematical process, and it's rarely a matter on an intellectual level.

Fig. 21. *Fern Table*, 1983. Lime wood, carved and painted, 29½ x 42 in. diameter (74.93 x 106.68 cm). Photograph: David Caras.

Is there a piece you feel gets as close to your idea as it possibly could?

The *Leopard Couch* [fig. 20] was an example where I tried things that I didn't know would work and then happily they worked—right down to the color and the feeling and going looking for the upholstery and burning in those marks, which was a little risky. It was a satisfying piece to make because in the end everything worked the way I visualized and wanted it to. But there is an aspect of that to

Watching Dogs Headboard, 1991. Carved maple, gold leaf, and paint, 32 x 60 x 1½ in. (81.28 x 152.40 x 3.81 cm). Photograph: David Caras.

Fig. 19. *Table with Birds and Fish*, 1979. Carved mahogany, painted, 29½ x 66 x 36 in. (74.93 x 167.64 x 91.44 cm). Photograph: Greg Heins.

any piece that works. Occasionally, there is one where it just didn't quite make it, but usually I try to work on it and change it until it does work. It may take a longer time and it may go through several frustrating stages.

If I do two of the same thing, I experiment and will take it a step farther. That's another case where a commission sometimes isn't as successful as the one that comes next. You get to learn. Although the *Fern Table* [fig. 21] wasn't my first painted piece [fig. 19], it was the first thing I painted for my 1983 show at the Elements Gallery in New York. With the ferns, I wanted to try adding a little color to the wood, so I just painted the leaves on that. After I did that, I made the tall cupboard that Garry Bennett has. It was a very straightforward cabinet and all the decoration was in the paint. I still feel really good about that chest. It's not one of the pieces that people would necessarily respond to because it doesn't have the craftsmanship. It looks too easy. It actually wasn't easy to pull off. If every painted mark didn't go on right, the whole thing would have been ruined. It was totally dependent on the surface treatment and it had to go on like a fresh drawing, like something that you just did once. I just had to draw the lines on it and start painting. It was hours of work. That particular piece is very strong. It has an impact that a lot of the more refined work loses. It's got an energy

Monkey Chair, 1994. Cast bronze and walnut, 36 x 25 x 25 in. (91.44 x 63.50 x 63.50 cm). Photograph: Scott McCue.

Bird Chair, 1997. Alaskan cedar and paint, 39 x 20 x 27 in. (99.06 x 50.80 x 68.58 cm). Photograph: Greg Heins.

that's right there on the surface. Sometimes labor-intensive finishes go dead at a certain point and they lose their vitality, but this one didn't.

Do you work out your ideas through prototypes?

I think it's a big waste of time to make a mock-up because it just seems like an extra step. Why bother to do that? You can't often tell in a different kind of wood what it's really going to look like. I have to have the confidence that I can make it work the first time around. If it doesn't, I'm just going to have to throw it away. Part of the fun in building is the not-knowing part. If I bother to work it all out in a model, then I don't enjoy building the final piece because I'm just repeating myself. I like to have the danger be in the actual piece because it makes the process much more fun.

Your friend Garry Bennett noticed that you were painting some of your wood pieces to look like metal. Was this the prompt that got you to work with bronze?

Yes, and also what was interesting about switching and experimenting with bronze was the idea that I was dealing with a different material. There is something that the material itself can give to the work, and I had to work with that and had to be respectful of the material. Bronze lends a quality to the work that wood doesn't have—a quality of age and timelessness and permanence. I had to think in terms of an image that quality would enhance; it just couldn't be anything. It had to feel like something that was coming out of the Bronze Age in a way. The *Panther Table* [fig. 24] was the piece of furniture where the bronze worked

Fig. 23. *Jaguar Side Table*, 1991. Cast bronze, 31 x 60 x 16 in. (78.74 x 152.40 x 40.64 cm). Photograph: Eva Heyd.

Fig. 24. *Panther Table*, 1988. Bronze and glass, 17 x 50 x 40 in. (43.18 x 127.00 x 101.60 cm). Photograph: David Caras.

Fig. 22. *Snake Table*, 1987. Maple, polychrome, and glass, 20 x 16 in. diameter (50.80 x 40.64). Photograph: Andrew Dean Powell.

to best advantage—it was the first bronze piece where the glass wasn't just sitting on the forms. The first wood piece where this happened was the *Snake Table* [fig. 22] made in 1987. I think the *Jaguar Side Table* [fig. 23] I'm working on now will make sense in bronze.

What are you experimenting with now that pushes you in other mediums?

Doing the monotypes is a chance to work slightly differently. I'm learning about some ways of applying color and even thinking about imagery that could loosen the furniture up. As long as there is an activity—it might

103

Lion Bench, 1994. Cast bronze, 17 x 72 x 17 in. (43.18 x 182.88 x 43.18 cm). Photograph: Scott McCue.

Fig. 16. *Bench with Horses*, 1979. Carved mahogany, 24 x 62 x 26 in. (60.96 x 157.48 x 66 cm). Photograph: Museum of Fine Arts, Boston.

be making pottery, working in paper, doing monotypes, or experimenting with bronze or just doing whatever comes along—as long as you explore another avenue, it will always enhance the work. In the chest I'm working on now, I wanted to design something in which the framed panels would take paper pieces. I'm thinking I will do them as monotypes. The image will be quite painterly in a way because of the process. It's another case of feeling it out.

How does the current demand for your work by collectors, galleries, and museums affect you?

In the beginning, I couldn't have paid somebody to look at it. There is a big difference between the interest of a museum now and when the Museum of Fine Arts, Boston, called in 1979 and wanted to commission a piece for the *Please Be Seated* show [fig. 16], that was thrilling. I didn't even believe it was happening. Todd used to have this running joke about leaving messages for me that so and so from some museum or gallery had called. When he left that message, I didn't pay any attention to it.

There was a long time when my work did go through some dramatic changes and I was having a terrible time even figuring out what to do with it. It wasn't made for a public and it didn't seem there was a public that would be interested in it. So now it is a bit ironic. It gives me self-confidence in terms of the work to know that there is an interest in it. Sometimes I'm shocked and surprised and other times I think, "No—you know the work is good and there is a good reason why there is interest." It's not as if I feel like this is coming for no reason at all.

In thinking back, who and what are the influences in your work?

Outside of Todd's work, I've been mostly influenced by contemporary sculptors and painters. I remember being knocked out by James Surls's work. He builds things that have a certain kind of energy to them. I don't look at furniture for inspiration. I look everywhere else in a museum, but I never walk through the furniture places. I might get more inspiration from looking at a Japanese carving in the oriental wing of a museum, for example.

Dove Bench, 2000. Botticino Classico marble, 37½ x 62 x 27 in. (95.25 x 157.48 x 68.58 cm). Photograph: Ricardo Barros.

Hippo Bench, 2006. Champlain black marble, 20 x 72 x 22 in. (50.8 x 182.88 x 55.88 cm). Photograph: Digital Stone Project.

One of your colleagues said his ambition was to make a great piece of furniture.

If I were to think about what greatness is, I would hope that I'm always trying to make great furniture—not in the sense that everybody's going to see it and it will be the most important piece of furniture ever made. I just want to make great furniture—great to live with, great to look at, great to build. Great furniture, exclamation point!

Cambridge, Massachusetts
March 1991

Tiger Table, 2010. Cast bronze, 34 x 72 x 22 in. (86.36 x 182.88 x 55.88 cm). Photograph: Scott McCue.

AFTERWORD

When I started out, I tried to list all the methods and materials I could possibly use to make a piece of furniture and the different kinds of furniture objects I could make. I have continued to try to do this over the last 40 years. I have experimented with wood, bronze, frosted glass, plastic, and iron. I tend to avoid materials with shiny surfaces, as I am usually trying to inject the work with a sense of age.

I studied painting at the Rhode Island School of Design, but when I got out of school I had difficulty making work that was only "to look at." My practical nature (combined with a lack of money) had me building furniture for the apartment. Soon, friends were asking me to build things for them. Another friend introduced me to a "1960s style" cooperative woodworking shop, and furniture making became a full-time job. Gradually over time, I was able to combine my education in the visual arts with the woodworking skills I was learning.

Over the years, this field has shifted away from conventional influences toward more abstract versions of furniture objects. The latest trend seems to be to design and build furniture objects that do not function as furniture. I have no objection at all to people working in this way, but for me the challenge has always been to try to make something that is both beautiful or interesting to look at and totally useful.

Cambridge, Massachusetts
September 2011

DAVID EBNER
b. Buffalo, New York, 1945

David Ebner studied furniture making at the Rochester Institute of Technology in the 1960s at a time when Wendell Castle's sculptural approach to furniture was particularly influential at RIT. Although he had a notable gift for sculptural form, Ebner emerged from the ranks of studio furniture makers with a commitment to practical furniture and a conviction that he was foremost a craftsman, not an artist. This choice served him well, and he has made a living in his Brookhaven, New York, studio, building utilitarian furniture that embraces an array of styles. Along with other practically minded makers such as Hank Gilpin and James Schriber, Ebner has broadened the reach of studio furniture by introducing it to a wide audience that includes not only collectors and museums but also those individuals who enjoy its functional beauty in their homes.

Born in Buffalo, New York, in 1945, Ebner established his first shop in 1973 in Blue Point, New York, some 50 miles from New York City on the south shore of Long Island. After completing his training in furniture making at RIT's School for American Craftsmen, where he earned a bachelor of fine arts in 1968, he continued his studies in England at the London School of Furniture Design and Production in 1969. From 1971 to 1973, he served in the Army exhibit unit at Cameron Station, Alexandria, Virginia, a company attached to the Pentagon that designed and built exhibits promoting the army. There, he met Ivan Barnett, an illustrator with whom Ebner would, in the future, collaborate on furniture projects.

He made his first *Renwick Stool* in fir in 1974. His second stool, made in walnut (page 123), was acquired in 1976 by the Renwick Gallery, part of the National Museum of American Art at the Smithsonian Institution in Washington, DC, as part of the *Craft Multiples* exhibition. Since then, Ebner's work has been included in permanent museum and public collections, such as The Museum of Arts and Design (formerly the American Craft Museum), New York City; The Art Institute of Chicago; High Museum, Atlanta; Museum of Fine Arts, Boston; the University of Virginia Museum of Art, Richmond; and the Yale Art Gallery, New Haven.

Ebner's work is in a number of homes and private collections, such as those of Jack Lenor Larsen, LongHouse Reserve, East Hampton, New York; Lord and Lady de Rothschild, London, England; Malcolm Morley, Brookhaven, New York; Gerald D. Hines, Dallas, Texas; Willem and Elaine de Kooning, East Hampton, New York; Ron Abramson, Washington, DC; Isabella Rossellini, Bellport, New York; and Glenn Close, New York City.

He was a Daphne Awards finalist in 1984, and his work has been featured in a number of publications, including *The New York Times*, *Fine Woodworking* magazine, *House & Garden*, *American Craft* magazine, and *Cosmopolitan*.

In addition to his numerous commissioned furniture projects, Ebner has participated in many museum exhibitions and gallery shows, such as *Bed and Board* at the DeCordova Museum, Lincoln, Massachusetts; *The Room* at Pritam & Eames, East Hampton, New York; *The Chair* at the Worcester Center for Crafts, Worchester, Massachusetts; *The Edward Jacobson Collection* at Cooper-Hewitt National Design Museum, New York City; and *Craft Multiples* at the Renwick Gallery, Smithsonian Institution, Washington, DC. Ebner's work has been shown at Art Basel, Switzerland, and at SOFA (Sculptural Objects and Functional Art Fairs) shows in New York, Chicago, and Santa Fe.

Ebner's home, which he purchased in 1989 from a shipwright in Brookhaven, New York, was originally an early twentieth-century hunting cabin. Today, the bungalow, which Ebner has completely restored, is adjacent to his Brookhaven studio.

In my first five years, I worked 80 to 100 hours a week. If it was light, I worked. All I did was make furniture—by myself. It was pure enjoyment. It was freedom. It was commitment. I knew I had to do this.

Franz Wilheim, in one of our group discussions at RIT, talked about five-year plans when setting out to be a professional. He said you should set up a house and studio and try to establish a local clientele.

I came to Long Island with three five-year plans. At the end of fifteen years, this is what I would hope to accomplish. The first five, seven, ten years were just blocks of uninterrupted time that allowed me to develop my own design sense, to watch the public interrelate with my work. I waited to do what I really wanted to do—without being fingered as copying or not being sufficiently individual.

At that time, I had no power tools. I had a tiny table saw and a lot of hand tools. I number all my pieces and I'm up to about 580. I'm sure that with a decent shop early on, which most of the Boston students had immediately, I'd probably be up to 700, 800 pieces by now.

Coming from RIT, you don't seem to have the kind of close peer camaraderie that others from the furniture programs in Boston, Providence, and Philadelphia enjoy. How do you feel about this?

I think I have the advantage of a stronger, earlier foundation. The intensity and diversity was in Rochester, not in Boston. We had a choice from stacking to architectural-type work. We did some painting. I was fortunate to be in the right spot to meet the California woodworkers, to see the Renwick Gallery's *Woodenworks* exhibit in DC in the early 1970s. So while these people were still getting ready to go to school, I had already experienced the fruits of the field

Desk, Chair, and Cabinet, 1980 (detail; see p. 115).

and what a commitment to it meant. When I came to Long Island, I was very committed. I was prepared to do whatever I had to do to make it work.

You're one of the few who has really made a living by making furniture. You haven't taught, you don't have a wife to support you—you've done it on your own.

That's part of the reward. I wanted to make everything by hand and work in an unheated shop to begin with. I wanted to be able to reflect and say I went the full gamut. It was a personal thing and it was a very good education. Once you've learned it that way, it's well learned. Then, of course, you have to apply it, and you have to continue to grow.

Were you exposed to woodworking as you grew up?

My father was a salesman in Buffalo. What made this furniture field accessible for me was the fact that he had a small shop. My mother and father both took woodworking courses in night school. My father had been a tool-and-die cutter, trained as a machinist, and my grandfather was a master machinist.

When I was in Cub Scouts, my mother was a den mother. When the meetings came to our house, we would use the little shop in the basement for the kids in the pack to work in. I can remember turning a baseball bat on the lathe to use for Little League. I also made a little contemporary A-frame for my mother's manger set for under the Christmas tree. I remember making the pillars and framing it all out and taking bark and attaching it to the plywood superstructure.

Then the basement shop sat unused for five or six years until I got into high school woodworking and was prompted to go back down.

My father said that if I cleaned the machines, he would give me some instruction. I spent the winter taking the rust off all the tools.

Starting in my sophomore year, I had Kenneth Hodge as my shop teacher. I think a teacher occasionally finds a student or two where he feels he can make a difference, and he accelerates their direction. Hodge brought me along just as fast as I could go. He opened up the shop for me during study hall; he met me on Saturday mornings and let me work in the shop. Hodge focused on the specifics of hardwood furniture: the planning, construction, and awareness of what you want to do before you pick up a piece of wood. We had to do a full-size working drawing and a total cutting list. Hodge taught me the professional cabinetmaking approach to furniture.

He was on the Board of Regents for New York State and wrote a lot of the curriculum for the woodworking program for industrial arts in New York. He had been a North Carolina prototype maker. In those days, there was a prototype shop in every major company—Drexel, Heritage—they would make each piece, work out the bugs, do the patterns, and put it into production. That's where I thought I would end up, but that field died before I even got into it.

I was a below-average high school student—not a good reader, not a good speller. You spell five words wrong on a Regents, you fail the exam. There is a pile of those red 65s sitting around in somebody's file right now. But I learned how to cope and work around it.

By my junior year, I was interviewed at Buffalo State's Industrial Arts Program. The department head told me that I would qualify for the Industrial Arts program as a teacher, but there was no sense in my taking a wood program because there wasn't anything they had that was more involved than what I was already doing in high school. That prompted me to look for a more comprehensive program. The program at South Carolina University was very technical—formulas for glue and this type of thing—no hands-on cabinetry. Hodge knew of Tage Frid and the program at RIT, so I interviewed with the idea of being there with Tage. I probably went up there in 1963.

Stand Up Desk, 1968. Walnut veneer on chipboard, 30 x 40 x 36 in. (76.20 x 101.60 x 91.44 cm). Photograph: Bill Apton.

I was approaching my education from two different directions. In addition to woodworking, I also considered physical education. My mother had been a gymnast who toured the country when she was young. I trained as a gymnast and played soccer in high school, which made me think seriously about teaching Phys. Ed. I applied to four or five woodworking schools and four or five Phys. Ed. schools. I was not a letter athlete in a major sport—soccer wasn't considered a major sport at that time—so I wasn't accepted by any of the Phys. Ed. programs.

RIT had a good soccer program along with woodworking and my commitment to soccer was very strong, so it was RIT. I was accepted on condition that my academics would hold up. Actually, I was placed on a waiting list. My

Ebner drawing, *Stacked Table*, 1969.

father, being the salesman that he was, and being in Rochester every other week, would stop by and talk to the dean of admissions to the point that, to get him out of their hair, they moved me up to the top of the waiting list. I wasn't accepted at RIT until June, right before I graduated from high school.

Was being placed on the waiting list strictly because of the academics?

Yeah—and, also, I wasn't the type of student they were looking for in the School for American Craftsmen. They were looking for the artistic, creative individual. They were changing the curriculum focus from technical to artistic.

I was the first Ebner to go to a university—and then to be in an arts program! My mother is creative, though. My parents built five or six homes by the time I grew up; they enjoyed decorating, furnishing, and landscaping. I can remember their custom-made sofas in this brilliant orange fabric that the Danes were using at the time. The sensitivity to furniture and color came from her.

When I got to RIT, I wanted to transfer out right away. I was not ready for this group of artists, this free-thinking that a chair doesn't have to have four legs. We studied techniques and joinery mostly through Bill Keyser. Wendell Castle advocated creative thinking about furniture. There wasn't a course on traditional furniture, the history of furniture—it was considered to stymie creative thought. I was really disenchanted. I wasn't ready to be the heady, philosophical designer, innovator; I wanted to learn about woodworking.

And the soccer did not go over very well with Bill or Wendell. I was asked to leave school twice when I got hurt playing soccer and couldn't work in the shop. "Artists are not athletes," they said.

I find myself most at peace and most expressive when I'm building solid wood furniture. Rochester was not at all receptive. It was very competitive; it was "sharpen your nails." We had a critique at the end of each semester; the work would come out and that's when everybody sat in a circle with the piece in the middle. Wendell would walk over, turn it upside down, and tell you to justify it this way.

And how did you respond?

Devastated—until I became more prepared for it. There were overly honest remarks back and forth between instructors, between students and instructors. I have no problem with that now. As a matter of fact, at the end of my sophomore year, I picked Wendell as my adviser for my thesis—and I got along with Bill. He was more of an architect—planes, very hard-edged

forms, and construction and veneering. But the use of carving tools kept me looking at Wendell and kept me interested in what he was doing. I felt I had to first learn how to get along with people who came at things from a different direction than I did.

It was definitely a gradual adjustment. I think it was also this idea of being away from home for the first time. I was a pretty preppy individual and being around a bunch of scruffy, dusty, dirty, smelly people; the physical work and the lack of hygiene was a bit much. There were some people who believed in the backwoods approach to life—like you don't shower too much because the oil on your skin is good for you. They brought that into class with them. I was very meticulous.

I love the techniques and steps you go through making furniture—the spoke shaving, the scraping, the wonderful shapes and forms—but I felt I couldn't touch them at RIT without being admonished for not being sufficiently individual, not being creative. So, I learned as many different techniques as I could. For what I was paying for an education, I wanted to get as much variety as possible out of the curriculum. I specifically waited to do the romantic, elegant stuff because if I had done it at RIT, I would have been copying Wendell.

Wendell taught me how to explore and recognize concepts that were worth pursuing. He would be sitting at the drawing board and he would say, "Look at this. There's an idea." Then he'd flip the page and come up with the most precise, observant next step in this little thumbnail sketch. From day one, I was in awe of Wendell and his ability to draw. We talk about his furniture, but his ability as an artist—to draw, to illustrate! He's the only person I've ever seen put three lines on a piece of paper and I could see the shape behind it. Just the confidence of the hand and line on paper, it went freely and concisely.

Wendell and Bill still insisted on full-size ink mechanical drawings before we went to work, and that was a lot of tears and heartaches because furniture is big. The inked line doesn't always end where it's supposed to end.

My thesis was hard-edged, geometric, monolithic forms in furniture. Wendell liked the idea of taking a solid form and cutting into it, just doing one slice and making that the sculptural element of the piece. I did a lot of veneering on forms—cubes and rectangles and trapezoids coming together. I did a sofa all with trapezoids and a parabolic concave shape at the very end that was highly lacquered. I did a stack piece of white cubes, and the comment at the critique was it looks like a bunch of refrigerators. It would have been better if I'd taken refrigerators and stacked them because it would have been a found-object piece. It would have worked creatively!

We made five to seven pieces a year as students. When the grading was done and the portfolio assembled, they would tell you what they thought would be the best fit for your future. I was told to go into industry and be a designer. Forget about ever being a studio craftsman.

Where did you go after RIT?

I wanted Cranbrook [Academy of Art], but the people Wendell had tried to help get into Cranbrook the year before didn't get in. I was accepted at Pratt [Institute] in 1968, but that was a very industrial-design oriented program. So, I figured I'd go to Europe. I got into the London School of Furniture Design and Production, and found it a very traditional school. My introduction to ergonomics—a subject never touched on at RIT—was there.

Desk, Chair, and Cabinet: Three-Piece Office Suite, 1980. Afromosia; desk: 30 x 48 x 29 in. (76.20 x 121.92 x 73.66 cm); chair: 30 x 20 x 20 in. (76.20 x 50.80 x 50.80 cm); file: 27 x 17 x 32 in. (68.58 x 43.18 x 81.28 cm). Photograph: Gil Amiaga.

Someone told me that every vertebrae bends differently and the back has a number of zones that technically should be supported with different densities of foam. That was the point when I started really thinking about healthy seating—the idea that a successful chair is a healthy chair. Anyway, I only lasted a semester in London. I dropped out. I was drafted and did two years in the Army.

I was going to Fort Sill, Oklahoma, to be a field artillery observer. But the company needed a woodworker in the exhibit unit—which helped with recruitment. I ended up in this group of 80 people in Alexandria, Virginia. We did everything from concept to construction to touring. We would do a total exhibit—we would design everything, silk-screen everything—do all the model making.

We had shops for every specific thing. Surprisingly enough, there were RIT photographers in one lab, General Motors model makers in another place, people coming out of law school doing the research. It was like two years of graduate school. It was another mature, cutting-edge experience for me. I stayed active, committed to my furniture. I met some very creative people in the Georgetown-Washington, DC, area who gave me studio space, so in the evenings I would continue making furniture, and it got me thinking about the next step. Where does one settle if one is going to be a studio craftsman furniture maker?

After the Army, I took a year off and ended up out in California—beautiful California—in the early 1970s. I met three woodworkers there. The one I remember was Ed Stiles, who was a student of Art Carpenter's. Ed, who got into the Peace Corps and became a woodworker down in South America, worked for some very wealthy people doing great commission work. He was working for Crosby, Stills, and Nash. A great woodworker—very romantic. He was receptive to my portfolio. He thought that I should give it a shot.

The time came and, well, where can I go? I had a friend on Long Island and I remembered reading about how Willem de Kooning and Jackson Pollock ended up on the East End—the light and all that. And then I saw a Jackson Pollock show. So, that is where the idea of Long Island came from. From there, it just grew. I found people who helped me out. I came out with a brand-new workbench that my mother gave me as a birthday present and a painted van from my hippie days in California with "Love America, Live Peace" and international flags all over it.

I had a BankAmerica card. I took a $500 advance draw and said this is it. For $1 an hour, I can live. I gave my friend $100 a month so I could use his garage and a bedroom. So, I had a place to live and work. I'm that type of person—I need to know where I'm going, where I can sleep. I wasn't going to work out of the van.

I worked for a cabinetmaker helping him install cabinets, pounded nails a little bit. But within a year, I found a way, through the outdoor art shows and the various craft shows, to be able to support myself.

What really helped me was meeting up again with Joe Reboli, an Army friend who was a painter. When I looked him up, he was making a living as a street artist. The outdoor

Fig. 25. *Chest of Drawers*, 1965. Honduran mahogany, 44 x 33 x 24 in. (111.76 x 83.82 x 60.96 cm). Photograph: Bill Apton.

art shows were beginning to become a reality. People were very aware of what was happening in the arts, and they were enjoying buying good art before it got to the galleries and they had to pay the prices. People enjoyed discovering talent on the street—1973 and 1974 were the outdoor shows. In 1975, I graduated from local shows to upscale areas like Armonk, Bedford, Pound Ridge, where people would buy a sweater chest, a blanket chest, a *Renwick Stool*. My first sale of a *Renwick Stool* was for $90.

It strikes us how these outdoor shows, with some very good art, were a creature of their time.

I had to fight to get in. No crafts allowed. So, I would enter my work as sculpture. I brought my work and my photography portfolio. When it came time to show, I had some RIT student work, my chest of drawers [see fig. 25], and things like that. People had to stop; it was a good draw. The chest of drawers got them in to

Fig. 26. *Wishbone Rocker*, 1980. Oak and cane, 30 x 26 x 28 in. (76.20 x 66.04 x 71.12 cm). Photograph: Gil Amiaga.

buy cutting boards, allowing me to fill the tank and go home and go back to the bench.

Remember, the gallery system was not set up at this time. I was knocking on doors in Soho and uptown saying, "Yes, you can show this work with… it shows well with… and here's some painter friends who I show with," and they were just like, "What are you talking about?" I remember George of Gallery Henoch [fine arts] when he was uptown and above The Elements gallery [decorative arts] saying, "The Elements is downstairs." I'm going, "No, George, I want to show upstairs, I want to show with the painters, with the sculptors."

So, in your mind, you were doing sculpture?

No, it's furniture. The term "art furniture" wasn't quite there. Functional sculpture was what I would say to people. These discussions came up in critiques at RIT, and the people in the art department became threatened by this. If you take the sculpture off the pedestal and sit on the sculpture and the sculpture touches you, you're getting more out of the art, getting more for the dollar, you're getting more involved with the art.

I met an individual who had a summer gallery on Fishers Island—Bill Button. Fishers Island is a very blue-blood summer place. I got good reactions. I met my very first true collector, Mr. Bertram—he was one of these people who had the hunger. For the following five years or so, I always knew that there was someone there who would buy almost everything new that I made. He made his money buying and selling. He bought carpets, gold coins, emeralds. He bought low and sold high. He bought first-edition Chippendale. When he met me, he said, "Here's a young furniture maker who makes wonderful pieces that I can buy at a fraction of the cost." So, virtually every time he sold a piece at Sotheby's, I'd get a call: "Dave, I need a table. Dave, I need a desk." I didn't know what was happening. I didn't realize he was selling off his Chippendale.

Talk about the *Wishbone Rocker* [fig. 26].

I can remember pulling out the sternum bone of a Long Island duck and watching it rock, noticing the cantilever, what nature allowed to happen. A bone growing like a tree—it showed me where the strength was and where to reinforce it.

It took me awhile to make a model for the rocker, to get the tooling and the engineering to work. How is it going to sit when you get in it? How secure are you in the chair? When you approach a chair and turn around and begin to sit, particularly with older people, there's a falling sensation. You're blind when you go to sit down; you're accepting that something is

Fig. 27. *Gateleg Table and Ladderback Chairs*, 1980. Bird's-eye maple and leather; table: 29 x 45 in. diameter (73.66 x 114.30 cm); chairs: 34 x 18 x 16½ in. (86.36 x 41.91 cm). Photograph: Gil Amiaga.

going to catch you. It took a lot of time to get that rocker to receive you, to level out as you sat in it. There was an old bayman, a river rat, who used to come into the shop. I would make him get up and sit down, get up and sit down, and watch how he'd grab the chair because he was old and not that mobile.

The first one was for the opening show at Pritam & Eames in 1981. I won't forget pulling up in a borrowed Porsche with the rocker draped over the targa bar. I had just picked the rocker seat up from the caner. You had left a place on the floor open, and I put the rocker down and put the seat in. Your doors opened about five minutes later. First warm conversation with Judy McKie for me. I really became a fan of hers at that point. I knew she was someone.

We remember our first meeting in your studio. Wasn't the first of your gateleg tables [fig. 27] there?

Right—and the ladderback chair came after the gateleg. There was a need to show that a ladderback chair could be comfortable. Sometimes history stops, doesn't go the next step, things get put down for hundreds of years. I felt that the ladder-back was one of the things that had been put down.

What was the step that you saw missing in the ladderback?

The curve of the back, the angle of the back. I was so concerned with comfort and the relationship of the slats in the back. I can remember changing that through the third prototype just by moving each slat a quarter of

Liquor Cabinet, 1982. Walnut, 54 x 32 x 20 in. (137.16 x 81.28 x 50.80 cm). Photograph: Bill Apton.

Onion Blanket Chest, 1982. Red oak with bleached and painted ash, 44 x 30 in. diameter (111.76 x 76.20 cm). Photograph: Gil Amiaga.

Lounge Chair, 1985. Wenge and calf leather, 30 x 30 x 28 in. (76.20 x 76.20 x 71.12 cm). Photograph: Gil Amiaga.

Lingerie Chest, 1984. Honduran mahogany, 44 x 24 x 14 in. (111.76 x 60.96 x 35.56 cm). Photograph: Gil Amiaga.

an inch up or down, or by turning a slat half a degree, which, over thirty inches, can be a lot.

I like to work in areas that have been ignored by other studio craft people. The way furniture used to be done, the best ideas got disseminated in the pattern books. Now we have the idea—carried over from the art world—that everything has to be original, and when you talk about doing an impression, you're on thin ice. It may be on thin ice in art furniture, but it's not on thin ice in handmade wooden furniture—and I guess I have established my corner.

I've changed my way of working, particularly with the chairs. I find a design component or an element that I like and then go through it in a series of pieces or studies. When I feel I've gotten it to its potential, I use it the way I want to use it; then, generally, something else comes along to catch my eye. Early on, I spent my time on the prototypes and on the paper. Now, I'm not upset if the first piece does not quite work. I can afford not to get it. I can wait until the third try to get the total piece.

Who were some of the furniture makers who influenced you?

The Renwick's *Woodenworks* show in 1972 defined the first generation of woodworkers. This was it! The Smithsonian said this is the first generation of American studio

"The Room" at Pritam & Eames, 1986. Furniture by David Ebner and paintings by Joseph Reboli. Photograph: Warren Johnson.

craft furniture makers: Wendell Castle, Art Carpenter, Wharton Esherick, George Nakashima, and Sam Maloof. That show had quite an effect on me. Both Wendell and Esherick's work were great influences on my work, particularly Esherick—how he lived, how he built his studio step by step, and then the house, and how he worked with his men and his clients through the commissioning process—he made it all come together. Esherick showed me that, yes, I can find a spot somewhere and develop a local trade and expand. I'm also aware how profoundly Esherick influenced Wendell.

I saw myself working exactly how Esherick did. His early work—like the triangular desk with all the wedges—was very architectonic. His commitment to some of the exotics early on and the more romantic things, and then his commitment to local native woods—"If you can't find it in your own backyard, you can't see," he'd shout. Looking around Long Island, I thought that twisted sticks seemed to be

Scallion Coat Rack, 2005. Bronze, 69 x 12 in. diameter (175.26 x 30.48 cm). Photograph: Gil Amiaga.

Library Ladder, 2009. Rosewood, 49 x 19 x 22 in. (124.46 x 48.26 x 55.88 cm). Photograph: LuAnn Thompson.

Wave Table, 2009. Pigmented maple, slate, and steel, 22 x 20 x 18 in. (55.88 x 50.80 x 45.72 cm). Photograph: Steve Amiaga.

something that hadn't been focused on as a material for furniture. So, I used both honeysuckle-choked sassafras and maple saplings. Also, I realized that this kind of thing is what Gaudi looked at and what the Art Nouveau furniture makers were copying when they did the twisted legs on their pieces.

I can remember Sam Maloof coming to lecture at RIT. I did not want to do what Sam set out to do with a catalogue of 15 or 20 fixed pieces and maybe adding to it one piece every other year or so. I said, "Boy, I don't want to fall into this. I want to always be able to experiment, grow, and change." At that time, I didn't want to be locked into remaking pieces. Today, I do remake pieces—whether or not I'm locked into it, I don't know.

Speaking of others in the field, whose work do you admire?

John Dunnigan and Richard Newman, because we have some common threads and commitments. I use their abilities as my own discipline. Sometimes when I want to get off the drawing board, I realize John would have been at the drawing board for hours longer and it inspires me to stay there to get the answers. Sometimes when things slip—because I consider myself somewhat of a loose woodworker, more of a sculptural woodworker—then Richard's discipline is always a great inspiration. I have a lot of respect for it. Richard's genius and innovation are very inspiring. Tom Hucker should have been at RIT; he would have been the consummate RIT student.

Fig. 28. *Twisted Stick Chair*, 1990. Spalted maple and twisted sassafras, 25 x 20 x 16 in. (63.50 x 50.8 x 40.64 cm). Photograph: Gil Amiaga.

Fig. 29. *Book Chair*, 2009. Pigmented sassafras and spalted maple, 25 x 20 x 16 in. (63.50 x 50.80 x 40.64 cm). Photograph: Gil Amiaga.

Fig. 30. *Renwick Stool*, 1974. Walnut, 16½ x 16 x 15 in. (41.91 x 40.64 x 38.10 cm). Photograph: Bill Apton.

Do you feel there was a turning point along the way that let you know your course was set?

Without doubt one of the most important events in my career was getting into the *Craft Multiples* show at the Renwick Gallery's bicentennial show at the Smithsonian in 1976. It was then that I realized I could compete nationally and be accepted as an artisan. It was an open show in any field for a multiple, an edition, but it had to be handmade. It was American contemporary craft, but it was folk art, too. Generally, all of the work was well designed and well received. There was a hot-air balloon with a hand-woven wicker basket in the show, as I recall.

I submitted my first *Renwick Stool* [fig. 30]. The initial jurying was done by slide. After the first cut, the judges called the work in to make a final selection. They were very methodical, the way you would envision the Smithsonian working. It was 22,000 slides or some fantastic amount of entries for 102 places. I had made the stool as a Christmas gift to my mother. She gave it back to me because she felt if I could sell it, I could use the money. Without the return of that gift, I never would have entered the competition.

East Hampton, New York
February 1991

Dining Table, 2012. Mozambique/ovangkol, 30 x 54 in. diameter (76.20 x 137.16 cm). Photograph: LuAnn Thompson.

AFTERWORD

My approach to making a piece hasn't changed that dramatically over the years. I still go through the same steps—from napkin sketch to full-scale mechanical drawing to construction. My ideas can come from sculpture or architecture or furniture, and that mix has stayed pretty constant, too. My thoughts about function have also remained the same. Some of the forms in my work may be more abstract and the materials more unusual, but they still produce functional furniture. A piece of my twisted-stick furniture [see fig. 28 and fig. 29] can look like pure sculpture—especially if it's ebonized—but in the end, it's still a bench.

Other things have changed, though. When I started out as a designer, I sometimes explored classic periods of furniture—I'd look at Chinese or Japanese or colonial stuff, pare it down to its bare roots and make some furniture in that mode. I don't do that at all anymore. There are almost no period references in my current work. My inspirations tend to be much more abstract. I might look at Chinese calligraphy and develop furniture forms from the simple, beautiful lines of those brushstrokes.

My stamina and attention span today aren't what they were. I used to be able to put my head down and just go; when I looked up, it was 15 hours later. Today, after a couple of hours I find myself needing to look at other things. So, I don't work those huge blocks of time on one specific thing. But at this point, having made 1,400 pieces, I have the luxury of working very intuitively. I trust my own eye much more, and I can look at something and come up with a solution almost immediately. If I belabored the decision and spent two weeks worrying, I would probably end up with the same solution.

I see fewer new faces in the field than I did years ago. Fewer energized, committed young makers. I'm not sure what the cause is, but it seems that the idea of embracing the whole process of making rather than just the result doesn't hold much appeal anymore. Or maybe it's the economy. I know I've felt the downturn very significantly. It's certainly not the 1980s anymore. I now have one full-time and one part-time assistant. In the late 1980s, I had three full time and two part time, and we were all young and energetic and working like hell. It wasn't a matter of "where's the work coming from?" It was "what's the next due date?" Today, it's piece to piece.

A friend recently reminded me that I've been through this three or four times in the past, and it's true there have been ups and downs in the field before. But when I was young, the bumps in the economy didn't matter because I could live on much less. Now I need to turn a bigger nut, so the economics are a real challenge.

Despite the struggles, I'm grateful I still have someplace to go every day and something I want to do. I wound up making furniture because I enjoyed the whole process—from concept to drawing to engineering to fabricating to working with clients—and I still do—and I still have a whole tent full of wood waiting to be used.

Brookhaven, New York
January 2012

RICHARD SCOTT NEWMAN

b. Bronx, New York, 1946

Richard Scott Newman's path to a career in making things or making "stuff" wound through the science techniques lab at the Bronx High School of Science, the engineering department at Cornell (where he arrived at 16 and dropped out two years later), the Sohmer piano factory in Long Island City, and the woodshop at the School for American Craftsmen at the Rochester Institute of Technology. During Newman's years at RIT, the mood at the school was antihistorical and Wendell Castle's avant-garde art furniture held sway.

But through a chance commission in the early 1980s, Newman began exploring a time and place in history when, he says, some of the best furniture extant was made: eighteenth-century France. Newman, who comes out of the earth-toned days of the 1960s and 1970s, shocked many with his unapologetic use of gold and ebony in a brilliant, technically unrivaled body of work he calls his " neo-neoclassical" work. Newman is making less furniture today in his Rochester shop, but he has returned to making banjos—his first passion.

Born in New York City in 1946, Newman attended Cornell University from 1962 to 1965 and studied engineering physics. While at Cornell, he started making banjos, which would prepare him technically for the fine decorative detail work in the furniture for which he is known; however, this passion was underappreciated at Cornell and he took an "involuntary leave of absence." After that, Newman worked as a flag finisher at the Sohmer piano factory in Long Island City, New York. He returned to Cornell briefly in 1965, and then completed his formal education in three separate stints at the School for American Craftsmen at RIT, where he received his bachelor of fine arts in woodworking and furniture design in 1972, and where he studied with Wendell Castle, Bill Keyser, James Krenov, and Jere Osgood.

After graduating from RIT, he continued making furniture and musical instruments at his shop, Ruff Alley Works, in Rochester during the remainder of the 1970s. He taught both disciplines at RIT in 1977 and 1979, and returned later, from 1999 to 2002, as a visiting professor to teach furniture making. Newman worked in Wendell Castle's studio in Scottsville, New York, from 1966 to 1969, and was an instructor there from 1982 to 1984. In 1988, the New York Foundation for the Arts awarded Newman a fellowship.

Newman's furniture was included in both the exhibitions and catalogues of the *New American Furniture Show: The Second Generation of Studio Furnituremakers*, at the Museum of Fine Arts, Boston, in 1989; and *The Maker's Hand: American Studio Furniture, 1940–1990*, also at the Museum of Fine Arts, Boston, in 2003.[1] His work also appeared in *Art That Works: Decorative Arts of the Eighties, Crafted in America*, an exhibit that originated at the Delaware Museum of Art, Wilmington, in 1990, after which it toured to 12 American museum venues from 1990 to 1993.[2] Richard Newman has participated in numerous shows at Pritam & Eames, East Hampton, New York, since its opening in 1981, including a solo show in 1987. His work has been shown at the Peter Joseph Gallery in New York City, including a solo show there in 1995; at the Snyderman Gallery in Philadelphia; and at Gallery Faire in Mendocino, California.

The New York City native now lives in Rochester, New York, where he still occasionally makes furniture but, more commonly now, makes banjos and teaches swing dancing.

I used to be a binge worker—just go on binges and work like crazy. I was fast and efficient. I wouldn't even eat; I wouldn't stop to piss; I would just go. I got a lot done. I can still do that, but I don't care to anymore. I'm trying to lead a more responsible life—which may be a terrible mistake.

The question is, do you just surrender to your weakness, just spend all your time in the shop, where things go well? Or do you struggle with things—such as relationships—that are difficult for you but have the potential for rewards that work can never offer? It is a very difficult question.

I was very curious about the history of other artists. You see the history of tormented personalities, horrible lives and difficulties, people who are users, abusers, and dependent. You wonder, "Is it something you accept and give in to? Or do you struggle and try to be more than the easy way to be?" I'm still confused about that. Here I am in the middle of my life; it's not easy all the time. Even having a daughter is not easy. My instinct is to just go to work, but it doesn't feel like the kind of life I want to lead.

Maybe 100 percent is an unrealistic goal as far as relationships go, but is there a piece of yours where you think you got 100 percent?

I always liked the demilune tables [p. 130]. I think that they are, in many ways, perfect.

All three sizes?

No, the two little ones, really. The big one is an amazing piece, but there is something unsettling about it. I'm very seldom comfortable with my work. There are always things that bedevil me. It's like there really is no perfection in the world. There are good angles and poor angles. There is always some weak spot. I think the only time you ever see things that are perfect is in nature.

It's a remarkable system of stretchers that connect the base of the *Ten-Foot Demilune* [fig. 31].

I thought it needed stretchers, both visually and structurally. I drew all sorts of systems and came up with something that looked pretty interesting. I thought it would be an important part of the table and give it a real balance. We gave it a shot. It was hard to make.

Let's pick up on the early steps that led you to furniture making.

All I can remember as a little kid was just wanting to make stuff. My dad gave me some tools when I was about five years old. They were kid's tools. They drove me nuts. Did you ever try to use a kid's saw? They just wouldn't work. I was pissed. All I ever wanted were toys that would work.

The things that I wanted to make were often of a scientific nature—electric motors, radios. I was interested in science and I'm sure that was my father's doing. I had a chemistry set, dynamos. There were all sorts of experiments that we would do at home. I went to Bronx Science School because it was the best school. I can't remember whether my parents were pushing me. I just wanted to be the best.

What was your father's work?

He was a chemistry teacher. I wanted to be an engineer or a scientist of some sort and have a shop in my basement. I had an uncle in Tuckahoe, New Jersey, and he had a workshop in his house, and that's what I wanted. There was a science techniques lab in school. It

Desk and Chair, 1985 (detail; see p. 138).

Fig. 31. *Ten-Foot Demilune*, 1989. Cherry and ebony, 34 x 120 x 36 in. (86.36 x 304.80 x 91.44 cm). Photograph: Northlight Studio.

Fig. 32. *Demilune*, 1983. Maple and ebony, 34 x 46 x 20 in. (86.36 x 116.84 x 50.8 cm). Photograph: Northlight Studio.

had a woodshop with metal lathes and some elementary stuff. I built a wind tunnel, or at least a smoke tunnel, testing air foils. I designed it and built it, and it sort of worked. Actually, it did work. When I graduated, I got the shop award. I was really disappointed that I didn't get a chemistry award, but I got the shop award. It was a Starrett micrometer. It was the writing on the wall.

You skipped a grade and graduated from high school at 16, right?

Yeah, I went to engineering school at Cornell. Then I started making instruments. I got thrown out of school because I spent all my time doing instrument making and other various deeds. You know—adolescence. When I got bounced out of school, I tried to get a job as an instrument maker. I wound up with a job at a piano factory. I was a flag finisher. The flag finisher fitted all the parts that are removable. We did the box, the key slip, the fall, and the lid. All this stuff had to be fitted. You had to plane things until they fit just so. You had to drill holes and do a little routing and screw it in. It was skilled work. When I first started, the entire factory was filled with Germans and

Prologue from the catalogue of *Fantasy Furniture*, Museum of Contemporary Crafts, New York, NY, 1966.

Italians, except in the rubbing department, where they were all Puerto Ricans. Then I showed up. They didn't know what to make of me. I had just come from college and I wanted to work with my hands, so they trained me. They used to call me the professor because I knew stuff.

Then I went back to Cornell to start my junior year. I wound up in—I don't know what you'd call it—an anxiety crisis. I decided that I really didn't want to be an engineer. I felt like I really wanted to be involved in the arts. I wanted to transfer to the art school, such as it was, at Cornell. Remember, this was the beginning of the whole 1960s thing. I don't mean politically—I wasn't into political. I'm talking about sex, drugs, and rock and roll. I wanted to be an artist. I felt I had ideas and I knew what I was doing. I went to see the dean of engineering. I told him I wanted to transfer to the art school. He said, "Don't you think if you really wanted to be an artist that you'd be doing some drawing or painting instead of all this woodworking?" I left Cornell in the summer of 1965.

When I was working at the piano factory, I had discovered the Museum of Contemporary Crafts [now the Museum of Arts and Design in New York City]. What I discovered was Wendell Castle and Sam Maloof. There was this show—*Fantasy Furniture*—and Wendell had a library piece in it; Sam had a cradle.

Chair, 1967. Walnut, 50 x 18 x 18 in. (127.00 x 45.72 x 45.72 cm). Photograph: Joe DalSanto.

Tommy Simpson was in there. I thought, "Look at this stuff—this looks great!" I started hanging out there.

Later, I heard about RIT from a woman at the craft shop at Cornell. Wendell had gone there to teach. At the time, this was the only place you could get a degree. I suspect that it was very important to my parents at that point that I go to college. They didn't want me in the Army; they felt okay as long as I was in college.

I remember flying up to Rochester for an interview, walking into the school, and thinking it was a mansion. There were all these guys working on all this furniture. I couldn't believe it—all these handmade dovetails. Guys were sawing things—there was somebody there sawing on a piece of furniture and I thought, "Holy shit! How can he saw on a piece of

Coffee Table, 1971. White oak, 16 x 72 x 23 in. (40.64 x 182.88 x 58.42 cm). Photograph: Chuck Gershwin.

Spiral Coffee Table, 1980. Ebony, 16 x 30 x 28 in. (40.64 x 76.20 x 71.12 cm). Photograph: Northlight Studio.

Scalloped End Table, 1980. Macassar ebony with mirror, 24 x 16 in. diameter (60.96 x 40.64 cm). Photograph: Northlight Studio.

furniture? What if he screws up?" It was so amazing—the confidence! I thought, "It's really interesting. I want to do this." I showed them a banjo and everybody was really impressed. I got in.

How had you come to make banjos?

I got interested in the banjo in junior high school. I got into music—there were more girls in music than in model airplanes. My parents got some Weaver records and I got really excited about the Weavers. Then I got some Pete Seeger albums, and I got more excited and decided I wanted to play the banjo. I got a junky little banjo and a Pete Seeger book. I was teaching myself and then I started taking lessons. I stayed with it and got better and better. Everybody taught themselves how to play in those days. It was the beginning of the folk movement. Then, in my freshman or sophomore year at Cornell, I started making a banjo. Later, after I finished at RIT, I got very seriously involved in banjo making.

When did you go to RIT?

I arrived in 1966. When I got there, I set out to learn everything that I possibly could. You had to start off building a box and then you had to make a stool with hand tools and the next piece was maybe a coffee table. I was surprised at how good I was. Then I set out to try to do any technique that interested me. I aggressively designed my own curriculum. I designed problems to try different techniques of my own.

There was an awkward situation at RIT. There was tension between Bill Keyser and Wendell, and each one had a camp. Bill was

perceived to be technically more adept—an engineer and a very good craftsman. Wendell was perceived to be the sculptor. I personally got along with both of them. I thought what Wendell was doing was real cool. It was Wendell who had attracted me to the school and also it was Wendell who appeared to be a much more romantic character. Bill was straight and modest, a shy guy, and Wendell was driving around in this little MG, dressed real cool.

They had these drafting stools and Wendell would just kind of sit on the stool and watch. He taught drawing. He was pretty good at that, but there wasn't much teaching going on.

I remember when I got there I was thinking that if I do okay maybe in my senior year, I can work for Wendell. After the first quarter, he asked me if I wanted to start working for him. So, I started working for him that Christmas, December of 1966. That put me in an awkward spot with Bill. I did everything I could to keep things open between us. I'd go out of my way to seek out his advice, and I probably got as much from him as could be expected.

I was working for Wendell at nights and maybe weekends, working in the school all day. I remember getting very tired coming home from work at night and sometimes not even taking my clothes off, just falling into bed. I was eating hot dogs and beans, but I was making interesting stuff. I was having all the fun I could. I had my own studio, shared it with Joe DiStefano. We had this little space under Shop One in Rochester, a craft gallery founded in 1953 by Tage Frid and some teachers at RIT.

Then, midway through my second year, I just quit school. I don't really remember why. Maybe I started flunking out again. I don't think I was a difficult kid—a difficult adult, yes. I had begun to do commission work. I got some

work with America House in New York City.

I worked for Wendell three days a week for about three years doing all the sanding, all the scraping—it was great. I did my own work two days a week. I quit working for him at the end of the summer of 1969. I was trying to get a job teaching at Brockton [SUNY]. I had a friend who taught there and she said they needed somebody to teach woodworking. But they hired some guy from industrial arts who didn't know anything. I was pissed. So, I decided to start my own shop.

I found a space and set up my shop, Ruff Alley Works. But first it needed a lot of work. I had to pour concrete floors, put windows in, put plumbing in, put all the wiring in. I had to do everything. It was a neat building. I was having some fun. It was an irresponsible time. I had the shop. I had an apprentice. I worked when I worked. It didn't take much to live. I squeezed by the best I could. I was playing music semi-professionally and I was making stuff.

At the same time, I felt like maybe I should have a degree because the reason I didn't get the teaching job was that I didn't have a degree. Then I found out that Krenov was coming to RIT, and it seemed like it would be neat to study with him. In September of 1969, I went back and studied with Krenov.

I thought Krenov was great. His approach to wood was a dream to me after working for Wendell so long. I think I became a little disenchanted with Wendell as a result of working for him as long as I did. He was moving in directions that I hated. All that plastic stuff. I needed some fresh air. Krenov was that breath of fresh air—the reverence for wood. Wendell's thing was form; he had started painting things and moved further and further from wood. Krenov's way was quite the opposite, much more in tune with my feelings, and I became

attuned to his. We got along. For a chest of drawers, I re-sawed some four-inch mahogany and book-matched it, hand-planed it, and left the plane marks on it. Unfortunately, Krenov didn't stick around for very long. He had a big blowout with Wendell. Went home for Christmas and never came back.

I stuck around for a while longer. Things got political at RIT. The dean felt that Wendell was more interested in a career than in being a teacher. He decided that it was in the best interest of the school to make a change. Bob Jorgenson got the job, but the students ate him alive and he left.

Then they brought Jere Osgood in to replace Jorgenson. I had seen Jere's work in the *Objects USA* show. He had that mahogany chest of drawers in there [page 78]—bowled me over. I was stunned. It was the most sophisticated piece of furniture I ever saw in my life. It was a stunning piece. When I found out he was coming to RIT, I thought, "This is for me." I went back and finished my last year with Jere.

Jere was as much of a mentor as I've ever had. He spoke very eloquently about his work. I remember wanting him to say a little more, but it wasn't his way. Working for him would have been terrific, but then I would have been a different kind of furniture maker.

With Jere, I learned a different approach to structure. Before that, I never really learned anything about structure, about putting carcasses together properly. Nobody ever taught me what was going on. I had to discern it myself and I found that to be a terrible disadvantage.

Do you think Frid gave that leg up to Jere?

Somebody did. Frid was real traditional, from what I gather. "This is what you do. You go like this, and this is this wide, and that is this way, and so forth." I certainly didn't get that from

Fig. 33. *Newman Banjo*, 1975. Maple, ebony, mother-of-pearl, brass, and bronze, 36 x 12 x 2½ in. (91.44 x 30.48 x 6.35 cm). Photograph: Northlight Studio.

Wendell. I don't think the education we had at RIT was training. It was a fertile bed in which you sprout and were expected to blossom—or not.

What gave RIT its reputation was mostly the fact that it was the only game in town and it had some quality people. But as far as its program—how to learn how to make furniture—it wasn't there. Wendell's attitude was that technique will get in your way. I would

Fig. 34. *Blanket Chest*, 1981. Cuban mahogany, 22 x 52 x 18 in. (55.88 x 132.08 x 45.72 cm). Photograph: Northlight Studio.

have preferred to learn how to make furniture. I'm not making art; I'm making furniture. I still feel terribly disadvantaged. I'm just doing what I feel like doing, pretty much intuitively.

What did your work look like at this time? This would be late 1960s, early 1970s.

It started to evolve. I started getting into distorted boxes. Taking boxes and curving the sides, twisting them, blowing them out. That culminated in the mahogany blanket chest you had in your opening show in 1981 [fig. 34]. I finished at RIT in 1971 or 1972. After graduation, I started out to make a banjo [see fig. 33, p. 134]. I decided to make the whole thing—all the hardware. It came out a lot better than I ever dreamed it would. I felt this spirit like I was possessed. I couldn't explain where it was coming from. I didn't know what I was doing. I don't know why it was so intense. I made one and I just started making more and I never stopped. After a while, they got better and better.

It was an obsession. I just dropped the furniture. I loved the process of banjo making—I just loved making the parts. I hired a guy. He was a great guitar player; we did everything. We steamed our own wood for the laminations, I did the patterns for the castings, we had the castings made, machined them, all the plating done, everything. We made all the parts ourselves—then I could change it, make it better. I was really making instruments that were better than anything that had ever been made! People knew I was serious about it, and they started selling. The first one I sold was to RIT; the dean bought it. I started getting somewhere.

What was interesting about the banjos was that I started by copying a traditional design and making some subtle changes. I took off from a very firm foundation; I made modest

Fluted Box, 1987. Ebony and satinwood, 7 x 6½ in. diameter (17.78 x 16.51 cm). Photograph: Northlight Studio.

Chairs, 1984. Pearwood, silk, and vermeil, 36 x 19 x 19 in. (91.44 x 48.26 x 48.26 cm). Photograph: Northlight Studio.

changes and then started finessing it out. I was perfectly happy in doing that, instead of feeling like I had to reinvent the wheel, which is what we were doing as furniture makers. With the instruments, nobody wanted them to be new. I remember Wendell had gone to Penland [Penland School of Crafts in Penland, North Carolina] to teach and there was a guitar maker there. This guitar maker made a really weird-looking guitar, a real sculptural guitar. He wanted Wendell to buy it, but Wendell wasn't interested in it at all. Wendell wanted a guitar that looked like a guitar. It was pretty funny.

There was a show at the Johnson Gallery at Cornell. It was called the *Hand Wrought Object* or something like that, so I put a banjo in. It came to the attention of the art world. Then there was a show at the Smithsonian that I was invited to and I showed two banjos. The show went to the American Craft Museum and it went around a bit. There was recognition on that level and then there was an article in *Fine Woodworking*. I became known amongst certain musicians. I made an obscure kind of banjo, too. Bluegrass banjos, tiny banjos—very limited appeal. A very specific group of musicians were interested in them. The best known was Mike Seeger, who at that time was quite well known. He commissioned a couple of banjos from me; he's still waiting for one.

You didn't say much about banjos when we met you in 1980.

I was done. I'd lost thousands of dollars, tens of thousands of dollars. I pumped every cent I ever made into it, to tool up. We [Newman and metalworker Ken Parker] were going to produce a whole new banjo. They were so hard to make because we made them perfectly. Everything had to match perfectly. It is really hard to make a good instrument. We were in production and then the Japanese started loading this country with the cheapest instrument they could make. After a while, it became apparent that it was impossible. I just collapsed on it. But I learned so much doing it—that's where I really

Fig. 35. *Dining Table and Chair*, 1982. Cherry, ebony, maple, and vermeil; table: 29 x 72 x 46 in. (73.66 x 182.88 x 116.84 cm); chair: 36 x 18 x 18 in. (91.44 x 45.72 x 45.72 cm). Photograph: Rameshwar Das.

perfected my craft. I learned how to control things. I learned how to work in thousandths; I did pearl, I did metal work, I carved, I used contrasting woods—things I had never used in furniture.

By this time, we were making furniture again. I got some big commissions. It was all original stuff. At the same time, I was perusing stuff. I discovered Ruhlmann's [French furniture designer Jacques-Émile Ruhlmann, 1879–1933] furniture somewhere there in the early 1970s. I saw it at the Met. Can you believe that we went to a school that gave a degree in furniture design and didn't teach the history of furniture? I didn't know what a Duncan Phyfe was. It was a joke. I get pissed when I think of that school. I didn't know squat.

There was a certain view at RIT that what we are doing is art. So, you look at the old stuff and say this is all irrelevant. But at some point, the old stuff really blew me away. Maybe it was Ruhlmann that did it. I thought, "This stuff is great. This stuff is hard to make. I'm going to have to figure out how to do this." I started experimenting and basically continued my education by designing all my commissions in order to achieve some sort of mastery of technique. I wanted to learn how to apply veneers, how to do compound curves, how to cooper.

We remember that burst of energy when your neoclassical work initially came about. What led up to that?

I remember it very specifically. I made a table for my mother-in-law. I did it very reluctantly. The table was to go with a set of 16 nineteenth-century reproduction chairs. I hated that

Desk and Chair, 1985. Cherry, ebony, vermeil, and silk; desk: 29 x 54 x 27 in. (73.66 x 137.16 x 68.58 cm); chair: 35 x 19 x 19 in. (88.90 x 48.26 x 48.26 cm). Photograph: Northlight Studio.

furniture—the world's worst pansy furniture. It was all painted colors and so delicate that it would break. I tried to design something original that would work with it, but I finally decided I was going to do something that really was of that period. I got a bunch of books, but I couldn't find any dining room tables from that period. So, I made one that I thought would be of that flavor.

It was designed partly as a joke. Anyway, the faces on the apron, the ormolu, were a joke. I should've known better than to suggest that we put the family's faces on the table. They thought it was a great idea. So, we did.

I thought I'd design this thing and get it done real quick before anyone sees it. I started working on it and while I was making the legs, Wendell walked in and said, "These are great." I really liked them and everyone who walked in thought they were great. Suddenly I realized, this is okay—why should I be embarrassed about making something that is historically correct?

I kept thinking, "Why is it okay to make things that look Chinese or Japanese but not

Writing Table, 1988. Cherry and ebony, 30 x 54 x 27 in. (76.20 x 137.16 x 68.58 cm). Photograph: Northlight Studio.

French?" Guys were making furniture that looked like Chinese Ming furniture. I'd make some furniture that looked like Louis XVI and everybody shits. What's going on? What's the difference? Why is it okay to make furniture that looks like somebody else's sculpture, or Bloomingdale's window dressing, or MTV, but it is not okay to make furniture that looks like American Federal furniture? I don't really understand it. I think it's some kind of cultural Nazism.

While I was making my mother-in-law's table, I was thinking, "Gosh, if I do this and put a little ebony on here, wouldn't that look neat?" Before I even finished my mother-in-law's piece, I had started two more tables. You got one in 1982 [see fig. 35, p. 137]. The process of opening myself up to possibilities burst everything open for me. Instead of saying, "Well, you can't do this and you can't do that," all of a sudden it was like, I can do anything I want as long as it is good. It was like the entire history of mankind was open to me. I felt completely liberated.

A number of your peers had a problem with the gold.

The gold upset everyone. I liked it because it never got dull. I had seen a lot of ormolu and, well, it can make you nauseous on a lot of trendy furniture. On the other hand, it's pretty stunning stuff. Can there be a better combination than gold and ebony? It really dresses stuff up. I was playing with the metal. I love the

Fig. 36. *Umbrella Stand*, 1984. Mahogany, ebony, and ormolu, 32 x 14 in. diameter (81.28 x 35.56 cm). Photograph: Northlight Studio.

Bedside Table, 1988. Cherry and ebony, 26 x 23 x 18 in. (66.04 x 58.42 x 45.72 cm). Photograph: Northlight Studio.

metal. Gold is the only thing you can put on there that won't tarnish. If you put silver on, bingo, it's going to gray out on you. Anything in brass or bronze is going to patinate. Gold looks great; it's noble—it's that simple. I love the way it looked. I was surprised when people were upset by it. On the other hand, I couldn't possibly live with all that gold. I like making things that are really full-blown, but I could never live with a piece like that.

What was the genesis of your ormolu-and-ebony umbrella stand [fig. 36].

I was looking at flutes and thought, "Where the hell is that really coming from? What does neoclassical really mean, anyway?" I didn't even know what neoclassical meant. I had gotten all these ideas from looking at the furniture, but I had no idea where that furniture had come from. I found out that it all derived from Greek and Roman architectural forms, not from furniture at all. Then I looked at the columns, and I thought, "Where did columns come from?" They looked like sheaves of reeds tied together, so I decided to make a vessel that looked like that. That's what the umbrella stand was supposed to be like. It was as if I were reinventing the column as a vessel.

The gold banding at the top and bottom, which seems to hold the sheaves together, is like a necklace.

Yes, each link was an individual section of a larger band. I carved it in wax, then had it cast, finished it off, and had a mold made. It was really hard to do. I enjoy working with small tolerances and that was a piece where everything had to fit. There had to be a lot of precision.

The 1988 maple and ebony *Fluted Cabinet* [fig. 37] evolved from the earlier fluted boxes, right? I remember seeing sketches of the cabinet in your journal a number of years before you actually made the piece.

Yes, that's right. The cabinet came right out of those boxes; they were like little studies, in a way. I had two pretty skilled guys working for me at the time, and I guess I just designed this piece, which I thought would be a shit-kicker. I wanted to make something that would blow everybody away, even me. So, I designed this thing. I put into it everything I could—and more, actually. I had to put it aside. I think it sat for three years.

There were things with it I couldn't resolve, things I couldn't figure out how to do. I had designed something that was a little harder than I could handle. Then, I finally came back to it because of your prompting. I came back to it and I was intimidated and horrified by the piece. I looked at it and thought, "What have I done?" It was so exuberant, so full of ease. I thought, "This is too much." I thought I had overdone it. I thought that I was trying to show off—I had gotten out of control.

Fig. 37. *Fluted Cabinet*, 1988. Maple and ebony, 63 x 20 x 16 in. (160.02 x 50.80 x 40.64 cm). Photograph: Northlight Studio.

It was odd to be working on it again because it was a vision from three or four years past, and I had matured in a certain way. It was also not long after I had split up with Jennifer and I was feeling, well, real trimmed is the best way to put it. Trimmed, like I had lost a lot of vitality, a lot of spirit. I had gotten very conservative—and this piece was anything but conservative. It was difficult to work on because I was horrified at that exuberance, but on the other hand, I kind of missed it. I felt like I was growing old and getting gray. We are what we are at any given moment.

I completed the piece and I can only say it is a remarkable piece. I am glad that I did it. It's a phenomenal piece. I don't think I could ever do it again. I don't think I would want to do it again. I was looking for it to be more sublime than outrageous, and what an outrageous piece it was—it stunned me. I worked on it and I think in many ways it is the finest thing I have ever done. Certainly the most amazing thing I have made in terms of setting myself up against some of the outrageous French furniture of the eighteenth century.

I find myself wondering about that. Why do I want to be so refined and so calm now? What happened to all that crazy energy? Wasn't it, in fact, that crazy energy that really made the best stuff? Where did it go, and how do I tap into it again? What do I have to do—and can I? I'd like to get back again to being bizarre and crazy, and do some wild shit. I think that sometimes being successful kind of calms you down. You stop taking risks. You get all this commission work and everyone wants stuff that looks like what you did before. I must admit that one of the exciting things about doing a show for Peter Joseph is the idea that I'll be able to make some outrageous stuff again. I feel as though I can still make some pretty wild shit.

End Table, 1988. Maple and ebony, 24 x 16 in. diameter (60.96 x 40.64 cm). Photograph: Northlight Studio.

What about your design thinking? Your drawings have always struck us as a complete resolution of the piece.

When we make this furniture, it's all made as parts—the legs, the aprons, the tops, the doors—so how can you possibly have it all come together unless you see the whole piece? It's got to be worked out totally. That's what I try to do. I think that doing the drawing sets up a higher authority—I'm almost like an employee at that point. I can work more relaxed because the decisions have been made.

Do you see any cross-purpose in trying to be more productive in the kind of work that you do?

I see a huge danger. I've seen it in other people. I can see where success ruins people or changes them. I can see running a more efficient shop, but in terms of hiring a million guys, that doesn't seem like a really great idea. I like to

Commode, 1989. Mahogany, cherry, pearwood, ebony, maple, and brass, 36 x 46 x 20 in. (91.44 x 116.84 x 50.80 cm). Photograph: Northlight Studio.

have employees, but I think if you have too many, the quality of work ultimately suffers. I don't want to let productivity come ahead of quality. That's number one—and control, which is synonymous with quality. So, there is a danger in having a huge shop where people are cranking things out. It's harder to keep to the standards that you want, so maybe you even start designing with an eye towards what is practical, what's easy to make, what's easy to do. I don't want to design from my employees' limitations. I've never simplified anything so

these guys can do it. If anything, I have insisted that they come up to my level. But it's hard to find people who can do it.

You've said that the "neo-neoclassical" work allowed you to bring the best you could do into a single piece. All of a sudden, there was potential.

What was neat about the neoclassicism was that it was taming. It had a ruling aesthetic. Before that, I felt like I was floundering around. Having this very formal framework was like

having a religion, having a code, something that would help me contain myself as opposed to being wild and free. All of a sudden, bingo, I was restrained. I felt like that energy I had was still there and it was going to squeeze out around the edges. It was bulging here and there. It's a highly refined, a highly disciplined form, yet that wild energy was still there. It was that combination—the wildness and this really restrained and conservative approach—it seemed perfect for me.

I could work with the kind of precision that I wanted. The more precise it was, the more zing it had. I felt that there was a sublime quality, a sublimated quality to the work. It created a vibration. The tauter the standards, the more subliminal the quality. The pieces vibrated with that precision. They had a little zing that you could not put your finger on, but it was there.

What really took balls was to dare to be historically derivative and to be that literal about it—to say, "Hey, this stuff is great." I was saying, "Let's make some real furniture. Let's put ourselves up against the real shit." I remember someone said in some article that all these PIA [Boston University's Program in Artisanry] guys could knock off a Philadelphia highboy, no problem. Bullshit! Very few people can knock off anything without a lot of work and a lot of practice. This is hard stuff to do. And the use of the materials was perfect. I could frame wonderful pieces of wood, pieces of wood that I thought were superb. I could outline in ebony and create little pictures and work with contrasting woods. I was always taken by the ebony, having these black lines running though highly figured cherry or maple. I started thinking of them in terms of confections. I was thinking this would be delicious to put them together, like pastries. I think of pearwood like mocha.

Chest of Drawers, 1990. Cherry, maple, and ebony, 44 x 46 x 23 in. (111.76 x 116.84 x 58.42 cm). Photograph: Northlight Studio.

That's right. I've heard you describe pearwood as yummy.

It is delicious. When I made these pieces, I've tried to think in terms of something that would be so good you'd want to eat it.

How much of this work is really handmade, and, of the tools that you work with, are there a couple that go to your personal best?

As to how much of it is handmade, I always think that is a goofy question. Wendell says, "If it's really handmade, you use your fingernails." What that question really refers to is how much of it is done with hand tools and how much of it is done with machines. Or maybe what's at the heart of the question is what David Pye calls workmanship with risk as opposed to workmanship with certainty.

How much of it is determined purely by the stroke of the hand as opposed to jigs, guides, machines—stuff where the outcome is guaranteed? I tell you, in my work there is an

Vessel, 2003. Curly maple and ebony, 3 1/2 x 18 in. diameter (8.89 x 45.72 cm). Photograph: Northlight Studio.

awful lot of machine work. I like to use fixtures and jigs. Jigs are the engineering side. The kind of precision that I require in the work, the kind of perfection I require in the joinery can, in many cases, only be achieved through the use of machines. So, we use machines for a lot of shaping work. The shaper is probably the most commonly used machine. At the same time, there is a great deal of handwork. The final fitting and the final surfaces are determined by handwork. A lot of hand-planing goes on.

The surfaces on the tabletops are hand-planed for a finish. Then we hand-plane the veneers. So, the hand-plane is a pretty important piece of goods. I guess my favorite tool is my dial caliper and my six-inch Starrett ruler marked off in thousandths of an inch. That's my favorite tool. It's the one that enables me to see what's going on.

Rochester, New York
March 1991

1. Edward S. Cooke, Jr., *New American Furniture: The Second Generation of Studio Furnituremakers* (Boston: MFA Publications, 1989); and Edward S. Cooke, Jr., Gerald W.R. Ward, and Kelly H. L'Ecuyer, *The Maker's Hand: American Studio Furniture, 1940–1990* (Boston: MFA Publications, 2003).
2. Lloyd E. Herman, *Art That Works: Decorative Arts of the Eighties, Crafted in America* (Seattle: University of Washington Press, 1990).

Fig. 38. *Banjo*, 2012. Curly maple, snake wood, satinwood, ebony, bone, and gold-plated brass, 38 x 11¾ x 3½ in. (96.52 x 29.84 x 8.89 cm). Photograph: Elizabeth Lamark.

AFTERWORD

It's an interesting time to be reflecting on the changes in my work and the studio furniture world, as I've just been informed that my building has been sold. I will have to move from the shop I've occupied for the past 25 years—what kind of studio do I want next? Looking ahead 5 or 10 years, what will I be making? How much space will I need? Will I be full time, part time, or is it time to hang up the tools? Hard to imagine not making objects—that's what I do. But things are so very different now from when this interview took place.

I can't remember anything I said back then, nor have I seen the written version, but of one thing I'm certain—I burned with a passion for making furniture; it seemed the most important thing in the world. I can't say that now and as much as I may miss that excitement, I would never want to return to the intense emotional pitch that enabled me to produce my work—while managing employees and a business. Whew!

I have a different energy strategy these days. I'm trying not to fuel myself with anxiety and stress as before; I'm looking for a healthier and more peaceful source. This has not been an easy and smooth transition. In the late 1990s, I found myself completely burned out. I had shed all my employees and eventually stopped working in the shop altogether for a year in 1998. I had become interested in swing, Cajun, and zydeco dance some years earlier and I took it up with a passion, cofounding a local dance community.

Then I spent three years at RIT as a visiting professor in the wood studio and returned to my shop part-time. I enjoyed teaching, but when the visit came to an end, I found I just couldn't rekindle the passion for making that I'd had in the past. Demand for my work had also been tapering off for years. I can't really attribute that to anything but my own waning enthusiasm, but, at the same time, I felt that the studio furniture movement was losing momentum, too.

So, what happened to studio furniture—a field that for a time was so vital and exciting and provided a bunch of talented and committed people an opportunity to realize their dreams? Some think these movements have a limited life cycle and ours has run its course. Or perhaps most of the collectors were of a certain age and have reached a point in their lives when they've stopped accumulating and are looking elsewhere for fulfillment. Or maybe we bear some of the responsibility ourselves. Did the problems begin when furniture makers preferred to see themselves as artists and sought to move furniture out of its traditional home in the decorative arts and into the far-less-hospitable fine arts? Was it that the "concept" of furniture and the "artistic process" became more important than the work itself, more important than that piece of furniture we need someone to purchase and live with? Is this an intellectual experience, or is it a visual, tactile, and visceral one? I really don't know, but it sure feels chilly out there.

The last few years, I've been making five-string banjos, my original love [see fig. 38, p. 146]. When I dropped out of engineering school in 1965, I wanted to make musical instruments. But I feared I'd get bored repeating the same item over and over, so I applied to the furniture studio at the School for American Craftsmen. When I visited, in lieu of a portfolio, I brought a banjo neck I had just completed. In the mid-1970s, I made a bunch of banjos, but when my daughter was born in 1977, it was time to get serious and make a living, so I gave them up and focused entirely on my furniture career (the easy money!). Now it appears that banjo making may just be profitable after all. But that was not my motivation for going back to it—I wanted to be making work I could get excited about and banjos beckoned. It may well lead me to a new way of making furniture, or maybe reenergize me so that I pick up where I left off. I'm wide open, just so long as I can enjoy the day in my shop and continue to grow and learn.

Rochester, New York
October 2011

HANK GILPIN
b. Stamford, Connecticut, 1946

Hank Gilpin's straightforward, utilitarian furniture does not unsettle traditional ideas of what furniture is about. Gilpin cuts away from the auteur notion of art furniture, designing pieces with deep ties to familiar interiors that ensure his furniture forms, however quirky in their details, will be intuitively understood. Flamboyant, opinionated, but ever practical, Gilpin says, "I don't want a confrontation. I want people to be sucked in."

Wood is his muse and Gilpin has worked just about every species that grows in the United States, using each of their characteristics to spur his creativity. The prodigious output from his Lincoln, Rhode Island, shop is an ongoing affirmation of wood's historical place as furniture's natural medium.

Compared to that of his peers who teach furniture making, Hank Gilpin's résumé is slim. This fact, however, stands in vivid contrast to the number of pieces he has produced in his nearly 40 years as an active woodworker: more than 2,500 by his count.

Born in 1946 in Stamford, Connecticut, Gilpin studied photojournalism at Boston University from 1964 to 1968, and served as a photojournalist in Vietnam in 1969 and 1970. While still in Vietnam, he successfully applied to Rhode Island School of Design for graduate work in photography. Once there, he took a woodworking course as an elective with Tage Frid and discovered the path that would lead him to his life's work: furniture making. Frid accelerated Gilpin's woodworking studies to a graduate level after the first semester. Gilpin received his master of fine arts from RISD in Industrial Design in 1973. He worked for Frid for two years after that.

In 1973, Gilpin bought a small, old church in Lincoln, Rhode Island, where he still maintains his shop and his home. A prolific maker, his numerous sketchbooks are filled with furniture designs of which only a fraction, he estimates, have been produced by him and the two to three people usually found working for him at any one time. A glance at his sketches shows his command of scale and line—any small thing could easily be a large thing.

Known for his solid wood furniture construction, Gilpin works almost exclusively in domestic hardwoods. He air dries—as opposed to kiln drying—the unusual boards of elm, beech, locust, and oak that he finds at sawmills or lumberyards. Gilpin's impressive knowledge of trees and forestry practices led him to a second career, that of landscape design and planting, which he has pursued professionally since the late 1990s. Today, he divides his time between his two loves, furniture making and landscaping, and operates both enterprises profitably.

In addition to the numerous homes and offices where Gilpin's furniture can be found, his work can also be seen in the Museum of Fine Arts, Boston; the Rhode Island School of Design's Museum of Art, Providence; and Smith College's Museum of Art, Northampton, Massachusetts. His work has also been included in three important Massachusetts museum exhibitions: *New American Furniture*, Museum of Fine Arts, Boston, 1989; *The Maker's Hand: American Studio Furniture 1940–1990*, Museum of Fine Arts, Boston, 2003; and *Inspired by China: Contemporary Furniture Makers Explore Chinese Traditions*, Peabody Essex Museum, Peabody, Massachusetts, 2006. Additionally, he has been the subject of many articles, including Jonathan Binzen's affectionate account of Gilpin's flamboyant, yet pragmatic nature, "Practical Genius," in *Woodwork* magazine, August 2006.[1]

One thing I concluded early on was that most of the stuff that made an impression on the artistic community over the last 100 years—the movements, styles, fashions—wasn't rooted in any reality I could find. I don't trust ideas that aren't soundly rooted in reality. They don't get me; I don't get them. There's a subculture that somehow gets its notions into the headlines, but it's not really relevant. It's sort of a hobby. Almost all of the well-known designers and makers and buyers were rich. Instead of "what do people need, what do people want, what can they afford?" it's "what do I want to do, what's my philosophy?" My idea was to break that barrier down a bit, and to a certain extent, it's happened—on a minor, minor level.

My goal was to be a local woodworker, a generalist. What else was there? Either you taught or you were a local woodworker. I'd do anything anybody asked as long as it was wood. "What do you want? I'll take care of it." All of my moves were schemes to sell my work. That's why I looked back to times in history where there was a reality to these moves, where things were made with limitation: time, client expectations, cash, any number of things that give the maker an easy focus. In the eighteenth century, that powerful Queen Anne period, furniture was richly carved and highly articulated, but it was reasonably simple to make. You could make a beautiful Queen Anne leg that was cheap or you could make one that was expensive. Both of them were beautiful. Both were well articulated; both suited the effort of the maker and the expectation of the client. The client had two dollars and could afford a duck foot or ten dollars for a claw foot. In that period, which is the one that most influences me, they had the ability to work within quite a broad framework and satisfy everybody. That's what I was looking for.

I started rethinking design as it relates to economics. I explored different ways of making things that were reasonable, that I could interest the local clientele in. We were doing simple pieces of furniture, restoration work, kitchens, and bathrooms, all at the same time. I had to make money while thinking about where I wanted to get to.

Hank, let's go back to the first step. How did you get to woodworking? What about your father?

My father was an insurance salesman in Connecticut. He came out of a very poor and struggling background. He managed to get his act together after his tour in the Army. Life to him was like "get yourself on a track that's got some social prestige"—not a snotty thing, just something to raise your position socially, something that's got some security—"and stick with it."

He put me to work caddying when I was about 12. "You have to learn how to make money and at the same time learn how to save money." Earning was easy, saving was hard. I can't say that didn't help me in this business. He also wasn't very ostentatious. He worked hard and made his money, but I didn't see him spend money. He had simple needs. What do you need? Some food, a roof, maybe a car, something to keep you warm. He wasn't a deep-thinking guy, but he had a great impact on me as far as the skills of survival—establishing and maintaining a reasonable standard of living.

So, the strong points of old Bill were: go to work, learn to like work, learn to save money, don't buy things, don't look to things as a way of making you feel good. You feel good because

Desk, 2012. Cherry, 28½ x 52½ x 26 in. (72.39 x 133.35 x 66.04 cm). Photograph: Warren Johnson.

you are good. You work hard and are good to people, you're honest and fair. He wanted me to be a lawyer or an Air Force officer. You can see it, right?

Was it encouragement or a chance event that turned you to furniture?

I was just interested in those things from the start, interested in that side of life that my dad didn't have an interest in. I got caught up in music, reading, literature. My first record was the *Nutcracker Suite* and I played the grooves off it. I started reading early and I started doing visual stuff early, carving all kinds of crazy things. I made lots of model airplanes. I had a group of guys over to my house Saturday afternoons and we would carve tikis, these little idols in wood, in my den. I did that for two years, every Saturday. I probably did 2,000 of them, all different. I was always building forts. I made lots of model cars, too. We'd buy these kits and then saw the top off this one and the bumpers off that one. We took Chevys and Fords and turned them into things that no one had ever seen before. Meanwhile, there was no recognition of this interest in the family—none.

All through high school, I tried to take shop. I sat by the window in math class looking at the guys making custom cars—there was welding, there were band saws flailing out things, and I'm in Algebra II. The closest I got to the shop was when they let me take mechanical drawing. "Oh, you want to be in the shop? Well, you should take mechanical drawing because you'll probably be an engineer." So, then I'm over here in the mechanical drawing room and the shop is buzzing over there.

Finally, in my senior year in high school, I rebelled. I didn't take Spanish IV and I didn't take physics. I took art. I'm intimidated because

Marquetry Cabinet, 1973. English brown oak, blister maple, and bubinga, 19 x 5 x 5 in. (48.26 x 12.70 x 12.70 cm). Photograph: Hank Gilpin.

I'd never had an art class and all the kids in there have had art classes forever; I think these kids are really hot artists. Out of the blue about halfway through the year, my teacher said to me, "You should go to art school." I said, "No, I could never get into art school."

I went off to regular college to pursue whatever—liberal arts. I'm in BU [Boston University]. I hated it. This is 1964 to 1968, the height of fiddle and diddle—and heaven as far as seeing and doing goes. I didn't want to be in school, but there was a war going on, so I stayed. Every semester, I'd try to find a way to get into some kind of visual arts program. I didn't care what it was. I went to the graphic design department and said, "Look, I gotta get out of this liberal arts. I gotta get into something else." I'd go reeling out of that interview and the next week I'd go to the

Carved Box, 1972. Maple, 10 x 24 x 25 in. (25.4 x 60.96 x 63.50 cm). Photograph: Hank Gilpin.

Benches at RISD Museum of Art, 1978. Cherry, 19 x 54 x 16 in. (48.26 x 137.16 x 40.64 cm). Photograph: Museum of Art, Rhode Island School of Design.

Boston architectural society. "I want to be an architect." "What do you mean you want to be an architect? What have you taken?" I'd go reeling out of there.

Every semester, I'm quitting school and then my friends are talking me out of it. I even went so far as to take the Army induction test in 1966. At the height of the madness, I'm thinking of joining the Army 'cause I'm up to here with school. I was gonna go, but a friend of mine talked me out of it again. Finally, my senior year comes around and I find out there is a photojournalism major. I'd never taken a picture in my life, but something rings a bell. I take journalism so I can get a camera in my hands. I ended up getting a degree in journalism, which saved my ass in the Army.

I got drafted about six months later, and they made me a journalist in the Army. I got sent to Fort Carson in Colorado. Two months later, they sent me to Vietnam. I got sent to the Americal Division, I Corps, south of Da Nang, in northern South Vietnam, and I got another lucky break. I go to division headquarters there and they have no slot for me. They attach me to the 14th Combat Aviation Battalion, which has no slot for a journalist. I very quickly realize the significance, the strength, of my position. Since no one really knows what I'm up to as an attached journalist, I had freedom. Because I had a camera, I had some power. The colonels are all straightening their collars. I learned how to use this power to my advantage. I also had a bunker that was a darkroom and whenever I wanted to do something, I would just go in the bunker and put "Do Not Disturb—Developing Pictures" on the door. So, that was our little hideaway, me and my pals.

The instant I set foot in Vietnam, I started applying to schools back home. The Army had an early release program if you were accepted to a school. I got into RISD. This was 1970. When I got to RISD, I was studying photography, but then I took an elective with Tage Frid. I wanted to take glass, but it was full, so I took wood. Frid impressed me with his down-to-earth, hardworking, serious, skilled, real-life kind of deal. No bullshitting around, no pretensions. Maybe now he's got a couple, but that's okay—he's old and famous. At the time, he's just a guy teaching woodworking and teaching people how to get out of there and make a living. That's all I was interested in doing.

At the end of the semester, Frid took me aside and said he thought I should give some

thought to bagging photography for woodworking. Frid, cool guy that he was, tried to get me in as a special student, but RISD wouldn't hear of it. Then he said, "Wait a minute. You have a degree, right?" I said, "Yeah, in journalism," and he said, "I'll make you a graduate student." Up until then, graduate students were people who studied woodworking and then became woodworking graduate students. I'd made one thing in my life and here I am in a graduate program.

The next two years, Fonse [Alphonse Mattia] and I are graduate students side by side, bench by bench. He was experienced, he had presence, and he had a good effect on me as far as tempering Frid cracking the whip. Fonse is over here like this: tedious, perfect, and careful. Frid's over there going, "Let's get something done—boom, boom, boom." I knew I fell somewhere in between these two guys: Fonse taking six months to make something, Frid taking six minutes, and I figured I'd take six weeks. It was a nice balance of not just work ethics and efforts, but philosophies and aesthetics. The third grad student was Roger Bird, who now runs a Mason Sullivan clock factory up in Cape Cod somewhere. Roger was a hard worker and between the three of us, we made something like 35 or 40 pieces of furniture in two years. There was always somebody in the shop. My hours were 7:00 in the morning until 6:00 at night; Roger's were from like 10:00 in the morning to 9:00 at night; and Fonse's were 3:30 pm to 4:00 am. We'd see each other for a few minutes and it was always very, very dynamic and exciting.

Were you married by this point?

Risa and I had gotten married and she's working in the library, taking care of things, tempering my time at school. I would have spent 24 hours

Keyhole Chairs, 1983. Ash, fumed oak, and upholstery, 36 x 36 x 36 in. (91.44 x 91.44 x 91.44 cm). Photograph: Warren Johnson.

a day there, slept on the bench. I'm 23 or 24 and I'm doing what I think I always wanted to do. I like the material a lot. That was that. Two really, really good years. Frid said we were the best students he ever had—me, Fonse, and Roger.

We've come to know a distinct Gilpin style. What about those early years?

No, no, no. I figured I've got to learn everything there is to know about woodworking in two years. So, my designs included new techniques every time—steam bending, laminating, marquetry, tambours, dovetails, a little upholstery.

Roger, Fonse, and I built the circulation desk for RISD's library, this big plywood thing, under Frid's supervision. One of the most significant moments in this piece was when we're doing the last corner. There are all these crazy angles and we're clamping it up and we stand back and "Boom!" the whole corner explodes, the clamps fly in the air, the wood breaks, everything falls to the floor. Frid comes in,

Chest on Stand, 1981. Oak; chest: 42 x 20 x 15 in. (106.68 x 50.80 x 38.10 cm); stand: 12 x 40 x 16 in. (30.48 x 101.60 x 40.64 cm). Photograph: Hank Gilpin.

Bench, 1982. Curly maple, 19 x 60 x 15 in. (48.26 x 152.40 x 38.10 cm). Photograph: Warren Johnson.

looks at the pile of stuff, picks it up, sticks some glue on it, puts the clamps back on and walks away. He says, "You gotta fix your fuck-ups." It was great—no panic, no nothing. You have to make money, so get on to the next thing and don't do that again. That was a great moment. It saved me a thousand times afterwards.

Frid hired Fonse and me right out of school. We worked with Frid for the summer on quite an interesting job. We removed a huge English brown oak boardroom from one of the banks downtown. It was going to be reinstalled in one of the new towers in downtown Providence.

After that, Fonse went off to teach in Virginia and I stayed with Frid doing restoration work for Mystic Seaport—there was a ship interior I worked with him on. We also built an addition on his house. I learned how to build a house—windows, doors, roof—no fooling around, no worrying, just get into it.

This guy has really got his shit together. He's showing me that there's another way to look at this life routine. You don't have to have a house in the 'burbs or an apartment in the city. From 7:00 to 3:00, you work like a dog—no overtime—and then you go out and garden. No talking in the shop until coffee break: you get in there and you work. Coffee break: 20 minutes, real casual, real loose, the only time I saw Frid just taking it easy. Emma [Frid's wife] would come out with piping hot coffee and some biscuits or something she'd put together. We'd ask our questions and he'd answer—then right back to work. Half an hour for lunch, right back, 3:00, out of there. There's more to life than woodworking. Then, in December he's going off to St. Croix—or one of those islands—for Christmas. I had worked for him for six months and I was loving it. I'm probably prepared to stay there the rest of my life at that point, but he says, "Okay, I'm going away. No more work—you gotta go. You're out of here."

Just then, somebody calls him up looking for him to do a kitchen, and he says, "I can't do it, but I have a guy right here who can. I'll put him on." I say, "Hello. Sure, I can do a kitchen."

I don't know what I'm talking about. I'd never built a kitchen in my life. But that was it; that was my first job. Frid gave me that job and I haven't been out of work since. I bought a table saw with the money I saved at Frid's. Then I milled some wood and built the rest of the kitchen with the table saw. I saved some money and bought a jointer for $300 and built another kitchen.

People would come in and have their chairs fixed; next thing you know I'm doing restoration work, but I'd always have a piece of furniture going. Instead of thinking about what I wanted to make, I had to start thinking about what I could make that would sell, what I could make in a reasonable amount of time that would interest people.

Were you looking at the work of others to find some answers?

When I got out of graduate school, I didn't know anything about furniture. I started reading books on furniture and technique, and discovered this whole furniture thing was complex. It wasn't just some crafty phenomenon that started in Rochester. This was a continuum that's been going on since civilization existed. I wanted to understand the whole picture: the historical picture, the economic picture, the materials picture, and the social order picture. All these ideas, where did they come from? What happened? I read a million books. I wanted to see the stuff firsthand, so I started hitting the museums.

The English and French stuff from about 1880 to 1914 intrigued me. There was a lot of philosophy and conflict—the Art Nouveau

Chest of Drawers, 1987. Curly maple and ebony, 54 x 34 x 20 in. (137.16 x 86.36 x 50.80 cm). Photograph: Warren Johnson.

period, the beginning of Art Deco, Cubism—this confluence of new ideas. Some ideas were pulling strongly from the past and some were seeking the future. France and England had better examples than here so I wrote letters to the Victoria and Albert in London and the Museum of Decorative Arts in Paris explaining that I was a woodworker who was studying furniture.

I didn't have letterhead. I grabbed a piece of yellow-lined paper and told them what I was up to and signed it Hank. And they sent me back letters of introduction. Have you ever had one of those in your hand? Talk about power! A letter of introduction from the Victoria and Albert! The English are particularly susceptible to this. I would just come in and it was from the head of the museum: "Please allow Mr. Gilpin access to anything he wishes in the

Fig. 39. *Collector's Cabinet*, 1979. Maple with cast brass pulls, 72 x 40 x 16 in. (182.88 x 101.60 x 40.64 cm). Photograph: Hank Gilpin.

I was in London for four weeks in 1976. I'd be at the front door when they unlocked, show my letter, and assault whatever department I was interested in. A lot of the stuff was not on display. It was all in storage.

How did you know it was there?

I just knew. I had done research. I gave myself a grant to go to Europe to study. If I didn't do the research, it would have been a waste of time. So, I get into these departments and just explore the furniture from head to toe. I had the keys to every room and saw everything there was to see. I'd go there at 9:00, scope the stuff out, do my research, make my notes, and sit and think until 1:00.

I did the same thing in Paris at the Museum of Decorative Arts during that 1976 visit. The museum was closed, but I pounded on the door, showed them my letter. They read the letter through the door and said, "Come in." I go to the storage department where all the Art Deco and Art Nouveau and Ruhlmann have never been on display! This was really questing. I'm trying to figure out how to think in terms relevant to me and my times by studying history and how others responded to their means and times. That's what this was all about.

The maple cabinet over there [see fig. 39] is the first piece of yours that we saw. It was at the 1979 Roitman show in Providence.

This was at the height of my quest. This was my first attempt at coupling together some of these influences I'd had—William and Mary, Krenov, Arts and Crafts, all of these things. I used the pulls and dovetails as decorative and structural elements. It was a contemporary expression within strict limitations. That was the first piece I tried to do that with. There were probably 15 major influences in that simple thing.

entire museum at any time. Thank you." At the same time, I was visiting woodworkers around England, trying to catch a clue as to what they were up to—Richard Latrobe-Bateman, John Makepeace, and some others. Makepeace's place was interesting. I came back and built my woodshed a week and a half after seeing his wood emporium.

Fig. 40. *Church Torchères*, 1990. Walnut and brass, 48 x 12 x 15 in. (121.92 x 30.48 x 38.10 cm). Photograph: Hank Gilpin.

Chairs, 1991. Yew and upholstery, 33 x 22 x 22 in. (83.82 x 55.88 x 55.88 cm). Photograph: Hank Gilpin.

Side Table, 1994. Ash and yew, 18 x 15 x 15 in. (45.72 x 38.10 x 38.10 cm). Photograph: Jonathan Binzen.

It looked like one of the most labor-intensive pieces in the show.

To me, it was as simple as you can get and still have a level of sophistication that justified the cost. I was looking for a voice. I'm not sure if there is such a thing anymore.

Those church torchères [fig. 40] upstairs are surprising.

Well, there's a little development time in those babies. I don't lose often, but I lost on that one. The church came to me, and they had this much money to spend. This is a very social church—they deal with the homeless, they have a soup kitchen, they take care of people. I'm just going to give them the torchères. They don't have to know I didn't make money, that's between me and me. I can't make all of my decisions from the wallet.

You've been called a "Krenovian" by some.

Sure, you could say that. I was influenced by everybody. You could say I was this guy or that guy—in some six-month period—because I was exploring all these ideas. I studied Krenov. His work is traceable historically in every bit of its form. He just does it in a personal way. I think his work is fantastic. I think he's underrated.

Krenov has touched upon some ideas that, if a few people really pursued them, could turn into fantastic ideas with real body behind them. But none of his ideas have been pursued enough to develop the way the ball-and-claw foot

Cambridge Desk, 1994. White oak and ebony; desk: 29 x 72 x 24 in. (73.66 x 182.88 x 60.96 cm); chair: 33 x 22 x 22 in. (83.82 x 55.88 x 55.88 cm). Photograph: Hank Gilpin.

Saddle Bench, 1995. Elm, 34 x 68 x 20 in. (86.36 x 172.72 x 50.80 cm). Photograph: Hank Gilpin.

developed. Back then, everyone was pursuing it. The best minds pursued it and took it to levels of articulation that are just breathtaking. There are a lot of hobby guys pursuing Krenov, but they don't understand it, so of course they take it backwards.

Some of Castle's work is great. But Castle makes a piece and then goes on to something else. He doesn't develop it. There are things he's done which could have worked out into something fantastic, but today you have to have uniqueness. It's the worst part of our particular field, this God-awful quest for uniqueness. It doesn't allow ideas to really develop. I'm frightened by uniqueness. It gets in the way of the few good ideas that may be kicking around.

I find a lot of contemporary furniture conceptually interesting. People are capable of some pretty strong ideas. The weakness is that they're not pursued with more vigor over a longer period of time. The compulsion to make each piece new and different renders most ideas sketchlike.

MFA Boston Cabinet, 1992. Curly red oak with wenge pulls, 84 x 60 x 24 in. (213.36 x 152.40 x 60.96 cm). Photograph: Museum of Fine Arts, Boston.

Shouldn't furniture be of its time?

That's what I'm saying. That was my quest. Anything that's truly successful uses history to understand how to be an expression of its own time. But furniture that excludes the buyer from the concept—not the collector, but the user of furniture—can't be successful and that's what I don't like about what's being done today. Today, it's more of an expression of what the maker wants to do, as opposed to the buyer having a need for what the maker sells. When a person has a specific need and you solve it better than they imagined, to me that's really being creative.

People confuse novelty with decoration and sometimes that's the major problem. This

Sideboard, 1995. Wire-brushed, quarter-sawn white oak with brown oak pulls, 34 x 68 x 20 in. (86.36 x 172.72 x 50.80 cm). Photograph: Hank Gilpin.

Sideboard, 1998. Curly maple and joewood, 34 x 76 x 20 in. (86.36 x 193.04 x 50.80 cm). Photograph: Jonathan Binzen.

Desk, 2006. Curly white oak, 29 x 66 x 25 in. (73.66 x 167.64 x 63.50 cm). Photograph: Karen Phillipi.

Eight-legged Bench, 2005. Curly white oak, 20 x 96 x 15 in. (50.8 x 243.84 x 38.10 cm). Photograph: Hank Gilpin.

Screen, 2009. Yew, 54 x 48 x 15 in. (137.16 x 121.92 x 38.10 cm). Photograph: Karen Phillipi.

stuff is just too loud. It's not considerate. It doesn't allow for the fact that this is going to have to be compatible in some fashion with 50 objects that are within proximity of it and, yes, it is going to have some use.

People who make these really crazy, wild things say, "Look at the French stuff." I do look at the French stuff. In the eighteenth century, it was totally compatible with its surroundings. The whole room was rococo and gold and gilt and polished and veneered rich-guy stuff. The simple-guy stuff had the same forms, but plain, very beautiful. Country furniture had the same forms as Louis XV furniture, just simply articulated; the only difference was there weren't any doodads on it. The doodad pieces wouldn't have been good if the forms weren't top of the pops.

You've given a lot of thought to what the home is about.

The home is the critical area. I don't think of it as a contrived situation that's subject to

individual whims and curiosities. There are things that transcend that. There are very, very simple needs that great pieces of furniture take care of. If you cover those needs, then your bells and whistles will come alive, but if you deny those things, then you can't succeed. What is this thing? Give me some context. Give it some scale. The home is the whole deal. I don't like doing commercial work because it's prone to the winds of change.

To me, the home is the whole deal. You sell a table to a person like myself—if I'm buying a table, it's probably the last one I'll buy. Probably the kids will get it. I like that, your pieces being in a family setting, maybe being argued over. It's a curious thing to think that someone wants to have their pieces in anything but a home. Where is the next show? What is that gallery doing? Who's collecting? You don't hear any talk about how people spend their time with their furniture—what do they do when they have little kids? Do the pieces have points? Get rid of the points. Use is important to me.

Another factor is that if a person isn't a collector or a New Yorker or San Franciscan or somebody who is redecorating every few years, most people already have a substantial amount of furniture and it's very unlikely that the average person is going to re-outfit their house to fit your coffee table. You have to be clever enough to be unique within a familiar context. You have to get people to say, "I understand this," even if they've never seen it before. Then it will fit into their life. I try to be completely familiar as opposed to totally unique. I don't want a confrontation. I want people to be sucked in.

Here's the other deal: I got these guys who come to work for me, women, guys, whoever, working in the shop. I have to keep them in mind. I keep their skill level and their

Fig. 41. *Seven-Drawer Chest*, 1989. Macassar ebony, 54 x 34 x 20 in. (137.16 x 86.36 x 50.80 cm). Photograph: Warren Johnson.

164

Fig. 42. *Wardrobe*, 1989. Wire-brushed, figured white oak and wenge, 54 x 34 x 20 in. (137.16 x 86.36 x 50.80 cm). Photograph: Museum of Fine Arts, Boston.

temperament in mind when I'm making stuff. I want it to be pleasurable because, after all, we work six weeks on a piece of furniture. All you do is give me money. I give the piece to you. I've got six weeks to cover before I get that money; I want those six weeks to be enjoyable. That's part of the deal in making stuff. Also, we've gotta keep moving. I'll never run out of exploring. It was a seminal moment to find a leg that offers me options in all formats and does the most important thing—it eliminates the corners.

Describe the leg you're talking about.

The leg I use in my chest, my cabinets. It's complicated, it's multifaceted, but it comes out and it's a round thing and it's not a sharp corner. It eliminates that corner that I dislike in furniture.

Your little ebony chest [see fig. 41, p. 164] did that.

I'm glad I came up with that idea.

Is there a piece of yours that you feel especially strongly about?

If someone wants me to describe my work, I'm gonna give them that 1989 oak wardrobe [see fig. 42, left]. If I'm gonna be talked about, those are the terms I want to be talked about in. Even if I explore other ideas, that's the one I want referred to most often because I can do that stuff with my eyes closed. I just feel like I understand this.

We've sold a lot of Gilpin pieces in 10 years.

Over 100, maybe over 120. Here's my thinking: What can we make that's irresistible that they can stick in the trunk and take home with them? All this stuff we've been talking about is really a vehicle for working in wood. I couldn't work in any other material and be a designer today. There's no doubt about it. If wood went away, I'd go away. I don't know who's doing what anymore. I don't read. I don't get any books or magazines and I don't have any interest in knowing what's going on. I don't even open up the old books. Basically, I've read enough. I just work away.

Lincoln, Rhode Island
October 1991

Desk, 2010. Claro walnut and red oak, 29 x 54 x 27 in. (73.66 x 137.16 x 68.58 cm). Photograph: Hank Gilpin.

AFTERWORD

I don't think my work has veered too far from the path I stumbled on all those years back. I continue to find the work of making and designing practical furniture interesting—and even occasionally exciting. The varied woods of the world are still inspiring, though more and more I seek out the less-valued and unwanted species and cuts. The love of joinery that I discovered as a student of Tage Frid has never diminished and, in fact, might be stronger than ever. There's something maybe a bit spiritual (did I say that?) about fabricating furniture with techniques that have remained almost unchanged over hundreds of years. Preserving continuity, connecting the dots of history, and sustaining all those hard-learned lessons. Hands and mind....

Furniture as a vehicle for creative expression? I bet the creative expression is now fundamentally more important than the furniture. The craft revival, which was incubated in the 1950s and 1960s' regard for Danish design, seems to have evolved into an early twenty-first-century love affair with ideas rather than with craft. I think of it as the Milan-ization of the art of furniture.

Not a bad thing, either. The economic complexities of the last 25 years have made it nearly impossible to remain wrapped up in the romance of small-shop furniture making. I'd say that paradigm shift—away from making, toward thinking—reflects the biggest change in our small field over the last 30 years.

Lincoln, Rhode Island
September 2011

1. Jonathan Binzen, "Practical Genius," *Woodwork*, special issue 100 (August 2006).

ALPHONSE MATTIA

b. Philadelphia, Pennsylvania, 1947

Alphonse Mattia animates his furniture with wit and topical commentary. A connoisseur of popular culture, he also displays a keen knowledge of furniture history and an impeccable mastery of complex furniture construction. His brilliantly playful mirrors and valets are classics in the American studio furniture field. Mattia has also been influential as a teacher (recently at Indiana University) who encourages his students to take the less familiar path in furniture making and explore the conceptual aspects of their work, and he counts among his students five other makers featured in this book.

Mattia was born in 1947 in Philadelphia. He received a bachelor of fine arts in furniture design from the Philadelphia College of Art (now University of the Arts) in 1969 and a master of fine arts in industrial design from the Rhode Island School of Design in 1973. Established as a maker of witty, colorful pieces that often play on the issue of usefulness, Mattia is also highly regarded as a teacher.

He was an associate professor of woodworking and furniture design at Boston University's Program in Artisanry from 1976 to 1985, where he and Jere Osgood taught a constellation of students who would go on to become prominent furniture makers. Among Mattia's students at PIA were James Schriber, Michael Hurwitz, Wendy Maruyama, Tom Hucker, Bruce Beeken, Timothy Philbrick, and Rich Tannen. Mattia has also taught at Virginia Commonwealth University in Richmond; the Swain School of Design, New Bedford, Massachusetts; Southeastern Massachusetts University in Dartmouth; San Diego State University in San Diego; Indiana University in Indiana, Pennsylvania; and, for many years, at the Rhode Island School of Design in Providence. In addition to teaching, Mattia has lectured extensively in the United States, from California's San Diego State University to Maine's Haystack Mountain School of Crafts on Deer Isle.

Mattia's work has been shown nationwide in such museums as the Smithsonian American Art Museum, Washington, DC; the Museum of Fine Arts, Boston; the Rhode Island School of Design Museum of Art, Providence; the Fuller Craft Museum, Brockton, Massachusetts; the Henry Flagler Museum, Palm Beach, Florida; the Museum of Arts and Design, New York City; and the Huntsville Museum of Art, Huntsville, Alabama. His work has appeared in the Peter Joseph Gallery and the Franklin Parrasch Gallery, both in New York City, and in Pritam & Eames Gallery in East Hampton, New York. Mattia has also shown at the Helen Drutt, Rick Synderman, and Dick Kagan galleries in Philadelphia.

Mattia was awarded a fellowship by the Massachusetts Artists Foundation in 1986 and, in 1984, a Visual Artists grant by the National Endowment for the Arts. He was also named a Fellow of the American Craft Council in 2005. Mattia's work is in the permanent collections of New York's Museum of Arts and Design; the Yale University Art Gallery, New Haven; the Museum of Fine Arts, Boston; and the Rhode Island School of Design Museum of Art, Providence.

In addition to many museum and gallery catalogues, his work has appeared in such publications as the *New York Times*, *House & Garden*, *American Craft* magazine, the *Christian Science Monitor*, *Antiques and The Arts Weekly*, *Casa Vogue*, and *Fine Woodworking* magazine.

My father was a carpenter in this country. He came from Italy in 1925, when he was 25, from a little town called Calabritta, further south than Naples and inland. In Italy, he apprenticed to the village woodworker, doing everything from making wine barrels to furniture. His brother had come over to Philadelphia the year before. My uncle was the one who ushered my father into a lot of stages and changes in his life.

Eventually, my father drifted into becoming a carpenter for the Board of Education in Philadelphia. He did that until he retired. Early on, he had bought apartment houses, three-floor brick row houses in Philly, and he worked restoring and renovating them on the side. He lost those houses during the Depression and started over again. He got married shortly after the Depression ended. My mother was a housewife at home all the time.

The basement in our house was a cross between a shop and a storehouse. My father always said to me, "If I need six screws, I buy a box of screws," or, "If I need a plumbing fitting, I buy 10 plumbing fittings." He had an inventory of stuff in the basement. He was a junk collector and a junk resurrector. He never threw anything away. Everything was hanging from the ceilings and the walls—there were corridors to walk through.

He had a workbench, a lot of hand tools, and a little coal stove that he had gutted to burn trash and wood. It would preheat the hot water. He would spend time in the basement either building things or fixing things or preheating hot water. He built a table saw once; it was still there when I recently cleaned out the basement. Even though then I didn't know what one should look like, I knew this thing was frightening and homemade-looking. He cut a few boards on it and the lights went dim. After that, he never used it because it was too frightening.

Did you work alongside your father?

I remember the majority of my lessons with my father were spent waiting to be released from what we were doing—like when it was time to paint one of the apartments in his buildings or fix the windows, or build something in the basement. I would be watching the clock from the time I was a very little kid until I was in high school, the level of impatience growing as the time went by. The lessons were along classic father lines: "Half the job is the preparation" or "You're not done until you clean up all the tools." What happened in the middle, I really don't remember. My father was more eccentric than I realized at the time. He did a lot of screwy things that I didn't realize were screwy, things like making toys in the basement. One Christmas I got an airplane—the kind on a string, a fly wire—and he insisted we try it out in my grandfather's basement. We took hours to adapt it to fit the radius of the basement. I remember when it finally got started, it went too fast because we shortened the radius so much. It went up into the rafters and exploded.

What about your mother?

I learned a lot from my mother, too. My mom came from a creative family in a totally unschooled way. Her brother was a really good carpenter—very imaginative.

I don't think my parents had any preconceived ideas of what they wanted me to do. I was an altar boy in high school and figured I would end up in a seminary. After a Catholic education all the way through high school, I

Architect's Valet, 1985 (detail; see p. 14).

Music Cabinet, 1975. Bubinga and figured maple, 30 x 22 x 19 in. (76.2 x 55.88 x 48.26 cm). Photograph: Alphonse Mattia.

Practice Chair, 1975. Bubinga, figured maple, and leather, 35 x 21 x 21 in. (88.90 x 53.34 x 53.34 cm). Photograph: Alphonse Mattia.

ended up at the Philadelphia College of Art [PCA]. I still don't understand why I ended up in an art school, given my parents' range of experience.

What led you to PCA?

When I was in high school, I had a job working in a small, very exclusive, family-owned hobby shop. The folks that ran it seemed sensitive to me. They were supportive and became an extended family. There were two brothers who were college age who encouraged me to think about art school. Prior to that, it would never have occurred to me, even though I liked the art I did in grade school, which was mostly religious art. The three of us tended to do a lot of artistic-related things—anything from doodling to wandering around the Pine Street area, which was sort of the beatnik area of Philadelphia at the time. So, I ended up in PCA—this was 1965 or 1966. I was shocked to find myself in art school and to find my father helping me make some of my freshman and sophomore projects.

I thought I was going to be an industrial design [I.D.] major. It was a big joke. I figured they designed toasters and that was it. Whenever I imagined what I was going to do, I would sit and look at a toaster. Then I wandered into the woodshop one day. They had just had a crit and there were five or six pieces of furniture, all freshly oiled and gleaming, and the space was beautiful. It was kind of basement-y, but above ground with brick, vaulted windows. It just clicked right away. It was warm and intimate—as opposed to the

Wingback Chair and Ottoman, 1974. Andaman padauk, cotton velvet, and down, 42 x 26 x 26 in. (106.68 x 66.04 x 66.04 cm). Photograph: Alphonse Mattia.

I.D. shop, which had no intimacy whatsoever. The woodshop had seven benches. It was easy to identify with, given my background, my childhood. I understood it. I felt, "This is what I want to do. This is really me."

I remember having to bring the news home to my father, anticipating that it would be difficult. I knew that woodworking would be the last thing he would want me to be involved in. Whenever there was some kind of dilemma, my uncle would be brought in. I remember the two of them were sitting there—my father silent and my uncle doing the diplomatic talking. He was sort of counting on his fingers and said, "Have you thought about going into jewelry making?" He said, "If you go into jewelry, you don't have to have a half-acre shop. You can always wear a suit of clothes because you won't be dirty all the time and you can carry half-a-year's inventory in a briefcase." It was all so frighteningly true. At every troublesome stage in the furniture thing, I would always think back to what he had said. I never really gave those two guys enough credit. When Jonathan [Bonner] and I went off to RISD, we no sooner got in the door than Jonathan switched to metals. I thought, "What's going on?" He probably talked to my uncle.

I got through undergraduate school at PCA and stayed in Philly a couple of years. Ed Zucca and I rented studio space with Dan Jackson; he had a cavernous shop with no windows. We worked there a year, maybe two summers and a winter. He gave us the shop for $70 a month. I had some very good teachers at PCA who became mentors and still are—you think about

what they would say or how they would react to something you do. There were a couple in particular, Bill Daley being one, and Dan Jackson, who started the furniture shop there.

If you asked Ed Zucca, I don't think he would react too differently from me about Dan's vitality, his catalyst quality, and compulsive energy—manic, definitely very intense, and erratic. I never saw him depressed; he was either intensely animated or almost hyperanimated. He would accelerate up from a certain baseline. But Dan was such a dark personality—there was troubling emotion relating to him. It wasn't so easy and as time passed, he went through emotional changes and he was very different for some people. There were students who followed me who had a lot of trouble. They were very critical of Dan. Some saw Dan as being a detriment to their education. I thought of him as an incredible animator. He definitely had a dark side and he could become troubling. He was on an edge.

At the time, there weren't many gallery shows, but the Philadelphia Council of Professional Craftsmen shows were big ones for me. Helen Drutt and Bill Daley originally organized the shows. There was *Craftsmen '67*, which was the first one I saw. I must have been a sophomore in college. I was in *Craftsmen '69* and in *Craftsmen '73*. They were wonderful shows, educationally based. There was an invited section for craftsmen or teacher-craftsmen from Philadelphia in all mediums; there was an open section so young, emerging artists could apply. You had some huge target to shoot for. If you got into the show, you would be in there with all these people who had taught you.

There were a few galleries in Philly at the time—Ruth and Rick Snyderman were running The Works on Locust Street. Dick Kagan opened in 1970. Dick found a space on South Street big enough for his own studio with his apartment above it and this tiny little gallery, which must have been 10 feet by 16 feet, with the little store windows that projected out. It was a pioneer move. Then Rick moved down to South Street and opened up The Works gallery there. He sold a dining room table for me.

Was your work purely wood at this point in time, and who were your influences?

Yes. My work was what I called "Scando-organic-eccentric"—it had one foot in Scandinavian Modern and another in this wild organic PCA thing—everybody staring inside a walnut, bilateral symmetry, the convoluted crease—which Dan was very intrigued with. Then there was this wild eccentricity that everyone was infected with, to be as unique or inventive as you possibly could and throw convention to the wind. No one challenged function, but the interpretation was pretty open. It was wild and enthusiastic work. It was easy to catch Dan's fever, his compulsion to make new work. He had a limited bag of technical tools he used, but they were sound. He wasn't like Jere Osgood. Dan wasn't interested in finding an elaborate technical solution. At the time, for me and everybody I knew, Philadelphia was a bleak place to be. Dan represented a very dark presence. It was exciting, but also a very neurotic environment. People were almost competing with their neuroses—who was more screwed up? It was compulsive. You would think that smoking a lot and staying up all night was the only way to be creative. You could see how it would get to be detrimental. I started to get a little afraid of it, so I decided to go to graduate school as a way to get out of Philly.

Knothead, 1984. Ebonized walnut and sycamore, 64 x 22 x 18½ in. (162.56 x 55.88 x 46.99 cm). Photograph: Andrew Dean Powell.

What were your options?

The options were RIT, Wisconsin, or RISD. That was it. There weren't any other choices at the time. There were one or two schools in California, but that was like going to the moon. Dan Jackson [who had studied under Tage Frid at RIT] had some funny thing with Frid. He would never say he was wonderful, but he never would say anything really negative about him. He might imply that he was a little antiquated. There was this little friction or something. In the end, we decided that Frid [then teaching at RISD] was the best place to go, which did turn out to be true. I ended up applying to RISD with Jonathan Bonner and Jackie Ott. We were friends and we all got in.

Now here we were at RISD, and it was a whole different thing. We were suddenly in the land of the happy-go-lucky leprechaun. Frid was like Mr. Happy, Mr. Bon Vivant, Mr. Gourmet, Mr. Cut-Dovetails-with-a-Brown-Paper-Bag-over-His-Head. It was absolutely what I needed. For me, Frid was such an important mentor in terms of approaching the idea of creative work in an upbeat way as opposed to a depressed, manic, compulsive way. I needed that but didn't know it. I knew I was sick of Philadelphia, but I didn't know why. Now I could breathe. It was healthy and productive in a whole different way. It worked out well for me.

Frid had an influence over certain people's work. He had a strong influence on Hank [Gilpin] in setting the foundation for the way he thinks, just like Dan Jackson did for me. Frid was no influence on me in that respect. He was another incredible creative catalyst, but not directly related to the aesthetics in my work. It was almost like I hid things from him; that's what Dan told me to do. Frid said, "That Jackson guy, he was always sitting around carving fish and he'd hide them under the bench when I came around."

Frid used to really put down Dan. Frid is territorial. He doesn't like to acknowledge anyone else's influence or even existence. He'd say, "That Dan Jackson. You didn't know beans about making furniture until you came here." In fact, Frid did teach us a lot of new things. There was a whole new opening up of techniques and different processes that were beyond what Dan would have aimed us toward.

The first piece I did at RISD was this "Scando-organic-eccentric" spider chair, laminated and completely shaped. It had six legs and rocked on the two center legs, so you could

tip it back or forward. Frid loved it because he liked the story about how my mother didn't like me to rock back in the chairs at home. He'd tell that story all the time. At the end of school, Frid said there was some guy from a school in the South who had seen the graduate show and was impressed. He said they needed somebody in a hurry. It was May and they were worried about September. I got the job. That summer, Hank and I both worked for Frid.

What happened after that?

I went down to Virginia [Virginia Commonwealth University] and was there from 1973 to 1976 teaching furniture shop. They had a nice shop—undergrad and grad students, too. I modified something between Dan's and Frid's curriculums. I had a lot of elective students and a small group of majors. Elective students were fun to work with and then they were gone. I had six majors, and they were really intensely interested. Ronnie Puckett was one of them. I liked my job—a good department, a big college, state school, a little bit of money—everything I don't have right now. Rosanne [Somerson] and I were carrying on the relationship via the mailman. She'd come down on breaks. We had met at RISD.

 Then 1976 came along and I heard that Dan was commuting and teaching in Boston. The program had opened the year before with [James] Krenov and Jere. I didn't know that Dan was crumbling. I heard the next year that Dan wasn't going to go back because of the pressure, so I applied for the job at BU and I got it. I left Virginia and went to Boston. When I walked in the door, there was Tim Philbrick, Rich Tannen, Bruce Beeken, David Trough. James Schriber came in a little later. These people were the C of Ms [Certificate of Mastery students]. The school was looking for people

Fig. 43. Show catalogue cover, 1984. Photograph: Warren Johnson.

who had outside experience and they got it. Rich had worked with a sculptor, Tim had a long apprenticeship with Johnny Northup, Bruce had worked with Simon Watts. Tom Hucker came in later. Mitch [Ryerson] came up out of the undergrad department. It was a pretty wonderful time. Somehow they had magnetized some dynamic talent. The school had just opened, and they had beaucoup money and they were spending it. Ever since then, I've been in a position where I had no money. Not only did we not have to worry about supplies, we could buy a good German table saw. Eventually, we got thrown out of BU by Long John [Silber], but it was a wonderful stint—that 10 years was incredible.

 Jere had things the way he wanted them and ran the studio in terms of budget control. I was pretty green, only three years teaching. Jere wasn't a seasoned teacher himself, but he had everyone's love and respect. In time, I took on more responsibility.

Primates (valets), 1986. Bleached and stained ash and poplar, 74 x 18 x 18 in. (187.96 x 45.72 x 45.72 cm). Photograph: Andrew Dean Powell.

In the end, there was a schism between Jere and me in terms of my pulling more in one direction and Jere pulling in another—a classic scenario of the underling wanting more independence from the system. We did this little catalogue [fig. 43] with a drawing of mine on the front—a tall, thin highboy and a funny little chair turned upside down with some spikes and a hairdo. It was clearly an autobiographical thing about Jere and me, although it was never spoken about that way. The field was changing—Jere was resisting the change and I was throwing gasoline on it.

Describe the change.

It was pretty evident that the field was opening up. The commitment to form follows function; to basic, unadorned material; to the soft, satiny hand-polished oil finish—all of that was being challenged. More art-related influences were being applied to furniture. In hindsight, although I hate to use the term, Post-Modern thoughts were coming in.

Our work had grown out of Scandinavian Modern and organic influences of the early 1960s, and also out of Modernist thinking in terms of art and architecture. All of a sudden, those things were being challenged.

People were restless. I was restless. We had a lot of transitional students who were shaking loose of the confines of what had been going on for 10 years. Jere's attitude about it was protective, but that would get wrapped in other issues—issues like diminishing quality.

What was your furniture like at that time?

Something wasn't quite right. I liked what I was doing and understood why it made sense, but I felt that it was a little foreign somehow. I was becoming estranged from my own work.

I felt a groundswell movement happening, a restlessness that was surfacing in a lot of other things, in the design world and certainly in the music world. People were becoming uncomfortable with that easy rock and roll going on. I saw this as a parallel with what was going on in furniture.

It was a change that keyed directly into people's attitudes about what meant something to them. Art is supposed to mean something to us. It seemed to me that these old precepts weren't holding together anymore—the idea that self-expression was in the lifestyle of being a craftsman; the concept that expressive qualities in work had to do with "centering"; the idea that "process is content." It was not really working anymore.

The majority of students were thinking in that way. I was watching the work evolve—my

Chair-o-Drawers, 1985. Baltic birch and bird's-eye maple, 68 x 22 x 18 in. (172.72 x 55.88 x 45.72 cm). Photograph: Andrew Dean Powell.

Mr. Potatohead, 1984. Bleached oak, colored sycamore, and dyed Baltic birch, 72 x 18 x 18 in. (182.88 x 45.72 x 45.72 cm). Photograph: Andrew Dean Powell.

Raccoon Bench, 1993. Bleached and stained mahogany, 22 x 91 x 21 in. (55.88 x 231.14 x 53.34 cm). Photograph: Andrew Dean Powell.

own and the students'—and it was getting more and more alien. It was beautiful stuff amongst a circle of focused, educated furniture people, but the minute you took it out of that context, people would say things like, "It's great, but what is it?"

I can't remember if it was in 1976 or 1977 when Rosanne and I first met the McKies [Judy and Todd]. I can vividly, vividly recall looking at Judy's work for the first time. It was so strong, even at an early stage for her. It was around the time when she had stopped making furniture for her own house. The thing that shocked me was that her work looked so foreign to the kind of thinking everyone was buying hook, line, and sinker, but it was powerful. You could sense where she was about to go. I remember looking at the work and being excited about it and about her and then watching everyone in the shop categorize it as "that's really nice" and put it aside because it didn't fit the thinking, the philosophy we were all just handed.

And so you left and headed west, right?

Around 1979, Rosanne and I got a chance to teach at San Diego State while Larry Hunter was on sabbatical. I got in the car—I do a lot of prethinking in the car, so I don't mind being stuck in a traffic jam or taking a long drive—and as we were driving across the country, I made sets of goals for my work. 'Why am I not happy?' I decided something was wrong. I wasn't going to do any more furniture until I figured out what it was.

I tried to isolate some things. One of these was the pain factor. It was always a long, introspective process every time a new piece was coming. It was rewarding in some ways and torturous in others. I never really solved that. The other thing was that I drew too much. It was more than a doodle addiction. I was doing what you might call automatic drawing—it wasn't questioning what I wanted to do with my work or questioning the rules that I was losing respect for. I decided to force myself not to doodle the piece before I had made my mind up what it would be.

I can remember sitting in some diner on our drive across the country. I would pull my pen out and get my napkin ready to go and then I would put my pen back. I had to come to some idea before I would start drawing, to get

Red Mirror, 1979. Koa, figured maple, and bacote, 32 x 90 x 12 in. (81.28 x 228.60 x 30.48 cm). Photograph: Alphonse Mattia.

Fragile, 1982. Painted wood, glass, and aluminum, 30 x 26 x 2 in. (76.20 x 66.04 x 5.08 cm). Photograph: Alphonse Mattia.

some answers that didn't involve black ink on paper. I would stare at the wall and try to make something appear three-dimensionally rather than draw.

That's how the mirrors started. I decided I wanted to work on a series of pieces with the idea that it would help me conquer the torturous design process at the beginning of each new piece. I built the first mirror in San Diego—that big, red-lacquered one (above) that you had in your opening show. When I got home, I continued the series of mirrors.

I've always said that I think of design as a problem-solving process. You have a problem and the problem has parameters and the solution is the design. I wanted to keep it grounded in function, but allow some other aspects to play up—visual, sculptural issues. Yet I really didn't want to make sculpture. I still wanted the functional reference. The mirrors made sense for that.

If I had to think of a key mirror, it would be the one that Ronnie [Abramson] bought. It was the one that got closest to what I wanted to happen. It's not just the function of the piece, it's the line. That was the first piece that Ronnie bought in his wood collection.

After I came back from California, a lot of people said, "What happened to you, you went to the Coast?" And I would answer, "No, I got away from Boston. I got away from my peers. I got away from the philosophy we were immersing ourselves in."

One of the things I started thinking about when I came back was that I didn't want it to be called a furniture shop anymore. The boundaries in wood were much too rigid. David Powell

Chopsticks, 1980. Burled sedua, birch, and painted wood, 24 x 52 x 4½ in. (60.96 x 132.08 x 11.43 cm). Photograph: Bobby Hanson.

said there is no such thing as woodworking; there's furniture and there's sculpture. Why? Why can you have functionalists and nonfunctionalists in all craft mediums except wood? If someone wants to make earthenware dinner sets, they are legitimate ceramic artists. If Bob Arneson wants to do ceramic sculpture, he is in the Whitney. What's the problem here? I didn't buy the idea that a contemporary young artist must think of process as content, that the strength of the idea was the process. There are people who live by that.

Such as?

Jere is the personification of it. I think Maloof is, although he and Jere are so radically different. Each year at BU, as I got more vocal about my beliefs, it got increasingly more

City Boy, 1985. Bleached and dyed cherry and poplar, 72 x 18 x 18 in. (182.88 x 45.72 x 45.72 cm). Photograph: Andrew Dean Powell.

uncomfortable. We went through a succession of students who were failing in some way—not because their work was bad, but because they didn't fit the clear, focused, narrow band we were pursuing in the program. We didn't know what to do with them and they became trouble. There was this line: A piece was either furniture or it was beyond that and it didn't fit. We never did adapt or adjust. I remember being in

Fig. 44. *Are You Building or Are You Renovating?* 1982. Wenge, sycamore, and epoxy resin, 60 x 126 x 30 in. (152.40 x 320.04 x 76.20 cm). Photograph: Alphonse Mattia.

Fig. 45. *Sideboard* designed by Gerrit Rietveld, 1919, made by Gerard van de Groenekan in 1983. Painted beechwood, 41 x 78¾ x 17¾ in. (104.14 x 200.03 x 45.09 cm). Photograph: Unknown.

the middle, acting like a liaison, saying, "Listen, how do you expect Jere to support what you do when you're always challenging the belief of the program?" And other times saying to Jere, "But his work is good." As I got more frustrated, I got louder. There was one particular critique when Jere and I had an altercation. It was a silly thing. I was saying that I didn't buy the idea that a chest of drawers always had to take 12 weeks. I didn't see why you couldn't build one in a month or in two weeks. I was saying that there were other types of chests of drawers. I was passionately stuck on my point of view. It led to a separation in the way we were thinking about things. I didn't believe anymore that students had to make a chest of drawers like that as a rite of passage to become an artist–craftsman.

Don't you have to master perspective before going on to Abstract Expressionism?

Yeah, I guess I believe that. It was a big sacrifice—don't think it wasn't. It wasn't like I wasn't aware that giving up that chest of drawers would mean giving up that huge educational foundation block. But, on the other hand, I felt that doing the chest of drawers put people into a style of thinking that was hard to get out of later. Once you're out in the real world, forget it. When the overhead is there and the commission is there and the style is there, you don't have any time to question. Some

Fig. 46. Valet designed by Hans Wegner, early 1950s. Ash and teak, 37½ x 20 x 21 in. (95.25 x 50.80 x 53.34 cm). Photograph: Unknown.

Fig. 47. Sketches of valets, 1983.

people find a way and some don't. This thing with Jere happened almost at the end of the program. At that point, Jere went on sabbatical and the school closed.

Also, about that time, Ronnie [Abramson] called me. He wanted a piece of sculpture. It was the magic word to me. At the time, he was a visionary patron. The point where somebody stops being a client and starts being a patron is when they say, "What do you want to make?" I feel that patrons help you continue your educational process in some way. They support your new thinking; they help you move ahead. Ronnie was like that. He had this magical thing. I've been on buying trips with him; he's very public about it. He has a wonderful way of moving through the process of selecting and rejecting without hurting people's feelings. In hindsight, it always looked like he bought the right one.

The piece I did for Ron was to go in the lobby of his office building in Washington. I wanted it to mean something to me and strike a chord in others. The piece [see fig. 44, p. 182] was called *Are You Building or Are You Renovating?* To me, it was about being surrounded by a continual renovation process, which is my problem. Rosanne says

that anything that's not finished, I did. The sketch I brought to Ron came from the idea of walking through doorways with stacks of lumber. The boards were twisted, laminated, and warped, and there were these exaggerated shaper moldings—I had to get a little process in there! The planks had inlaid epoxy in blue for chalk lines, like a carpenter's building marks. I liked the idea of accessibility through literal reference. When it was finished, I thought, 'Now what am I going to do?' I had finished my mirror series. I did a piece of sculpture. I still hadn't built any furniture.

About that time, I got a call from someone who asked if I had ever done a valet. I have always loved the Hans Wegner valet [fig. 46]. It was right up there with [Gerrit] Rietveld's sideboard [see fig. 45, p. 182], which is another key piece for me. They're both on my top-10 list. So I did this composite group drawing of 10 valets [fig. 47] and blew it up and hung it in my studio. That became my working drawing. I started building three at once. The pieces

Bottle Bookshelf, 1993. Stained and colored mahogany, 80 x 23 x 16 in. (203.20 x 58.42 x 40.64 cm). Photograph: Andrew Dean Powell.

Clothespin Bookshelf, 1993. Stained and colored mahogany, 76 x 22 x 14 in. (193.04 x 55.88 x 35.56 cm). Photograph: Andrew Dean Powell.

Tall Buffet, 1995. Bubinga and Swedish pearwood, 45 x 46 x 14 in. (114.30 x 116.84 x 35.56 cm). Photograph: Andrew Dean Powell.

were so flexible that I could bring in anything I wanted—carving, organic line, geometry. I wasn't stuck on one format. I did a show with Helen Drutt in 1985 and it was all valets.

What else was going on in furniture when you started the valets?

It was the early stages of the Italian design movement called Memphis; it wasn't even called Memphis then. There were Mendini and Sottsass leading the movement over there, and there was a group of people here who were aware of it. Memphis was the Wendell Castle of the furniture world, a sort of high marketing process. Post–Modern thinking was breaking, too. The thing that was key about the Post–Modern movement was that there could be life after Modernism. People were saying The Museum of Modern Art was not a contemporary museum but a historic museum, and that made sense to me. I then realized that Modern was going to fit in right after Art Deco.

I began to realize that there is room. You don't have to beat Sam Maloof. You can just go somewhere else. You don't have to out-do the king of the rocker. I do have a lot of respect and affection for those key people who built the American craft thing. But when all of a sudden you can get wonderful manufactured things or handmade things, then it starts to make sense that some things could have holes in them, that they wouldn't have to hold the food, or that they could hang on the wall like this Esparmer piece [ceramic plate]—that work could give you some spiritual fulfillment instead of soup fulfillment.

Do you have to invent reasons today for a piece to be useful?

Our idea about what usage is changes. It could be religious. It could be nonfunctional and have very important usefulness. In the book *Artists Design Furniture*, Terry Mann talks about some people who believe that conveying meaning and emotion is a form of usefulness and I subscribe to that.[1]

Like this ceramic thing of Esparmer's—there ain't no question that you're not going to put bologna on it. It's just not a good lunch-meat tray. But for me it's wonderful. It conveys this swirling religious confusion I grew up in and it's an important thing to me. It's useful to me. That's what I wanted the valets to have—some other level of interaction. If you woke up in the morning and they made you chuckle or pissed you off, it was working on another level.

I had a lot of publicity out of those valets from big shows like the American Craft Museum's *Poetry of the Physical* [New York City, 1986], as well as the European tour of that show

Fetish, 2008. Baltic birch, poplar, bubinga, and polyethylene fabric, 38 x 36 x 36 in. (96.52 x 91.44 x 91.44 cm). Photograph: Eric Gould.

Fig. 48. MFA *Asymmetrical Wingbacks*, 1989. Soft curly maple, ash, and knitted wool, 49½ x 36 x 31½ in. (125.73 x 91.44 x 80.01 cm). Fabric: Jane Barnes. Photograph: Museum of Fine Arts, Boston.

and *The Eloquent Object* [Oakland Museum, 1988]. I finally learned—and admitted—how the publicity angle works. I had much more success with the valets and more publicity than with the chairs in the Boston Museum show [*New American Furniture: The Second Generation of Studio Furnituremakers*, Museum of Fine Arts, Boston, 1989]. It's hard to shrug that off—that stuff is valuable.

What led you to make those wingback chairs [fig. 48] for the Boston MFA show?

I had a severe case of museum block with the MFA show. I knew it was going to happen. I didn't want it to happen. It did happen. I had a hard time with it.

First of all, the museum is a conservative organization. Having to pick a museum piece to respond to is a conservative starting point. But I love those wingback chairs—that upholstery tradition in furniture and I like the historical game I played. I was imagining a setting of two reading chairs in a library. I've always loved the idea that the wingback chair started out as a shield from climatic problems, like a huge fireplace and roaring cold air. In the 1990s, it has more to do with social flexibility. I wanted one wing to be big enough so that you could hide behind it and the other one very open. If I had to do them over again, I would make them bigger and softer—cozier. I think they're a little too rigid.

I was happy with the MFA pieces and the route I picked, although it was a dilemma. I see my work as being on two tracks and I go back and forth. The best description I can come up with is "straight furniture" and "the other stuff." Some people would say, "Well, I think those chairs are really funny." But I don't think they are funny enough for me to push it all together into one thing and be happy. In some ways, I felt better about working closer to the straight furniture end than the humorous end with those chairs. Maybe it was the museum; maybe it was me.

New Bedford, Massachusetts
April 1991

Steppin' Out, 2012. Woodcut print for the exhibition *Poplar Culture: The Celebration of a Tree*, Wharton Esherick Museum, Paoli, PA, 2012; image 11 x 7½ in. (27.94 x 19.05 cm); framed: 21 x 17 in. (53.34 x 43.18 cm). Photograph: Alphonse Mattia.

AFTERWORD

Most of my career has been spent dividing my time between teaching and studio. I've gotten better over the years at keeping the balls in the air and the plates spinning, but sometimes with a certain degree of blurred vision about my goals. Usually, an idea for a new chair or sculptural piece will tip the balance and get me into the studio. Then a former student comes along who has managed to succeed in the midst of all this design excellence in the world and I feel just as pleased about having dedicated so much of my life to teaching.

I don't think my work has changed in any way more greatly than it has in quantity. The truth is it has become increasingly more difficult to be productive in my studio with each new phase. Years are so short. I still have a schizoid approach to furniture and sculptural objects, but the blending of the two and the balance between humor and design comes a little more easily. I love floating in off-centric orbits around the big white moon of function. While I respect high-style furniture, it is still something in which I have little interest. I pretty much discount reproductive attempts at period furniture, unless there is something very new (and contemporary) added to the work. I still believe there are new forms in furniture to discover and fabulous things to say through this medium.

From the onset, I have been interested in a broad definition of furniture, one that includes objects that remind us of furniture through their form, function, familiarity, materials, or maybe just their posture and stance. The word furniture just doesn't encompass all that is being made in this medium. Wood, plastic, metal, concrete, stone, glass, natural fibers, synthetics, and a plethora of digital outputs are all being used to make objects that serve function, convey meaning, and reference furniture. There will always be potential in contemporary object making for self-expression, social commentary, and plain ol' beautiful, comfy furniture. The more I think about it, the more I like the word things.

One trend I see in our field is toward a "creative impatience" with time-intensive processes. I see it most in my students, but attention spans have shortened for all of us; do you think the computer has something to do with that? Whatever the reason, there are pluses and minuses. This impatience endangers traditionally learned techniques and reduces them to the status of rarefied collectibles or fetishes—"Oh, she sets type and he's a dovetailer." Very real concerns with being able to make a living can result in a closed mind-set. The dwindling supply and rising cost of "conscientious" materials further limits choices. All of this results in a feeling of desperate pressure to find faster and easier ways to create art objects.

On the bright side, we are discovering new and often better ways to make things and bring them to market. For both one-off and batch-made pieces, we are harnessing digital design and fabrication in creative and personal ways—ways that do not have to lose the mark of the hand.

Galleries are terrific places to show work, but exciting new sales and exhibition venues are opening every day. Social networking, virtual shows, and even virtual galleries, design blogs, dedicated online marketing sites, and impromptu storefront, warehouse, rented-truck, and even converted Airstream exhibits are just a few of the new ways of showing and selling work. Yes, it's a barrage, a deluge, a tech-tsunami both scary and thrilling. It's fun to see how things are transforming. Once again, I struggle to embrace the changes and to be included in the party.

Indiana, Pennsylvania
November 2011

1. Denise Domergue, *Artists Design Furniture* (New York: Harry N. Abrams, 1984).

JOHN DUNNIGAN

b. Providence, Rhode Island, 1950

John Dunnigan's furniture blends the esoteric with the erotic, the elevated with the gaudy. When Dunnigan gives form to a piece, his design language might include references to wrapped papyrus bundles, scrolls and obelisks, or the ancient orders of the triglyph and metope found in Greek and Roman architecture. He has also been known to incorporate plastic bangles, bordello fringes, and neon colors in his pieces.

With his trademark upholstered pieces that he makes in his Rhode Island shop, Dunnigan has created alluring compositions that emphasize the sensual nature of furniture. He concedes that some of his work employs asymmetry, exaggerated proportions, and unexpected materials that can take you to the edge of good taste. But to art critic Helen Harrison, who notes Dunnigan's stylish allusions to Art Deco, Egyptian tomb decoration, and Japanese lacquer, what his furniture delivers best is an "exquisite theatricality."

Dunnigan was born in Providence, Rhode Island, in 1950. Although he originally wanted to be a writer, he took some art courses in college and stumbled upon a new direction. He says of the art classes, "I was trying to make sculpture, but it kept looking like furniture." Dunnigan opened his first furniture workshop just outside Providence in 1970, while still in college. After graduating with a bachelor of arts in English from the University of Rhode Island in 1972, he worked full time making furniture. He went back to school in the late 1970s, studying under Tage Frid at the Rhode Island School of Design and earning a master of fine arts in Furniture Design in 1980. Dunnigan has taught at RISD since 1980 and he is currently a professor in the Department of Furniture Design. He has held the titles of Department Head in Furniture Design (2005–2008) and Dean of Architecture and Design (2008–2009). He has also taught at Haystack Mountain School of Crafts in Deer Isle, Maine; Penland School of Crafts, Penland, North Carolina; Rochester Institute of Technology, Rochester, New York; and Anderson Ranch, Snowmass, Colorado.

His furniture has been included in more than 100 exhibitions, in venues such as the Museum of Fine Arts, Boston; the Museum of Art, Rhode Island School of Design, Providence; the John Michael Kohler Arts Center, Sheboygan, Wisconsin; the Smithsonian American Art Museum, Washington, DC; the Peabody Essex Museum, Salem, Massachusetts; The Museum of Arts and Design, New York City; and the Oakland Museum of California. In addition to a number of private collections, his work is in the permanent collections of public institutions such as the Museum of Fine Arts, Boston; the Smithsonian American Art Museum; and the Museum of Art, Rhode Island School of Design.

Dunnigan's work has been featured in publications including *The International Design Yearbook Five*; *Art for Everyday: The New Craft Movement* by Patricia Conway; *New American Furniture: The Second Generation of Studio Furnituremakers* by Edward S. Cooke, Jr.; *The Maker's Hand: American Studio Furniture, 1940–1990* by Edward S. Cooke, Jr., Gerald W.R. Ward, and Kelly H. L'Ecuyer; and *Inspired by China: Contemporary Furnituremakers Explore Chinese Traditions* by Nancy Berliner and Edward S. Cooke, Jr.[1] Dunnigan also edited Books 2 and 3 of *Tage Frid Teaches Woodworking*.[2]

He lives in West Kingston, Rhode Island, with his wife, artist Wendy Wahl, and their daughter, Hannah.

My parents are wonderful people, but I wouldn't say that I got a great deal of support from them to be creative or to be an artist or to be a writer. They have always thought, and perhaps still do to this day, that I should get a real job. This life as an artist is something that isn't completely understandable. It's very difficult to grasp. They always ask how I'm doing and how things are going. They love the fact that I teach at RISD—that's something they can understand: I'm a teacher.

So what started you on the artistic path?

I didn't have any exposure whatsoever to art until I went to college. Even in my high school, we didn't have shop, we didn't have music, and we didn't have art. The closest thing we had was drafting and mechanical drawing. In grade school, there was nothing—no music, no art. In first and second grade, we must have pasted up valentines and that sort of thing. The only role models that I had in terms of art were literary role models. The only thing I knew that was even remotely creative was poetry—and prose, too. I read Longfellow and poets like that.

I never had a music lesson. I know that every kid who has music lessons complains bitterly about their parents making them do that. I, on the other hand, have complained bitterly about not having gotten them. I think if I had another life, I would be a violinist or a pianist. To me, music is the ultimate art form; it's the purest kind of art. I learned on my own how to play several instruments. I keep threatening to get lessons.

Did you have friends in school who you shared this with?

It seemed there was no one else around me who felt some of the things I was feeling. I was always on some sporting team or other. I was ice skating from the time I could walk—my father would flood the yard. I wasn't ever a particularly good athlete, but I had a lot of experience at it. I was sociable and accepted and had a lot of friends and was gregarious. But there was the other side to me: It was clear to me from an early age that I was sort of an alien in a foreign world. I didn't share any of this creative or artistic side of me with anyone—not because it was a secret, but because there was no one else who appeared to share it.

I'm the youngest. I have twin sisters who are three years older than I am, and then I have another sister who's six years older than I am. My father managed a small finance company in Providence. He was president of the Providence Exchange and the Consumer Finance Bureau. We were very comfortable. It was a good, middle-class, Irish Catholic family.

We had whatever we needed, but there was no overdoing it. It was a modest upbringing—and it was very Catholic. I went to Mass every morning at 7:00 for the first eight years of my schooling and then in high school not so often. I went to an all-boys school, LaSalle Academy, in Providence. It was so strict I always felt it was easy for me to know what to rebel against. Typical of my generation, we had it so shoved down our throats that we didn't believe a word of it. All I wanted to do was get the hell out of there. I have since discovered that it wasn't at all that clear-cut and I've described myself on more than one occasion as a recovering Catholic.

I must say that my grade school and high school education was horrible. We just goofed off until we got the teachers upset enough to provoke them. We got beat up plenty, but we didn't learn a damn thing. That was pathetic.

Settee, 1990 (detail; see fig. 54, p. 207).

They all had their own particular tortures. If I hadn't been self-motivated, I would be even less educated than I am. I wish I had a better education, but I worked very hard to get what I got. My parents are not highly educated or really literate themselves, but that's because they didn't have the opportunity.

We got a very strong dose in my family of how we were, in some respects, a burden. This is something that's kind of Catholic. My father always said that he would have liked to have done X or Y or Z, but goddamn it he was out working at a job to support us. There are one or two things that have made me do what I do today. I knew very early on that I did not ever want to say to someone in my life that I wanted to do something or other but I couldn't because of them. I have lived my life from a very early age on that basis.

From the time I was a freshman in high school, when I would have been 14, until I graduated from college, I worked. Even when I was 12 or 13, I would work on farms in the summer down here in Matunuck, picking potatoes, baling hay. I had an uncle who had been a builder and became a federal housing inspector. He had all these connections and would get me jobs. At the age of 14, he got me a union job as a carpenter building apartment buildings. I did everything from studding to nailing on trim. I was unimpressed with carpentry, so my uncle said, "Look, in the laborers' union the dues are cheaper, the wages are a little less, but you don't have to buy any tools and you get to do a wider variety of work." I joined the Laborers' International Union at the age of 16, which was illegal, but the whole thing was a racket. I don't know who was paying who—I didn't ask. I did everything from drilling and blasting, dynamiting rock, to working with plumbers and working with electricians.

Did you contribute these earnings to your family?

No, my parents let me keep all of it. I had money in the bank. I used it in college to live. That discipline they believed in, the preparation for a life so that you could survive and be on your own.

It was always assumed I would go to college. I went to the University of Rhode Island. Despite the fact that I say my education was poor, I was always in the top class in high school. There was a smart class and a dumb class and classes in between, which I think is horrible, but that's the way they did it. I had a high B, low A average, somewhere around there. For goofing off, it was pretty respectable. I wasn't too interested in college except to keep me from going to Vietnam. It was also time to go away from home. The University of Rhode Island was fine because it was big and kind of anonymous.

I majored in English. All I wanted to be was a writer. It was a clear intent. The year I entered as a freshman, I went to the literary magazine to try to get on as a staff member. It was a very stuffy old thing and they told me to go away. You couldn't be involved as a freshman. I went off and started my own underground literary magazine. We published all the real wild stuff that they wouldn't have dreamed of publishing in the official university thing. We made quite a splash. We xeroxed it, cranked it out on the little machine, mimeographed it. We had kind of a coffeehouse culture. It was 1967 and there was a counterculture even at the University of Rhode Island. I became part of that. For the first time in my life, I felt there were people who were kindred spirits. By my sophomore year, I was taken into the regular literary mag. By the second semester of my sophomore year, I had become the editor. Then

I somehow or other decided that what I wanted to do was make furniture.

What? That's a drastic change in plans!

It just came. I didn't want to be an English teacher and that's what was beginning to shape up. I'd had that work experience of building things and I also built things on the side. When I went off on a cross-country trip with some friends in a van, I was the one who built the bunk beds and the cabinets and all the stuff inside the van. It was pretty awful stuff, but I was attracted to doing that.

The question is how I made the jump from one to the other. There is no simple explanation that I can think of, but I did have one or two really wonderful courses at URI with a guy with whom I'm still friends, Eric Scoonover. He had a broad, cross-cultural approach to teaching literature. This is an English class, we're studying Emerson and Thoreau, but we'd go to a historic building and look at a site.

When we'd visit these sites, I was the one under the furniture, opening things, looking at the pieces. All I ended up caring about was the furniture. I kept being drawn to the furniture objects and how they were a cultural and artistic expression.

Through this period, I didn't know about [Tage] Frid or RISD or any of the stuff that was going on. I just decided that it would be a nice life, maybe, to open up this little shop and learn to make furniture. So that's what I did.

This was in Saunderstown?

This was in Saunderstown [Rhode Island] in September of 1970. I didn't have a clue what I was doing. I really didn't. I had the same table saw that my dad had in his basement. I borrowed that. It was an old 10-inch Atlas. It was a

Boat interior worked on by Dunnigan, 1975. Photograph: John Dunnigan.

great old piece because my dad had mounted it on a wooden table with casters on the bottom of it. I was given a little 4-inch jointer. It was a Craftsman back when Craftsman used to make good tools. A friend of my dad's gave me a drill press. I went out and bought a little lathe. At that time, you could buy a cheap lathe for about 100 bucks or 75 bucks—brand new. And I had a bunch of chisels and a saw and hand planes.

I was determined. I taught myself how to do everything. I was completely self-taught. I was on cloud nine. This was wonderful. I was still a student, but I was looking forward to moving beyond college. When I rented the shop, I was in my junior year. I would go into school and edit the literary mag, show my face at a couple of classes, race back to my shop, and work in my shop as much as possible. I had a new girlfriend and life was great. We had a ball.

We lived on nothing in those days. I didn't make anything. My rent was 40 dollars a month and that took most of what I could muster.

Had you met Tally by this time?

I met her at just about the same time. There was no support from any source anywhere for me to do what I did when I opened that shop and decided to become a furniture

maker—except from Tally, who thought it was a great idea. She supported it all the way and always did.

She was teaching at Brown. Her office was next door to my apartment and her dog, Rosalie, a black Lab, would come over and rifle through my garbage. I got to be friendly with the dog and a few weeks later I saw a person with the dog. We got to be friendly and started going out and eventually moved in together. In Tally, I had met somebody who was older, already a professional, already divorced, and not looking to get married. She's a specialist in ancient art, particularly Roman sculpture. She was, and still is, such a good scholar and such a hard worker. She was a role model. I finally learned how to study, how to be a professional.

So Tally is the second reason that got me doing what I do today. Maybe the third is that I'm sort of meant to do this.

When I graduated from college, I hadn't applied to graduate school, didn't want to be an English teacher, and was offered a job by a construction company, again a connection through my uncle. I could obviously build, I could read a blueprint, I could articulate, so they gave me a good-paying job and asked me to be the guy who went around New England with blueprints and acted as the liaison between the architect and the man in the field. I would go off with a set of blueprints to some field in the middle of Massachusetts or Connecticut and meet a guy with a backhoe and say, "Okay, here's where we want you to dig." This had great potential for making money and moving up in the company. I lasted about a month, maybe; I was so bored I couldn't stand it. I left the job and went back into my shop and got a couple of kitchen jobs.

I'd moved my shop about a quarter of a mile down the road to a building that was essentially a four-car garage. We had a horse at

Grossman Armchair, 1978. Black walnut and cotton, 30 x 30 x 30 in. (76.20 x 76.20 x 76.20 cm). Photograph: John Dunnigan.

the time, so we turned one of the parts of the garage into a stall. In three of them, I had my shop and, in the fourth, there was a horse.

Through Tally, I met another guy who was doing the same thing that I was doing, just down the road. He'd moved from New York and didn't know what to do either, so we became partners. I moved into his shop. We did kitchens and a couple of huge, freestanding cabinets. The shop was so small—it was an old barbershop—that we had to take a board outside to turn it around and bring it back in.

In 1974, I broke up the partnership and it was a really bleak period in my life. You may recall it was the oil embargo, a real disaster economically, and I was suddenly unemployed. When I got out of this partnership we had

Table and Mirror, 1980. Mahogany, 72 x 36 x 18 in. (182.88 x 91.44 x 45.72 cm). Photograph: John Dunnigan.

Vanity Suite, 1984. Maple, lacquer, and gold leaf; table: 30 x 48 x 24 in. (76.20 x 121.92 x 60.96 cm); stool: 17 x 24 x 16 in. (43.18 x 60.96 x 40.64 cm); mirror: 34 x 24 x 1½ in. (86.36 x 63.50 x 40.64 cm). Photograph: Warren Johnson.

essentially nothing but debts. I was absolved from the lease and the debts, but there were no assets for me to take away except a few of my tools. I had no shop, no money, no means of support.

Tally was in Europe on an extended leave without pay and I was taking care of things. Since I had the house to myself, I was working in the kitchen. I got a woodworking vise that I could clamp on the kitchen table and I made some things with hand tools and a router. I still have one of them, a little Shaker-style candle stand, a three-legged tripod table, which I still like.

Finally, I landed a job building boats. A friend of my sister's called me up one day and said, "I found a great job for you." She had just talked to some people who were coming over from Sweden and were trying to establish a boat-building company in Newport. In Sweden, they jobbed out all of their boat interiors to cabinet shops so they were well crafted. They were bringing over their molds to make the fiberglass hull, but they had no way of doing any of the wooden parts. Was I interested in setting up a shop for them? I set up shop for them.

Myself and another guy set this shop up and did the prototypes and bought all the machinery. Basically, we spent six months or more making the first interior and the first set of wooden parts for one of these boats; thereafter, it became a production item. When I quit in 1976, I went back into my own shop. By then I'm in my fifth or sixth shop space in as many years.

Metope Writing Table and Chair, 1986. Purpleheart and maple, 30 x 60 x 24 in. (76.20 x 152.40 x 60.96 cm). Photograph: Ric Murray.

Had you met Frid by this time?

I had known about Frid and RISD since maybe 1972 or 1973. A couple of years later, I went up to see him. I said, "I just got this boat-building thing and its kind of interesting, but I think I'd like to go to school, too." He advised me against it. He always asked everybody right off the bat how much money have they got. I said, "Well, I don't have any." He just said, "You're doing great; you're earning money. You can come up here any time you want and we'll talk," which I did with some regularity. He thought I'd learn more and make more money building boats. He said, "You don't need to come here."

The stuff that we were doing for these boats was very *furniture-y*, if I can use that word. The way the Swedes did it, there was a nice chest of drawers, a nice freestanding drop-leaf table with a trestle leg, and there was a little chart desk for your maps and stuff. It was pretty decent cabinetwork. It was all teak. I ate and breathed teak for a year and a half.

I went back and I said to Tage, "You're going to retire in a couple of years and I want to go to school." I applied and got accepted. The only way I could do it was if I did commissions as school projects. This was a little bit frowned upon, but Frid was extremely practical. I simply said to him, "Look, I've got these things I can make, they satisfy the requirements for school, I can get paid for them."

When I went to RISD in 1977, I'd already made my living as a woodworker for seven years. After one year at graduate school, they offered

Day Bed, 1986. Maple and hand-painted silk, 72 x 24 x 24 in. (182.88 x 60.96 x 60.96 cm). Photograph: Ric Murray.

me a job as Frid's assistant and manager of the shop. At the time, Frid was the only faculty member and there was a shop manager who did everything from ordering the sandpaper to teaching. Working for Frid was very difficult and very rewarding at the same time. He was writing his first book and Rosanne [Somerson] was editing it. I edited number two and number three. I did a lot of teaching for him—ran the whole place. It was an unofficial teaching position. I was technically staff, not faculty. Quite honestly, Frid wasn't interested in teaching me or anybody anything at all, but in spite of himself, he taught us all a great deal. It was fantastic. What it did for me was that it validated what I had hoped I had learned by myself in seven years. My success there was largely because I was entirely self-motivated. If he didn't pay attention to me, I wasn't going to sit around and wait for him. I was on a mission.

I got my degree in 1980. I'd been now 10 years making my living. I came out of school with my master's degree and money in the bank. When Frid retired in 1980, I quit being the shop manager. I began teaching there the next fall and have taught there for the last 10 years. I go in one day a week and teach my course. I met you guys at that point, and you opened shortly thereafter. Suddenly there was a gallery and I was back in my studio full time.

Knowing now about Jere and Alphonse teaching Boston University's furniture program, do you think your work would have changed if you had elected to go there for a Certificate of Mastery?

I don't think it would have changed my work much. I would have gotten a little more support for what I was doing if I'd gone there. Tim Philbrick is really a kindred spirit in that respect. He has very similar interests and, although I can't speak for him, we share a lot of things about our work. He speaks so highly of John Kirk, and always has, that I know I would have been in heaven being around that kind of atmosphere. I would have really enjoyed Boston. I was not fully aware of art furniture. This was my mission, if you will.

What does that mean to you?

I'm not sure it means anything different than it did in 1972. I am trying to express something unique from within myself in a piece of

Fig. 49. *Skirt Table*, 1989. Cherry and silk charmeuse, 30 x 36 x 18 in. (76.20 x 91.44 x 45.72 cm). Photograph: Ric Murray.

furniture. That's the thing that distinguishes it from anything else. It's not better or worse, but the only reason for doing any of this is to get at what's inside you. Otherwise, every table has already been made, every chair has already been made. The only one that hasn't been made is the one that I do or you do. I've had a lot of time to think about this and talk about this over the years because this is very much what I teach. I spend all that time with my students and try to explain to them that it's the only reason to do anything.

Frid couldn't tolerate the fact that I was playing with the furniture and putting stuff on it. Yet I never was the sort who went to the other extreme and made it self-consciously artsy. If I had to describe my furniture, I would say that it's sensual sometimes, that it's comfortable sometimes, that it's traditional or historically referenced sometimes, but it's really about what I see as a basic issue of human existence—it's about how a person moves their body in space and how they interact with other objects. Furniture is about how the body sits on it or puts something on it. It would be the same for someone living in 2000 AD or 2000 BC. I find it not only fun but also appropriate and helpful to try in a somewhat scholarly way to research

Asymmetrical Chairs, 1988. Curly maple and cotton sateen, 34 x 22 x 20 in. (86.36 x 55.88 x 50.80 cm). Photograph: Ric Murray.

how other people have dealt with these kinds of issues over the years. If the work I do is sometimes kind of sexy, and it is intentionally so, that's because the idea of sensual quality is about as basic a human issue as there is.

Like *Skirt Table* [fig. 49, p. 200]?

Yes. It's pushing the idea of what a table is all about, it's pushing the idea of function, it's pushing the idea of gender, which is something that's always kind of appealed to me with my work.

What about *Versailles Table* [fig. 50]?

The first *Versailles Table* that I did was for your opening show in 1981. It has to be one of the most important pieces that I've ever done. The table is very carefully proportioned, but it's too tall by the amount of the pink plastic feet. The piece is intended to be tight and historical and under control, and yet it has plastic feet. I wanted to treat it with respect and not have it be just a joke. I think it worked.

Fig. 50. *Versailles Table*, 1982. Wenge, purpleheart, and epoxy resin, 24 x 16 in. diameter (60.96 x 40.64 cm). Photographs: Roger Birn.

There was another version of *Versailles Table,* with a white stone top and a gold rim. What were your considerations there?

I don't know how many we ultimately made of the *Versailles Tables*, 10 or more. I was playing with proportion as I went through the pieces. The relationship of the height to the width of that table in elevation is a golden section, but the feet stick outside that.

Cleavage Couch, 1988. Curly maple and silk, 36 x 64 x 32 in. (91.44 x 162.56 x 81.28 cm). Photograph: Ric Murray.

Small Cabinet, 1990. Bubinga and solid brass, 32 x 14 in. diameter (81.28 x 35.56 cm). Photograph: Warren Johnson.

Fig. 51. *Reading/Desk Chairs*, 1986. Ebonized imbuya, Lamous, and bubinga, 34 x 26 x 23 in. (86.36 x 66.04 x 58.42 cm). Hand-painted Lamous: Wendy Wahl. Photograph: Ric Murray.

Proportion is one of the ways to give ideas three-dimensional reality. Any piece of furniture is just a combination of details and parts, like a sentence is made up of all these little phrases and words. We've all heard the many analogies between music and architecture or design. You play a particular note, it evokes a particular emotional response. Play something in a minor key, it's different than playing it in a major key. Proportion is the same kind of detail. It controls where the eye goes and how you see parts in relation to one another.

In *Reading/Desk Chair* [fig. 51] that looks like an easy chair but is actually quite light and versatile—you play with perspective.

I'm glad you noticed that some effort goes into that exaggeration in proportion. You may recall that Peter Joseph commissioned those. It was not an easy commission. They were chairs to go with my Egyptian-style desk, which has trumpet-style legs, but Peter wanted saber legs on the chairs. I felt there was a real inconsistency there and it was a very difficult thing to pull off. I really agonized over that one.

The front legs curve forward. They're straight in the front view, but since I curved the front rail of the chair and faceted the leg, the legs appear to curve in two directions when, in fact, they only curve in one—the same for the back legs.

Bronze Table, 1993. Cast bronze and cast pâte-de-verre, 18 x 14 in. diameter (45.72 x 35.56 cm). Photograph: Ric Murray.

When we met in 1979, you said you wanted to take upholstery as far as it could go. How did you learn?

I would go out and try to find somebody to do it and admittedly in the beginning they were pretty schlocky. It wasn't until I was at RISD that I took some upholstery courses myself. It's a very tricky business. If you made five frames and brought them to five different upholsterers, you'd get five different chairs, even if you stayed there and watched them. We've gotten to the point where I pretty much by necessity have taught myself the thing inside out. I know what frame, what kind of structure I need to achieve what I want, and then I just say this is what I want. I'm sort of the upholstery guy. Nobody can challenge me in upholstery.

I approach chairs from a conceptual basis. To me, you cannot take a simpler approach to a chair than to define it as something to sit on.

Twin Cabinet, 1997. Cherry, 84 x 48 x 24 in. (213.36 x 121.92 x 60.96 cm). Photograph: Erik Gould.

It's where your butt goes that defines a chair. Everything else—arms, back—is secondary, and so I try to make the seat broad usually, and inviting as well, which is something you see in a seventeenth-century or eighteenth-century French chair. You have this broad seat that opens up in front. It's inviting, it's like open arms. Not only is it comfortable to park your behind on, but it looks comfortable—and that's the key.

We have often thought there are clients who ought not to commission work because they don't have the confidence to let go at a critical time. Similarly, there are makers who may not put forward their personal best in a commission situation. However, we've always regarded the proposal that Ron

Abramson presented to you in 1983 as one of the happier commission experiences.

The clock commission [see fig. 52]? That was an extraordinary experience. It really was.

And it's a good piece. What did he say to you?

He said, "Make me a clock." That was it. And I said, "I don't do clocks." He said, "I think you'd make a nice clock." And I said, "I'll think about it," and I proceeded to think about it for almost two years.

As I started to think about a clock, I necessarily began to think about time and as soon as I started to think about time, I got lost. If you've ever had occasion to do this yourself, the more you know about time, the less you know about time—it's not definable. We can talk about the ways to measure it, but we can't talk about what it is. I proceeded to get just completely lost. I couldn't draw anything, I couldn't build anything.

Finally, I decided just to pick some manifestation of time, nevermind about trying to define it. So I locked in on some numerology—the way we organize time. Most of us organize it in terms of twelves. Twelve works well on a number of levels: months, hours, the zodiac. From there, I could generate geometry.

Once I had the concept down, the form began to happen. The entire piece is made up of twelfths and elements thereof, with the predominant elements being three and four. There are three steps here and four steps there, and sometimes there are seven of something, because three and four are also seven. The entire piece, down to every little aspect, is a numerological exercise.

Fig. 52. *Grandmother Clock*, 1986. Paduak, wenge, and sand-blasted glass, 64 x 16 x 10 in. (162.56 x 40.64 x 25.40 cm). Photograph: Ric Murray.

Slipper Chairs, 1990. Purpleheart and silk; left: 26 x 28 x 24 in. (66.04 x 71.12 x 60.96 cm); right: 43 x 28 x 24 in. (109.22 x 71.12 x 60.96 cm). Photograph: Michael Galatis.

That clock is one of our favorite Dunnigan pieces. But we don't sense that you're as close to it.

Well, I had been thinking and thinking about this piece for so long, and in the process of thinking I had a conversation with Wendell [Castle] about clocks. And before I finished my one little clock, Wendell had started and generated and exhibited 13 major clocks. That sort of made my piece less important—although I love my clock and I think it stands up well to any of Wendell's. Another thing was that after all this labor, I delivered the piece to Ron and he said, "Wow, I thought you were making me a mantel clock." I think he likes it now.

It seems you sometimes work by pushing your pieces close to the edge.

I've never tried to make jokes with furniture, but I've occasionally tried to go just a little bit beyond the bounds of good taste. The plastic ring on the *Pylon Table* [see fig. 53, p. 207] is an example. The very first piece that you had, the upholstered boudoir chair, had three colors of pink velvet on it. I thought that was just a little bit tacky, but I also liked it. It wasn't a joke, but

Bonheur du Jour Desk, 2001. Pearwood, madrone burl, and leather, 44 x 32 x 18 in. (111.76 x 81.28 x 45.72 cm). Photograph: Erik Gould.

Fig. 53. *Pylon Table*, 1984. Ebonized mahogany, maple, and plastic, 16 x 52 x 16 in. (40.64 x 132.08 x 40.64 cm). Photograph: Warren Johnson.

Fig. 54. *Settee*, 1990. Curly maple and cotton damask, 36 x 64 x 32 in. (91.44 x 162.56 x 81.28 cm). Photograph: Ric Murray.

I was pushing the bounds of taste. No one was doing that at the time.

I think the asymmetrical work is symptomatic of my wanting to move away from what I've been doing and get a little less controlled. The asymmetrical stuff is not easy to do; a lot of work just wants to be symmetrical. I've been working on a daybed and I want the thing to be asymmetrical, but it just won't work. I have to make both ends the same.

In my asymmetrical chairs and couches with one big hump and one little one [fig. 54], the cleft is a real important detail—it's intended to be pure sensuality, unabashed cleavage. It also has a nice historical reference to a camelback sofa, so it works in a dual way. I have a pretty good grasp on classical forms and what classicism is about. I don't ever want to abandon that. I like those forms, but I think I can use them in new ways.

I'm in my 21st year, and I feel like I'm just beginning. I feel very fresh about the whole thing, although I'm exhausted from the business and from the pressures. I love woodworking and it's a real problem for me that I don't get to do enough. I hope to be able to do a little more. The last 10 years have been a decade more and more about running the business rather than making the work. There's enormous satisfaction in that and somebody's got to do it—and I'm the only one that can. So it's become a luxury for me to get in the shop and build. But it's a luxury that I love.

West Kingston, Rhode Island
February 1991

Table and Chair, 2006. Mahogany, cotton, and viscose; table: 30 x 48 x 22 in. (76.20 x 121.92 x 55.88); chair: 34 x 21 x 21 in. (86.36 x 53.34 x 53.34 cm). Photograph: Erik Gould.

AFTERWORD

At the time of your interview in 1991, I had already been working for almost 21 years; from today's vantage point, that is a chronological midpoint of my career. In 1991, I was enjoying a long stretch of success with my work and was trying very hard to take advantage of the opportunities that came my way. I was very focused on meeting demand and I don't think it was a stage of my life where I had as much time to be reflective as I had in other periods both before and after that year. Now I'm probably more aware of a larger context in which my work developed.

Through the 1980s, I felt it was important to comment on the state of the art, which I felt was a little parochial, by pushing the boundaries a bit. This is only natural. I did this by making work that was very decorative and full of historical references. It wasn't all wood. It wasn't modern. It was well crafted but it wasn't very crafty. As a result of this and also of my interest in making comfortable furniture, I invested a good amount of time in designing upholstered furniture. I'm still interested in the rich history of furniture and in the social life of furniture, though my current interests are aesthetically simpler than they were 20 years ago.

From a business perspective, I have changed the way I work a little. Where I always trained and employed full-time assistants in my shop, I prefer to work mostly alone now and rely on a network of colleagues for outside help when I need it. Twenty years ago, I still worked full time in my studio and part time at RISD, but that pattern changed in 1995 when I started teaching full time.

In 2004, I had an opportunity to pursue a long-term interest in designing furniture for a larger audience. Along with my RISD colleagues Rosanne Somerson and Peter Walker, I started a company called DEZCO Furniture Design. While Peter, Rosanne, and I all continue to pursue our separate studio practices, we came together to create a partnership through which we designed a line of furniture for mass production that was innovative, green, and affordable. DEZCO is dedicated to modeling responsible business practices in furniture design.

From a process perspective, my way of working—that is to say my way of conceptualizing, designing, and producing my work—hasn't changed much. I still care just as much about quality in materials and construction. I still enjoy the whole process of producing something that will be useful for someone else and might develop meaning for them as they build associations with it over time. I still care that the objects are accessible and durable and enjoyable. My eyesight is much worse now, but I hope my vision is better.

West Kingston, Rhode Island
September 2011

1. Oscar Tusquets Blanca, Nonie Niesewand, and Carrie Haines, eds., *International Design Yearbook Five* (New York: Abbeville Press, 1989); Patricia Conway, *Art for Everyday: The New Craft Movement* (New York: Clarkson Potter Publishers, 1990); Edward S. Cooke, Jr., *New American Furniture: The Second Generation of Studio Furnituremakers* (Boston: MFA Publications, 1989); Edward S. Cooke, Jr., Gerald W. R. Ward, and Kelly H. L'Ecuyer, *The Maker's Hand: American Studio Furniture, 1940–1990* (Boston: MFA Publications, 2003); and Nancy Berliner and Edward S. Cooke, Jr., *Inspired by China: Contemporary Furnituremakers Explore Chinese Traditions* (Salem MA: Peabody Essex Museum, 2006).
2. Tage Frid, *Tage Frid Teaches Woodworking*, bks. 2 and 3 (Newtown, CT: Taunton Press, 1980 and 1982).

WENDY MARUYAMA

b. La Junta, Colorado, 1952

Wendy Maruyama exerts a powerful influence both as a maker and a teacher, and she plays the role of the provocateur in both cases. Despite spending eight years in various university furniture programs "learning to do things the right way," Maruyama has, during her entire career, resisted doing the expected. "What can I do with my furniture to make it mine?" she asks. Her answers have often taken her into territory more familiar to the artist than the furniture maker. However, along the way, she has provided the studio furniture field with some of its most iconic works. She has also inspired and directed a new generation of artistically inclined furniture makers as head of San Diego State University's Furniture Design program.

Wendy Maruyama was born in La Junta, Colorado, in 1952. She received her bachelor of fine arts from San Diego State University in 1975; a Certificate of Mastery from Boston University's Program in Artisanry in 1978; and a master of fine arts from the Rochester Institute of Technology in 1980. Currently, Maruyama is a professor and head of the Furniture Design/Woodworking program at San Diego State University, where she has taught since 1989. Previously, she headed the woodworking and furniture programs at the California College of Arts and Crafts, Oakland, California, from 1985 to 1989. She also taught and eventually headed the woodworking program at the Appalachian Center for Crafts, Smithville, Tennessee, from 1980 to 1985.

Maruyama has lectured and taught workshops throughout the world, with stints at Tokyo University of the Arts, Japan; Penland School of Crafts, Penland, North Carolina; and Haystack Mountain School of Crafts, Deer Isle, Maine. She has been artist-in-residence at Buckinghamshire College, High Wycombe, England; La Napoule Art Foundation, La Napoule, France; Boston University, Boston; Carnegie Mellon University, Pittsburgh; and Artpark, Lewiston, New York.

She has received three National Endowment for the Arts fellowships, The Furniture Society's Award of Distinction (2008), and the Aileen Osborn Webb Award from the American Craft Council (2009). Other awards include a Japan–United States Friendship Commission residency grant; and a Fulbright lecture and research residency grant. Maruyama has served as a curator or juror on numerous occasions. She has also served on the boards of the James Renwick Alliance, Washington, DC; Haystack Mountain School of Crafts, Deer Isle, Maine; and The Furniture Society, Asheville, North Carolina.

Maruyama's work is found in many public collections including the Queen Victoria Museum and Art Gallery in Launceston, Australia; the Victoria and Albert Museum, London; the Tennessee State Museum, Nashville; the Philadelphia Museum of Art, Philadelphia; the Museum of Arts and Design, New York City; the Mint Museum of Craft + Design, Charlotte, North Carolina; Oakland Museum of California; Mingei International Museum, San Diego, California; and ASU Art Museum, Arizona State University, Tempe.

In addition to extensive traveling and teaching, Maruyama devotes her considerable energies to two currents of artistic endeavor: The Tag Project, a community-based art project for which she is re-creating 120,000 identification tags representing the 1942–1946 wartime internment of Japanese-Americans in the United States; and E.O. 9066 (Executive Order) that incorporates both work made by Maruyama as well as actual archival objects belonging to the Japanese American Historical Society of San Diego.

She and her husband, Bill, and their two dogs live in San Diego, California.

My father was born and raised in Colorado. His father came from Japan when he was a young man, alone, through Seattle, and worked on the railroad. He ended up somehow in Colorado as a farmer. There were no women in Colorado at that time, Japanese women, so he ordered a wife through the mail. A mail order or picture bride, they called them. My grandmother wrote a couple of letters to my grandfather from Japan and they decided that they would get married, and so he brought her over. They'd never even met beforehand. My mom's father came over when he was a young boy; he was a houseboy for a family. He was a highly educated guy, went to college, and became a very successful businessman in San Pedro, which is a fishing town. He had a fishing business, wholesale fish; his bride, my grandmother, was a seamstress. They actually met in this country. He came at 16; she came later. They met, they married, and their family lived in San Pedro.

Then World War II broke out; they were all in church when they heard about it. My mother remembers being put into a cage after Sunday school because they were Japanese. They put the kids in cages and held them there until the mothers claimed the kids, like a dog pound. Then they were told to leave the state. You either went into camp or you got the hell out of California. You dropped everything you owned and left. That's what they did—they left everything they owned, their house, their business, their piano, everything. They lived in a tent in Utah for a while. To make a long story short, they eventually ended up in Colorado. They had to start over again. I think my grandfather ran a seedy hotel in Denver.

My parents met in Colorado and married; I was born in La Junta, Colorado, and then the family later settled in California. My father was a farmer in Hemet, a small agricultural town outside of San Diego County, where he raised vegetables on his plot of land. He also worked as a laborer from time to time. That's how we learned to speak Spanish and that's where we developed a love for Mexican food. My mother was also from time to time a laborer. I remember going out to the fields with her to pick strawberries.

One of the reasons my parents moved to California was that I was born with a hearing impediment. They knew the speech and hearing therapists were better in the public schools in California. I remember getting speech therapy in Hemet, but they said, "You should move to San Diego County because they have a much more advanced program." So we moved to Chula Vista when I was 8 and my father became a produce manager at a grocery store. Later, they had their own little mom-and-pop type of store where they sold produce and Japanese food. I went to a great public school. My parents believed in mainstreaming. You could choose to go to a school for the deaf where everybody else is deaf or hearing impaired, but my parents chose instead to send me to a school that promoted mainstreaming, so that you would communicate mostly with hearing people and try to develop skills like speech, which I'm thankful for. Otherwise, I would have been isolated. I would have been in some sign language class in some place and never would have done my work, probably. So my friends were mostly hearing people.

Because of my hearing problem, I didn't do so great in academics, but art classes were always the best things. I couldn't wait until it was time to make clay dinosaurs and stuff. Drawing and painting were very important

Angry Asian Women Cabinet, 2005 (detail; see p. 224).

at a very early age. Then, I remember my first experience with wood. I was in fifth-grade camp. It was a very stupid project. What you did was you went out into the woods and tried to find a piece of wood and then you sanded it and then you oiled it and that was it. It was a stupid project but I got a big kick out of it. That was my first wood experience. By the time I got to college, I started to worry what my future was going to be, but I knew it was going to be art of some sort. I also knew from high school that crafts were really special.

How did you know that?

Well, we had a ceramics project where we could make anything we wanted. I wanted to make functional ceramics, so I made my first pitcher out of clay. It wasn't a very big art program. Most of the kids who took art were delinquents, throwing the clay around all over the place. This is in southern California, a border town. I was the only one who was actually making anything out of clay. I was such a good kid in high school—I was well behaved and did my little projects.

Southwestern Junior College had a great introductory craft program. I thought ceramics was my favorite thing, but then the teacher had just had a child and she made a cradle for her son. She brought the cradle into the shop to show us and it was really interesting. I thought, 'A woman was working in wood,' and that was very important. Japanese-American families are usually very patriarchal, very conservative, and traditional—in the 1950s era, the men did this and the women did that. You couldn't wear pants to school. In high school, you couldn't take shop classes; you had to take homemaking or sewing. I loved my sewing class by the way.

How did you get from sewing to woodworking?

I made my first chair in the craft class in junior college. This is in the 1970s. Everything is very organic—even the jewelry, the ceramics, and the textiles were organic. I just made this three-legged chair and slung a leather seat on it and stuck a wishbone type of thing on it. The back of the chair was like a T and the leather slung down to the two front legs. I was pretty impressed with myself. I remember the excitement of doing the wood project that I thought was only for men. That was half the excitement—doing something that I thought was reserved for men—kind of stupid, but it's true.

What were your interests at this point?

I became interested in doing more furniture. By the time I finished Southwestern, Joanne, who was my teacher, said that there was a furniture

Lamp, 1971. Teak, 20 x 16 x 16 in. (50.80 x 40.64 x 40.64 cm). Photograph: Wendy Maruyama.

214

Blanket Chest, 1976. Walnut, ebony, and leather, 20 x 40 x 18 in. (50.80 x 101.60 x 45.72 cm). Photograph: Neil Hoffman.

program at San Diego State. Actually, in junior college I majored in two things. Initially, I thought I was going to be a jeweler and I took a lot of metalworking classes. Even when I made that one chair, I thought that jewelry was going to be my main field. Of course, San Diego State had a very well-known metalworking program that Arline Fisch headed—you're talking about a faculty totally dominated by female teachers. Anyway, I went to San Diego State, studied with Arline, who was a very strong figure, very intimidating, very active in the American Craft Council. She was constantly flying to foreign countries, representing jewelry and all this stuff. This being San Diego, it was kind of a big deal. I remember I wanted to be just like her. After one year at San Diego State, I became real interested in furniture. I realized that furniture was much more unique. Metalworking was fun and interesting, but the scale wasn't of interest to me anymore, working on a tabletop. Making a tabletop was more exciting to me—working

large. That was one of the reasons I steered toward furniture. Larry Hunter was my teacher; he introduced me to the book *Fantasy Furniture*.[1] You know that *Fantasy Furniture* book that Tommy Simpson put out in 1968? That book did it for me. That's what I wanted to do. It had pieces by Wendell [Castle], which impressed me. It had pieces that were made of other materials, which interested me. It's funny because when I talk to my friends back East, like the Boston University crowd, a lot of them didn't respond to that book. A lot of them were more interested in the process, making a mortise and making a tenon, planing that wood and sanding it, whereas my interest comes from the final form, the shape, the surfaces, and that sort of thing.

The functional part was the initial interest. You could make something and make it usable. But here was furniture that didn't really look like furniture. All of a sudden, the function was hidden, so it wasn't obvious that you could sit on this thing. That brought a whole new perspective for me in terms of object making.

Larry Hunter was a little nonconventional. I mean, he was a hippie. He used to wear beaded necklaces and bright Mexican shirts and sandals and had hair down to here. It was reflective of the times. His furniture was very organic and his methods of construction were very primitive. That first chair was screwed together. Screwed and half-lapped, half-lapped, screwed, and then a dowel cap put over the screws. After I studied with Larry, I advanced from screws to dowels. That was a big advancement. Stack laminated—everything was stack laminated when I was going to San Diego State—two-and-a-half years of that. At that point, I started thinking about graduate school, mostly because I wasn't ready to leave school yet. I wrote a letter to Wendell Castle

because he was teaching at SUNY Brockport. He recommended Virginia Commonwealth University [VCU] and said, "Why don't you look up Alphonse Mattia?" I had never heard of Alphonse. The East Coast was a whole vast, strange land—I didn't know anybody there from Adam.

So I decided to study at VCU. I never thought I would ever go to Richmond, Virginia of all places. It was terrifying. It was tough. It was terrible. It was the first time out of California. I have to admit I was pretty unhappy there. Not because of Alphonse so much, but the place was so old and depressing. The shop wasn't what I had hoped it would be. It was a basement shop, old and dusty and everything was strange. All the benches were beat up and the grad students were put in this small room in the back. It was January, too; I had waited an extra semester to find a new school. I always tell my students: "Never enter a program in mid-year because all of the bonding happens in the fall, and then you show up and you're odd man out."

Alphonse would go on to become one of the most influential teachers of studio furniture, so you lucked out when you met him at VCU, right?

Alphonse was great. We got along fine, but during the first two weeks of school, I realized I didn't know anything about woodworking—nothing. He would say, "What have you done at San Diego State? Welcome to Virginia." And I said, "Stack lamination." And he goes, "And?" And I said, "That's it." And he goes, "What kind of joinery have you used?" and I said, "Dowels." I was trying to be very energetic and sound very experienced and I quickly realized that I knew nothing. And he goes, "Well, have you ever done dovetails before?" and I said, "What are dovetails?" And he said, "That's a

Maruyama in BU's Program in Artisanry woodshop, 1978. Photograph: Jon Peterson.

Fig. 55. *Salami Tray*, 1980. Painted poplar, 6 x 18 x 4 in. (15.24 x 45.72 x 10.16 cm). Photograph: Wendy Maruyama.

project the freshmen do here."

So my first assignment was to do a dovetail box, which was very flat, very square. It was very difficult for me to design a piece using those techniques because the forms I had been using were very bulbous and round. I struggled with that for the longest time and that had a terrible effect on me because I realized that your virtuosity was measured in your ability to cut dovetails. You were no good until you could cut dovetails and I couldn't cut them. To this day, I get paranoid when I put dovetails into a piece. After 10 years of giving demos, I still work up a sweat before I have to do a dovetail. And then he said, "Have you ever done a mortise and tenon?" And I said, "No, what's a mortise and tenon? Gee, I guess you're going to have to show me how to do that, too." So I did a chair, the most God-awful, the ugliest chair you've ever seen with the mortise and tenon joint. I gave

it away a long time ago. And I had never done lamination before, bent lamination. Then he said, "Have you ever done finger joints?" And I said, "No, I've never done finger joints."

I did a lot of things in that one semester, but all the pieces I made were a failure design-wise. They just weren't fitting, like putting a round peg in a square hole. And then it got pretty traumatic because Alphonse had decided to leave VCU.

He said, "Well, I'm leaving and you have the option of coming to BU. It's a great program but there is no MFA program there." And obviously, I wasn't qualified to be a Certificate of Mastery [C of M] student. It was kind of a blow to my ego that, all of a sudden, I was down to ground zero. I was upset because I had come all this way. I talked to my parents who were also pretty upset. "Are you going to spend more money on tuition and not even get an MFA? You're going to school where? For how much and how long?" But I knew I had to do it.

How did you know that Boston would be right for you?

I just knew. Jere was there, Dan had left. Jere reminded me of my craft teacher from high school, kind of quiet, very shy. He was a very strong person as an artist or craftsperson. The difficulty was that he mumbled and I couldn't understand what he was saying because of my hearing problem. I thought, "Oh my God, this is going to be tough." But Jere was great because he simplified woodworking quite a bit. He was able to explain things and make a lot of sense. What was perfect for BU was that Alphonse was the person you spoke to about design and criticism, and Jere was the guy from who you learned how to transform ideas onto paper and to make them out of wood. It was the perfect combination of people. Of course, I

James Schriber, *Wooden Toilet Plunger*, 1975. Cherry, walnut, and rubber, 30 x 6 in. diameter (76.20 x 15.24 cm). Photograph: James Schriber.

didn't understand what the big deal was about Jere until much later. You have to understand woodworking to understand what made this person the way he is. Most people who came to BU came because they had this profound love for the material and this profound interest in traditional techniques. Look at Bruce [Beeken] and Tim [Philbrick]. Maybe James [Schriber] was an exception. James was the only one who understood what my background was like because he studied with Dan Jackson, and his work was a little more sculptural in the early days. I mean, my God, he made a toilet plunger in undergraduate school! I can relate to James on that level—a wooden toilet plunger is kind of neat.

Boston was more welcoming than Richmond. The studio was much more impressive, and gee, all those guys were so cute! I

Bruce Beeken, Tim Philbrick, and Alphonse Mattia at Boston University, 1978. Photograph: Jon Peterson.

mean have you ever seen so many cute guys in one shop? That was overwhelming. But other than that, there was definitely this separation. The C of M guys were over there, with the exception of Tom Hucker, and then I was in this other room. That wasn't a big deal for me because they knew all this stuff and I didn't. So the competition was never a problem for me, although I saw it everywhere at BU amongst the other students. They were like a bunch of dogs, you know what I mean, marking their territory and lifting their legs everywhere. From a female point of view, it was pretty juvenile. The guys were terrible to each other at times. I think Tom went through a lot of hard times. Michael [Hurwitz] was also in that room. We became pretty good friends and, because he's such a friendly, likeable guy, I got to know everybody else through him. I was kept busy learning how to do things "the right way" at BU. I did all the required things. I did double tenons and tapered lamination. I did all those assignments, the carcass pieces. Jere made carcass construction very simple, very uncomplicated. To this day,

carcass pieces are my favorite kind of pieces to make, mostly because it gives me a lot of material to decorate after they've been made. I also like the idea of making this hollow form and putting these little interior structures inside. That became fun for me, but nothing happened with the work I was doing. Looking back on it now, I was doing work to please that group. Boston is such a proper kind of place. Furniture making on the East Coast was such a cut and dried, proper sort of thing. You don't think of it that way any more, but you have to remember 15 years ago it was a very conservative atmosphere—very conservative. I felt a little bit lost for a while.

I knew I wanted to make furniture, but I kept thinking, 'What can I do to my furniture to make it mine?' because I was looking at the thing I had made and it looked just like a BU product. I've got to do something different, but first I'd decided that I wanted to get my MFA and try to teach. That's always been a goal for me, but sometimes I wonder, 'How could I teach class? How could I project myself to students,

Fig. 56. *Writing Desk*, 1980. Maple, crayon, epoxy resin, and Plexiglas, 30 x 78 x 18 in. (76.20 x 198.12 x 45.72 cm). Photographs: Rochester Institute of Technology.

being that I'm hard of hearing and speech impaired?' But I wanted to try and you don't know until you try.

Between VCU and BU, I had taken a summer workshop at Penland where I met Bill Keyser. Bill said, "We have an MFA program. When you're ready, you might want to consider coming to our school for your master's." He also told me about this program for the hearing impaired and deaf, the National Technical Institute for the Deaf [NTID], and said that you can get funded. You can still go to school at RIT, but you would be supported by NTID and, plus, you would get special support services from that program.

I know that I would have flunked if I had gone to RIT first. I would have suffered tremendously. It was important for me to have gone to BU. So I went to RIT for graduate school. I finally decided to do that and, God, I hated it so much. It was mostly because, maybe it was me, but they were so conservative. If you thought BU was conservative, RIT was extremely conservative, plus it was a "good old boys" network. You didn't see a whole lot of innovation coming out of there. The great part about RIT was that I hated it so much and rebelled against it so much that it actually helped me to develop the experimental work. That's when I did *Writing Desk* [fig. 56] and that's when I started doing my trays and colored work [see fig. 55, p. 216]. Sometimes when you get emotionally charged, whether its negative or positive, I think you benefit from the energy that comes from that. I was also searching, trying to shake off BU.

Describe *Writing Desk*.

It was a very asymmetrical piece. It had two different sets of legs; one was tapered and traditional, the other set was two very heavy slabs of wood that supported the end. The top was a tapered triangular top. It had tenons, but the tenons were filled in with epoxy at the very last eighth of an inch so there was bright red epoxy coming through the top. Now it sounds like a very tame piece. This was the one with the crayon marks. I decided that it needed some decoration. With the maple top something was missing, some gesture. The form was very rigid, very angular, there was something needed to loosen it up a little bit. So I took a green crayon and scribbled a mark across the top. Because it was a *writing desk*, I wanted to emphasize that fact. Mostly it just needed a little bit of color there. I had no idea that people were going to be so upset by it.

Wasn't it compared to Garry [Knox Bennett] driving the 16p nail into the padauk cabinet [fig. 57]?

It upsets me when the two are compared because what Garry did was very different in philosophy than what I did. I was not seeking to destroy the piece. I was not really thumbing my nose at technique and beauty and workmanship. That's what the difference is. I find that a destructive act and mine wasn't intended to be destructive at all. It disturbed me that we were both on the back page of *Fine Woodworking*. The letters to the editor were pretty cruel.

It was perceived as a desecration of the material?

Exactly—it was a very unholy, awful thing to do. If you can get people that upset over such a simple little thing, it showed you what the woodworking field was like. It was so overly sensitive and so resistant to change. It's better now, but there are some individuals who I can think of who have a hard time with people trying out different things.

Fig. 57. Garry Knox Bennett, *Nail Cabinet*, 1979. Padauk, glass, lamp parts, and copper, 74 x 24 x 17 in. (187.96 x 60.96 x 43.18 cm). Photograph: Unknown.

What was your reaction to the furor *Writing Desk* caused?

It made me want to do more. Let's get more people upset. But now I was upset because they misunderstood the concept completely. They completely missed it. To me, it wasn't any different than somebody applying a glaze to a ceramic pot or painting on fabric. I saw that as being equivalent as a form of finishing the piece. That was 1980.

Fig. 58. *Bench*, 1981. Padauk, 18 x 58 x 20 in. (45.72 x 147.32 x 50.80 cm). Photograph: Rochester Institute of Technology.

That's when we first met you.

I remember meeting you in the fall and thinking to myself, 'What kind of slides should I show these people? Should I show them the new colored stuff or do I show them the wood stuff? Well, I think I'd better show them the wood stuff so they'll accept me.' Of course, you were totally impressed.

That's right. We had your padauk bench [fig. 58] in our opening show in 1981 and then the infamous *Writing Desk* the next year.

My circle of friends at RIT was not from the furniture program—they were printmakers and painters and ceramic artists. They were the ones that encouraged the use of color. If you remember, in the late 1970s and early 1980s, that's when color became a very important element. They didn't think in terms of woodworking. So when I used to get feedback, it had nothing to do with joinery or thickness of material or types of wood, it was mostly about shapes and colors and forms. That was important to me. We just didn't talk about those kinds of things in furniture making at BU and at RIT.

Bill Keyser had a poster on his office wall. Bill, of all people. I said, "Bill, what is this? What's this all about?" I think it was called "Studio Alchemia" then. It was a Milanese group and it eventually became "Memphis." I was really curious about it. I remember there were some interesting shapes on the poster that were different. At the time, it was the form, not color, that was different. After I left school and got the job teaching in Tennessee, I saw a bunch of magazines and all of a sudden *Progressive Architecture* had an article on this new furniture. I thought, 'Gee, this is what I've been looking for all this time.' I became totally aware of the new Italian design movement called Memphis and I remember Tim Philbrick hated Memphis. He was just up in arms about all the press that Memphis was getting. At the same time, I was just so happy because finally there was this new stuff that was getting some visibility and that made me feel less restrained, and I started to do the work I have been doing.

The forms became simpler, but the color started to dominate the forms. I activated the surfaces with the painted surface. Furniture tends to be very static at times and I think the color gives it a sense of movement that we were never able to experience before other than by using very highly figured wood.

Of course, it got a bit clichéd after a while but then, it was intended to. The people from Memphis always said that this is going to be out of style pretty soon and we don't intend for this to be going on forever. This was supposed to represent a certain time and place, which is important to remember because I think people are so concerned about doing work that's going to last. People think that it's important for their work to last forever and ever, when in fact things that we make or do are significant at the time in which they are produced, like hairstyles, and the way we dress, and the kind of cars we drive. The show I did at P&E in 1982 with Ed Zucca was the first group of pieces coming out of grad school and the first work that I really felt belonged to me.

That was an exuberant show of work. It included *Mickey MacIntosh Chair* [fig. 59] as well as the glass-seat chairs [see fig. 60, p. 223]. We didn't sell any of your work, though. How did you feel about that?

I have to admit I was disappointed, but I think the thrill of showing was stronger than the disappointment. Nowadays, I get very disappointed if I don't sell anything. I get really mad. Then I was disappointed but, at the same time, I began to realize why I wasn't selling. I saw everything else that you were showing in the gallery with those little red dots. I saw that.

Fig. 59. *Mickey MacIntosh Chair*, 1980. Wood and paint, 60 x 18 x 18 in. (152.40 x 45.72 x 45.72 cm). Photograph: Michael James Slattery.

Fig. 60. *Primary Chairs*, 1982. Maple, acrylic enamel, and glass, 35 x 20 x 18 in. (88.90 x 50.80 x 45.72 cm). Photograph: Tennessee Tech University.

I-15 to Vegas, 1982. Plywood, enamel, and neon, 18 x 8 x 8 in. (45.72 x 20.32 x 20.32 cm). Photograph: Cary Okazaki.

Chair, collaboration with Hank Murta Adams, 1982. Wood, cast glass, and paint, 34 x 18 x 18 in. (86.36 x 45.72 x 45.72 cm). Photograph: Hank Murta Adams.

Actually, Wendy, we don't recall many red dots in those days. Anyway, how did you get to Tennessee?

Well, from Tom [Hucker] of all people. I was teaching a workshop in Vail, Colorado, and I get this phone call from Tom who said, "Hey, would you like to be my assistant?" I said, "Your assistant?" Well, he had been offered this job at this new school in Smithville, Tennessee—the Appalachian Center for Crafts, as the Master Craftsperson. He needed a studio manager. Because Tom and I had worked side by side at BU, we sort of had a friendship based on

Vanity, 2006. Pau ferro, mixed media, and video, 42 x 16 x 16 in. (106.68 x 40.64 x 40.64 cm). Photograph: Andrew Dean Powell.

Angry Asian Women Cabinet, 2005. Polychromed mahogany, quarter-sawn white oak, laser-etched stainless steel, glass, digital images, and figurines, 64 x 25 x 20 in. (162.56 x 63.50 x 50.80 cm). Photograph: Larry Stanley.

Fig. 61. *Armory Neon Piece*, 1989. Basswood, plywood, neon, satinwood, 65 x 30 x 18 in. (165.10 x 76.20 x 45.72 cm). Photograph: Cary Okazaki.

working next to each other. I was really afraid. I didn't want to go back to the South ever again, but he convinced me to try it, and since I didn't have anything to lose, I did. It turned out to be a great experience, really one of the best five years I've ever had. First of all, everybody was new and there was this little community placed on a hill. We had a great shop.

Were all craft media represented?

Yes, it was glass, ceramics, textiles, wood, and metal. The way it worked out is that Tom would teach two classes and I would teach one beginning class. But we only had six students at that point, so I decided to get on the horn and try to recruit more students. I couldn't recruit for Tom

Urban Amazon, 1989. Carved and polychromed basswood, 70 x 24 x 20 in. (177.80 x 60.96 x 50.80 cm). Photograph: Cary Okazaki.

because his class was for a very special kind of student. I really worked my butt off to get students to come. Of course, I had a tendency to draw from fine arts programs as opposed to woodshops—Chicago's Art Institute, Memphis School of Art, all these specialized programs.

Six students sounds almost ideal.

I don't think it's enough. The energy is just not there with six students. I think 12 to 15 is ideal. Anyway, Tom left Memphis after a couple of years. We got rid of the title of Master Craftsperson and I became the head of the department. I stayed there for three more years. I experimented with other materials and with the process of decorating the surface because, all of a sudden, it was okay to do it. I was suddenly free to do whatever I wanted. So I took that *Writing Desk* piece a little further by doing more epoxy resin inlays and painted surfaces. I was still definitely teaching myself, being a student with myself being the teacher more or less. I wasn't committed to one idea yet. I tried to do the work long enough to feel good about it. I wanted to experiment. Collaboration was another aspect that helped me look at the material and to look at furniture through another pair of eyes. Hank Murta Adams was a resident artist in glass in Tennessee. What was nice about collaboration was that you're dealing with two completely opposite materials and two completely different processes. Glass is hot and molten and, in some ways, very unstable, and then you have wood. I can't think of a way to describe it—just wood. You just cut it up and you fabricate it. We used glass in a very unconventional way. Glass is usually smooth and sexy and clean, but we used it in a very thick, rough, textured kind of state. We cast it in sand and made little indentations in the mold so the glass stuck out. We drilled holes into it and epoxied it together. We fabricated glass parts just like

Peking, 1994. Painted mahogany and gold leaf, 38 x 22 x 9 in. (96.52 x 55.88 x 22.86 cm). Photograph: Cary Okazaki.

we would a piece of wood. I think it's difficult to collaborate with a strong-headed artist if you are pretty strong headed yourself, but it was a very nice process dealing with another person and listening to other ideas in combination with your own. Some strong work came out of it. Also, I think it was the first time, other than glass-topped tables, where a glass piece was integral to a wood form.

It seems that you're constantly testing in your work—communicating ideas that people don't have sentences for yet.

I have to tell you about the time between

Fig. 62. *White Sideboard*, 1983. Bleached mahogany, 38 x 60 x 18 in. (96.52 x 152.40 x 45.72 cm). Photograph: Cary Okazaki.

Credenza, 1990. Carved and polychromed poplar, 36 x 44 x 18 in. (91.44 x 111.76 x 45.72 cm). Photograph: Cary Okazaki.

Tennessee and San Diego. I was going through a period where I was getting sick of everybody painting everything. So I did nothing but white pieces for almost a year. I also started to change the form—they were organic again. Instead of painting them, I bleached them white or whitewashed the form. They were mostly carved and some constructed forms. I did a sideboard that was all white [fig. 62], but it had a lot of textured surfaces, so even though it was all white you got a sense of different colors because of the way the light touches the piece. That was a nice experience, but I missed the colors enough to abandon the white series and go back into painting.

It's difficult to imagine your work without color.

There is a series that I did with neon, which was just an excuse to work with light and color. They were pretty simple uses of neon—the tube just stuck out of the wooden form. The piece I did for the 1989 New York Armory show was a double large cabinet where all of the neon stuff was hidden between two walls and the tubes come out momentarily and then go back into the case and come back out [see fig. 61, p. 225]. They became sort of a gestural

Fig. 63. *High Chest*, 1989. Mahogany, maple, basswood, copper leaf, and casein paint, 75 x 34 x 16 in. (190.50 x 86.36 x
Photograph: Museum of Fine Arts, Boston.

element to the outside of the case, which was very straightforward and static, but it had these organic forms supporting it. Those pieces are significant to me. I began them in 1986 and they grew bigger and bigger. You can see it in the 1989 MFA Boston piece [fig. 63], those pod shapes on the side. The case started to grow with the pods and then the pods had to catch up. I'm still doing pieces with the leaflike forms supporting a small case, like those boxes. So maybe I've found something I want to commit to for a little bit. It feels like my own. It doesn't feel like somebody else's idea.

Work does a lot of things for me. It

communicates for me. I can't express myself very well—I use the work to express who I am. While growing up, drawing and painting and working with my hands was the best way I could communicate. I felt the most secure about it. Even to this day, I don't feel that secure about the way I sound, so the work kind of makes up for that. Maybe it's just my way of avoiding dealing with it—that's probably a more honest reason—so that I don't have to face the world, the work has to go out there and face it for me.

East Hampton, New York
March 1991

Kanzashi Hair Ornament, 2009. Carved, painted jelutong and paper, 55 x 20 x 2 in. (139.70 x 50.80 x 5.08 cm). Photograph: Larry Stanley.

Hinamatsuri, 2011. Wood, tar paper, glass, and doll, 24 x 30 x 2 (60.96 x 76.20 x 5.08 cm). For the traveling exhibition *The Tag Project/ Executive Order 9066*, originating at the University Art Gallery, San Diego State University, CA, 2011. Photograph: David Harrison.

AFTERWORD

My way of working has generally stayed the same. The work migrated stylistically, so there were some technical changes—heavy-duty carving with Arbortech wood-carving tools, textures, paints. I still enjoy the carcass work, which definitely comes from studying with Jere Osgood—I learned much about that type of construction through him. In the early days, I moved around quite a bit, and the work was informed by my location, the friends I had, the work they did, etc. I would definitely say that the scale of my work has changed to accommodate my own physical limitations. Building tea houses and pieces that require 8 foot by 4 foot by 4 foot crates is most definitely out of the question. Working on a smaller scale feels safer to me and I like being more independent, not having to call some strong 20-something over from the university to help me move something all the time.

For me, furniture was always intended to be a vehicle for creative expression. Working with Larry Hunter played a large role in defining what intentions my furniture would have. His woodworking class was part of San Diego State's School of Art, not an industrial technology department. This orientation would remain a priority for me. Even during the days when I struggled to learn traditional woodworking techniques from Jere, Alphonse Mattia, and Bill Keyser, it was really important for me to have a certain degree of experimentation and expression in the work. As I mentioned, all the places I lived—from San Diego to Virginia to Boston to Rochester, and then from Tennessee to the Bay Area and, finally, to San Diego again—certainly have had a strong impact on my work, and so have the many foreign residency programs I've participated in. My heritage floated in and out as an influence on my work over the years and then definitely became a focus. The current work addresses my heritage as a third-generation Japanese-American, and how my personal family history was shaped by the bombing of Pearl Harbor and the subsequent forced evacuation of all Japanese-Americans on the West Coast. Furniture never fails to surprise me as this vehicle—so many possibilities and benefits!

The current economy certainly has had an effect on studio furniture: makers are being more pragmatic. In addition, the advent of technology and its availability to small shops has shaped and grown the possibilities of what can be made. The making is more effective with CNC [computer numerical control] technology, and some impossible things can now be made with the help of digital technology. It's very exciting, but I sense a trend away from technology as well, where people are returning to "the hand" and "the handmade." Donald Fortescue hosted a "whittling soirée" at the Headlands Center for the Arts [Sausalito, California]—that was an interesting divergence from dependence on machinery; it was an experience of connecting with a single knife and a block of wood.

This sort of varied response to what we do in studio furniture is what makes it all so interesting. It is constantly evolving and morphing and moving or slowing. I take offense when people say that studio furniture is dead. I think sometimes it's just asleep or on hold.

San Diego, California
September 2011

1. Thomas Simpson, *Fantasy Furniture: Design and Decoration* (New York: Reinhold Book Corporation, 1968).

JAMES SCHRIBER
b. Dayton, Ohio, 1952

James Schriber grew up "building stuff" in Dayton, Ohio. It was what he knew how to do. Schriber, who settled in northwestern Connecticut after college, is successful today as both a studio furniture maker and custom cabinetmaker. His large and varied body of work reflects a rare ability to produce powerful designs in a range of styles. Whether making architectural built-ins in a mid-century idiom, neoclassical dining tables with wrought-iron stretchers, or thoroughly reimagining the pencil post bed, Schriber displays an eye for the essence of historical styles and a gift for giving the past a bracing dose of the present. In his speculative and commissioned work, Schriber is comfortable moving between an urban and a rustic aesthetic, between marquetry and milk-paint, between high-tech processes and handwork. This versatility makes Schriber one of the field's most accomplished furniture designers.

James Schriber was born in 1952 and raised in Dayton. He attended Goddard College from 1970 to 1972, Philadelphia College of Art from 1974 to 1975, and received his Certificate of Mastery from the Program in Artisanry at Boston University in 1978.

His work has been included in museum exhibitions at the Museum of Fine Arts, Boston; Lyman Allyn Art Museum, New London, Connecticut; Fuller Craft Museum, Brockton, Massachusetts; the Renwick Gallery, Smithsonian American Art Museum, Washington, DC; and The Butler Institute of American Art, Youngstown, Ohio.

Schriber has shown at Pritam & Eames gallery since its opening in 1981. His furniture was included in *Material Evidence*, a show at New York City's Workbench Gallery in 1983. In 1993, he had a solo show at the Peter Joseph gallery in Manhattan.

His work has been featured in many publications, including *The Maker's Hand: American Studio Furniture, 1940–1990* by Edward S. Cooke, Jr., Gerald W.R. Ward, and Kelly H. L'Ecuyer; *Art for Everyday: The New Craft Movement* by Patricia Conway; *New American Furniture: The Second Generation of Studio Furnituremakers* by Edward S. Cooke, Jr.; and *The New Furniture: Trends + Traditions* by Peter Dormer.[1]

He has been a periodic guest lecturer at Brookfield Craft Center, Brookfield, Connecticut, since 1980; he has also lectured at the Rhode Island School of Design, Providence; The University of the Arts, Philadelphia; Rochester Institute of Technology, Rochester, New York; the Center for Furniture Craftsmanship, Rockport, Maine; San Diego State University, San Diego, California; Savannah College of Art and Design, Savannah, Georgia; California College of the Arts, Oakland; and the Appalachian Center for Crafts, Smithville, Tennessee.

Schriber's commissioned work is found in many private and public collections, including Yale-New Haven Hospital, Mutual of New York, and NationsBank in Charlotte, North Carolina. There is no better example of his trademark style of historically referenced but highly individuated work than his own home in New Milford, Connecticut, which he built, furnished, and shares with Karen Ross. Considered one of the most business savvy of the studio furniture makers, Schriber has maintained his shop in New Milford, Connecticut since 1979.

Do you think utility limits furniture in ways that don't limit other craft mediums?

Well, if you look through books that describe American crafts over the last 20 years, the furniture looks like furniture, but the pottery and glass look like sculpture. Potters broke away from throwing pots a long time ago, glass blowers backed away from blowing goblets, and weavers broke away from making blankets. Woodworkers did not break away from making furniture a long time ago. A lot of us never will and never intend to.

Can furniture makers make sculpture?

I think they can. Some of them do successfully, some of them do less successfully. Wendy Maruyama is certainly not making furniture anymore. Wendell Castle is certainly not making furniture anymore. Alphonse Mattia goes back and forth; he would love not to be making furniture anymore. Tom Hucker does a little bit of both. If it is important to the individual, then it is important to do it. It's not something I want to do. The one thing that is consistent in all of my work is that I'm comfortable calling myself a furniture maker and nothing else. I'm not striving to be a sculptor. I never was.

But it's still a struggle for me trying to figure out where and how I fit into the whole thing. Growing up in Dayton, I didn't make any connection between creativity and construction. I didn't know architects. I didn't know designers. I didn't know any of that world. No one ever presented me with that connection. I grew up building stuff in the shop. Normal stuff—bicycles, go-carts, toolboxes. When I was a junior or senior in high school, I got serious about it. I began to realize I liked doing it—and it was also the only thing I knew.

My father ran the family contracting business, Schriber Sheet Metal. His father started the company. My grandfather was a coppersmith. He came over here from Latvia, went through Ellis Island, took the Ohio River, settled in Dayton for some reason, and started the company with another guy.

My dad was the oldest of nine. He was too old to be in World War II, so he was in Dayton through the war. After the war, all his brothers and brothers-in-law came back and he put them all to work—with the exception of one who actually got rich, my Uncle Louie. All of the rest worked for my dad who was a commercial roofing contractor and also a sheet metal contractor. It was a very large custom shop, sort of a giant version of what I am. They had a bunch of craftsmen hammering out metal; this was a time when they made ductwork by hand.

At the end of high school, it was either go to college or go into the family business. I almost preferred the idea of going through a sheet metal apprenticeship and then going into the business, sort of learning it from the bottom up and being one of the guys. Then I started looking into schools and somebody introduced me to this Goddard College place in Vermont. They had a program that was architecture from a building point of view. It had a staff of three hippie architects and a bunch of students and they were physically building buildings. I thought this was unbelievable.

I went to Goddard and got right into this program. It was a great place if you knew what you wanted to do, but if you didn't have the self-motivation, you were in trouble because they didn't make you do anything. Most of the people there had already been in college. A lot of them had been in art school or architecture school and this was sort of dropping out and

Table, 1993 (detail; see p. 246).

trying something different for them. They had background. I had no background. I knew how to swing a hammer. My enthusiasm was there, but I was 18, just a kid out of high school from Dayton, Ohio. These guys were from Boston, New York, had been at MIT for two years, or had been at Harvard for two years. They had the context for understanding what we were doing. I didn't know who Le Corbusier was. We would build all day long with our hammer holsters and all that stuff, and then at night we would sit around and have these theoretical design discussions with blackboards. It was real exciting, but I got lost.

Were these building projects for local clients?

No, we were building college facilities. We built a community center, a sculpture center. They were big—4,000- to 6,000-square-foot buildings. These were Yale-trained architects who were teaching us. The leader of the whole thing was a guy named Dave Sellers. He was a brilliant, oddball eccentric and sort of a difficult personality, but he was an inspiring teacher. Dave lived in Warren, Vermont, on this hill that was one giant commune.

Dave had a friend, Randy Taplin, who was a furniture maker. I found myself drawn to him. I was having a hard time in this group of 12 guys and 3 teachers. Randy was not a faculty member at Goddard, but this was a liberal place—see what you can cook up. I went down and spent some time with Randy and we invented a program for me. We decided that I would build components for the buildings. I somehow convinced the school to hire Randy as a faculty member and create a spot in the sculpture building for a little woodworking program. I was the only student. The first thing I built was the entrance door to the sculpture

A. Max Schriber, James's father, center, The H. Schriber Sheet Metal Company, 1928. Photograph: Unknown.

Schriber, early 1970s, first truck, Vermont. Photograph: Unknown.

building, out of cherry. The door warped. I learned about wood. It gave me direction.

The New Hamburger co-op in Cambridge [Massachusetts] was originally a commune in Plainfield, Vermont. They had facilities in both places and a lot of guys in New Hamburger were woodworkers. That's how they made their money. They had a tiny shop in Plainfield that hardly ever got used and I rented space there. It started out Randy would give me a couple of jobs and I would do them. I was doing stuff just like he did, which was sort of like Nakashima

James and Dayton, 1980, Full House Cabinet Shop, New Milford, CT. Photograph: Unknown.

and Maloof. I took off for six months and traveled to South America. I came back and spent another year working in this little shop. All the guys I started with at Goddard were now finished and were going to make the transition to the next step.

I had used up all the resources that little corner of Vermont had to offer in terms of learning anything about woodworking, so I went back to Dave Sellers and said, "What do you think? What should I do now?" I had heard about this guy Wendell Castle and a furniture thing going on up in Rochester, New York. Dave Sellers, it turned out, had a cousin who was an old friend of Wendell's. "Why don't you call Wendell and tell him that I told you to call him?"

So I drove over to Rochester. This is about 1972, 1973. I didn't know anybody or anything. I went over to RIT and talked to Wendell, talked to a couple of guys at his shop. It was just as enlightening as going to Goddard to begin with—to find that there were people who were combining building and art—that a whole world of woodworking was going on.

I had an interview at RIT with Jere Osgood, but I didn't know Jere Osgood from Jere Nogood. It didn't mean anything to me except that I was in what seemed like a gigantic industrial shop in a huge industrial complex and there were all these guys building what seemed to me to be super-sophisticated furniture. Then I went over to Wendell's shop and I couldn't believe what was going on there. That's what started me.

Did you consider going to RIT?

No, no. I couldn't bring myself to move.

But you moved to Philadelphia and went to Philadelphia College of Art.

The thing was that Philadelphia, compared to RIT, was earthy. First of all, Rochester is so dismal. It looked like it had missed out on the late 1960s. Philadelphia had a couple of things. One, the school was sort of old and funky. RIT had those big, modern, sort of fascist-looking buildings. And then there was Dan Jackson at PCA compared to Jere and Bill Keyser at RIT. I'm crazy about Jere now, but upon meeting him and Bill you think, 'Oh my God, these guys are like lab technicians.' I saw these two guys with pens in their pockets and stuff. Then I went down to Philly and there is Dan with his cowboy hat and he is totally different. I thought, 'Well, here is somebody I can aspire to. This guy has got a lot of energy. He is interesting.'

Desk, 1981. Padauk and dyed maple, 29 x 72 x 36 in. (73.66 x 182.88 x 91.44 cm). Photograph: John Kane.

Some people who I was friends with at Goddard—Mac Patterson and John Horton—had decided that they were going back to school at Penn. That period of dropping out was sort of over and now it was time to get back to business. So they were moving back to Philadelphia and we ended up sharing a house. I had never lived in a city. We had this great house. During that time in Philadelphia, Mac and John and I decided that someday we would work together.

Dan Jackson was fantastic. I was learning how to draw. I was learning about the history of furniture. I was taking real courses. None of this stuff existed at Goddard. PCA [now The University of the Arts] had a real art library, plus I was going over and using Penn's library, which was fantastic. I was being forced to write. I wrote papers, took tests, took life-drawing courses, took blacksmithing. That year ended and then I think that summer I went out to Colorado to build a house for Dave Sellers.

Come August, I called Dan and said, "Listen, I'm going to be a week or two late for

Bed, 1984. Bleached maple, pink ivory, and satinwood, 40 x 64 x 84 in. (101.60 x 162.56 x 213.36 cm). Photograph: John Kane.

school. Is that all right?" He said, "Well, it's okay with me. I'm not going to be there." Then he told me about the Program in Artisanry at Boston University. I had heard some rumors that there was something going on up in Boston, but I didn't really know what it was all about. I asked Dan if he could get me in up there. He said, "Well, let me see what I can do." He got me in the program. I knew nothing about it other than Dan was going to be teaching there with his friend Jere.

I got to Boston and there was Tim Philbrick

Sleigh Bed, 1987. Cherry and Macassar ebony, 44 x 64 x 86 in. (111.76 x 162.56 x 218.44 cm). Photograph: John Kane.

and Bruce Beeken—guys who were basically just like me, who had somehow decided after high school that this was the route that they were going to take. We had all done it a little differently. Tim got out of prep school and went to work for Johnny Northup. Bruce got out of school and went to work for a canoe builder. The three of us became a unit immediately. Within days, we were best buddies—the three musketeers.

That was a totally inspiring year. We had John Kirk and Tim Philbrick telling us all about antique stuff. Then there was Jere, who was equally as impressive as Dan. It was another groundbreaking year for me.

Tim, Bruce, and I had spent years becoming regular guys. Tim was from this sort of artsy family in Providence, but had spent years rejecting that. Bruce pretended that he was from the backwoods of Vermont when, in fact, his father was an MD in Burlington. I was just a Jewish kid from Dayton. We were all into driving pickup trucks and being woodworkers and having kind of an alternative lifestyle.

There were others. Michael Hurwitz came around, Rich Tannen, and Tom Hucker. Hucker felt really out of it. It took a while to adjust to Tom and we just ribbed the shit out of him every chance we got—in a good-hearted way and eventually he came around to being a regular guy. He is a true eccentric and I know that now, but when I was 22 years old and he was 18, I thought, 'This guy is full of shit.'

I've been real fortunate in the teachers that I have had. Sellers was still probably the single biggest influence. He changed my life. Those other guys certainly made me develop as a furniture maker, but Sellers actually changed the direction of my life. From Sellers, who changed a lot of people's lives, to Dan Jackson, who certainly changed a lot of furniture makers' lives, to Jere, who didn't change my life, but gave me a whole fresh way of looking at and constructing furniture.

My work has always been highly influenced—that is not something I necessarily strive for. When I was Dan's student, I was making Dan Jackson furniture—as everybody

at PCA was. Then, when I met Jere, I sure did my share of Jere Osgood furniture. Fortunately, at BU there was a much stronger-willed body of students with a stronger sense of design and a stronger personal sense of themselves. The first year, while Dan was there, Jere was really the nuts-and-bolts man. He was not an easy guy to connect with, especially with Dan around. Jere was the guy who made sure there was sandpaper in the storeroom and wood on the shelves and that the machines ran. Dan was running around doing everything but that. Jere was perfectly comfortable being the guy who wrote the analysis of things and sent stuff into the administration and made out requisitions. That's what he did for that first year and then the next year he came into his own a little more. He worked upstairs and we used to go up and look at his stuff and see the way he worked and see the way he had his tools. He became more of an influence. Jere was into tapered laminations. We had people doing double-tapered laminations, triple-tapered laminations. We all did that. Hucker got into it. The only one who didn't was Tim.

Getting back to Dan for a moment, how did you see him? Was he an artist who happened to work in wood?

Well, I never evaluated it like that. Dan was another one of those strong personalities, like Sellers, that you had to respond to and against. The important thing was that here is this guy who is excited about his work and his life. That was the reinforcement that I needed at that time. The design development would occur. Once you are committed, that will develop. What Dan represented was a total commitment—your life's commitment. He was clearly—and Sellers was the same way—hell-bent, and when you're 18 or 20, it is amazing to latch onto someone like that.

Fig. 64. *Tall Cupboard*, 1984. Poplar, paint, fiberglass, and metal, 86 x 40 x 20 in. (218.44 x 101.60 x 50.80 cm). Photograph: John Kane.

Table, 1987. Maple, pearwood, ebony, and holly, 29 in. x 60 in. diameter (73.66 x 152.40 cm). Photograph: John Kane.

Side Cabinets, 1996. Poplar, chestnut, milk paint, 22 x 24 x 20 in. (55.88 x 60.96 x 50.80 cm). Photograph: John Kane.

Side Cabinets, 1999. Pearwood and steel, 22 x 24 x 20 in. (55.88 x 60.96 x 50.80 cm). Photograph: John Kane.

Cupboard, 1989. Maple, cherry, aluminum, and milk paint, with industrial casters, 66 x 42 x 20 in. (167.64 x 106.68 x 50.80 cm). Photograph: Museum of Fine Arts, Boston.

I remember Jere talking an awful lot about making kitchens, building built-in window seats for people. He had a whole production line of little tchotchkes that he made for America House before it became the Museum of Contemporary Crafts. I identified with that. I had already done half-a-dozen kitchens and I thought, 'Well, if Jere Osgood isn't too good to do that, then I'm not too good to do that kind of work.'

I remember him saying, "At this point in my life, I think I could move to Indiana and within a couple of years, I could be making a living there. I've got skills and I'd do whatever it was—somebody wanted me to build them a sign, I'd build them a sign. And the next thing, I'd be building their door and then the next thing, I'd be building their kitchen, and within a couple of years I'd be making a living in that town. I'd be the local woodworker." I remember him telling us this. Even though he was making art furniture at the time, he wasn't talking about that. He was talking about nuts-and-bolts kinds of issues.

Jere pretty much has always been a teacher, but that is not what he is proud of. He is proud of those few years when he made a living as a woodworker. "If you are trained as a furniture

Recent Schriber interior. Photograph: Warren Johnson.

maker, you should be able to make a living as a furniture maker." I identified with that. There were those who argued, "No, that's a compromise. I'd rather work in a grocery store bagging groceries and then go home at night and make art." I thought that was bullshit. I'm not going to bag groceries. I'd much rather support my shop by making kitchen cabinets and someday I'll make furniture.

The summer after my first year at BU, Mac, John Horton, and I went up to Vermont together. By this time, we are calling ourselves "Full House." We've got the logo, we've got the whole bit. We decide to move to Connecticut, probably the spring of 1977, to start this cabinet company. I'm not done with school—the idea was that I would take a full year off and make starting this company part of my thesis project. I would be in Connecticut building cabinets for half of my thesis project, and for the other half, I'd return to BU with some furniture projects in mind and build them.

So the combination of furniture plus the cabinet shop has always been in the mix for you.

Yeah, it's just a natural thing. People ask me how I can do both. It's just a natural—I have always done both.

You said some years ago that when you and the others got your Certificates of Mastery from BU, none of you expected you could make a living by just making furniture.

It was unprecedented that you could. None of our role models did. Even Wendell taught. To what extent he taught and to what extent he made money making furniture, I don't know.

Recent Schriber interior. Photograph: Unknown.

Recent Schriber interior. Photograph: Unknown.

The only guy I left out of this whole thing is Alphonse Mattia, who came to BU my second year, after Dan left. Alphonse was the next generation. He was clearly art-school trained. There were no rules against plastic and color and metal with Alphonse. He didn't use a whole lot of it, but he used more of it and was much more open to it than Jere and Dan were. Alphonse was open to all kinds of new ideas and encouraged people to be trying out different things. His friends were glass artists and potters who were much more advanced in terms of their craft than we were. It was Alphonse's idea to bring in someone like Tommy Simpson. Tommy clearly did shake things up at BU. Judy McKie was working in Boston at that time, too. I remember Alphonse and Rosanne Somerson being influenced by Judy: "Here is this woman who is coming out of art school and look at how great her stuff is. She is painting things and carving things—isn't this fantastic?"

Wendy Maruyama showed up. I guess she came that second year, the year that Dan was gone. She tried being a woodworker like all the BU people, but she was rejecting that all along the way, fighting it, trying it but being clumsy at it, not finding it comfortable. She was much more loose than we were.

Tom Hucker showed up that second year, too. He was wild and crazy and unconventional about how he put his work together. His work was highly influenced by Jere, but he was just totally fearless, plus he was full of shit, which was good. He was much more intellectual than any of us. He made us start thinking about how we talk about our work. We were talking about a nuts-and-bolts issue, and Tom was talking about the Japanese guy, Noguchi. He was looking at paintings and stuff, working barefoot and his bench was just a total mess. We were drawing things out, making cutting lists, doing drawings of how the joints worked, and Tom would just start building stuff. We thought, 'God, how does he do this?' He would have this cockeyed way of putting things together, these

Swag Bench, 1988. Bubinga and leather, 18 x 66 x 20 in. (45.72 x 167.64 x 50.80 cm). Photograph: John Kane.

elaborate structures. It was another way of doing things. He had no background in architecture. He had worked for that Leonard Hilgner guy, but he clearly had his own way of working. Hucker was influential—he was an artist.

Then the other person who came along, and I remember thinking about her work a lot, was Alice Terkal, Mitch Ryerson's wife. Alice also had a completely new viewpoint. She was making this sort of folksy stuff. Alice was the first person I knew who used milk paint. Mitch was a boat builder and he was making Danish Modern kind of stuff like all the rest of us. Laminate this and laminate that—now, of course, he is not doing that at all. Alice never did that. Alice would make some folksy chest and paint it with representational imagery. So there was Wendy, there was Tom, and there was Alice.

Arm Chairs, 1997. Mahogany and Macassar ebony, 32 x 22 x 20 in. (81.28 x 55.88 x 50.88 cm). Photograph: John Kane.

Then there was Ed Zucca, who came and showed slides at various times. Ed, of course,

Armoires, 1999. Pearwood and maple, 72 x 36 x 20 in. (182.88 x 91.44 x 50.80 cm). Photograph: John Kane.

Table, 1993. Bubinga and iron, 29 x 96 x 44 in. (73.66 x 243.84 x 111.76 cm). Photograph: John Kane.

has always had his own personal direction. Alphonse was a big fan of Ed's and encouraged us to think about this guy Ed Zucca.

Of course, Tim Philbrick really rejected this. He had a whole different background. He grew up in an academic family. He was much better read and much more broadly educated. Also, he specifically had that period furniture training with Johnny Northup and he grew up with real antique furniture. His father was a poet.

In school, we were sort of discouraged from looking at old stuff. We were trying to invent new. But John Kirk's course got me to actually look at the old stuff. In 1975, it looked like old furniture, but at one time the claw and ball foot was not old furniture. It was new and groundbreaking.

John's lectures were really stimulating, really exciting, and really funny. He was

Blanket Chests, 1997. Cherry and milk paint, 24 x 32 x 16 in. (60.96 x 81.28 x 40.64 cm). Photograph: John Kane.

another one of those great teachers who you couldn't help but get fired up about; he made us make the connection. I remember his first lecture. He showed two slides, one of which was the front end of a Volkswagen Beetle. The other was some seventeenth-century thing. All of a sudden I thought, I'd better look at what he is talking about because one of these objects

Steinway Piano and Bench, 2001. Pearwood and holly, 40 x 60 x 72 in. (101.60 x 152.40 x 182.88 cm). Photograph: John Kane.

I can clearly relate to and the other object I'm just going to have to learn how to relate to. He made us look. That was his key word—look—he taught us how to see things.

Then there was Tim Philbrick, saying, "This is fun. Let's go over and spend the afternoon in the museum and look at this stuff, then go out and drink beer and smoke cigarettes and talk about it."

How much of the aesthetic you developed in your early cabinetmaking and kitchens do you still see in your work?

Well, when I was sort of forced to do those large painted cupboards recently—the first one an assignment from the Workbench Gallery, the second a commission [see fig. 64, p. 240]—it made me think about early influences. Because there was a time before I started furniture school when I was making things out of sheet metal and building kitchens out of corrugated sewer pipe and rubber tubing and fiberglass and painted metal and cherry and spray paint and handmade hardware—I was doing all

Double Chest with Stand, 2000. Macassar ebony and pommele mahogany with cast-bronze pulls, 76 x 36 x 20 in. (193.04 x 91.44 x 50.80 cm). Photograph: John Kane.

that stuff. Well, I abandoned all of that when I got to PCA. When I started those painted cupboards, it allowed me to think back on the use of other materials and how I used them by taking familiar utilitarian kinds of construction materials and giving them a new life—making them elegant in an unexpected way. Those

Big Chair with Ottoman, 2005. Bubinga and mohair, chair: 42 x 28 x 48 in. (106.68 x 71.12 x 121.92 cm); ottoman: 15 x 23 in. diameter (38.10 x 58.42 cm). Photograph: John Kane.

Bench, 2010. Cherry and curly maple, 17 x 66 x 22 in. (43.18 x 167.64 x 55.88 cm). Photograph: John Kane.

Fig. 66. *Pencil Post Bed*, 1991. Maple and holly, 84 x 64 x 84 in. (213.36 x 162.56 x 213.36 cm). Photograph: Jonathan Binzen.

Fig. 65. *Game Table*, 1984. Padauk and leather, 29 x 42 x 42 in. (73.66 x 106.68 x 106.68 cm). Photograph: John Kane.

things were fun for me, were sort of a lightening up, looking back on all that.

Now, I look primarily at furniture to inspire other furniture. That's the vocabulary I'm comfortable with—that and architecture and other decorative objects. There was a table that I did a bunch of that I still think is a real successful table. You had the square one in padauk with the leather top [fig. 65]. There again, a very traditional leg, but a different top. At first glance, it's a table; at second, there is some other architecture about it. There is a part of me that says it is almost enough of an accomplishment to take something that has already been done and make it mine, give it a new life. In the case of the *Pencil Post Bed* [fig. 66], that was all I was trying to do and I still feel good about that.

You asked earlier about making furniture versus sculpture. This is what it comes down to: You have to do what you like. If you're unhappy making functional objects, then you shouldn't be making functional objects. If you're forcing yourself to make sculpture, then you're out of your mind. We are obviously not making a lot of money.

We all made this decision to make things with our hands. I'm a woodworker. What I do every day is to make things, so I had better enjoy the process—and I do enjoy the physical part of it, making shapes more gracious with hand tools. It's sort of a scholarly way of working with your hands. So you really have to get joy out of it—otherwise, what's the point?

New Milford, Connecticut
January 1991

Dining Room Extension Table, 2008. Bubinga, 29 x 66–102 x 54 in. (73.66 x 167.64–259.08 x 137.16 cm). Photograph: John Kane.

AFTERWORD

Let's get the bad news out of the way first. The audience and its support of studio furniture, which were always modest, have been declining for the past 10 years. I would like to blame the recession (or the Republicans…kidding), but I think the truth is that the generation that supported our field now has different priorities. To a large extent, they are simply done acquiring new furniture. It remains to be seen whether a new generation of collectors can be convinced to see the value of our work.

The good news is that I never quit my day job. My business continues to concentrate mainly on cabinetmaking and millwork with furniture as a secondary focus. My pragmatism may have limited my artistic heights, but I've always been skeptical about viewing myself and being viewed by others as an artist—that was never my intent. I simply wanted to create a home, a business, and a life that would allow me to make stuff I care about and be surrounded by family and close friends. Although I now find myself working harder than ever and being possibly less creatively fulfilled, I still enjoy rising to the new challenges I face. I feel pretty good about the stuff I get to make, have lasting and cherished relationships with colleagues and clients, great friends outside of that community, and a wonderful family. I can easily live with that.

New Milford, Connecticut
September 2011

1. Edward S. Cooke, Jr., Gerald W.R. Ward, and Kelly H. L'Ecuyer, *The Maker's Hand: American Studio Furniture, 1940–1990* (Boston: MFA Publications, 2007); Patricia Conway, *Art for Everyday: The New Craft Movement* (New York: Clarkson Potter Publishers, 1990); Edward S. Cooke, Jr., *New American Furniture: The Second Generation of Studio Furnituremakers* (Boston: MFA Publications, Boston, 1989); and Peter Dormer, *The New Furniture: Trends + Traditions* (New York: Thames & Hudson, 1987).

TIMOTHY S. PHILBRICK
b. Providence, Rhode Island, 1952

"The reasons that I make furniture," **Tim Philbrick** has said, "have nothing to do with topical things." Instead, his work springs from the past. In contrast to most of his peers, Philbrick overtly draws on period sources for his designs. Philbrick, who is descended from a long line of Rhode Islanders and lives in Narragansett, was first trained in furniture by John C. Northup, an expert in restoring and reproducing antiques. Northup believed that nothing good was made after 1815. Philbrick might quibble with the date—he's an ardent admirer of Louis Majorelle, for example, the outstanding French Art Nouveau furniture designer who worked at the turn of the twentieth century—but he has no problem identifying with exemplars of the past. Philbrick brings to his luscious designs not just a deep knowledge of historical furniture, but a mastery of proportion and an ability to reanimate the spirit of an old form rather than copying the original.

Timothy Philbrick was born in Providence, Rhode Island, in 1952 and lives and works in nearby Narragansett with his wife, Claudia. He served a four-year apprenticeship after high school with Johnny Northup. In addition to restoring and reproducing American period furniture as Northup's apprentice in the early 1970s, Philbrick worked on the restoration of the Jamestown Windmill in Jamestown, Rhode Island, and the Christopher Townsend House in Newport, Rhode Island.

Philbrick went to Boston University's Program in Artisanry in 1975 and received a Certificate of Mastery in wood furniture design in 1978. While there, he also took graduate courses in the American Studies department with furniture historian John T. Kirk.

His work has been exhibited in galleries and museums across the country, including the Renwick Gallery, Smithsonian American Art Museum, Washington, DC; the Mint Museum of Craft + Design, Charlotte, North Carolina; The Butler Institute of American Art, Youngstown, Ohio; the Contemporary Arts Center, Cincinnati, Ohio; the Museum of Fine Arts, Boston; the Museum of Art, Rhode Island School of Design, Providence; Newport Art Museum, Newport, Rhode Island; and Fuller Craft Museum, Brockton, Massachusetts. Through the Art in Embassies program, he has furniture in the U.S. Ambassador's residence in Tashkent, Uzbekistan.

Philbrick has pieces in the permanent collections of the Providence Athenaeum, Providence, Rhode Island; the Museum of Fine Arts, Boston; the Mint Museum of Craft + Design, Charlotte, North Carolina; Philadelphia Museum of Art, Philadelphia; the Museum of Art, Rhode Island School of Design, Providence; Brown University, Providence; and the Renwick Gallery, Smithsonian American Art Museum, Washington, DC.

His commissions include furniture for NationsBank, Charlotte, North Carolina; MONY, New York City; the Henley Group, New York City; the Museum of Fine Arts, Boston; the Museum of Art, Rhode Island School of Design, Providence; Brown University, Providence; and the Providence Athenaeum, Providence. He has built three art-case pianos for Steinway & Sons.

Philbrick's awards include the 2002 Pell Award, presented by Trinity Repertory Company, Providence; two Rhode Island State Council on the Arts Fellowships in 1997 and 1991; and a National Endowment for the Arts Artists Fellowship in 1988. His work has been published in the *New York Times, Art & Antiques, Town & Country,* and *American Craft* magazine, and in books such as *Art for Everyday: The New Craft Movement* by Patricia Conway; *New American Furniture: The Second Generation of Studio Furnituremakers* by Edward S. Cooke, Jr.; *The Maker's Hand: American Studio Furniture, 1940–1990* by Edward S. Cooke, Jr., Gerald W.R. Ward, and Kelly H. L'Ecoyer; *American Crafts: A Source Book for the Home* by Katherine Pearson; and *Crafting a Legacy: Contemporary American Crafts in the Philadelphia Museum of Art* by Suzanne Ramljak.[1]

You grew up in Rhode Island in a university environment—amid a lot of creativity.

Yes, my father was an English professor and his friends and the neighbors were mostly people who taught at Brown University on the east side of Providence. It is an interesting area with a lot of good libraries and museums and films—a lot of creative people.

My father published four volumes of poetry. His mother was a painter. She studied with Claude Monet and taught art in the Wheeler School in Providence. My mother's mother was also a painter. She did a lot with watercolors.

I'm one of four brothers. My oldest brother, Steve, is a poet and he's just had a poem accepted at *The New Yorker*. I'm the second eldest. Ben, who is two years younger than me, restores yachts in Stonington, Connecticut. My youngest brother, Harry, is 32 and has just graduated from Goldsmiths College in London; he just sold two of his thesis pieces to Doris Saatchi. They are paintings cast in bronze.

Was there a lot of creative competition among the brothers?

I don't think so; it was more a kind of support, really. At the age of 9, I started going to Saturday morning ceramic lessons, which I did for years. There was a lot of support for creative things in our house. We made all of our Christmas tree decorations, which some people thought was terribly creative, while others thought we had a tree with a lot of garbage on it!

From an early age, I enjoyed doing projects with hand tools; my father encouraged me. He taught me how to use a plane and, when I was about 10, we built a foldboat together. It is a kayak that comes in kit form; the kit advertised on the box that it was a 12-foot, two-seater kayak that could be put together by two high school girls. Well, we sweated like crazy. We had to do some steam bending and some heavy-duty clamping and stretching of this special fabric. It was a real project and it was fun.

I spent my senior year of high school, 1969–1970, in California, doing off-campus study of Eastern thought. I was studying Sufi dance with Sufi Sam Lewis, who was a famous kind of guru in the San Francisco area.

I also spent a good deal of time at a Gurdjieff school in the wine country in Sonoma. I don't know how familiar you are with Russian mysticism, but one of their first tenets is that you should be a good house-holder—you should get your day-to-day physical life in good order. That meant getting a haircut and not smoking pot and getting a job.

I started to think about what I would do when I got out of school. I always liked collecting old things and around Providence there were a lot of junk stores. I noticed that what was considered junk in Rhode Island—a lot of second-rate Victoriana—was considered antique in San Francisco. I got the idea of opening up a little antique store out there that I would furnish from the junk stores on the East Coast.

So when I got out of school, my brother Steve and I got a truckload of Tiffany-style leaded-glass lampshades. They certainly weren't by Tiffany, but you could pick them up for 30 dollars here and sell them for 150 dollars out there. We opened our little antique store, Mt. Ararat Antiques—Ararat was the mountain where Noah's Ark ended up.

I found that what I enjoyed more than running the business was fixing the occasional broken chair. Someone would ask me if I could put in a cane seat and I would say, "Sure," then get a book from the library to learn how to do it.

Grecian Sofa, 1994 (detail; see p. 266).

At the same time, I was doing a little building project for the Gurdjieff Ranch. They needed some low tables, so I went to a local mill yard and had some teak milled up. I was watching this guy in the mill yard who was planing some teak boards and edging them. Watching this guy handle the lumber, I could see he knew just by glancing at the board which way the grain was running and his hands knew instinctively which way to turn the board when he flipped it over to joint the other face. I was impressed. I thought it was magic. About that same time, my father's health took a real nosedive. He had developed cancer and I decided it was time for me to reunite with my family.

I came back to Providence and there was an old family friend, Mrs. Standish, who had a big collection of antiques. She had one particular cabinetmaker who always maintained, repaired, and fixed her stuff for her. Much more than selling antiques, I wanted to learn how to build furniture. When she found out what I was up to, she said, "You have to go talk to Johnny Northup." His shop is in what was his grandfather's wheelwright shop, in the town of Allenton, Rhode Island; his father had a blacksmith forge in the same building. It was this tumbledown old place and Johnny is totally a nineteenth-century kind of man who uses all kinds of old, suave Yankee witticisms and vocabulary. He was a riot.

This was in 1970. He was 60 when I met him. He's now 80. Anyway, I went in and talked to him. He showed me around the shop. He talked to me for two or three hours about everything in the world except my working for him. Finally I said, "What do you think? Could you use some help?" He said, "I don't know. I guess if you want to come down sometime it would be all right." I said, "Well, when should I come?" and he said, "Monday is good. Tuesday

Mt. Ararat business card.

Johnny Northup's Shop, 1970, Allenton, Rhode Island. Photograph: Alphonse Mattia.

is fine. Wednesday, Thursday, Friday. I usually work Saturday; I don't give a good god-damn when you come!" So I went down the following Monday morning at 6:00 and I worked for him for four-and-a-half years doing everything from sawing wagon shafts to restoring Windsor chairs to making reproduction John Goddard pieces. I'd do anything—repair a rotten storm door or make a Queen Anne highboy.

He had gone into business during the Depression and his idea of sound business practice was to have a lot of work, so he refused nobody. One time, there was a shortage of 2 x 4s and the local lumberyard asked him if he would trim 2 x 8s into 2 x 4s, and they brought in thousands of feet of wet hem-fir. It was horrible. I'd be in there trying to cut dovetails and there are 4,000 feet of wet hem-fir going through the table saw.

Found headboard with Philbrick-designed posts, 1970s. Pine and maple, 56 x 54 x 80 in. (142.24 x 137.16 x 203.20 cm). Photograph: Peter Harris.

Jere Osgood, left; Dan Jackson, right, 1975.

Tim Philbrick, Program in Artisanry, 1976. Photograph: Unknown.

I think it's unusual that your father encouraged this apprenticeship for you.

Well, as I said, he had been teaching at Brown through the 1960s—he died in 1970—and there were a lot of students in college then to avoid the draft. It drove him batty seeing students who really didn't want to be there, who were there for absolutely all the wrong reasons, taking up space. So when I suggested an alternative, something I really wanted to do, he encouraged me. He said it was probably a great idea to become an apprentice.

Apprenticing to Johnny was one of the best things I could possibly have done because, first of all, restoring broken furniture is a great way to learn how not to build furniture. After you've reglued the same bad joint in any number of different styles, you learn what works and what doesn't work. Also, I was exposed to so many different styles of furniture—everything from the very earliest to the most rustic stuff to very high-style urban veneered work.

It was great educationally, but after a while I wanted to learn more about design. Johnny's approach to antiques was, if it was early, it was good; if it was late, it was bad—and there was nothing built after 1815 that was worth saving. After a few years, I began to realize that there were good things built after 1815—and there were some early things that

were absolute dogs. There were some incredibly beautiful Chippendale chairs and there were Chippendale chairs that were oinkers. But I didn't know why I liked one more than the other, or what made one better than the other, and that was what I wanted to learn.

About that time, I went to a lecture by John Kirk, who was a consultant to the RISD Art Museum and the Rhode Island Historical Society. His whole point of view about furniture was that by learning to look at furniture, you could identify its strong and weak points aesthetically. You could learn to identify what separates a good chair from a bad chair. Also, by learning to look at it technically—by knowing the history of both style and construction techniques—you could learn where it was made. I was completely impressed by his knowledge of furniture, so I spoke with him after the lecture and told him what I was doing and what I wanted to do. I asked if he could recommend any schools and he said, "I've just accepted a position teaching in the American Studies Department at Boston University and they are opening this new program called the Program in Artisanry."

I went up and applied and was accepted by Jim Krenov on the basis of the portfolio of stuff I had built working for Johnny. Then I was accepted into two graduate courses taught by John Kirk, also on the strength of what I had learned from Johnny.

John Kirk had a test to get into a graduate-level class. He showed you a photograph of a Centennial reproduction of a Chippendale chair and a photograph of a very similar original Chippendale chair, and you had to say what the difference between the two chairs was. Fortunately, I had worked on some Centennial Chippendale chairs and I was able to recognize the difference. Johnny gave me a good enough

Upholstered Settee, 1977. Pearwood and ash, 38 x 54 x 26 in. (96.52 x 137.16 x 66.04 cm). Photograph: Peter Harris.

education so that with no undergraduate background, I was able to go straight into two graduate-level courses. I owe him a lot.

I didn't know who Krenov was. He taught one semester in 1974 and then he departed for reasons I can't explain to you. When I showed up, in the fall of 1975, it was Dan Jackson and Jere Osgood who were running the program. Krenov had started the program and then took off. There were all these Krenov aphorisms painted on the walls in the woodshop, but the atmosphere was not at all Krenovian.

Can you tell us a bit about how the program's Certificate of Mastery worked?

Since it was a brand-new school and a brand-new program, and they had never issued one, we used to call it the Certificate of Mystery. There was a review panel composed of your teachers—in my case, Jere and Alphonse Mattia—plus the program's administrator, who was Neal Hoffman at the time, and two other faculty members representing different

Grecian Sofa, 1984. Curly maple and silk, 32 x 66 x 24 in. (81.28 x 167.64 x 60.96 cm). Photograph: Doug Dalton.

Arm Chair, 1986. Swiss pearwood, ash, poplar, and wool fabric, 32 x 27 x 28 in. (81.28 x 68.58 x 71.12 cm). Photograph: Michael Galatis.

departments within the program. You had to propose a body of work to this review panel that would then constitute your thesis. The work was judged by an outside jury of professionals. They would decide if this group of work was of peer quality. It was something like the guild system in the Middle Ages: this jury would decide if you graduated from journeyman to master level. So that was the theory. In practice, it was interesting how it worked out. My first several faculty reviews were rough. Jere and Alphonse were supportive, but the representatives from the ceramic and textile departments thought my work was not original enough, that it was too historically intertwined. They pushed me hard to break the molds.

Describe the student/faculty mix at BU during this time.

Jere had been working in his own shop in New Milford, Connecticut, at that time and came up. Dan had been teaching at PCA [Philadelphia College of Art] and Jere got him to come up and help set up the program. I think a lot of the un-Krenovian feelings of that shop in its inception were because of the Dan Jackson influence. He was so fabulous! He was such a nut! The first semester, he was on that borderline between sanity and insanity, which was so creative. He pushed people in all kinds of directions that a sane mind never would have done. He made comments that a sane man never would have made. It was wonderful. It was so sad when he kept deteriorating, but that first semester was just amazing.

Dan and Jere were sharing an apartment not far from school. I remember once that James Schriber and I had walked over there for some reason to get something. We walked in and Dan and Jere were sitting at the table eating, neither of them looking at the other. Dan is sitting there saying "bupia" and Jere was saying "bupia" and Dan was saying "bupia." This was a discussion of the correct pronunciation of the program's acronym, BUPIA—Boston University Program in Artisanry. They were hilarious. Jere is so quiet and understated and Dan was so flamboyant and outrageous, but both of them had a great sense of humor.

Dan's work was all highly shaped. There was nary a straight line nor a square edge; joinery was not his expertise but shaping was.

All I had learned about shaping before I went to BU was strictly traditional. Queen Anne legs—that was basically all I knew about shaping. Dan really excited me about the more sculptural possibilities of shaping—the doming of edges and swelling of forms and avoidance of rectangular forms. Everything in Dan's work is swelled, curved, swooped, and domed. I do it much more subtly than Dan, but those influences have stayed with me, as has Jere's use of technical laminating. They were both very big influences on me.

Alphonse was a student of Dan's. Dan had a major influence on Alphonse's work and his way of thinking about furniture as sculpture. Some of Dan's influence was passed on through Alphonse. Alphonse was also so personable and friendly and so much closer to us in age that it was like having an older brother. It was not so much like a teacher-student relationship. He was a teacher, but we were all very close.

It was an amazing confluence of people. We all came to the school blind, basically. Bruce Beeken had built boats and houses, James Schriber had built houses, and I had four years of furniture restoration. Those first couple of years at BU, things were really percolating. I think we all learned as much from each other as we did from the faculty, which is the case in any program where things are really cooking.

I did do some work that was pretty sculptural; that tambour-fronted liquor cabinet with the carved ends and bent front legs [fig. 67], and that lady's dressing table with the silver feet [fig. 68]. They were successful in getting me to loosen up.

Given your own background, the Northup apprenticeship, your historical knowledge, and your interest in Majorelle [Louis Majorelle, 1859–1926, a French artist,

Fig. 67. *Tambour Liquor Cabinet*, 1976. Mahogany and maple, 54 x 42 x 20 in. (137.16 x 106.68 x 50.80 cm). Photograph: Peter Harris.

cabinetmaker, furniture designer, and ironworker who was one of the leading exponents of the Art Nouveau style], at times, didn't you feel at odds with Dan and Jere?

I felt it as a great release. It was difficult but it was exhilarating. I loved studying all the styles that come after 1815. I soaked up Art Nouveau furniture and Biedermeier and Hitchcock chairs. I'm still not that crazy about some of the twentieth-century stuff. But I look at Shaker furniture, all kinds of Victorian furniture that I thought was great, ancient Egyptian, Roman furniture, all these things that I had never been exposed to. I thought it was great.

Fig. 68. *Lady's Dressing Table and Mirror*, 1977. East Indian rosewood with silver feet, 31 x 31 x 18 in. (78.74 x 78.74 x 45.72 cm). Photograph: Peter Harris.

About that time, you wrote an article on proportion for *Fine Woodworking* magazine. As we recall, you said that article represented a direction you could have taken, namely, as an academician on the history of furniture.

It was tempting. Benno Foreman offered me a job teaching at Winterthur. He was head of Winterthur and was part of a senior seminar in Boston that I took. I loved those graduate seminars and then going over to Boston Museum where you can handle everything on the floor, everything in storage. I identified a couple of fakes on the floor that had been sitting there for 60 years that everybody had been accepting as legitimate originals. By being a furniture maker, I had a little bit of extra training that the historians didn't. I pointed out to them where a drawer front, for example, had mortises in its lower edge, where it may have originally been the rail of a chest and that this whole thing was just cobbled together.

I also showed it to the director and he said that was all very interesting, and then put it right back on the floor again with the same label. It turned out the family that had donated it still had some things the museum was interested in. They were not about to say this thing is a fake. So, I learned a hard lesson. I had always believed museum labels—until John Kirk told me that you can't believe a single museum label.

So, I really loved that and I was really good at it. I could spot things that people who weren't trained in furniture making could not; I had a leg up on everybody. It was fun and it was easy and it was exciting. I never really liked the scholarly approach to it where you do all your studying of furniture by studying household records. The current kind of sociological approach to furniture didn't interest me, but I loved studying the historical aspects of furniture.

Then Benno Foreman made me the job offer. When I told Jere Osgood I got a job offer at Winterthur, he said, "Ah, don't do that. Stick with this. You could be another Chippendale yourself!" That was enough of a plug. I figured I'd take a crack at it and if I found myself starving later I could always call Johnny Northup. Actually, that article I did for *Fine Woodworking* was a paper I did for John Kirk.

Nightstand, 1988. Pearwood and curly maple, 29½ x 18 x 16 in. (74.93 x 45.72 x 40.64 cm). Photograph: Ric Murray.

Chest of Drawers, 1986. Morado, 36 x 42 x 18 in. (91.44 x 106.68 x 45.72 cm). Photograph: Ric Murray.

On the subject of proportion, John Kelsey, the editor of *Fine Woodworking*, once said the analogue is what rhythm is to music, proportion is to furniture. Is proportion a result of a mathematical formula or is it a product of intuition?

Proportion is the relationship of parts to the whole. It can be expressed mathematically, but I think it's a trap to start trying to do what Chippendale did with the five orders of architecture in a piece of furniture, that every little molding has to be some percentage of the module. You waste an awful lot of time with that and end up designing some pretty ridiculous looking furniture that would all be proportionately correct. I don't use an awful lot of math in proportioning. When I'm blocking things out at the sketch stage, I use rough mathematical relationships. There are whole-number relationships, which are crude expressions of those more refined proportions—in other words, 3 to 5, 5 to 8, or 1 to 1. Even then, I may do it with a pair of dividers at the sketch stage, not with a calculator and inches and rulers. The golden section is a kind of rectangle. If the piece of furniture is anywhere near that shape, then of course I'm going to use a golden section rectangle, but I don't compress it to make it fit. I don't change the view dramatically to make it fit some preconceived set of relationships.

For me, trying to get proportions right is more often a matter of mockups. I get a sketch that I like and then I work up a full-size drawing and a mockup at the same time. I'll make a cardboard pattern for the leg that looks about right, make a sample leg out of poplar, look at it, decide what's wrong with it, and make a new pattern. Make a new leg, decide what's wrong with it, make a new pattern, make a new leg—and I might do that three or four times, sometimes more, sometimes less. That's

Dressing Table, 1989. Ceylonese satinwood and curly English sycamore, 30 x 36 x 17½ in. (76.20 x 91.44 x 44.45 cm). Photograph: Museum of Fine Arts, Boston.

Vide Poche Table, 1989. Ebony, satinwood, and mammoth ivory, 32 x 18 x 16 in. (81.28 x 45.72 x 40.64 cm). Photograph: Ric Murray.

how I get the final proportion—by working with the full-size forms. I have a little closet in my shop that is full of mockup legs.

I don't draw very well. If I could do that process in the sketchbook, I would save myself hours and hours of work. I need that third dimension to establish the special relationships—how full, how far, how thick things should be. With a simple pencil line, you can say, "there's how an arm should join a back leg," and it's a matter of drawing a pencil line. But when you actually go to make that happen, there's a third dimension. Things have to fit; planes are changing from one leg to another. It's so complicated that I don't see how anybody can do it just on paper.

Designing furniture is so difficult—it's the hardest thing I do. Maybe it's because I come from New England that it seems to me that one should always take the more challenging and more difficult thing.

I'm still striving to build a great piece of furniture. That's the goal that I set for myself, to build a really beautiful piece of furniture. When I think about every piece that I've done, I can tell you instantly what I don't like about it, what I want to try to correct, what I want to try to do better. I never look at what's right about it, I look at what's wrong in my attempt to create a great piece of furniture.

I change my opinions about my work constantly. When I make something and deliver it, all I can see is what's wrong with it and I hope the client will accept this horribly flawed object that I'm delivering. Then there is some period of time when I don't think about it and then two years later I'll be going through my portfolio and I'll see it again and say, "It's not that bad." I feel very differently about things with the passage of time.

Fig. 69. *Rosewood Sideboard*, 1979. East Indian rosewood with silver pulls and hinges, 40 x 60 x 20 in. (101.60 x 152.40 x 50.80 cm); *Continuous Arm Chair*, 1979. Pearwood and wool, 37 x 26 x 26 in. (93.98 x 66.04 x 66.04 cm). Photograph: Warren Johnson.

But tonight the piece that I think of as pivotal would be the *Rosewood Sideboard* [fig. 69] with the polished bone back plate and silver drawer pulls that I did for Neal Patterson in his Steichen house. Its back legs are different from its front legs to help establish the stance for the piece. The front legs look the same as the back legs from the direct front view, but they have an arris on them, so as you move around toward the side, you become aware that they have a gentle cabriole carved into the front. Light shining on it will show up on one side of the leg but not the other. Even if you are looking at it straight on, it has a sculptural quality. It is also one of the first pieces that I did that had a curved back. That curved cove sets it out from the wall and brings it out into the room. It means it is no longer a frontal object. It could be standing in the middle of the room like a piano and be equally viewable from the back as it is from the front.

The sideboard is also a good example of the weighted apron, which has been such a part of the style of your work.

Yeah, the doors, the drawer, and the panels all have the swags that I still do, the curve that I go for there. There is a story that John Kirk tells about Kaare Klint, a famous Danish designer who was trying to design a simplified version of a Chippendale chair, a chair where the lower edge of the front rail had a curve to it. He tried

Club Chairs, 1992. Claro walnut and Italian calfskin; chairs: 38 x 33 x 31 in. (96.52 x 83.82 x 78.74 cm). *Table*, 1991. Claro walnut, 20½ x 27 in. diameter (52.07 x 68.58 cm). Photograph: Michael Galatis.

every known way of getting a curve. He tried radius, he tried bending sticks, he tried boatmakers' spline weights, and he couldn't get the curve right. Finally, one of his students brought him a long gold chain, a fine gold watch chain, then put two pins into the board and draped the chain between the pins. That's how he got the perfect curve. That's the kind of quality to the curve that I like, that draped swag.

With some of the legs that I do, the turned ones with the little ring, the idea is that the ring is pinched at the swelled leg. It has caught the leg, but it has also caught the rail. That ring is holding the rail up.

Is there a tool that brings out your personal best?

I have about three tools that do about 90 percent of my work. Since most of my work is shaped and curved and bowed, I need shaping tools. A nineteenth-century cast-iron spokeshave has just the right curve to the handle and takes just the right amount of shaving. For tighter curves, I have a little beechwood spokeshave that is probably about 100 years old and I have a set of Buck Brothers patternmaker's chisels and gouges that I use for shaping. I do most of my work with those few tools. I prefer to use cutting tools rather than the grinders and rasps that people who were trained as sculptors might use.

There is something awful about a rasp, isn't there?

Ugly, ugly things. What a difference in using a well-tuned spokeshave on a piece of wood, especially woods like Macassar ebony, rosewood, and other high-grade woods. When you are shaping them with a spokeshave, they look beautiful from the first shaving to the last one.

Grecian Sofa, 1994. Curly maple and Larsen upholstery, 31 x 66 x 24 in. (78.74 x 167.64 x 60.96 cm). Photograph: Ric Murray.

They gleam and shine under the spokeshave. When you put a rasp to that thing, it is just ugly. It makes a horrible noise. You can't see what you're looking at. I have a Skilsaw, but I don't use it. I don't have a radial arm saw. I cut all my cutoffs with a handsaw. It maybe takes me 30 seconds longer, but it is much more satisfying.

What do you think about the claim that art furniture ought to respond to the world today, that it ought to reflect our times and not the past?

I think it depends on the artist. I think it depends on what your reasons for making art are. If your reasons for making art are to be doing topical commentary, that's one kind of art; if your reasons for doing art are to pursue some kind of inner goal or ideal, then it doesn't really matter whether the stock market is up or down, or the kids are wearing purple hair. Topical things don't concern the reasons that I make furniture.

You mentioned going to Judy and Todd McKie's show at the Rose Art Museum at Brandeis.

That show had a major effect on me—just to see how much work they had done in such a brief span of time, in so many styles, in so many materials. I found it inspirational. It really made me want to go back and make some more furniture and try some new things and materials.

I've recently enjoyed doing things in ivory, which is, given the elephants' condition, kind of a delicate subject. I've been using fossil ivory and pre-Act [CITES treaty and Endangered Species Act] ivories and antique ivories, trying

Steinway Piano Commission for Art Case Collection, 2001. East Indian rosewood and Ceylonese satinwood, Model B, 82 in. long (208.28 cm). Photograph: Steinway & Sons.

to make sure I'm not doing the species any harm. Ivory does things that no other material does visually and tactilely. I have a bunch of designs for some bronze exterior furniture and I'm working on some designs for furniture using parchment panels. However, there are so many species of wood, there are so many different ways of cutting it, and the fact that no two pieces are alike makes it an endless palette. I feel no more trapped by wood than an artist would feel trapped by paint.

Secretary, 2003. Cuban and Honduran mahogany, 98 x 44 x 24 in. (248.92 x 111.76 x 60.96 cm). Photograph: Karen Phillipi.

Asymmetrical Pier Tables, 1991. Cuban and Honduran mahogany with fossil walrus ivory, 30 x 43 x 19 in. (76.20 x 109.22 x 48.26 cm). Photograph: Michael Galatis.

Arm Chair, 2004. Cuban mahogany and silk fabric, 36 x 24 x 20 in. (91.44 x 60.96 x 50.80 cm). Photograph: Images Design.

Do you ever have assistants working with you?

I like working alone. Given that my shop is in my house and I've been in the same shop for 20 years, I'm fussy about who hangs around in there. What I've done is work with Steve Turino. His level of craftsmanship is as high as anyone's and he has excess capacity. He is right down the road, so I supply him with working drawings and we consult on any questions. That's worked out very well. With him, I can double the capacity of my shop. I have complete control. I select the materials, I do the drawing, and I'm right there to make any decisions if there are any questions that weren't clear on the drawings, so it's still my piece. I would also do the details, the carving of the knobs, anything that was in my area of expertise.

When you look ahead, what do you see?

I'm very optimistic about the work that my contemporaries and I do. I'm a little nervous about the economy and what that will mean for the people who collect our work. One thing that worries me most about our field is how few people there are collecting. You take two or three of them out of it and I'm not sure the market exists. That kind of fragility is terribly frightening. Every year, my resolution is to try to expand the base a little bit. If Peter Joseph's idea for a gallery in Manhattan comes to fruition, that would expand the client base, which would be good for everybody.

It's precarious, but the level of work is high and seems to get better, not worse. If the 1989 Boston MFA show had been done five or six years ago, it wouldn't have been as good. That's encouraging. I'm hopeful, excited, and nervous.

Narragansett, Rhode Island
October 1991

Loving Cup, 2012. Gabon ebony, warthog tusks, and silver by Jeffrey Herman, 9½ x 8 in. (24.13 x 20.32 cm). For the exhibition *Recasting the Loving Cup: From Traditional Silver to Contemporary Media*, Newport Art Museum, Newport, RI, 2012–2013. Photograph: Jeffrey Herman.

AFTERWORD

I really don't think that my approach to furniture making has changed over the past 20 years. I've learned a lot about making and designing furniture, but my fundamental approach remains the same. I've always worked by seeking out historical examples that I thought were of particular beauty—be they Egyptian or Greco-Roman, Art Nouveau, or Victorian—and then emulating that beauty in my own voice. I pick a historical piece that particularly speaks to me and try to re-envision it—see it through my own eyes, draw it with my own hand.

Unlike most other students at BU's Program in Artisanry, I came from an apprenticeship background, making reproductions and doing restorations. When I first got to BU, my professors were constantly trying to get me to loosen up and look at other things. To some extent, they were successful. Instead of just looking at eighteenth-century furniture, I began to look more closely at Art Nouveau and also nineteenth-century furniture, which I'd never paid much attention to. I started looking at Shaker furniture and Hitchcock chairs—and even some Victorian things that I had disdained when I was younger. Whatever the era, my response was always to beauty.

My inspirations may have been different than my peers', but I never thought that what we were doing was that different. Tom Hucker thought Noguchi was beautiful. James Schriber thought muscle cars were beautiful. For Bruce Beeken, canoes were the ideal form of beauty. We were all following our own muses.

By the time I finished at BU, my teachers and peers had succeeded in loosening me up somewhat. But it was a two-way street—most of them had softened in terms of their antihistoricism. There were just one or two who remained adamant that nothing that had been made before mattered. To me, that was ignoring 5,000 years of relevant experience.

I've never thought I was making a political statement of any kind in furniture making. I've never thought of what I do as anything other than the pursuit of some kind of functional beauty, which is a concept that goes in and out of artistic fashion, and it's pretty unfashionable these days.

It's hard to ignore the doldrums affecting the field right now. There's very little demand at the moment for what we do. I can't tell you why. Has the zeitgeist shifted? Has popular taste changed? I don't know. It's a gloomy time. But this work has certainly had a vital life. It occurred to me this afternoon that studio furniture as a style has lasted longer than the Art Nouveau and Art Deco periods combined. How about that?

Narragansett, Rhode Island
December 2011

1. Patricia Conway, *Art for Everyday: The New Craft Movement* (New York: Clarkson Potter Publishers, 1990); Edward S. Cooke, Jr., *New American Furniture: The Second Generation of Studio Furnituremakers* (Boston: MFA Publications, 1989); Edward S. Cooke, Jr., Gerald W.R. Ward, and Kelly H. L'Ecoyer, *The Maker's Hand: American Studio Furniture, 1940–1990* (Boston: MFA Publications, 2003); Katherine Pearson, *American Crafts: A Source Book for the Home* (New York: Stewart, Tabori & Chang, 1983); and Suzanne Ramljak, *Crafting a Legacy: Contemporary American Crafts in the Philadelphia Museum of Art* (Philadelphia: Philadelphia Museum of Art, 2002).

MICHAEL HURWITZ

b. Miami, Florida, 1955

Michael Hurwitz makes furniture with the compression of poetry. Like the Japanese craft and architecture that he greatly admires, Hurwitz's furniture achieves an eloquent reserve. He does not need an editor: he may spend hundreds of hours on a project in his Philadelphia shop, but the finished piece feels distilled, not overwrought. Although function is a given in his work, Hurwitz is after something more. His pieces often record his response to a particular time or place or culture. "I'm trying to create something more human than just pieces of wood glued together," he says.

Hurwitz is a dreamer. His ideas for furniture forms are apt to spring from the branching of a tree, an urban rooftop, or the shape of a teacup. The forms are always fresh, but he might stretch their time frame with materials such as Damascus steel, mosaic tile, or intricate cedar filigree embedded in resin. Whether a piece is light and sprightly or dark and quiet, Hurwitz's furniture compounds intimacy with the power of its presence.

Michael Hurwitz was born in Miami, Florida, in 1955. By the late 1960s, his family had moved to suburban Boston, where his father was superintendent of the Newton, Massachusetts school system. As a teenager, Hurwitz came across a music stand by Wendell Castle at Ten Arrow, a gallery in nearby Cambridge; this was his introduction to studio furniture. Soon after that, he saw *Woodenworks: Furniture Objects by Five Contemporary Woodworkers*, an exhibition at the Smithsonian Institution in Washington, DC, that included work by Wharton Esherick, Sam Maloof, Art Carpenter, George Nakashima, and Wendell Castle. Hurwitz was deeply affected by the show and began to think about being a furniture maker, but first pursued instrument making and metals at the Massachusetts College of Art and Design in Boston from 1974 to 1975.

He then attended the newly established furniture program at Boston University's Program in Artisanry, where he received his Certificate of Mastery in 1979. Later, he would study lacquer technique with Kenkichi Kuroda, a master lacquer craftsman in Kyoto, Japan, from 1990 to 1991.

In 1999, Hurwitz was awarded a Pew Fellowship in the Arts; he received a Japan Foundation Fellowship in 1997; three fellowships from the National Endowment for the Arts in 1988, 1990, and 1992; a Venture Fund grant for travel to Japan in 1988; a craft fellowship from the Pennsylvania Council on the Arts in 1986; and an Artist in Residence Fellowship, Altos de Chavon, Dominican Republic in 1985.

From 1985 to 1990, Hurwitz was associate professor and head of the woodworking department at The University of the Arts (formerly Philadelphia College of the Arts), Philadelphia. He has lectured and taught at many institutions, including Tokyo University of the Arts, Japan; Rhode Island School of Design, Providence; Delaware Art Museum, Wilmington; the Renwick Gallery, Smithsonian American Art Museum, Washington, DC; California College of Arts and Crafts, Oakland; Haystack Mountain School of Crafts, Deer Isle, Maine; Honolulu Academy of Arts, Honolulu; and the Saskatchewan Craft Council, Saskatoon, Canada.

His work has been included in museum exhibitions such as *Inspired by China: Contemporary Furnituremakers Explore Chinese Traditions*, Peabody Essex Museum, Salem, Massachusetts in 2007; *The Maker's Hand: American Studio Furniture, 1940–1990*, Museum of Fine Arts, Boston in 2003; *Visiting Artist Exhibition*, Contemporary Museum, Honolulu in 1994; *Furniture Fantasy*, Susquehanna Art Museum, Harrisburg, Pennsylvania in 1993; and *New American Furniture: The Second Generation of Studio Furnituremakers*, Museum of Fine Arts, Boston in 1989.

Hurwitz's furniture has been featured in books such as *Furniture with Soul: Master Woodworkers and Their Craft* by David Savage; *Studio Furniture of the Renwick Gallery: Smithsonian American Art Museum* by Oscar P. Fitzgerald; *The Rocker: An American Design Tradition* by Bernice Steinbaum; *Art for Everyday: The New Craft Movement* by Patricia Conway; and *The New Furniture: Trends + Traditions* by Peter Dormer.[1]

Michael Hurwitz has made Philadelphia his home and workplace since 1986. He lives there with his wife, artist Mami Kato, and their daughter, Marina.

You think of Miami as a place for old folks. They send the old people down there, let them live out their days. I may have been one of the first to be born there. My father was running an off-Broadway theater in New York and the theater folded right after my brother was born. He's two years older than me. My father had an uncle who lived in south Miami who was building retirement homes and he said, "If worst came to worst, you could come down here and mix cement." Worst came to worst and that's where I was born.

Miami was pretty peculiar. I think of the people as being sort of blunt and hard. There wasn't really a lot of room for art, but my dad encouraged us to pursue any art interest that we had—art, music, or theater. He would always play the piano after dinner. It seemed like a normal thing to do—it was something in the air at the time. Everybody hung around with guitars instead of going to school.

My father abandoned theater and started teaching art. It was his other passion. He painted murals and mixed cement and did odd jobs until he started teaching in public high schools. Then he became superintendent of the school system in Dade County. When I was 11, we moved to Newton, a suburb of Boston, when he became superintendent there.

While in high school, I took some classes through the Museum of Fine Arts in Boston. There was a lute maker named Joel van Lennep. I took a class with him and classes with Steve Warshaw, who is an acoustic steel-stringed instrument maker, and I hung around a repair shop, E.U. Wurlitzer's. I wasn't allowed to work on any instruments, so I just sort of hung out and watched. If a kid keeps coming back 6 or 10 times and doesn't take no for an answer, then you stick him in the corner where he won't hurt anything and let him watch.

Instrument making requires a different kind of patience. I liked the fineness of the work and the scale. Perfection was something that could be realized, but I later felt that it was very limiting, that there was a *prescription* for perfection—it had already been done. You don't want to make a funny-looking guitar. You want to make one that feels familiar, out of a respect for history. The woodworking end of it probably becomes the least interesting.

Around that same time, I watched Wendell Castle's work come into a Cambridge gallery called Ten Arrow. Also, in 1972, I saw a show on furniture making called *Woodenworks* at the Smithsonian Institution in Washington, DC. When I saw that show *Woodenworks*, I knew I wanted to be a furniture maker. I remember the bus ride home, looking at the catalogue. I'd look at each page, get to the end, and just go back to the beginning. You want more and there's no way to get more.

I spent my freshman year at Mass Art [Massachusetts College of Art and Design] in Boston. They had a woodshop but no instructor, so I couldn't major in it. Instead, I majored in metalsmithing—something I had done all through high school. I used to take Saturday classes in silversmithing at the deCordova Museum. I also took blacksmithing in high school—it was something of an obsession while I was doing it.

At Mass Art, there was a very important teacher, Lowry Burgess. He's a conceptual artist. He used to be at MIT's Center for Advanced Visual Studies; now he's at Carnegie Mellon as dean. I had a freshman seminar with him and for me it was a real eye-opener as to what art can be about. I think his function was to

Tea Table, 1990 (detail; p. 281).

Woodenworks exhibition catalogue cover, 1972. Sponsored jointly by the Renwick Gallery of the National Collection of Fine Arts, Smithsonian Institution, Washington, DC, and the Minnesota Museum of American Art, Saint Paul, MN. Photograph: Warren Johnson.

disrupt us, confuse us, disturb us, and derail us. We came in with preconceptions and he was out to make sure that he shook them loose. I remember one of the assignments, I came away just dizzy with possibilities. The assignment was to make a map of your mind when you were 3 months old, and 3 years old, and 18 years old, and then to look at what you are now at 20 years old. They were to be superimposed so that it would be this layering of information and recollection. It forces you to be introspective. He got a lot of pictures of brains, which infuriated him. He said, "A map of your mind, not a picture of your brain." It was a lot of information to come up with, and a challenge to find some way to represent it graphically, and then to find some way of making it an interesting piece of art.

While I was at Mass Art, there was this rumor of a new school beginning and, after one year there, I transferred to the new Program in Artisanry [PIA] at Boston University. That same year I was at Mass Art, [James] Krenov was teaching in the wood department at PIA. I walked through a couple of times to see what was going on. I saw all these beautiful pieces of lumber—exotic woods that I had never seen in that scale—logs still with the live edge but band sawn in half, big chunks of ebony and tulipwood and cocobolo. I remember Krenov standing in the middle of the room, but there were no students. It was midweek, and people should have been in there working. I said, "Where are the students, where is everybody?" Krenov pointed up to the overhead ducting and he said, "Listen to this," and I hear this quiet little swish of air going through. "You can't blame them for not working with this racket." Instead, they were down in this dark cave of a basement playing ping-pong.

After Krenov left, Jere came in and I think Jere may have been there a few weeks when he talked the school into giving Dan Jackson a chance. Dan and Jere had different strengths and different positions and they fell in different slots. Dan—unfortunately his health failed very quickly while he was there—was very inspiring and very supportive of the students, kind of challenging. The more traditional the background of the student, the more he would twist the knife a little and he'd say, "Why don't you try this," and it would be a strange idea—so he was in charge of derailing.

Jere was a lot less verbal. I attached an incredible amount of importance to anything he would say because there was such an economy in the dialogue. 'If I'm only going to get one sentence this week,' I thought, 'I'm going to find meaning in it.' There was a kind of blind respect that was unchallenged.

I remember at my first big crit at BU, I actually thought that maybe—coming from Mass Art as I did—I just didn't know anything. I'm thinking, 'Why do all these chairs have to have four legs?' But I remember Jere saying to the other guys, "Well, these really look like very different chairs. I'm really pleased." And my feeling, which I was afraid to say, was "they all look the same to me."

Fig. 70. *Seven Percent Chair*, 1976. Bird's-eye maple and cane, 30 x 20 x 22 in. (76.20 x 50.80 x 55.88 cm). Photograph: Tim McClelland.

Side Table with Drawer, 1980. Cherry, 24 x 20 x 14 in. (60.96 x 50.80 x 35.56 cm). Photograph: Tim McClelland.

As a required course, we all took John Kirk's furniture history class. At that time, there was a real difference between New England woodworking and West Coast woodworking. The West Coast was cutting loose. They were making some really atrocious looking furniture, but it was more challenging to tradition and was possibly more expressive. It was nothing that you would want in your house, though.

Unfortunately, Dan's health failed very quickly while he was at PIA. When he got sick, Alphonse was brought in. Alphonse was very much younger than Jere. He would come back to school at midnight with coffee and pizza. Until I taught, I didn't know that was not normal behavior for a teacher.

How do you account for the coalescence of talent that assembled in Boston at this time? What were the ingredients?

I think—it must have been 1975—the time was right for that school to open. There were people who wanted to know more about what they were already doing, but no school offered the kind of climate that would allow for that. I think the Certificate of Mastery was also a big draw. James Schriber, Tim Philbrick, and Bruce Beeken—and Tom Hucker, too—came for that. This meant that they didn't have to have a previous degree and they didn't have to take other academic classes. But it also meant that this field of study would be taken as seriously as any other college field of study—more so, actually.

The heads of the different programs pretty much set the curriculum and the assignments.

One reason that the atmosphere was so charged was that there was a constant and common struggle for some kind of order to emerge. A new thing was happening and everybody felt they could make a difference in the way things were being shaped.

When we first met you in 1980, you were part of the New Hamburger woodworking cooperative in Cambridge along with Judy McKie, Mitch Ryerson, Jon Everdale, Jonathan Wright, and Tom Loeser. That's quite an association of talented people.

New Hamburger had been around for maybe 10 years and when I got out of school in 1979, I went straight to New Hamburger. I was there for seven years. New Hamburger was a way of going into business without knowing anything or having any money. For me, a lot of very happy, lucky circumstances surrounded that time. A rent-controlled apartment that was only four or five blocks away from the shop and the low rent of New Hamburger allowed me to do my own work.

The frustration I felt right after getting out of school was that woodworking took a lot of time and that I had so many ideas I couldn't keep up with them. I didn't want them to sort of dissipate or vaporize. That's why I drew a lot; it was a way of getting an idea out, of burning it into my mind.

I tried to do some things then that had to do with merging drawing and woodwork. I was frustrated knowing that a piece of furniture had to have a silhouette—that when you go to the band saw you have to commit yourself to a line. With a drawing, you can have a much livelier image, something that registers without the finality of a silhouette. The drawings often had a kind of vitality that the furniture didn't have.

Chest of Drawers, 1982. Padauk and purpleheart, 70 x 36 x 19 in. (177.80 x 91.44 x 48.26 cm). Photograph: Andrew Dean Powell.

That kind of thinking led me into working surfaces more heavily. I started putting heavier finishes and scratches on the surface. So it would be gessoed, almost like an etched surface, or I would scratch it away and rub pigment into it. That led to different types of surfaces and

Child's Chair, 1983. Painted wood and fabric, 14 x 15 x 12 in. (35.56 x 38.10 x 30.48 cm). Fabric: Cynthia Porter. Photograph: Andrew Dean Powell.

Vessel with Lid, 1983. Milk paint on wood, 12 x 12 x 4 in. (30.48 x 30.48 x 10.16 cm). Photograph: Andrew Dean Powell.

Vessel, 1983. Mahogany with milk paint, 15 x 14 x 6 in. (38.10 x 35.56 x 15.24 cm). Photograph: Andrew Dean Powell.

colors. If there's something meaningful about my recent work, it's the attempt to develop a relationship between surface and form.

There were folk art things at the time that were an influence, too—Japanese, Scandinavian—where you had painted surfaces that looked like a thousand hands had passed over them. Getting the surface to support the form was another tool to make it better.

There seem to be two distinct directions in your work. On the one hand, the bowls, boxes, and small, wall-hung stucco cabinets that emphasize texture and surface treatment; on the other hand, the pieces with bent laminate work, your tables, benches, and chaises longues focus more on flow of line and structural considerations.

Regardless of how it looks or what shape it takes, it's about presence. It might be a dark and quiet presence or it might be light and springy. I'm trying to develop something more human than just some wood glued together.

Slatted Bench, 1986. Wenge and milk paint, 18 x 52 x 14 in. (45.72 x 132.08 x 35.56 cm). Photograph: Tom Brummett.

Lagoon, 1985. Altos de Chavon, Dominican Republic. Photograph: Michael Hurwitz.

Much of your work is small in scale.

Yes, especially earlier. There's something intimate about that scale—and that actually might be a holdover from working in metals. Also, it was an affordable way of working at New Hamburger. I realized that to UPS things was the only way I could get something out of town and afford to pay for the shipping. Then, also, anything I made I thought, 'Well, if this doesn't sell, it's got to be something I want to have in my apartment,' and they have always been small.

We take it you're pretty happy when you're in the studio. Do you enjoy working alone?

Yes, absolutely. I'm still trying to work out having guys help me. On one hand, I feel good about the pile of work that gets done at the end of the day, but I don't like to give up the control. I don't like to have them sitting on their hands while I scratch my head about the way this thing should be. So, you keep them busy and then you look at what they've done and say, "That's not the way I would have done this." You say to yourself, "What do you expect? You didn't do it." I think if I were more organized, I could stay a step ahead of them and I could always be doing the stuff that makes it what it is—that is, the shaping of it.

What would be ideal is an assistant who comes in four days a week and gives you one day to regroup and come up with a list of things for him to do next week. But if everything else were equal, I would prefer to be alone and not to have to think about the radio station or do we eat lunch together.

Rocking Chaise, 1989. Mahogany and milk paint, 36 x 84 x 24 in. (91.44 x 213.36 x 60.96 cm). Photograph: Tom Brummett.

Tea Table with Chairs, 1990. Sand-blasted walnut, oil paint, and leather; table: 30 x 42 in. diameter (76.20 x 106.68 cm); chairs: 37 x 19 x 19 in. (93.98 x 48.26 x 48.26 cm). Photograph: Tom Brummett.

What piece of yours do you think represents a turning point in your work?

I think the most pivotal piece I've made so far was done in the Dominican Republic in 1985. It was the *Chest on Trees* [fig. 71] that Ron Abramson has. The situation there allowed for a luxury of time. There was no money in and no money out, so I didn't have to worry about paying the rent. The other major factor was that I had no machinery. I just had the hand tools I had brought down. Another thing was the whole sense of place. This was a tropical island, or at least a Caribbean island that had very different everything—music, food, smells,

Corner Cabinet, 1989. English brown oak and stucco, 30 x 15 x 11 in. (76.20 x 38.10 x 27.94 cm). Photograph: Warren Johnson.

the pace of the people. Everything was different, every hour of the day, including dream time. Maybe because I wasn't pressured by any deadlines and I was allowed to work in a stream-of-consciousness sort of way, *Chest on Trees* came together very naturally. I like the other things I made there, but this one's boundaries were bigger than its shape. Later, I realized that this work was a record of the experiences that shaped life. It's charged with the stuff I was living with at the time. I'm going to Japan in two weeks and I'm sure that Japan will have as strong an impact. I'm interested in the tradition of craftsmanship and all that goes with that. I hope to study with a temple carpenter. I also want to work with a teahouse carpenter, which is another whole echelon of carpentry. Everything

Fig. 71. *Chest on Trees*, 1985. Mahogany and paint, 48 x 15 x 14 in. (121.92 x 38.10 x 35.56 cm). Photograph: Tom Brummett.

Silver Chest, 1990. Curly hickory with cashew finish, 33 x 22 x 12 in. (83.82 x 55.88 x 30.48 cm). Photograph: Tom Brummett.

Bench, 1991. Bubinga and leather, 18 x 52 x 14 in. (45.72 x 132.08 x 35.56 cm). Photograph: Tom Brummett.

Seven Roses Plant Stand, 1993. Painted cherry with marble mosaic, 40 x 14 in. diameter (101.60 x 35.56 cm). Photograph: Tom Brummett.

is so carefully considered. It's a balanced composition; any little blip upsets the balance.

That kind of thinking interests me—there is an organization of space by manipulating the proportion, surface, color, and texture. The space that develops is presented in a certain way by juggling these different things. The teahouse carpenters have more license with that than the temple or shrine carpenters. They do some really magnificent woodworking. The teahouses will use lumber with natural edges in combination with timbers that have been squared off. It provides an environment for man to reflect on his position in nature. It is a very controlled natural environment, which is stark enough to allow you to meditate with your eyes open. Yesterday, I was driving down a bumpy road and I was thinking that if I were in Japan, I would probably have to be wearing my safety belt. How would you explain to them why you're not wearing your safety belt? That it offends your sense of constitutional rights? I realize this is a fundamental difference between the two societies and the kind of art that is tolerated or

Tea Cup Desk, 1994. Ash with marble mosaic, 29½ x 42 in. diameter (74.93 x 106.68 cm). Photograph: Tom Brummett.

Envelope Table, 1996. Padauk and milk paint, 30 x 50 x 50 in. (76.20 x 127.00 x 127.00 cm). Photographs: Tom Brummett (top); Warren Johnson (bottom).

Rocking Chair, 1995. Walnut and woven leather, 36 x 24 x 50 in. (91.44 x 60.96 x 127.00 cm). Photograph: Tom Brummett.

encouraged. There is something that is almost expected here about challenging boundaries or asserting your individuality. I think there is something that's peculiarly American about this work.

Is there a piece by one of your peers that has influenced you?

Maybe Judy McKie's white table, the one she has in her kitchen, *Grinning Beast* [see p. 94]. That to me is so beautifully resolved and so complete and so sensitive to the effects of light and shadow. Take anything away or add anything and it is a different composition that would be something less. Right down to the size of the top, give or take a quarter of an inch.

Michael, you appear to have understood pretty early on what your work would be about.

My work has always felt like a natural thing and it has gone unquestioned. I guess lately I've been wondering how much of it is following the path of least resistance. When you find something that you feel is rewarding, you continue to do it. It feeds itself. It's never been a conscious decision to become a this or a that. I guess I think more now about having become a furniture maker, a woodworker, and I wonder why. If you believe that nothing is formed without resistance—and I do believe that—then there is something appealing about that struggle. I see the struggle that people like Jere had just to survive. Now, every 2 or 5 or 10 years, you see a major change or acceptance of this work in society. Major museums are starting major collections and I think that is a real turning point. I think all of it is snowballing, so I don't think there is any fear of it disappearing.

But with all the support the field is getting now, it seems like there should be another group

Lattice Table, 2007. Alaskan yellow cedar and epoxy resin, 30 x 37 x 37 in. (76.20 x 93.98 x 93.98 cm). Photograph: John Carlano.

ready to go make furniture. I want to believe that it is something that will go on forever and continue to evolve as a new and separate entity, but there doesn't seem to be the same kind of hunger that there was 15 years ago. So I'm optimistic about the future, though it's hard to believe that there's not another generation.

How do you feel about museums purchasing studio furniture directly from your shop? In other words, how do you feel about making furniture that will never be used?

It doesn't bother me. I'm less concerned about how it's used or who uses it than about me making it. The pleasure, or the need, is in getting the piece made. Beyond that, it is nice to know that it is used or that it can be appreciated on some other level.

Philadelphia, Pennsylvania
October 1990

Twelve Leaf Resin Table, 2012. Ash, wenge, and epoxy resin, 16 x 40 in. diameter (40.64 x 101.60 cm). Photograph: David Harrison.

AFTERWORD

Physically, practically, and aesthetically, my relationship with my work has changed in varying degrees. I know that physically, I cannot—or choose not to—work as many hours a week as I used to. Twenty-five years ago, I was working all the time—every day, all day, with very little interruption, very little sleep. To some extent, I miss the singular focus and sense of purpose, the total immersion in the work. Bills, dishes, and laundry would pile up and it was a wonderfully productive time. Somehow, despite spending all that time in the studio, I did make some time for other interests, including music, dance, and maintaining friendships. It was, however, a lopsided lifestyle, one that put all other concerns at a very distant second place. Ultimately, it was neither healthy, practical, nor sustainable.

Perhaps now that I'm a middle-age agnostic and certain of my fate, I'm increasingly conscious of the way I spend my time. I am determined to live the rest of my life fully and that includes spending time on interests outside the studio. For whatever reason—a craftsman's pride, hedging a bet against mortality, or undue influence from the furniture history course we took while at BU—I always had as a goal that I should make each piece as if it were the last piece I would ever make and make it as good a piece as I possibly could. I still feel that way, but I'm now equally concerned with living a balanced life that is actively and broadly lived. Life continues to center around the activity of making things, but "making things" is now more broadly defined. For instance, to spend time with my 13-year-old daughter and to make that as good a relationship as possible is paramount. In short, I'm still struggling to build an economically viable and sustainable lifestyle for the three of us, one that allows time for music, dance, family, and friends.

Thinking about how my work has evolved brings to mind an enigmatic assignment Jere Osgood gave us in 1976. He asked us to design a chair that would be just seven percent stronger than its breaking point. That challenge has consumed me for 35 years [see fig. 70, p. 277]. It has become something like a Zen koan—except that instead of there being an immediate epiphany, there are layers of awareness that present themselves through the work over time.

At this point, I might redefine the assignment as a mandate to "make the furniture's structure the heart and soul of its design." I've known from the outset that decorating a form in hopes of enlivening it would be a misguided way for me to work; the answer was to make the form itself become the design. With his trademark economy, Jere provided a path for me in what has turned out to be a lifelong investigation.

My continuing challenge as a maker is to make furniture that, through time, continues to feel fresh and vital, with a physical presence that doesn't impose itself or dominate a space. My hope is that my furniture will be there when it is needed and quietly waiting when it's not.

Philadelphia, Pennsylvania
September 2011

1. David Savage, *Furniture with Soul: Master Woodworkers and Their Craft* (New York: Kodansha Publishing, 2011); Oscar P. Fitzgerald, *Studio Furniture of the Renwick Gallery: Smithsonian American Art Museum* (East Petersburg, PA: Fox Chapel Publishing, 2008); Bernice Steinbaum, *The Rocker: An American Design Tradition* (New York: Rizzoli, 1992); Patricia Conway, *Art for Everyday: The New Craft Movement* (New York: Clarkson Potter Publishers, 1990); and Peter Dormer, *The New Furniture: Trends + Traditions* (London: Thames & Hudson, 1988).

THOMAS HUCKER
b. Bryn Mawr, Pennsylvania, 1955

Tom Hucker has always lived on the edge—artistically, socially, and financially. Through the constant turbulence, furniture making has been his anchor and he has continued to produce some of the most provocative, engaging work to come out of the studio furniture field from his Hoboken, New Jersey shop.

His furniture often combines qualities that are seemingly incompatible—buoyancy and mass, abstraction and utility, richness and plainness. Deeply influenced by traditional Japanese aesthetics and contemporary Italian design, Hucker also taps into de Kooning, Noguchi, and Coltrane.

Although Hucker's challenging forms often grow out of theoretical constructs, his work is grounded by its fine craftsmanship and wonderfully wrought details. He credits his training under Leonard Hilgner, Dan Jackson, and Jere Osgood with giving him the confidence to question traditional solutions.

Tom Hucker's early apprenticeships, with master craftsmen Daniel Jackson in 1973 and Leonard Hilgner from 1974 to 1976, provided a strong artistic and technical foundation for the conceptually adventuresome work that would come. Born in 1955 in Bryn Mawr, Pennsylvania, a suburb of Philadelphia, Hucker received his Certificate of Mastery from Boston University's Program in Artisanry in 1980. While in Boston, he also studied the Japanese tea ceremony, attending the Urasenke school from 1977 to 1980. In 1982, he was an artist-in-residence at Tokyo University of Fine Arts. He also studied interior and industrial design at Domus Academy in Milan, Italy, in 1989 on a Fulbright grant.

Hucker has also received two grants from the National Endowment for the Arts, in 1983 and in 1989, and one from the Fragrance Foundation in New York City in 1990. He was a Massachusetts Artists Foundation finalist in 1986 and has five times received awards from *I.D.* magazine's *Annual Design Review*, including best-of-category in 1986 for lighting.

Hucker's work is in the permanent collections of the Museum of Arts and Design (formerly the American Craft Museum), New York City; the Cooper-Hewitt, National Design Museum, New York City; Detroit Institute of Arts, Detroit; Los Angeles County Museum of Art, Los Angeles; the Museum of Fine Arts, Boston; the Mint Museum of Craft + Design, Charlotte, North Carolina; Racine Art Museum, Racine, Wisconsin; and the Renwick Gallery, Smithsonian Institution, Washington, DC. His work has been featured in a number of museum exhibitions and gallery shows in the United States, including *Inspired by China: Contemporary Furnituremakers Explore Chinese Traditions* at the Peabody Essex Museum, Salem, Massachusetts, in 2006; *The Maker's Hand: American Studio Furniture, 1940–1990* at the Museum of Fine Arts, Boston, in 2004; and the seminal *New American Furniture: The Second Generation of Studio Furnituremakers*, also at the Museum of Fine Arts, Boston, in 1989.

Hucker has taught widely. From 1980 to 1982, he wrote the curriculum for the then-new furniture program at the Appalachian Center for Crafts in Smithville, Tennessee. He was chair of the furniture department at California College of the Arts, Oakland, from 1994 to 1995; in New York City, he taught at Parsons School of Design from 1992 to 1994; at the New York School of Interior Design from 1995 to 1997; and in the Industrial Design department at Pratt Institute from 1997 to 1999.

He has also worked as a designer–draftsman for architectural and design firms including Smart Design from 1995 to 1996; Michael Gabellini from 1996 to 1997; and Peter Marino and Associates from 1997 to 1998. Hucker was consulting designer for a 1980s line of wooden objects, *Light Woods*, and a stemware collection, *Elegance*, for Dansk International Design.

Tom Hucker currently designs and fabricates custom furniture and lighting in the small Hoboken, New Jersey shop where he settled in 1990.

You're the youngest of three children, right?

My sister is the oldest, then my brother. I am most like my mother; my sister, business-wise, is most like my father. I am the youngest. I'm the one who picked up on my mother—she would talk about painters and go to museums. It was something of a secret between her and me—not discussed much. She was my best friend growing up.

Her mother was a classical pianist. When my mother was sleeping, that's when her mother was practicing so there would be Beethoven and Brahms around the house. When we were sleeping, that's when my mother would listen to the music. There was always that kind of music. Once you get started and ask questions about who is Stravinsky, you end up somewhere along the line finding out about Picasso because it brings you into that whole world.

The pressure came from my father: "I don't give a damn what you do as long as you do something." He was talking about this to me at the age of 12, which in some ways I resent because I think it is an awful lot of pressure to put on a kid. But that's really all he said, that whatever you do, it is very serious. So I chose the arts. Hands down, there was nothing more interesting than the arts and, my God, everything else looked like books and study and who wanted any part of it?

When was this?

At about 14, I was getting interested in fine arts and took Saturday classes at Moore College of Art. Then I got a little scholarship to spend six weeks at the University of Kansas. When I was 15, I got into Rhode Island School of Design for its high school summer program. That's where I met my friend Sam, the painter. It was an absolute ball—Kansas, too. I really enjoyed the studio classes and the painting. I felt confident in that arena, whereas if I had to recite the chemistry chart, I got totally lost. Mild dyslexia hurt me for the school thing. I would never get a good grade whenever I handed in a paper; things were always backwards and turned around. But if you put me in a studio, that's where I could compete and do my best and blow the socks off everyone else around me. That's where I did my battling for social respect.

At the age when I was graduating high school, *talent* had become a tough, very subjective word. I felt very insecure about it, even though I was getting into any art school I wanted. I was already selling work—I was selling paintings. Some people cut lawns or worked on cars. I was showing at shows, going to Queens for public art shows or driving down to Philadelphia and putting on clothesline art festivals. I was the first student to have a one-man show in the library of the school.

Then came the crisis period—graduating. It comes back to the question of talent. I felt that I was just kind of scamming. The real talent wasn't there. I read all the art books in the library and read *Art in America* and *ARTnews* from cover to cover every week, and I felt there was an awful lot of hype in the art world. I felt extremely uncomfortable with the whole thing. I didn't really feel that in the traditional sense I was a talented painter. I was mimicking Abstract Expressionism and this kind of thing, but if someone said, "Okay, you're an artist, now do a portrait," I froze!

This period had an immense influence on what I do and how I think, even the way I approach furniture. I approach it the way Rothko would have approached a painting. I made a decision that I never wanted to do a

Rocker, 2007 (detail; see p. 307).

Blueberry Song, 1972. Oil, 60 x 48 in. (152.40 x 121.92 cm). Photograph: Thomas Hucker.

Untitled Sculpture, 1974. Cherry, 24 x 22 x 25 in. (60.96 x 55.88 x 63.50 cm). Photograph: Thomas Hucker.

piece of furniture to compete with Rothko, but one that would look proper in an environment with a Rothko. That's still my basic philosophy.

There were two things going on in the fine arts during this period. One was that people weren't really teaching technique anymore and the second was that all the criteria had to be your decision. With crafts, you get the criteria from functionality and to be a woodworker, to be a master craftsman, you have to learn a skill. I've always associated it with being a concert pianist or being a great violinist. If you want to do musical composition correctly, you start out learning one instrument and mastering it so that you are part of the fabricating of music. I felt that what was missing from the fine arts was that you no longer learned how to be a painter. No one was teaching it and no one seemed to care.

I moved into furniture because I needed the psychological parameters and I needed the clearer goal. The change from the arts to furniture was a very deep need for some form of security. Even though people said, "We will send you to art school," I was already projecting four years and saying, "I'm going to graduate and be a waiter." I had done some wood sculpture and, aside from painting, wood was still the most enjoyable medium.

I changed from fine arts to crafts as I was graduating. I was accepted to RISD for undergraduate painting and didn't go, and I wasn't accepted anywhere else to do wood. I had made this decision that I wasn't going

Fig. 72. *Low Split Table*, 1974. Benin crotch burl and teak, 18 x 54 x 18 in. (45.72 x 137.16 x 45.72 cm). Photograph: Virginia Kamenitzer.

to go to fine art school. I was going to do furniture—period! My father was freaking out. He got me a job building stuff. The first things we made were the cashier counter and a public bench for the Benihana Tokyo restaurant in Pennsylvania. He came up with the blueprints and said, "If you make this, you get this much money." I bought the table saw, and another little job came in, and that bought the band saw, and I cashed in a savings bond, and got the jointer. My girlfriend was at Tyler [Tyler School of Art in Philadelphia] and we would drive the wood there and I would run it through the thickness planer. It took five years to get on the road of knowing exactly what I was going to do from the moment I woke up to the second I fell asleep. But it was like I couldn't get it fast enough once that decision was made. It was Penland and Sam Maloof, meet Jere Osgood, go to RIT, PCA, get a job with Dan Jackson, fly out to California, stay two weeks with Sam [Maloof] and just eat it up, write Jim Krenov—you know, fill up every second getting as much information as quickly as possible. I stayed home in my parents' basement and worked for two years, just nonstop investigation.

I wrote 50 letters. I wrote to every craftsman in the country when I was 16. Sam wrote back and said, "Come and visit. I teach at Penland." Jere said, "I don't have space." Bill Keyser said, "I teach full time." I wrote to everyone for an apprenticeship and everyone said no. Then I met Dan Jackson. I went down to PCA and that day he had fired his apprentice. He looked at this 16-year-old kid who was willing to work for nothing and said, "You're hired."

So I sanded for three months. Then he had his first nervous breakdown. His wife called up one Saturday morning and said, "You don't have a two-year apprenticeship anymore." This was in September when all my friends were going to school and here I was facing nothing, thinking I had totally destroyed my entire future. But through Dan I met Leonard Hilgner, the old German craftsman. I would call Leonard all the time—"Could you show me how to sharpen a chisel?"—and we finally worked out our relationship so that I would work in Leonard's basement all day, then on Sunday, I would drive down and have a four-hour class with him.

Desk, 1981. Curly maple and ebonized oak, 30 x 86 x 58 in. (76.20 x 218.44 x 147.32 cm). Photograph: Andrew Dean Powell.

Leonard was brilliant, a fifth-generation craftsman. When Dan came up with a technical problem he couldn't solve, we got in the car and went to see this guy Leonard. Dan said, "You may think I am a master, but we're going down to meet the real master. I'm the artist, but this is a real craftsman." One of the greatest things that happened to me was studying with Leonard. This man would bring out books on Biedermeier because this is what he was taught to make in Germany. He would say, "This is great work," and I would say, "Why?" and he would say, "God, you American kids." After two years, you got to know why! Here was another real master of material. Leonard could do marquetry and he could do dovetails and joinery better than anyone. He was a classic woodworker.

The arrangement he made with me was this. He said, "I get paid $10 an hour for making furniture. If you want to commission me, your piece will be an education." The first piece I did was this very curvy, swoopy, stack-laminated box thing. He begged me to make a square box. He critiqued the swoopy thing for 10 minutes and the little square one for 2 hours—the proportion of the dovetails, the thickness of the side, how much you broke the edge, how consistently you broke the edge with the sandpaper, the direction of the grain, does it go thin to thick, how do the lines break up, what is the weight of the top, the slots in your screws don't line up.

Coming from an art background, these are things you never think about. This guy is talking about two strokes with the 220 to break an edge, not three strokes. He looked at it and said, "You got lazy here—it is rounded more here than there." I said, "So what?" "It looks bad." "Who's going to notice?" He said, "I notice." The work being done during this time is very much about me trying to balance Leonard off Wendell and Dan. You'll have coffee tables that are book-match crotch veneer, which is very much Leonard, and then the three-dimensional carved forms in the center, which is Dan. I was struggling with how I can put German precision and American sculptural aspects together. The corner cabinet, the burl table [see fig. 72, p. 295], and other things done at that time were very much about that conflict.

Seven Percent Chair, 1976. Maple, 36 x 21 x 21 in. (91.44 x 53.34 x 53.34 cm). Photographs: Thomas Hucker.

I was not in a school situation. I had no peers. I was totally alone. The only people I was in contact with were my friends like Sam who were going on to continue their painting. Every now and then, I would go to New York where Sam was going to Cooper Union, and it was humiliating. I felt as though I was missing out on everything. That's why I worked so hard.

My only way to compete was to work, as I felt in many ways I had made a wrong decision. I worked as hard as I could out of fear.

What attracted you to the PIA program in Boston?

They said they would love for me to come and study. Unlike PCA, which said you have to be a freshman and I told them, "No way in hell." When I was 16 years old, there was a big show in Pennsylvania. Dan wasn't in it, but other teachers at PCA entered. I got first and second prize. I was kicking butt to people who had been my teachers. I refused to become their freshman student. Maybe it was too egotistical, but I just wasn't going to do it. I was too wound up in making things and continuing and wasn't going to have someone tell me to sit down and cut dovetails. The way I saw it, I had Leonard teaching me dovetails better than any of these people could teach me anyway. So Boston said I could come in as a master student and not go through this. I waited a year and kept working with Leonard, living at home, very isolated.

So you got into the program at Boston and finally had a group of peers, right?

With whom I really didn't fit in. Work-wise, I fit in just fine; socially, I didn't fit in at all. I came in very, very shy, timid, inexperienced, never smoked or drank, had one girlfriend, never really dated, never been in a bar or club, never got together with a bunch of guys and went out drinking. I felt very outcast. Again, the only way to gain social respectability was to kick butt with the work. So I just went in the corner and did the same thing all over again.

I got accepted late into PIA. They took me on as this extra student. There were 20 people over here, and Tom in this other room. I was physically separated from everyone else, so it

just manifested everything all the more. One day, Jere saw this skinny kid in the corner and basically understood: "I know exactly where you're at." I showed him the drawings and we sat and talked and from day one, we went right into it. What he was talking about, I just ate up. He knew Leonard, so he knew my background. He was a great friend with Dan so he knew where I was coming from, the people I was associated with. He goes, "What's your background?" And I said, "I studied with Leonard Hilgner." He said, "I wish I could take a year off and study with that man."

Jere and I got along great. He understood what it was like to be shy. Alphonse and I never got along. I remember walking in the first day and him using some kind of tone that scared me. Maybe we never repaired that simple little thing. Where another person wouldn't have been so sensitive, would have understood, with me just one little thing would throw me into fantasies about being hated, distrusted.

The woodworking was, in a way, a sport. The only sport I could do was track and field, a nonconfrontational sport. You're put in a lane and you can run in it and no one touches you. If I'm put in that situation, I can function. If someone is going to come up and kick my shins because of the ball, I give them the ball. "Oh, you want the ball? You can have it. I couldn't care less!" The workbench is the same thing: "Give me my area, give me my tools, and leave me alone. I'll meet you at crit." Put me between the two lines and I can be fine.

How is Jere's work different from that of Dan or Alphonse?

Jere is one of the most complete artists. You get to the very end of *Janson's History of Art* and he comes up with a statement that the really fundamental issue of movement in the fine arts

Burl Table, 1985. Madrone and beefwood, 30 x 42 in. diameter (76.20 x 106.68 cm). Photograph: Andrew Dean Powell.

is when you attack the absolute structure of art; it's not when you deal with surfaces. And that's what this man attacks—the level this man goes to!

It's the same with music. When you switch from the classics to jazz, what you're doing is changing the structure of how the music is approached and created. I look at Jere as the jazz woodworker, the improviser. He is so good at what he does that he can afford to improvise. He is the classic jazzman of the field—the John Coltrane of woodworking. Listening to Coltrane and other phenomenal musicians who were altering the compositional approach to music—that's what Jere still is to me. I still think he is unbeaten at that. He deserves much more than he's getting—that bothers me. If we have national treasures, he is one of them.

The only other person who comes close to Jere's spirit is Bill Keyser—a master of improvisational work also, but shying away from it somewhat. In those early years when he was veneering on foam core and steam bending, that was very jazz, very improvisational woodworking. Let's take this from boats and put it here and this from some high-tech thing and let's mix it together and see what it looks like.

I was in Bill's studio talking to him about

Fig. 73. *Shield Back Chairs*, 1985. Wenge and black lacquer, 29½ x 46 x 19 in. (74.93 x 116.84 x 48.26 cm). Photograph: Andrew Dean Powell.

an apprenticeship before I went to PIA. Bill and I knew each other and got about this close to an apprenticeship and then he shied away. That's when he was steam bending things. He was doing brilliant, brilliant, brilliant work, which historically is one side that came out of Tage Frid. The most successful Frid students were the ones who could take Frid's technology and then build a philosophy of aesthetics around it. Bill wasn't about the image, he was about the structure. A very curious, very sophisticated person, much more so than Wendell. I'm not putting Wendell down—the stack things are very strong, but it's a different thing. A little bit like looking at de Kooning against Warhol, or looking at Coltrane against Mick Jagger. One is more popular, you can get it. It doesn't dilute it as an important thing; in fact, you can argue that pop is more important because of the number of people it affects. But de Kooning is still a classical painter; Warhol isn't. His image is flat; it's a one-liner.

Did Krenov have an influence on you at PIA?

Absolutely! I was at Penland the year before. One of the other students there was talking about this guy Krenov. I wrote to Jim and went to Canada to see him. We kind of became friends. He had a strong influence. There's Jere and then there's Jim. His pieces are wonderful. I look at Jim as the great watercolorist. They're like little Cézanne watercolors, perfect and controlled. When you get into oil, you can overwork; you can build layers and then erase. With a watercolor, you can't. If you screw up a door, you can't just get another plank to build a new door—you just blew it.

My problem with Jim is that he's not open-ended enough. It's a very closed philosophy. When Jim came out doing all these lectures and was saying, "me, me, me," he should have been saying, "This is an aesthetic. This is a school. There is history to this. What I'm trying to do is to go against this New York art scene." Jim's big mistake was he said, "It's me," when it never

was just Jim. That's where he hurt himself. He should have written one book on Jim Krenov and another on this whole aesthetic attitude.

I think what Jim is talking about is "country" work; the same way, in other words, the Japanese talk about this poetic aesthetic of materials. You don't need all this loudness; it's not about that. You can look at a Krenov the same way you look at a tea bowl, Shigaraki. It's not high style. It's kept at this kind of country level; very much the same thing as the teahouse, which is an international aesthetic that we find in a variety of cultures. It's Shaker, but it's not; it's Ming, but it's not. If you research, you can find it in other cultures.

It may not be Jim's role to make that connection—maybe that should be left to the historians.

But we need to make that. I mean, I don't think there is that much of a difference between some of the things Noguchi or Brancusi talks about and what Jim talks about. I think we need to put these things together and broaden that school of thought.

Instead, we have the Modernists with their reduction of elements.

And it's a totally different type of reduction: they cut the spirit out, where the Japanese don't. That's the thing that's hurting the Modernists right now. The Japanese are doing some very much Bauhaus-looking things, but they are bending it in a certain place and putting certain punched holes in the steel. By God, I like it—it's still sheet metal and tubes, but I feel good around this. How can you label this? It's so hard to articulate this spirit. But that's how the "tea" hits you.

Another very important thing for me in Boston was studying the tea ceremony.

Isamu Noguchi, *Chess Table*, 1944. Photograph: Unknown.

That was as important an impact on me as being in the woodshop, psychologically and experientially. There is a spirit there I can't get away from because I can't get to it. It ties in with Krenov, it ties in with Noguchi. There is an aesthetic, cultural perception that's been so refined over the century. Mozart in a way was part of that spirit, that efficiency, that correctness. There's a very strong difference between high-end English seventeenth-century furniture and what they were doing in China or in Japan at that time.

The wonderful thing about the celebration of tea was that the objects being used were works of art. Through this whole period of time in Boston, I felt second-class because I wasn't a painter. There were days I felt like a failure because I wasn't painting, which was what a real, honest, true pioneer would do.

My friends who went on to art school would always refer to me as the cop-out, sell-out person. Then the tea ceremony came around and it said, "No, you did the right thing. Today we are using a 300-year-old Oribe bowl. You are very lucky to be able to touch this object and to drink tea out of it." All of a sudden, being involved in functional things was a respectable thing to be doing.

Sideboard, 1985. Wenge and lacquer, 30 x 72 x 18 in. (76.20 x 182.88 x 45.72 cm). Photograph: Andrew Dean Powell.

Europe may be stodgier, but if you go to a truly wealthy person's home in France, they have beautiful furniture as well as paintings, whereas you and I both know people in New York who have $3 million in art but won't spend more than $300 for a coffee table. We have made the fine arts cultural icons. If you can afford it, you can prove your taste—buy your taste badge. What you should be talking about, though, is quality of life, which means the entire environment.

The longer we live in the shadow of the fine arts or put ourselves psychologically in the shadow of fine arts, the longer we will not get anywhere. Trying to make furniture into fine art is like trying to make a chocolate cake with no chocolate. I don't care how long you bake it, it's never going to taste like chocolate. No matter how many colors and things you stick on a chair, it's still not going to be a work of sculpture. It won't be. It can't be. It's pointless. Even [Ettore] Sottsass, who did Memphis and was the king of art furniture, never called it art furniture. It was design. Look at what he was doing in the 1960s. He was very much concerned with color, proportion, and modulation to break up the surface. It was very much about design-premised problems and how they apply to functional pieces. We're the ones who have to justify it as art—not Italy, not Sottsass.

Every day, I keep knocking into another piece of furniture by Noguchi when there's never been a book published that includes Noguchi furniture design. In the art world, it diminishes Noguchi as an artist to see his furniture, yet Palazetti just bought the rights to his new sofas. He has a little chess table, which is one of the most beautiful pieces of furniture I've ever seen in my life, yet no one knows it exists. The Philadelphia Museum of Art doesn't want to tell you that they have Brancusi's bench, that he made furniture for his studio. It's because the curators and the journalists go through an education system where the only way to get an education for art criticism is to get a fine arts education. It is built into the educational

system that you must discuss and critique things based against the fine arts. There is no foundation for dialogue.

Look at what was happening in America in the 1950s. I mean [Charles] Eames was an innovator of incredible ability, really beautiful work, really pushing form, really pushing material, obviously production based. If you want to talk about woodworking, the molded plywood seating that Eames did was an incredibly sophisticated thing. Even in our own culture, we have this very vital and important history that is neglected. It's self-destructive to neglect that kind of history.

Go back to Boston and the Program in Artisanry.

The other students intimidated me to death. There was tremendous peer pressure. I mean, being near Bruce Beeken. Bruce scared me the most. I kept an eye on him, but I wasn't going to give up. When I ran track in junior high school, there was one guy who was faster than me in track, but I refused to be more than three lengths behind. I would pace myself against Bruce. What a perfect thing to have happen, an incredible experience, but I can't call it a pleasant experience. There was a lot of pressure to compete in that arena. Because of that competition, the students' work coming out of that shop was better than most professional work being done in the country. I did a lot of the bent, laminated stuff there: the huge chest of drawers, which was really quite ugly but a technical thing, a little spice cabinet [fig. 74], the chair was done there, and the original boxes.

How did you get invited to Tennessee?

Because I knew Sam Maloof. I was at Penland; Sam had stopped and saw me and said they

Fig. 74. *Spice Cabinet*, 1976. French walnut, 34 x 19 x 12 in. (86.36 x 48.26 x 30.48 cm). Photograph: Thomas Hucker.

needed a teacher at Tennessee. "Do you want the job?" They were going to hire anyone who Sam recommended. I had taught at Indiana for one semester and I think I got the second job because Sam said, "Hire this kid—I like him."

Was the teaching a result of getting your degree finally?

It was me graduating from school and being seriously in debt. I was scared to death and looking for any way possible to make a living without making kitchen cabinets. I got out in January 1980, so when this little teaching job came up in Tennessee, I jumped on it. I played some politics to get the job. Socially, it was a bizarre, weird situation. My teaching schedule was one day a week and I had an income and a studio. I was able to get my feet on the ground and pay my debts and do work, do a lot of work.

Tennessee was a new school, very rural, not an easy adjustment, but a great faculty.

Cabinet with Screen, 1992. Quartersawn wenge and shoji screen paper, 74 x 58 x 22 in. (187.96 x 147.32 x 55.88 cm). Photograph: Andrew Dean Powell.

Wendy Maruyama worked with me, Robert Brady was in ceramics. I had a beautiful studio overlooking a lake in the foothills of Appalachia. I had a lot of time to work and the first opportunity to really concentrate after graduation from school. The first slatted table was designed and begun then, the Boston Museum bench with cast bronze was started, my first use of stone, and a wall cabinet with my first use of shoji paper for translucency.

My first trip to Japan, in January 1981, was very important—tea with the grand master in Kyoto, Tatsuaki Kuroda. At that time in Tennessee, in 1980 to 1982, the Memphis

Bench, 2006. Curly koa and bronze, 18 x 48 x 19 in. (45.72 x 121.92 x 48.26 cm). Photographs: Lynton Gardner.

movement was very strong—polychrome colors, etc. But I wanted to continue with the ideas that had been forming at PIA from Jere—line, form, structure, materials. At 25, I was considered an old fart. It wasn't easy. I like Wendy Maruyama a lot, but it wasn't easy teaching with her in Tennessee when Sottsass was the heavy leader of the Memphis movement. I had students coming up to me saying, "You are too old. I don't want to talk to you, I want to talk to Wendy."

It seems to us that you could give up furniture making more easily than furniture designing, right?

When I was really cranking in Boston, I got to the drafting table once a month. I would only draw when I had a new piece to do, whereas it should be a daily thing. In the studio, individual creativity is the fundamental aspect of the work. Now, unfortunately, the reality of the studio is that it's not a creative situation, but a workplace. You have 10 percent creative time and 90 percent is subcontracted to yourself as a laborer. It's laboring, it's sanding, and it's low paying. I still want a studio, but I want it to be more of a creative laboratory than a manufacturing facility.

Sottsass is designing in his studio. He's got paper, he's making some foam core models in the back. He goes out to the factory, gives them a foam core model and a drawing, and comes back in a week after they've made the prototype and he changes it. I'm not saying that's ideal, but more creative work comes out of that system than our system.

It's one of those lines that has to be drawn. Because, on the other hand, you can't get so distant from the material that it isn't a factor in making ideas flow.

You're right. It frightens me to start hiring people. What's being discussed right now—expanding shops—may even do more damage to real creativity. You get more and more involved in the managerial and you really end up running a cabinet shop. I survived by keeping my shop tiny, tiny, tiny. You can't do speculative work when you have $2,000 a week going out in cash. How? You can't do it. That's

Sagarra Cabinet, 1999. Madrone burl, mahogany, and glass, 76 x 46 x 22 in. (193.04 x 116.84 x 55.88 cm). Photographs: Laurie Lambrecht.

why I pulled back on it so severely. But it's a tough one—I don't have the answers.

I'd love to design an office chair. I'd love to design public seating for outdoors. I feel, at this point, that I would like to be a respected furniture designer with a studio who keeps one-of-a-kind work moving, but intelligent enough that if someone came to me and said, "We need 50 benches for a park" it wouldn't be, "I don't know what to do. Sorry, go see somebody else." I would say, "Nice problem. I like that. I've got some ideas for it." And I think it would be good for the whole field.

It's very important if you want to be involved in design that you have cultural awareness. There are certain things you need to go to. You need to have the night off. You have to be a participant in the culture. You can't lock yourself in the studio and worry about jointer knives and then create objects that have cultural significance. You have to interact in that culture and the woodshop can be extremely isolating. The fact that the Abstract Expressionists got together and got drunk every night and talked to each other was key when they went back to the studio. I need to get

Fig. 75. Museum of Fine Arts, Boston, *High Chest of Drawers*, 1989. Maple, mahogany, burl, aboya veneer, anodized aluminum, brass, and lacquer, 75 1/2 x 50 1/2 x 21 in. (191.77 x 128.27 x 53.34 cm). Photograph: Museum of Fine Arts, Boston.

Fig. 76. *William and Mary High Chest of Drawers*, 1700–1720. Maple, pine, walnut, and walnut and maple burl veneers, 63 x 40 x 21 in. (160.02 x 101.60 x 53.34 cm). Photograph: Museum of Fine Arts, Boston.

my batteries recharged. I need time to go see [Gaetano] Pesce and be hit with completely new ideas and think about what that means to me.

How did you approach the highboy [fig. 75] you made for the 1989 Museum of Fine Arts, Boston exhibition?

When I thought about the show, the original idea was to put the antique next to the new one. I thought if you take a Townsend Goddard highboy and do a new one, there's no way in hell you're going to look good. It was like asking me to put my new Rembrandt next to Rembrandt. I cannot look good next to a perfect piece! So I chose *William and Mary* because if the two pieces were put next to each other, it wouldn't totally close me down.

I liked *William and Mary* because of that huge mass on a very light base—trying to make mass float [fig. 76]. The other thing that's incredible about *William and Mary* is a very simple vocabulary. The transition from the box to the ornamental legs is in the skirt; it's the detailing in going from three-dimensional to two-dimensional. What bothers me with *William and Mary* is that they didn't pay attention to the sides of the box; sometimes there's not even burl, just second-grade lumber stuck on.

My piece would refine that more, but still keep that order, that proportion of mass to leg and reduce the transition. The transition becomes the most critical line of the whole composition. The bell form gets you from this to that. I hate the sides, so I erased the sides. It's got that incredible burl front. How can I reinforce the burl? I frame it out in black and it's a piece. It came in a night.

On my own, I would have done things differently. *William and Mary* has the two doors

Rocker, 2007. Walnut, 38 x 23 x 35 in. (96.52 x 58.42 x 88.90 cm). Photograph: Lynton Gardner.

Settee, 2011. Bubinga and cotton/linen-blend fabric, 36 x 88 x 24 in. (91.44 x 223.52 x 60.96 cm). Photograph: C.A. Smith.

Side Chair, 2011. Macassar ebony and linen, 31 x 23 x 22 in. (78.74 x 58.42 x 55.88 cm). Photograph: C.A. Smith.

on the bottom, so we'll stick with that. Get rid of the pulls, I never liked those things anyway because the veneer is so gorgeous. I stuck them over on the side and I can do that because I'm using aluminum tracks—I don't have the friction of wood on wood. With the aluminum tracks, I can pull from the side of the drawer. Somebody criticized me for aluminum glides. It's a simple move of accepting your own culture.

The Chippendale tilt-top, piecrust table was the other MFA, Boston, piece I was looking at. It's always been a favorite because it goes from function to function and it's so beautiful, with the top up, as a thing. And the Sheridan sideboard—it's very much the same thing, but a little more elegant than the *William and Mary*. It's a huge modulating mass on these thin little

Fig. 77. *Slatted Table*, 1982. Rosewood and ebonized walnut, 18 x 72 x 48 in. (45.72 x 182.88 x 121.92 cm). Photographs: Andrew Dean Powell.

legs. It's a beautiful piece to me. If I were to attack another one, that would be the one I would attack.

Going back to your slatted-top table [see fig. 77, p. 308], were you working against anything in the design process?

Two things: One was all that tapered lamination with Jere in school. You'd see millions of these articulated slats before they got glued up. So part of it was thinking, 'Why do I have to glue these things up? These are kind of neat as they are.' And the other thing is that I've always hated glass-top tables, but I've liked translucency. So it was very much a "how can I approach translucency and rhythm without the glass" answer. It has the Japanese thing, too, the lashings, the primitive against this other part. The rosewood table plays that game very well.

I like the whole idea of mass that isn't: the *William and Mary* thing—it's very heavy but doesn't look heavy because of the way it stands. The slatted table involved a huge sheet—the rosewood was a five by five square—but you could see through it, so it's not oppressive. Mass that isn't mass. It goes back to Rothko—huge blocks of forms that float and others that are heavy. The chairs that have a little bit of a wall in them, the environmental kind of thing, very simple [see fig. 73, p. 299], the richness or nonrichness of material; green bamboo against black lacquer; poverty against elegance.

What else? I'd like to have a studio. I'd like to have a home. I'd like to have relationships and not be in the shop—to have an assistant and be a designer and a creative person, not a manufacturer, to have a lot of friends. We talked earlier about this very isolated person. I adore socializing and talking, finding people I enjoy; it is good fortune to be with those people. My life is very much now about people, whereas in the past it was always the studio. I don't want that. I want to work hard, talk hard, and think hard.

I don't really know how people see me. I guess I've been around long enough that people know I exist. For the amount that I talk, some people are waiting to see if he ever will do what he talks about. What have I done this year? Where is the work? Where's the meat? That's part of what people are paying attention to. I will stay socially or historically where I am now, a little bit out of the group.

East Hampton, New York
February 1991

Couch, 2012. Bubinga and cotton/linen-blend fabric, 35 x 96 x 35 in. (88.90 x 243.84 x 88.90 cm). Photograph: C.A. Smith.

AFTERWORD

In reflecting on the past 20 years, what surprises me is not what has changed, but rather what has not. Yes, the digital revolution is dramatic and the recession has affected all of us. But I still wake up, have a coffee, and go to the shop today as I did 20 years ago.

Craft is a quiet field. It's not a career fueled and fashioned by public recognition, but by a series of individual relationships. Each object has its own story. My days are spent thinking of what furniture has been and what it could be. I try to understand my medium more clearly, to be aware of the unique and beautiful qualities that deserve to be respected. And there is the endless goal to improve one's craft, increase the skill of execution.

In the end, what is important is the poetics of the object. This struggle is the same today as it was in the past. One hopes the object will provide joy to its owner and, more difficult, feel successful to its maker. Some pieces are better than others, but all have their place in the series of experiences. And this series of projects, each presenting its own problems to solve, creates growth—one step at a time.

Each day starts with a coffee, each day with its specific tasks and trials. Each piece of wood is unique. As is each object. As is each day. And so it goes. I get older, but the excitement, the frustrations, the surprises remain the same. String it all together and call it a life—and it's okay.

Hoboken, New Jersey
September 2011

James Schriber, *2-Door Cabinet*, 2006. Cherry, painted poplar, and plexiglass, 76 x 32 x 18 in. (193.04 x 81.28 x 45.72 cm). Photograph: John Kane.

ACKNOWLEDGMENTS

We are indebted to the 14 furniture masters in this book for sharing with us their stories and their reasons for doing what they do. By the same token, we are indebted to the clients who chose to live with this kind of furniture and, by so doing, marked the first essential step in its provenance. Both the makers and the clients have been an indelible part of our lives for more than 30 years. After our first decade, our client and friend Mark Levine said to us, "You have to tell these stories." His prompt became the springboard for the conversations that compose this book.

We benefited mightily from our collaboration with two fine professionals: graphic artist Diana Zadarla, who established the format for the book and worked diligently to restore the hundreds of images found herein, and editor Jonathan Binzen, who handled the text in an intelligent, thoughtful manner and resolved how these conversations would read. We are extremely grateful to Janet Koplos and John Kelsey for their seasoned advice and constructive criticism that has made this a better book and us better writers. To David Welter and Kevin Shea, sincere thanks for their tireless, good-natured sleuthing of our many requests for images and data to complete the Krenov chapter. We also acknowledge the early contribution of Peter Joseph, who, together with us, did the first round of edits of the transcripts. In addition, we thank Edward (Ned) S. Cooke, Jr. for the Foreword essay, "Defining the Field," and Roger Holmes for the Introduction essay, "A Few Thoughts on What They Say."

Thanks, too, to Andrew Glasgow, Stoney Lamar, and Alf Sharp, the trustees of The Furniture Society, and The Windgate Charitable Foundation for the vital role they played in making this publication possible. We also note with appreciation the role that Michael Sonnenfeldt, a longtime friend of the studio furniture field, played in securing a Goldman-Sonnenfeldt Foundation, Inc., grant for *Speaking of Furniture*. Gratitude is also extended to Leslie Pell van Breen, founding director of The Artist Book Foundation, who believed in the value of this book from our very first conversation. There are others, they know who they are, who have provided invaluable advice and unwavering encouragement along the way, without which we—and this book—would surely be less.

Bebe Pritam Johnson
Warren Eames Johnson
East Hampton, New York
April 2013

Stepping Stones

Bebe Pritam Johnson and Warren Eames Johnson, 1981. Photograph: Leif Hope.

In 1981, Bebe and Warren Johnson opened Pritam & Eames in a nineteenth-century steam laundry building in East Hampton, New York. The Johnsons describe the stepping stones that led to their discovery of the emergent field of studio furniture in the late 1970s. They tell of the documentary film project they worked on together in France in the 1960s and how that experience gave them the confidence to open an ambitious new business, a gallery of contemporary studio furniture on which their future would depend.

Nineteenth-century steam laundry building, future home of Pritam & Eames, East Hampton, New York, 1979. Photograph: Warren Johnson.

Bebe: Warren and I met as juniors in a philosophy class at the University of Illinois in 1960. We were both from the Midwest, but by the time we met, he had lived half of his life in Africa and Sweden, as a result of his father's business. I had not yet seen an ocean, had never been out of the Midwest. Although our backgrounds were as different as could be, the attraction was immediate and mutual. A few years later, I was beginning graduate work in communications and Warren was going through law school as quickly as he could. At the time, we had a notion that we would be involved in something international, something that would demand legal and communication skills. He finished law school in 1964 and spent the summer in Chicago studying for the bar. While he studied that summer, I boarded a chartered Sabena flight for my first trip to Europe—to see in person what my French books were about.

Warren: After law school and a year of graduate economics at MIT, I was working at Chase Manhattan Bank on Wall Street and getting an introduction to international trade. I worked on a study of export receivable financing, and this led to a job offer—a writing position with Business International. These were terrific people; I should have been overjoyed. But things were shifting. I'd been taking an evening course in film writing at The New School and when my teacher, Harold Flender (*Paris Blues*, *Rescue in Denmark*), urged me to apply to Columbia's film program, I decided to do it. Bebe was quickly adjusting, supportive but quietly questioning—it was a head-spinner.

Columbia's film program was on the second floor above storefronts on Amsterdam Avenue. This said much about our status within the university. But if there was nothing special about the classroom, the mood at the end of Bob Lowe's first lecture on filmmaking was almost explosive. He assigned each of us to return to the next session with an edited-in-the-camera sequence. We were thrilled—what a start. "Don't have super-8 equipment? Go buy, borrow, or steal it: you have to be resourceful in this field." After so many years in school, how many inspirational teachers had I met? Not many. But Bob Lowe was one of them.

Bebe: I got my first sense of who I might become when my seventh grade art teacher got me a scholarship to The Art Institute of Chicago. Every Saturday morning that summer, I would take the bus down Michigan Avenue and join, as its youngest member, the studio art class in the museum. It didn't take me long to see how experienced this group of artists was and that I, with no training, didn't belong. However, I learned three valuable things from that museum experience—two were drawn from the studio art class. First, even though I felt I didn't get it, I could recognize those who did. Then, I learned that I liked being around them.

Massachusetts Living Room and Kitchen, 1675–1700, Thorne Miniature Room, The Art Institute of Chicago. Photograph: Unknown.

The third discovery came in another part of the museum, in the basement near the cafeteria. In a large, darkened space, there were 65 or so miniature rooms built at one-twelfth scale that replicated European and American interiors and furnishings from the late thirteenth to twentieth centuries. The project was the brainchild of Mrs. James Ward Thorne, a Chicago socialite, who commissioned local craftsmen in the 1930s to create these rooms. I was intensely interested in these vignettes. To me, the furniture stood as mute witness to the comings and goings of the occupants who, I imagined, had just left the room and would return momentarily. Drawn back again and again to these tiny evocative interiors, I became aware of the power of furniture to stir my feelings.

By the time I discovered the Thorne rooms, I had attended six different grammar schools in Denver, St. Louis, and Chicago. My single mother worked and she placed me with different families who were modestly reimbursed to house me. There's little doubt that the unsettled nature of my childhood accounts, in part, for the importance I attached to furniture and the home as anchor.

Warren: New York was film heaven in the late 1960s. Lincoln Center's annual film festival was the peak of excitement: "Look over there! Isn't that Godard with Anna Karina?" While I was in film school, I worked at The Museum of Modern Art repairing prints of old movies, which would be shown in the spacious public screening room. Every weekend, we keepers-of-the-prints would smuggle out a few classics for film soirées at Mimi's place in the West Village. The New Yorker Theatre on Broadway was a short walk from our Upper West Side apartment, and then there were the film showings at Japan Society's great new screening room—for someone who loved film, this had to be the perfect place.

Bebe: Almost immediately upon landing at the Brussels airport, Jean-Louis and I became friends. He was the European director of a Kansas City, Missouri–based organization that offered European home stays to mostly Midwestern students for a modest price. In addition to arranging home stays, he was a jazz impresario, a bassist, a superb cook, and knew all the cool American musicians touring Europe at the time. Jean-Louis, as it turned out, would usher us into important phases in our lives.

A year later, it was Jean-Louis who told us about the Fondation Maeght, providing Warren with the spark for his first documentary. Aimé Maeght was a Parisian art dealer who had opened his Paris gallery in 1945 with the work of Bonnard and Matisse, both of whom he befriended in southern France during the war. Maeght went on to represent Miró, Calder, Chagall, Giacometti, Leger, Kandinsky, and Braque—everyone but Picasso,

Warren and crew filming in New York City in the 1960s. Photograph: Bill Markson.

Galerie Maeght, Paris, France. Photograph: Unknown.

whose inclusion, it was said, was vetoed by Braque.

Jean-Louis told us that Maeght had just opened a very interesting museum called Fondation Maeght in the south of France. José Luis Sert, dean of Harvard's graduate school of architecture (and a Catalan compatriot of Miró) had designed the building and gardens. Maeght and Sert had collaborated with the artists most closely associated with Maeght's Paris gallery, so the museum had mosaic pools designed by Braque and fountains by Miró. In the museum's café, the bronze furniture was by Diego Giacometti; Alberto Giacometti's tall walking bronze figures filled the courtyard, the fourth wall of which was open to the sea.

Warren: Near the end of film school, one of my classmates said, "I've got a little money that I can invest in a film project. I'd like to do something with you." I described the Fondation Maeght to Bill, and we agreed that would be the film. Bebe wrote Maeght in polite but basic French and asked to meet with him. He did not respond. To our minds, that didn't mean "no." We went to see Sert in Cambridge. "Maeght won't answer your letters," Sert told us. "If you want to talk to him, go to Paris." Bebe and I bought two cheap airline tickets and left for Europe the following week.

Bebe: Jean-Louis and his partner, Monique, had recently opened a store for high-end Scandinavian- and Italian-designed furniture in a stylish section of Brussels, and they took us to see it. We were completely focused on our upcoming unscheduled meeting with Maeght, but there was something about their store that connected: It seemed like a familiar place. I saw how they arranged the furniture to suggest vignettes, and this was appealing.

Warren: When you travel together, you learn things about each other. Driving in Paris, I couldn't figure out the rules—what were the French doing with those giant rotaries? Bebe had no problem. She saw it like fish in a stream: you just flow in and around. I was okay figuring out the maze of rues and boulevards on the map, so Bebe did the driving in Paris while I navigated. This was a talent we discovered we had: quickly figuring where the strengths lay.

Bebe: We arrived at Maeght's Paris gallery unannounced and, being young enough to take a lot for granted, we were not especially surprised that he received us. I had never been to a gallery before; I was impressed with the photographs of Maeght with his artists that lined the shelves in his office. He listened as we explained our film project in fitful French.

Alain Resnais (*Last Year at Marienbad*, *Hiroshima Mon Amour*), Maeght told us, would do the official film on the foundation. But then, perhaps more amused by our youth and earnestness than persuaded, Maeght gave us what we came for: access to the foundation to make our film.

Giacometti garden. Photograph: Warren Johnson.

Fondation Maeght, St. Paul-de-Vence, France, 1966. Photograph: Warren Johnson.

Warren: We arrived at the Fondation Maeght in St. Paul-de-Vence late one afternoon and soaked up the scale of the project that lay ahead of us. Outside the galleries, the grass-covered expanse with its view of the sea was dotted with Mediterranean pine and dominated by a large Calder stabile. Sert had created a series of external spaces and interior galleries, each dedicated to a specific artist.

Pathways from the exhibition building led you to courts and gardens set with sculpture. Sert's building invited and channeled the rain and light, and his plentiful use of local stone linked it to its site in the foothills of the Alpes-Maritimes. Inside, individual rooms were labeled "Salle Kandinsky" or "Salle Chagall." The feeling was intimate, one of close collaboration rather than a distancing curatorial hand. This we had to try to express in a series of shots structured into sequences with intervals of interviews where voice took over the intimacy.

We needed a place to stay. St. Paul-de-Vence had been discovered and was way beyond our budget, but a friendly voice at the Bureau des Journeaux suggested the nearby village of La Colle sur Loup. There was a small, new pension there, and this turned out to be where we happily put down our bags for the next four months.

Warren filming at Fondation Maeght, St. Paul-de-Vence, France, 1966. Photograph: Peter Brown.

Monsieur, Bebe, and Madame, Pension at La Colle sur Loup, France, 1966. Photograph: Warren Johnson.

Madame kept the terra-cotta floors spotless and Monsieur (we never did learn their last name) tended the vines in his garden below the dining terrace, fed his cooing doves, and cooked lunch and dinner for his three or four tables of guests. Situated on our spacious second-floor terrace, in our canvas deck chairs with the portable Olivetti propped up on one of our laps, we began the work.

Bebe: Warren's classmate Bill spoke functional French, so the plan was for him to act as interpreter as well cameraman on the film. Warren would do the directing and sound. I would share the writing with Warren and be the all-around production assistant. The three of us were to be coproducers. But from the time of his arrival in France, Bill seemed to be a different person and the partnership quickly became rocky.

Warren: We were working in the Miró room of the Fondation. The natural light traps that Sert had created in the ceiling illuminated the color-saturated, calligraphic paintings by Miró on the walls. Bill was setting up the Arriflex camera for the introductory shot. I had to think about the transition to the next sequence and went to the outside corridor to find Bebe. The sound from behind me was sickening. Turning, I saw the Arriflex lying on its side on the tile floor, its lens housing shattered. Where was Bill? He had stepped away before securing the tripod!

When Bill dropped out of the project a few days into shooting, we were left with dwindling resources, a broken camera, no tracking equipment, and a lineup of interviews in the coming weeks that included Chagall, Miró, and Maeght himself. We also had to prepare for the tricky nighttime shooting of a performance by John Cage and Merce Cunningham in the Giacometti courtyard.

To even begin thinking about getting another Arriflex meant waiting in line in the local post office while the operator placed the international call to Munich. I would then be assigned a booth. It was a humiliating call to make because Arriflex had already extended itself to us by providing a camera without its customary six-month wait. At least I had privacy to make the call.

Shortly afterward, we had the good fortune to meet some Frenchmen in the film industry in Nice who went out of their way to help us acquire the equipment we needed. I was now cameraman and director. As Bebe pushed the dolly that carried me, the camera, and the tripod along the tracks, Maeght would stroll by with his summer guests and smile.

The film had to be processed in Paris, which meant crossing the Alps again to review the resulting rushes; we coasted downhill to save gas. I found the hotel in Paris I knew from my student days and it was as frugal as I remembered. In the room, we sat on the bed and, under the only light, used a pencil to unspool the first reel of rushes to see if we had images.

Architectural drawing of Japan Society, New York City. Photograph: Japan Society.

Yuri Kuri (center) with production assistant and Bebe, Tokyo, 1969. Photograph: Yasuo Inouye.

The film project was a test by fire and its demands forced us to reach deep into ourselves for energy and resourcefulness. We did finish the film and Grove Press in New York distributed it. Most important, the whole experience taught us that we could work together under pressure and create something we valued. Years later, when we took a leap and started our gallery, we drew on what we learned that summer—that if we had faith in ourselves, we could succeed.

From the mid-1960s to the late 1970s, we lived in New York City. Our apartment, a third-floor walk-up on West 90th Street, had a Pullman kitchen and since I had taken over cooking duties, it was really my space—one of continuing adventure. Jean-Louis, who had inspired us with his zest for cooking, gave us a copy of *La Cuisine Est une Jeu d'Enfants*. And the *New York Times* opened trails leading to the fragrance of freshly ground curries, apartment-born paella, and couscous. We especially ramped up the exotics when my mother visited—she loved things spicy. She must have slept on the couch, which converted into a single sleeper. Undaunted by my lack of training in woodworking, I had built the couch myself with some mahogany boards. My grandfather had made furniture—this gave me the idea that it could be done. Anyway, that couch accommodated an amazing number of friends and relatives in New York.

For a paycheck, I was reverse commuting to Connecticut where I worked for a three-person media company disarmingly called Mass Communications. It was a small firm, but one that kept a suitcase in my hand and a passport in my pocket. Bebe was working for an educational nonprofit. Her job entailed its own social life as well as travel. Life was full of new situations and excitement, but these parallel tracks would eventually make their demands.

Bebe: It was a delicious feeling each morning as the familiar rectangle of the United Nations Secretariat slid into view through my cross-town bus window. I was director of Asian Program Operations for the Council on International Educational Exchange and my office was across the street from the UN. The council was a federation of universities, colleges, and secondary schools, all of which had study-abroad programs. When I joined the council in 1965, it had just opened its Tokyo office and begun a trans-Pacific flight program to carry American and Asian students to their overseas study sites. My boss was in charge of this northeast Asian operation and he trained me to direct what would become a $5 million program. I learned that I work well within a perceived structure—and what clearer structure than an aircraft's configuration? Three hundred and sixty-five empty seats: fill them.

I also liked playing big sister to the departing students and the airport staff at Oakland International would let me stand outside with them on the tarmac as the opening whine of the jet's turbines signaled the warm-up before the big plane thundered down the quiet runway. Occasionally, I'd board the last flight and, 14 hours later,

One Day in Color, a Warren Johnson production, on set with filmmaker Manny Kirsheimer (camera), NYC, 1971. Photograph: Bebe Johnson.

arrive in Japan to work on the following year's program with the Tokyo staff. Warren and I traveled a lot throughout the 1960s and 1970s, often in different directions.

The council's representative in Tokyo was a North Carolinian who spoke fluent Japanese. He was also a stickler about his native language. *The Elements of Style* was my bible and our friendship was born through the exchange of inter-office correspondence. I loved getting his memos in which he would correct our memos. A little earlier, as I was finishing graduate studies in communications at Boston University, I had imagined myself to be a promising, but undiscovered, writer. These ambitions were fueled when Anatole Broyard, who was then teaching writing at The New School in Manhattan, invited me to join his group of established writers, which met weekly at borrowed East Side townhouses. The group was filled with older, more experienced writers—it was intimidating and I doubted I belonged.

At the council, I worked long hours and, with my good-natured part-time assistant, managed the U.S. side of the operation quite well. I found it easy to move between the nonprofit world of universities and colleges and the commercial world of airline negotiations and contracts.

I often represented the council at public events—conferences and openings—and enjoyed the role. I can still feel the smooth coolness of the Emilio Pucci silk tunic that I wore to my first opening at Japan Society's Gallery in Manhattan. It cost nearly two weeks' pay. But it was at the gallery's stunning exhibitions of Japan's material culture—folk art, ceramics, samurai swords, kimonos, and screens—that I began to understand how presentation can affect the power of the object.

It was also at Japan Society that I was introduced to George Nakashima's furniture, which looked handsomely at home in the elegant Junzo Yoshimura building. Meanwhile, Vietnam was a constant presence in our lives during those days, but, inexplicably, greetings never arrived from Warren's South Side of Chicago draft board. Otherwise, it was a good time to be in New York. John Lindsay was elected mayor in 1965 and this young, handsome patrician brought a moment of palpable optimism to the city. It wasn't long, though, before there was fresh urban chaos: strikes, blackouts, brownouts, Tombs riots, break-ins, and assaults; it was so tense on the street that coming home late or walking the dog at night was a hair-raising adventure.

One day in the spring of 1972, we strapped a 4-foot wood cradle onto the roof of our red Scout and made the two-and-a-half-hour drive east to Long Island and the old fishing village of Sag Harbor. The cradle was painted a bright baby-boy blue; its long sides were made of bent doweling and each end had a "Wings of Victory" cutout. Warren had made it in our apartment to celebrate the birth of our good friends' first child. They had made the transition from New York City a few years earlier. After the cradle delivery—the first of many furniture deliveries as it turned out—we lingered in the area before heading back to the city.

We explored nearby East Hampton and the moment we made the left-hand turn off Route 27 onto Main Street, I knew we would live there. Town Pond is on the right as you enter the village and, as the bend straightens, you get the first glimpse of the gracious colonnade of elms lining Main Street.

Being from the Midwest, we didn't question the flatness of the land or the number of working farms that still thrived just 90 miles east of New York City. What was revelatory, though, was the nearly 360-degree surround of

water—the ocean and bays—and the brilliant, shimmery light of the East End. It was the quality of the light, we were told, and the proximity to New York that had lured artists and writers to the East End for decades. In the coming years, the Hamptons would become synonymous with excessive wealth; at that time, though, there were only quiet indications. The village seemed like a nineteenth-century watercolor—simple, unpretentious, and very much at home in its loamy environs.

By the mid-1970s, my long workdays at the council were adding up and the city seemed a tough place to have a family, which we now knew we wanted. I had always lived in cities and had always worked; I got panicky at the thought of giving up the familiar din of urban life and living without the structure of a daily job and the security of a modest, dependable paycheck. But I had to admit that a change was in order. Our options were becoming clearer and fewer. The one that we kept returning to was to find a project we could do together; we wanted to work for ourselves, not others, although we didn't know what that project would be.

In 1975, while visiting our friends again, we came upon a small house that had stood unused and uninsured for two years and was begging for repair: perfect. We got a 30-year mortgage and bought it for $32,000. Our older neighbors, who owned the men's clothing store in town, leaned over the fence and said, "You paid too much." Two years later, I discovered I was pregnant with our daughter. This made the path clear and it pointed to East Hampton.

Warren: Once we made our decision to leave New York, we followed a series of stepping stones. During my Connecticut film production days, I went to see John Kelsey, then-editor of *Fine Woodworking* magazine, to pitch a documentary short film. Sweeping aside the question of the documentary, Kelsey said that what was really needed was representation for American independent furniture makers. "There's a lot of fine furniture being made on the East Coast," he said, "but there's no place to show it. The entrepreneurial end of this field is wide open." I sensed immediately that this was the project we were seeking.

Roitman & Son, Inc.
and
Prof. Tage Frid and John Dunnigan
of the
Rhode Island School of Design
invite you to a
Preview Showing
of an Exhibit of Unique
Handcrafted Home Furnishings
including furniture, accessories and textiles
By Southern New England Artists
Sunday, October 12, 1980, 2 to 4 p.m.
in the South Gallery at
Roitman & Son, Inc.
161 South Main Street
Providence, Rhode Island
The exhibit will be open to the public during Roitman's regular store hours October 13 through November 15.

Kelsey took the time to sketch an outline of the history of this "new" furniture field, explaining how the movement started in the early twentieth century with the solo shops of people like Wharton Esherick, Art Carpenter, Sam Maloof, George Nakashima, and James Krenov, all of whom approached furniture as a means of personal expression. Kelsey described how this movement took on academic backbone through adoption by college curricula after World War II. At the end of the meeting, Kelsey put two publications in my hand: *Fine Woodworking's Design Books I* and *II*, and said simply, "You should look through these." They contained photos of furniture by a great many creative makers, all of them needing a market.

Bebe and I compiled a list of names, drawing from these and other sources, and drafted a letter of introduction. Then we needed our first tool: business stationery. We drove to see a printer in Sag Harbor to order our first ream, and that six-mile trip made it real to us that we were in business. We typed letters to 50 furniture makers describing our plan to open the gallery and asking if they would submit photos for us to review. We got one reply. It came from Tim Philbrick, who told us (with echoes of José

Bebe with daughter Rani, East Hampton, NY, 1980.
Photograph: Warren Johnson.

Luis Sert), "Furniture makers don't write letters; if you want a response, you have to go visit them."

Philbrick also suggested we see an exhibition at the Roitman furniture store in Providence, Rhode Island. There, we encountered our first collection of furniture from a field that would become known as studio furniture. This would lead to meetings with Hank Gilpin, John Dunnigan, and George Gordon, as well as Tim Philbrick.

Two other field trips proved equally inspiring. The first was to the Program in Artisanry at Boston University, where we met the program's acting director, Jere Osgood. Soft-spoken and friendly in manner, he sat us down in a bare-bones college office and loaded up a slide carousel. Before starting, he gave this advice: "The most important part of your business will be communications." Then he turned on the projector, and we got our first look at work by Alphonse Mattia, Thomas Hucker, James Schriber, and Michael Hurwitz. Jere's own furniture was already well known, but he did not include any of it in this showing. Of importance, though, he had slides of work by a friend of Alphonse and Rosanne Somerson: her name was Judy McKie.

The second trip was to Philadelphia in 1980, and it gave us our model for quality of exhibition and selection. Dick Kagan's furniture workshop on South Street had a storefront window and retail space filled with his own work and work by peers he admired. There we saw pieces by Jon Brooks, Michael Hurwitz, Ron Puckett, Ed Zucca, and others. It's difficult now, after all the exhibitions and publications in the intervening years, to describe the visceral excitement Kagan's gallery gave us. It was gemlike. We were thrilled by this potent combination of original vision and superbly accomplished craft.

Closer to home, we came across Warren Padula's Bridgehampton Rocker in a home furnishings store on Long Island. He had attended the Rhode Island School of Design's furniture program and said schools like RISD would be a great resource for us. He was right—20 percent of the makers in our opening show had RISD connections. Furniture maker Peter Korn, who lived near East Hampton at the time, gave us a copy of James Krenov's influential *A Cabinetmaker's Notebook* to read. Our plans were beginning to take shape: what we needed now was a space for the gallery and a travel plan to meet the furniture makers whose work we wanted to represent.

During this time, Bebe and I would be taking turns in our duties of parenting, cherishing the early years with Rani, knowing that she was going to be our only family. It was tremendously ideal. We were smart enough to know how to make meager dollars stretch, realizing so much of any endeavor has to do with circumstances playing in your favor. The tax burden on the house was modest. We could stretch a single fish and a single chicken into food for a week. We lived extremely frugally, but never felt deprived. We were just careful. Materially, we weren't living any differently from the people we would come to represent.

Bebe often enlisted her mother to babysit for Rani as we embarked on a series of road trips to the shops, studios, and homes of furniture makers throughout the Northeast, many of whom we would end up representing for the next 30 years. We came to them with no background in the field, no retail experience, no five-year business plan, no spreadsheets—just a gut conviction about the intrinsic worth of their work. For us, it simply required no translation. As far as the business side of it, this was going to be our livelihood; there were no other means of support. We said, "Give us a space, don't put downtown pressures on us, let us have a little time, and, you know what, we'll find others who see what we see."

Bebe: I put 2-year-old Rani in the jump seat on the back of my bike and we headed toward the paint store. En route, we saw people milling around an open, barnlike door in a whitewashed building. A local artist, Leif Hope, had recently bought East Hampton's nineteenth-century steam-laundry building. We went inside to take a look. Leif was busy setting up an exhibition of paintings in his new space: *Women Artists at the Laundry*. He came over, gave Rani and me a hug, and said, "Stay in touch." And that is exactly what we did. Before long, his laundry building was our new gallery's home.

The back street location of this building, coupled with its reasonable rent, was going to fit our business exactly because it meant we could grow at a manageable rate. We were confident that, with the quality of work we would represent and with some local publicity, the naturally curious of the East End would seek us out. We got one of the last Small Business Administration loans to help women and minorities get started in business; we also got several small, friendly private loans. We were ready to take the plunge into a business of our own. The name Pritam & Eames came easily enough—Pritam is my maiden name and Eames is Warren's middle name.

Warren: We took the long trip to Rochester, New York, in part to visit Newell White, whose floor lamp we had admired in *Design Book II*. He said he would be pleased to be included in our opening show and promised to remake his remarkable lamp. And after a pause he said, "I want to introduce you to the best craftsman I know—maybe the best in this country—Richard Newman."

Ruff Alley Woodworks was an accurate description of the Rochester neighborhood of Newman's shop. Inside, Newman's brilliant work underscored the irony of this rough origin. A mahogany blanket chest, still shimmering from its recent coat of oil, was as much a modern take on the oxbow form as it was a belly dancer's contour [see p. 135]. A small end table was coolly geometric in shape—a graphic sensation in Macassar ebony [see p. 132].

Richard talked rapidly and passionately about the chemistry involved in using heat as a catalyst for setting the glue in vacuum veneering. Bebe and I barely hung on to the edges of this contemporary alchemy, but we were dazzled by the work.

Bebe: We visited Wendell Castle's studio in Scottsville, just outside Rochester. He was in California at the time, but his business manager cheerily showed us around the impressive studio and grounds on a gorgeous fall day in upstate New York. Passing through a storage area, I spotted a walnut and elm-burl game table on a high shelf. I knew I had to have that game table, with its four chairs, for our opening show. Outside, we followed the manager into the ceramic studio of Nancy Jurs, Wendell's wife. Nancy walked in. "Up here enjoying the fall foliage?" she asked with a smile. She had quickly read the purpose of our visit and her admonition to us was succinct: "Wendell will not consign works to an untested gallery."

Understandably, she was protective of Wendell's time and effort. Nevertheless, when we got home, we worked diligently on our letter of introduction, and Wendell replied, "Yes, I'll let you have that table and chairs for your opening" [see p. 54]. Apparently, there had been some conversation among Rochester-area makers that we should be supported. We recognized that Castle brought the attitude of a sculptor to furniture and we welcomed exposing this aspect of furniture making even though his work was clearly directed toward an arts audience.

Friends at Japan Society arranged a meeting for us with George Nakashima in his New Hope, Pennsylvania studio. In marked contrast to Ruff Alley Woodworks, there was a cultivated serenity to the surroundings there, both inside and out, and a thoughtful arrangement of objects placed for quiet viewing and appreciation. The meeting with Nakashima was cordial; his prominence in the furniture world was by then firmly established, and it was apparent how practiced he was in receiving guests.

Toward the end of our visit, a phone rang from inside the house. His wife came in and said something quietly to him; Nakashima rose slowly and made his way to take the call. He let us know afterward that the caller was

a member of the Rockefeller family who wanted furniture. He clearly enjoyed that. Although Nakashima did not work with galleries—he had no need to—he agreed to let us have a Conoid Chair in Persian walnut for our opening.

Warren: There were certain makers whose commitment of work to the opening show gave us a special assurance, like a major stake in the ground to hold up the tent. Nakashima and Castle were two; another was Judy McKie. The 1979 *New Handmade Furniture* exhibition at the American Craft Museum had established her career nationally. Her studio was in the New Hamburger Cooperative on Emily Street in Cambridge, Massachusetts, and the co-op also included such makers as Mitch Ryerson, Jon Everdale, and Michael Hurwitz.

When we visited New Hamburger, we talked first to Michael Hurwitz. He was interested in our plans and excited to tell us about his new idea for UPS-able pieces of furniture. He showed us a small cherry side table with drawer design [see p. 277] he was working on and said, "See, this will fit into a regular carton and can be shipped anywhere. No problem." In our naïveté about what lay just ahead, we thought this concern about transport a little esoteric, but the table was a knockout. In the years to come, we would find that this enthusiasm was always a part of Michael; it might be focused on an upcoming trip to Japan or the Dominican Republic, or it might be about bent laminations or mosaic tile work, but it was always there.

Judy's bench was in the main work room where there was a good deal of back-and-forth activity. It was difficult not to find yourself talking with more than one person at a time. In these challenging conditions, her quiet centeredness was remarkable. We knew that Judy's background was in the arts and we wondered whether our vision for a gallery would appear sketchy to her. She already seemed comfortable with what she was doing and what her work was about. But she agreed to give us a carved blanket chest and a console table for our opening show. As we discussed the details, I glanced at my watch and realized we were late for our ferry back to Long Island. We just have to leave. Wait. I forgot my Nikon. There it is. I was aware that Judy was regarding me with a look of concern. Knowing her better now, I realize this was a look of sympathy. But at the time, I could only think of how disorganized I looked.

Before we met Hank Gilpin, we had heard about him. He was described most often as a "Krenovian." I would shake my head at this later; there was nothing of the quietism of the Krenovian approach in Hank's personality. But there was this in common: his designs had to be fresh and were never separated from the wood he intended to use. Hank had investigated complex techniques early and had come down firmly on the side of simplicity. He couldn't tolerate anything second rate in his own craftsmanship or that of his colleagues.

His coffee was great and drinking a cup was the first thing you did on a visit to his Lincoln, Rhode Island shop. In our first meeting, Hank spent an hour tearing into galleries and decrying the harm they could do to the field. Obviously, he had given the subject some thought. There was no "sell" here. Once he had had his say, the meeting was pretty much over. Outside, Bebe and I exchanged looks and shrugged. "Can't win 'em all." We took a last look at the small church he had converted into a home and workshop, the building set off by a cow pasture behind and a limestone quarry to one side—certainly a forceful energy about this person inside. Getting back to East Hampton sounded good. Hank called two weeks later. "I'm making five pieces of furniture for your opening. Can you handle it?" In the ensuing years, we would sell hundreds of his pieces.

Bebe: We didn't meet Jim Krenov before the opening, but when he visited the following year, we were there to greet him when he got off the bus in East Hampton. At the time, we weren't aware of his mercurial temperament or his ability to empty rooms with a single harsh sentence. He arrived predetermined to like us, which made me a bit uneasy. But over a fine, Warren-prepared meal, Krenov and I began a wide-ranging conversation that lasted, interrupted by occasional fits of Krenovian pique, for 25

Jere Osgood, Bebe, Bruce Beeken, Hank Gilpin with daughter Michaela, *Pritam & Eames* opening, May 1981. Photograph: Warren Johnson.

years. He brought a refined European sensibility to the discussion, whether about furniture, poetry, or music; at his best, he was unbeatable.

I was at home that afternoon in mid-May when Warren and our artist friend Elwood rolled into town in a rental truck packed with the last pieces for the opening. The gallery was ready inside; outside, a sign proclaimed: Pritam & Eames Handcrafted Furniture. We had only to unwrap and place the work.

For the opening, on Memorial Day 1981, there was a generous spread provided by Soho Charcuterie, a landmark restaurant owned by two pals of ours in New York. Hargrave Vineyards, Long Island's first, sent a congratulatory case of their first varietal offering. Japan Society friends and my sister arrived to help serve and steer those who stopped by. By late morning, the furniture makers arrived with their partners, spouses, children, and friends, and fell into easy conversation with one another. Two things were obvious from the start: the in-built camaraderie among furniture makers and their love of a good party. And yes, there was a constant stream of East Hampton's famously curious residents who had to see what this was about.

DEFINITION OF TERMS

afromosia	*Pericopsis elata*, a valuable African hardwood.
arris	The sharp edge or salient angle formed by the meeting of two surfaces, especially in moldings.
carcass	Typically describes the enclosed volume of a furniture piece, especially as in cabinets and chests.
cocobolo	A Central American tropical hardwood (*Dalbergia retusa*) used mainly for knife and tool handles.
compound stave and shell construction	The creation of a larger three-dimensional surface from individually shaped staves or laminates, usually joined at an angle to create an overarching curve to the surface.
double tenons	Two identical tenons, tightly spaced, used to strengthen a joint that will be subjected to repetitive stress. See *mortise* and *tenon*.
doussie	A highly figured wood of the genus *Afzelia*, native to tropical Africa and Asia.
dovetail	Used particularly in drawer construction, it is a type of joint using "pins" cut in the end of one board that interlock with "tails" cut in the end of a second board. Both pins and tails are trapezoidal in shape and, when glued, require no mechanical fasteners.
drill press	A motorized drill with a rotating bit that is mechanically engaged in a piece of wood or metal and held steady by the drill press's work table.
ebony	A dense tropical hardwood, usually from the genus *Diospyros*, almost black in color, found in Africa and the East Indies, and popularly associated with a piano's black keys.
jointer	A woodworking machine that removes material along the edge and/or face of a board to create a flat plane.
lathe	A woodworking machine that rotates a length of wood at high speed allowing the operator to remove material and produce round objects of varying diameters, such as spindles, decorative posts, and wooden bowls.
marquetry	Differently toned woods used to create imagery or patterns on a wood surface. The woods are veneer thickness and jointed together with a specialized saw.
mortise	A hole in a wood member, either rectangular or with two opposite sides rounded, to accept a similarly shaped tenon and create a joint. See *tenon*.
ormolu	Golden or gilded brass or bronze used for decorative purposes.
padauk	Several species of trees of the genus *Pterocarpus* that are found in the tropical regions of Asia and Africa.
plane	A hand tool used to smooth or flatten the surface of a board.
6-axis robot	A machining robot that is programmable and able to do six completely different movements, either individually or all at the same time.
slot mortiser	A power tool used to create slot-shaped mortises into which biscuits, loose tenons shaped like oval disks, are inserted and, when glued into the mortise, create a strong joint commonly used in built-in cabinet construction.
spalting	A wood coloration, especially in lighter-colored woods such as maple, caused by a variety of fungi. Spalting most often occurs in dead trees, but can be present in living trees.
spokeshave	A draw knife or small, transverse plane with end handles for shaping and smoothing convex or concave surfaces.
stacked laminate	Layers of wood glued together to create a larger whole that can be carved or sculpted.

table saw	A woodworking tool with a circular saw blade that protrudes above the surface of a table that provides support for the wood to be cut; used to make straight cuts in boards.
tambour	Doors most recognizable from their use in rolltop desks that are normally constructed as a series of fabric-backed, linked slats that retract into the desk; these doors can operate vertically or horizontally.
tapered lamination	A series of thin, individually tapering strips of wood glued one to the other, face-to-face, typically over a curved bending form, producing a curved, tapering element.
tenon	A shaped projection at the end of a wooden construction member (e.g., a beam, apron, or stretcher) that is inserted into a mortise in a second member, creating a joint. See *mortise*.
3-axis lathe	A woodworking machine in which one axis rotates similar to a lathe and the shaping tool moves on a horizontal plane, either with an in-and-out or right-and-left motion.
tulipwood	An irregularly striped, heavy Brazilian hardwood (*Dalbergia frutescens*).
vermeil	Gilded silver.
yaka	A reddish-brown hardwood (genus *Dacrydium*), with bold darker striping, found in the South Pacific and Africa.

INDEX

Page numbers in *italics* refer to illustrations.

A

Abramson, Ron, 180, 183, 203–204, 281
Adams, Hank Murta
Chair, 1982, 223
discussed, 226
Alice in Wonderland, 65
America House, 72, 74, 75, 133, 241
American Craft Council, 215
American Crafts (Pearson), 253
Angel of Blind Justice, 1990 (Castle), 62
Angry Asian Women Cabinet, 2005 (Maruyama), *212*, 224
Arad, Ron, 67
Ararat Antiques, 255, 256
Architect's Valet, 1985 (Mattia), *14*, *170*
Are You Building or Are You Renovating?, 1982 (Mattia), *182*, 183
Arm Chair, 2004 (Philbrick), 269
Arm Chairs, 1997 (Schriber), 244
Armoires, 1999 (Schriber), 245
Armory Neon Piece, 1989 (Maruyama), 225
Art for Everyday (Conway), 69, 191, 233, 253, 273
art/craft question, 22–23, 36, 58, 60
Artists Design Furniture (Mann), 185
Asymmetrical Chairs, 1988 (Dunnigan), 201
Asymmetrical Pier Tables, 1991 (Philbrick), 269
asymmetry, 207

B

banjos
Banjo, 2012 (Newman), *146*
discussed, 127, 132, 135–137, 147
Newman Banjo, 1975, *134*
Barnett, Ivan, 109
Barnsley, Edward, 24
Barnsley, Ernest, 24
Barnsley, Sidney, 24
Baskin, Leonard
Wendell Castle on, 55
Oppressed Man, 1960, 55
Bayer, Patricia
Fine Art of the Furniture Maker, The, 47
Bed, 1984 (Schriber), 238
Bedside Table, 1988 (Newman), *140*
Beeken, Bruce
discussed, 176, 239, 260, 271, 302
pictured, *218*, *327*
Bench, 1981 (Maruyama), 221, *221*
Bench, 1982 (Gilpin), *155*
Bench, 1991 (Hurwitz), 284
Bench, 2006 (Hucker), 304
Bench, 2010 (Schriber), 248
Bench with Horses, 1979 (McKie), *104*
Benches at RISD Museum of Art, 1978 (Gilpin), *153*
Bennett, Garry Knox
discussed, 22, 50, 101, 220
Nail Cabinet, 1979, 220, *220*
Berliner, Nancy
Inspired by China, 191
Mr. Bertram, 117
Big Chair with Ottoman, 2005 (Schriber), 248
Bill (Warren Eames Johnson's classmate), 319, 321
Bill (Wendy Maruyama's husband), 211
Binzen, Jonathan

"Conversation with Judy Kensley McKie, A," 89
"Practical Genius," 149
Bird, Roger, 154
Bird Chair, 1997 (McKie), *102*
Blanket Chest, 1963 (Castle), 58
Blanket Chest, 1976 (Maruyama), 215
Blanket Chest, 1981 (Newman), *135*
Blanket Chests, 1997 (Schriber), 246
Blueberry Song, 1972 (Hucker), 294
boat interior, 1975 (Dunnigan), *195*
Bonheur du Jour Desk, 2001 (Dunnigan), 206
Bonner, Jonathan, 173, 175
Book Chair, 2009 (Ebner), *123*
Boston Two-Seater, 1979 (Castle), 59, *59*
Boston University show catalogue cover, *176*
Bottle Bookshelf, 1993 (Mattia), *184*
Box with Toads, 1975 (McKie), *94*
Brady, Robert, 303
Brennen, Harold, 60
Britta (James Krenov's wife), 29
bronze, 102–103
Bronze Table, 1993 (Dunnigan), 203
Broyard, Anatole, 323
Burgess, Lowry, 275–276
Burl Table, 1985 (Hucker), 298
Button, Bill, 117

C

Cabinet, 1982 (Krenov), 34
Cabinet, 1983 (Krenov), 36
Cabinet, 1985 (Krenov), 36
Cabinet, 1991 (Krenov), 38, 39, 41
Cabinet, 1994 (Krenov), 40, 41
Cabinet, 1995 (Krenov), 43
Cabinet, 1999 (Krenov), 41
Cabinet, 2004 (Krenov), 44
Cabinet on Stand, 1982 (Krenov), 35
Cabinet with Screen, 1992 (Hucker), 303
Cabinetmaker's Notebook, A (Krenov), 29, 32–33, 325
Calder, Alexander, 53, 71
Cambridge Desk, 1994 (Gilpin), *159*
Carpenter, Art Espenet, 13, 121, 324
Carved Box, 1972 (Gilpin), *153*
Castle, Wendell
on Alice in Wonderland, 65
Angel of Blind Justice, 1990, 62
on art/craft question, 58, 60
awards/honors, 47
on Leonard Baskin, 55
birth, 47
Blanket Chest, 1963, 58
Boston Two-Seater, 1979, 59, *59*
on Alexander Calder, 53
career, 33, 47, 59–60
Chair, 1959, 58, *58*
Chest of Drawers, 1962, 52
on clocks, 63, 205
Coat on a Chair, 1978, 60
collections, 47
on collectors, 67
Concrete Chairs, 2010, 66
on criticism, 65
on daydreaming, 49–50
Dr. Caligari Desk, 1986, 63
on drawing, 49, 50
early sculpture, 56
education, 47, 54
on Wharton Esherick, 52–54

exhibitions, 47, 52, 57–58, 63
family, 47, 49
on fence posts, 64–65
Fine Furniture series, 1983, 47
Game Table & Zephyr Chairs, 1979, 54
Ghost Clock, 1985, 61
on international fairs, 67
Bebe Pritam Johnson on, 326
Lady's Writing Desk with Chairs, 1981, 61
on model airplanes, 55
More Is More, 2011, 48
on music, 49
Music Rack, 1964, 53
Never Complain, Never Explain, 65
on *New American Furniture* (exhibition), 56–57
Richard Scott Newman on, 133
on painting, 64
pictured, *46*, *51*
portraits, 56
on problem solving, 50–51
publications, 47
on retrospective exhibition, 57–58
John Russell on, 47
James Schriber on, 235, 237, 242
Scribe Stool, 1962, 57, 58
Silver Leaf Desk, 1967, 23
on sports, 49
Stool Sculpture, 1959, 57, 58
Tablecloth without Table, 1978, 60
as teacher, 113, 114
Tipsy Osbourne, 2010, 64
trompe l'oeil, 47, 60–62
Untitled, 1960, 56
on watermelons, 64
Woodworks (exhibition), 121
Certificate of Mastery, 77, 258–259, 277–278
Chair, 1959 (Castle), 58, *58*
Chair, 1967 (Newman), *131*
Chair, 1982 (Maruyama and Adams), 223
Chair-o-Drawers, 1985 (Mattia), *178*
Chairs, 1984 (Newman), *136*
Chairs, 1981 (Gilpin), *158*
Chess Table, 1944 (Noguchi), 300, *301*
Chest of Chair, 1971 (Osgood), 75
Chest of Drawers, 1962 (Castle), 52
Chest of Drawers, 1965 (Ebner), *116*
Chest of Drawers, 1969 (Osgood), 78
Chest of Drawers, 1982 (Hurwitz), 278
Chest of Drawers, 1984 (Osgood), *11*
Chest of Drawers, 1986 (Philbrick), 262
Chest of Drawers, 1987 (Gilpin), *156*
Chest of Drawers, 1990 (Newman), *144*
Chest on Stand, 1981 (Gilpin), *155*
Chest on Trees, 1985 (Hurwitz), 281–282, *282*
Child's Chair, 1983 (Hurwitz), 279
Chopsticks, 1980 (Mattia), *181*
Church Torchères, 1990 (Gilpin), 158, *158*
City Boy, 1985 (Mattia), *181*
Cleavage Couch, 1988 (Dunnigan), 202
clocks, 63, 204–205
Clothespin Bookshelf, 1993 (Mattia), *184*
Club Chairs, 1992 (Philbrick), 265
Coat on a Chair, 1978 (Castle), 60
Coffee Table, 1971 (Newman), *132*
collectors, 67
Collector's Cabinet, 1979 (Gilpin), 157, *157*
Commode, 1989 (Newman), *143*
Concrete Chairs, 2010 (Castle), 66
Contemporary American Woodworkers (Stone), 69

"Conversation with Judy Kensley McKie, A" (Binzen), 89
Conway, Patricia
Art for Everyday, 69, 191, 233, 253, 273
Cooke, Edward S., Jr.
Inspired by China, 191
Maker's Hand, The, 191, 233, 253
New American Furniture, 191, 233, 253
Corner Cabinet, 1989 (Hurwitz), 282
Couch, 2012 (Hucker), 310
Council on International Educational Exchange, 322
Craft in America (Lauria and Fenton), 89
Crafting a Legacy (Ramljak), 253
Cranbrook Academy of Art, 114
creative impatience, 189
Credenza, 1990 (Maruyama), 227
Cupboard, 1989 (Schriber), 241

D
dance, 127, 147, 255
Day Bed, 1986 (Dunnigan), 199
demilune (Newman), 129
Demilune, 1983 (Newman), 130
Desk, 1981 (Hucker), 296
Desk, 1981 (Schriber), 238
Desk, 1987 (Osgood), 81, 82
Desk, 2006 (Gilpin), 162
Desk, 2010 (Gilpin), 166
Desk, 2012 (Gilpin), 150
Desk, Chair, and Cabinet, 1980 (Ebner), 110
Desk and Chair, 1985 (Newman), 128, 138
Desk Chair, 1974 (Osgood), 76
DEZCO Furniture Design, 209
Dining Chair, 1962 (Osgood), 73
Dining Room Extension Table, 2008 (Schriber), 250
Dining Table, 2012 (Ebner), 124
Dining Table and Chair, 1982 (Newman), 137
Dining Table and Chairs, 1982 (Newman), 137
DiStefano, Joe, 133
Dr. Caligari Desk, 1986 (Castle), 63
Dormer, Peter
New Furniture, The, 47, 233, 273
Double Chest with Stand, 2000 (Schriber), 247
doussie, 38
Dove Bench, 2000 (McKie), 105
Dragonfly Chest, 1987 (McKie), 94
Dressing Table, 1989 (Philbrick), 263
Dressing Table, 1996 (Hurwitz), 19
Drutt, Helen, 185
Dual Vision (exhibition), 89
Dunnigan, John
on assistants, 209
Asymmetrical Chairs, 1988, 201
on asymmetry, 207
birth, 191
boat interior, 1975, 195
Bonheur du Jour Desk, 2001, 206
Bronze Table, 1993, 203
career, 191, 194, 196, 197, 198–199, 209
Cleavage Couch, 1988, 202
on clocks, 204–205
collections, 191
Day Bed, 1986, 199
David Ebner on, 122
education, 191, 193, 194–195, 198–199
exhibitions, 191
family, 191, 193, 194
Floor Lamp, 1986, 24
on Tage Frid, 198
on furniture making, 195
Grossman Armchair, 1978, 196
Helen Harrison on, 191
meets Bebe and Warren Johnson, 325
Metope Writing Table and Chair, 1986, 198
on music, 193
pictured, 190
publications, 191
Pylon Table, 1984, 205, 207
Reading/Desk Chairs, 1986, 202, 202
Settee, 1990, 192, 207
Skirt Table, 1989, 200, 201
Slipper Chairs, 1990, 205
Small Cabinet, 1990, 202
on sports, 193
Table and Chair, 2006, 208
Table and Mirror, 1980, 197
Twin Cabinet, 1997, 203
Versailles Table, 1982, 201, 201
dyslexia, 293

E
Eames, Charles, 302
early sculpture (Castle), 56
Mrs. Eastmeade, 72
Easy Chair, 1965 (Osgood), 72
Easy Chair, 1994 (Osgood), 82
Ebner, David
on being away from home, 114
birth, 109
Book Chair, 2009, 123
career, 109, 111, 115, 116
Chest of Drawers, 1965, 116
collections, 109
Desk, Chair, and Cabinet, 1980, 111
Dining Table, 2012, 124
on John Dunnigan, 122
education
discussed, 109
high school, 111–112
London School of Furniture Design and Production, 114–115
Rochester Institute of Technology, 112–114
on Wharton Esherick, 121–122
exhibitions, 109, 116–117
family, 111
Gateleg Table and Chairs, 1980, 118
on Thomas Hucker, 122–123
influences, 122–123
Library Ladder, 2009, 122
Lingerie Chest, 1984, 120
Liquor Cabinet, 1982, 119
Lounge Chair, 1985, 120
on Sam Maloof, 122
on Judy Kensley McKie, 118
on Richard Scott Newman, 122
Onion Blanket Chest, 1982, 120
pictured, 108
publications, 109
Renwick Stool, 1974, 123, 123
"Room, The," 1986, 121
Scallion Coat Rack, 2005, 121
on sports, 112, 113
Stacked Table, 1969, 113
Stand Up Desk, 1968, 112
Twisted Stick Chair, 1990, 123
Wave Table, 2009, 122
Wishbone Rocker, 1980, 117, 117–118
Ebony Desk, 1989 (Osgood), 80, 80, 82
Eight-Legged Bench, 2005 (Gilpin), 162
Elliptical Shell Desk, 1970 (Osgood), 79
Elliptical Shell Desk, 1993 (Osgood), 82
Emma (Tage Frid's wife), 155
End Table, 1988 (Newman), 142
Envelope Table, 1996 (Hurwitz), 286
E.O. 9066, 211
ergonomics, 114–115
Esherick, Wharton, 13, 52–54, 71, 121–122, 324
Everdale, Jon, 69, 278, 327

F
fairs, international, 67
Fantasy Furniture (exhibition), 131
Fantasy Furniture (exhibition catalogue), 131
Fantasy Furniture (Simpson), 215
fence posts, 64–65
Fendrick, Barbara, 62
Fern Table, 1983 (McKie), 100, 101
Fetish, 2008 (Mattia), 186
Fine Art of the Furniture Maker, The (Bayer), 47
Fine Furniture series (Castle), 47
Fine Furniture series, 1983 (Castle), 47
Fine Woodworking article (Philbrick), 261
Fire & Smoke Cabinet, 1995 (Krenov), 42
Fisch, Arline, 215
Fitzgerald, Oscar P.
Studio Furniture of the Renwick Gallery, 89, 273
Five Not So Easy Pieces (exhibition), 32
Flared Panel Cabinet, 1992 (Krenov), 29, 30, 40
Flender, Harold, 317
Floor Lamp, 1986 (Dunnigan), 24
Fluted Box, 1987 (Newman), 136
Fluted Cabinet, 1988 (Newman), 141
Fondation Maeght, 318, 319–322, 320
Foreman, Benno, 261
Forsyth, Amy
"Jere Osgood and Tom Hucker," 69
Fortescue, Donald, 231
Fragile, 1982 (Mattia), 180
Frid, Tage
career, 21, 60, 74
John Dunnigan on, 198–199
and Hank Gilpin, 149, 153–154
on Alphonse Mattia, 175
Richard Scott Newman on, 134
Jere Osgood on, 71, 73, 82
and Shop One, 133
Tage Frid Teaches Woodworking, 191
Full House, 242
furniture, 11, 17
Furniture Fantasy (exhibition), 273
Furniture with Soul (Savage), 89, 273
furniture-making education, 13, 18, 23

G
Galerie Maeght, 318–319, 319
Game Table, 1984 (Schriber), 249
Game Table & Zephyr Chairs, 1979 (Castle), 54
Gateleg Table and Chairs, 1980 (Ebner), 118
Ghost Clock, 1985 (Castle), 61
Gilpin, Hank
Bench, 1982, 155
Benches at RISD Museum of Art, 1978, 153
birth, 149
Cambridge Desk, 1994, 159
career, 149, 151, 153, 155–156
Carved Box, 1972, 153
Chairs, 1991, 158
Chest of Drawers, 1987, 156
Chest on Stand, 1981, 155
Church Torchères, 1990, 158, 158
coffee, 328
collections, 149
Collector's Cabinet, 1979, 157, 157
Desk, 166, 166
Desk, 2006, 162
Desk, 2012, 150
education, 149, 152–153
Eight-Legged Bench, 2005, 162
exhibitions, 149
family, 151, 154
and Tage Frid, 149, 153–154
influences, 158

332

meets Bebe and Warren Johnson, 325, 328
Keyhole Chairs, 1983, 154
leg, 165
Marquetry Cabinet, 1973, 152
on Alphonse Mattie, 154
MFA Boston Cabinet, 1992, 160
on music, 152
pictured, 148, 327
publications, 149
Saddle Bench, 1995, 159
Screen, 2009, 163
Seven-Drawer Chest, 1989, 164, 165
Side Table, 1994, 158
Sideboard, 1995, 161
Sideboard, 1998, 161
Wardrobe, 1989, 165, 165
on wood carving, 152
Gilpin, Michaela, 327
Gimson, Ernest, 24
gold, 139–140
Gordon, George, 325
Grandmother Clock, 1986 (Dunnigan), 204
Grecian Sofa, 1984 (Philbrick), 259
Grecian Sofa, 1994 (Philbrick), 254, 266
Grinning Beast Table, 1986 (Hurwitz), 286
Grinning Beast Table, 1986 (McKie), 94
Grossman Armchair, 1978 (Dunnigan), 196
Grove Press, 322
Guild Gallery of Arts and Crafts, 32
guitars, 136
Gurdjieff school, 255

H
Hand Wrought Object (exhibition), 136
Hannah (John Dunnigan's daughter), 191
Harmon, Michael, 60
Harper, Paul, 12
Harrison, Helen, 191
headboard (Philbrick), 257
headboard, 1970s (Philbrick), 257
High Chest, 1989 (Maruyama), 228
High Chest of Drawers, 1989 (Hucker), 306, 306–307
Hilgner, Leonard, 244, 291, 295–296, 298
Hinamatsuri, 2011 (Maruyama), 230
Hippo Bench, 2006 (McKie), 105
Hodge, Kenneth, 112
Hoffman, Neal, 77, 258
Hope, Leif, 326
Horton, John, 238, 242
Howell, Elwood, 9, 328
Hucker, Thomas
awards/honors, 291, 293, 297
birth, 291
Blueberry Song, 1972, 294
Burl Table, 1985, 298
Cabinet with Screen, 1992, 303
career, 76, 291, 295, 302–303
collections, 291
Couch, 2012, 310
Desk, 1981, 296
David Ebner on, 122–123
education, 291, 293, 294, 297–298, 302
exhibitions, 291, 293, 297
family, 293
on furniture making, 294
High Chest of Drawers, 1989, 306, 306–307
influences, 291
in Japan, 303
on James Krenov, 299–300
Low Split Table, 1974, 295
Wendy Maruyama on, 223
on music, 293, 298
pictured, 290
Rocker, 2007, 292, 307
James Schriber on, 243

Settee, 2011, 8, 307
Seven Percent Chair, 1976, 297*Shield Back Chairs*, 1985, 299, 309
Slatted Table, 1982, 308, 309
Spice Cabinet, 1976, 302
on sports, 298, 302
Untitled Sculpture, 1974, 294
Hunter, Larry, 179, 215, 231
Hunter-Stiebel, Penelope, 63
Hurwitz, Michael
on assistants, 280
awards/honors, 273
Bench, 1991, 284
birth, 273, 275
career, 273, 327
Chest of Drawers, 1982, 278
Chest of Drawers, 1986, 262
Chest on Trees, 1985, 281–282, 282
Child's Chair, 1983, 279
Corner Cabinet, 1989, 282
Dressing Table, 1996, 19
education, 253, 255, 271, 273, 275–276, 276–277
Envelope Table, 1996, 286
exhibitions, 253, 273
family, 273, 275
Grinning Beast Table, 1986, 286
influences, 279
Lady's Dressing Table and Mirror, 1977, 261
Lagoon, 1985, 280
Lattice Table, 2007, 10, 287
Loving Cup, 2012, 270
pictured, 272
publications, 273
Rocking Chair, 1995, 286
Rocking Chaise, 1989, 281
Seven Percent Chair, 1976, 277, 289
Seven Roses Plant Stand, 1993, 284
Side Table with Drawer, 1980, 277
Silver Chest, 1990, 283
Slatted Bench, 1986, 280
Tea Cup Desk, 1994, 285
Tea Table, 274
Tea Table with Chairs, 1990, 281
Twelve Leaf Resin Table, 2012, 288
Vessel, 1983, 279
Vessel with Lid, 1983, 279

I
I-95 to Vegas, 1982 (Maruyama), 223
Inspired by China (Berliner and Cooke), 191
Inspired by China (exhibition), 89, 149, 273
interiors (Schriber), 242, 243
International Design Yearbook Five, 191
ivory, 266

J
Jackson, Daniel
Thomas Hucker on, 291, 295
Michael Hurwitz on, 276
Alphonse Mattia on, 173, 175
Jere Osgood on, 74, 77, 82
Timothy Philbrick on, 258
pictured, 257
James Schriber on, 238, 240
Jaguar Bench, 1991 (McKie), 90, 99
Jaguar Side Table, 1991 (McKie), 103, 103
Japan Society, 322
Japanese tea ceremony, 291, 300
Jean-Louis (Bebe Pritam Johnson's friend), 318, 319, 322
"Jere Osgood and Tom Hucker" (Forsyth), 69
Joanne (Wendy Maruyama's teacher), 214–215
Johnson, Bebe Pritam
career, 322–323

education, 317, 318
Fondation Maeght film, 319–322
meets Warren Eames Johnson, 317
pictured, 315, 321, 322, 327
Johnson, Rani, 324, 325, 325
Johnson, Warren Eames
career, 317, 318, 322
education, 317
Fondation Maeght film, 319–322
meets Bebe Pritam Johnson, 317
pictured, 315, 319, 321
Jorgenson, Bob, 134
Joseph, Peter, 10, 202
Jurs, Nancy, 47, 326

K
Kagan, Dick, 174, 325
Kanzashi Hair Ornament, 2009 (Maruyama), 229
Kato, Mami, 273
Kelsey, John, 324
Keyhole Chairs, 1983 (Gilpin), 154
Keyser, Bill, 60, 113, 132–133, 219, 221, 298–299
Kirk, John, 246–247, 258, 261, 264
Kirkham, Pat
Women Designers in the USA 1900–2000, 89
Klint, Kaare, 264–265
Knothead, 1984 (Mattia), 175
Korn, Peter, 325
Krenov, James
on art/craft question, 36
awards/honors, 29
bag, 31
birth, 29
books, 29, 32–33
Cabinet, 1982, 34
Cabinet, 1983, 36
Cabinet, 1985, 36, 37
Cabinet, 1991, 38, 39, 41
Cabinet, 1994, 40, 41
Cabinet, 1995, 43
Cabinet, 1999, 41
Cabinet, 2004, 44
Cabinet on Stand, 1982, 35
Cabinetmaker's Notebook, A, 29, 32–33, 325
career, 29, 32–33, 35
controversy, 29
death, 15, 29
education, 29
family, 29
Fire & Smoke Cabinet, 1995, 42
Five Not So Easy Pieces (exhibition), 32
Flared Panel Cabinet, 1992, 29, 30, 40
genuine, 29, 31
on his work, 11
Thomas Hucker on, 299–300
Michael Hurwitz on, 276
Bebe Pritam Johnson on, 327
Warren Eames Johnson on, 324
Judy Kensley McKie on, 99, 100
moccasins, 31
Music Stand, 1963, 32
Richard Scott Newman on, 133–134
Jere Osgood on, 77
Pagoda Cabinet, 1973, 33
Timothy Philbrick on, 258
pictured, 28, 32, 35, 43
signature, 36
and studio furniture movement, 13
in Sweden, 29, 31–32
Walkabout Cabinet, 1986, 38
Kuri, Yuri, 322
Kuroda, Kenkichi, 273
Kuroda, Tatsuaki, 303

L

Lady's Dressing Table and Mirror, 1977 (Philbrick), 260, *261*
Lady's Writing Desk with Chairs, 1981 (Castle), 61
Lagoon, 1985 (Hurwitz), 280
LaLiberte, Norman, 92
Lamp, 1971 (Maruyama), *214*
Latrobe-Bateman, Richard, 157
Lattice Table, 2007 (Hurwitz), *10*, 287
Lauria, Jo
 Craft in America, 89
Lawrence, D.H., 45
Layton Table, 2000 (Osgood), 85
L'Ecuyer, Kelly
 Maker's Hand, The, 191, 233, 253
Leopard Chest, 1989 (McKie), 95
Leopard Couch, 1983 (McKie), 100, *100*
letters, 32, 156–157, 295, 324–325, 326
Lewis, Sam, 255
Library Ladder, 2009 (Ebner), *122*
Lindsay, John, 323
Lingerie Chest, 1984 (Ebner), *120*
Lion Bench, 1994 (McKie), *104*
Liquor Cabinet, 1982 (Ebner), *119*
Loeser, Tom, 69, 278
Lounge Chair, 1985 (Ebner), *120*
Loving Cup, 2012 (Philbrick), *270*
Low Split Table, 1974 (Hucker), 295, *296*
Lowe, Bob, 317

M

Maeght, Aimé, 318–319
Majorelle, Louis, 253, 260
Makepeace, John, 157
Maker's Hand, The (Cooke, Ward, and L'Ecuyer), 191, 233, 253
Maker's Hand, The (exhibition), 89, 149, 273
Malmsten, Carl, 29
Maloof, Sam, 13, 122, 302, 324
Mann, Terry
 Artists Design Furniture, 185
Marina (Michael Hurwitz's daughter), 273
Marquetry Cabinet, 1973 (Gilpin), *152*
Maruyama, Wendy
 Angry Asian Women Cabinet, 2005, *224*
 Armory Neon Piece, 1989, *225*
 awards/honors, 211
 Bench, 1981, 221, *221*
 birth, 211, 213
 Blanket Chest, 1976, *215*
 career, 211, 223, 225–226
 Chair, 1982, *223*
 on collaboration, 226
 collections, 211
 Credenza, 1990, *227*
 education
 Boston University, 217–218
 discussed, 69
 elementary school, 213–214
 high school, 214
 Rochester Institute of Technology, 219
 San Diego State University, 215
 Southwestern Junior College, 214
 exhibitions, 227
 family, 213
 on furniture making, 214, 215
 on glass, 226
 hearing impediment, 213
 heritage, 231
 High Chest, 1989, *228*
 Hinamatsuri, 2011, *230*
 Thomas Hucker on, 303, 304
 I-95 to Vegas, 1982, *223*
 James Schriber on, 235
 Lamp, 1971, *214*
 Men in Kimonos III, 2005, *12*
 Mickey MacIntosh Chair, 1980, *222*
 neon series, 227
 Peking, 1994, *226*
 pictured, *210*, *216*
 Primary Chairs, 1982, *223*
 James Schriber on, 243
 Urban Amazon, 1989, *225*
 Vanity, 2006, *224*
 white series, 227
 White Sideboard, 1983, *227*
 Writing Desk, 1980, 219, *219*, 220–221, *226*
Mass Communications, 322
Massachusetts Living Room and Kitchen, 1675–1700, *318*
Material Evidence (exhibition), 233
Mattia, Alphonse
 Architect's Valet, 1985, *14*, *170*
 Are You Building or Are You Renovating?, 1982, *182*, *183*
 awards/honors, 169
 birth, 169
 Bottle Bookshelf, 1993, *184*
 career, 77, 169, 172, 176
 Chair-o-Drawers, 1985, *178*
 Chopsticks, 1980, *181*
 City Boy, 1985, *181*
 Clothespin Bookshelf, 1993, *184*
 collections, 169
 on creative impatience, 189
 on drawing, 179–180
 education, 169, 171–172
 exhibitions, 169, 174, 185
 family, 171
 Fetish, 2008, *186*
 Fragile, 1982, *180*
 Hank Gilpin on, 154
 Thomas Hucker on, 298
 Michael Hurwitz on, 277
 influences, 174
 Knothead, 1984, *175*
 Wendy Maruyama on, 216, 217
 meets Judy and Todd McKie, 179
 MFA Asymmetrical Wingbacks, 1989, *187*
 mirrors, 180
 Mr. Potatohead, 1984, *178*
 Music Cabinet, 1975, *172*
 pictured, *168*, *218*
 Practice Chair, 1975, *172*
 Primates (valets), 1986, *177*
 publications, 169
 Raccoon Bench, 1993, *179*
 Red Mirror, 1979, *180*
 James Schriber on, 243
 spider chair, 175–176
 Steppin' Out, 2012, *188*
 Tall Buffet, 1995, *185*
 valets, 183, *183*, 185
 Wingback Chair and Ottoman, 1974, *173*
McArt, Craig, 32, 33
McKie, Jesse, 93
McKie, Judy Kensley
 awards/honors, 89
 Bench with Horses, 1979, *104*
 Bird Chair, 1997, *102*
 birth, 89
 Box with Toads, 1975, *94*
 boxes, 97–98
 career, 89, 92
 collections, 89
 commissions, 98, 104
 Dove Bench, 2000, *105*
 on drawing, 97
 Dragonfly Chest, 1987, *94*
 David Ebner on, 118
 education, 89, 91
 exhibitions, 89, 92, 101, 266
 family, 91
 Fern Table, 1983, 100, *101*
 on furniture making, 92, 93, 96–97, 107
 Grinning Beast Table, 1986, *94*, 286
 Hippo Bench, 2006, *105*
 imagery, 89
 influences, 104
 Jaguar Bench, 1991, 90, *99*
 Jaguar Side Table, 1991, 103, *103*
 on James Krenov, 99, 100
 Leopard Chest, 1989, *95*
 Leopard Couch, 1983, 100, *100*
 Lion Bench, 1994, *104*
 meets Alphonse Mattia, 179
 meets Todd McKie, 91
 Mirror with Birds, 1994, *20*
 Monkey Chair, 1994, *102*
 monotypes, 103–104
 at New Hamburger Cabinetworks Collective, 94–96
 on painting, 91–92
 Panther Table, 1988, 102–103, *103*
 pictured, *88*
 on prototypes, 102
 publications, 89
 James Schriber on, 243
 Snake Table, 1987, 103, *103*
 on James Surls, 104
 Table with Birds and Fish, 1979, *101*
 Table with Cats, 1977, 99, *99*
 Table with Kissing Fish, 1975, 98, *99*
 Tall Black Cabinet, 1987, *97*
 Tall Cupboard, 1983, *96*
 Tiger Table, 2010, *106*
 on tools, 91, 99–100
 Wall Hanging, 1968, *92*
 wall hangings, 92
 Watching Dogs Headboard, 1991, *101*
McKie, Todd, 89, 91, 92, 104, 179, 266
Memphis, 221–222
Men in Kimonos III, 2005 (Maruyama), *12*
Metope Writing Table and Chair, 1986 (Dunnigan), *198*
MFA Asymmetrical Wingbacks, 1989 (Mattia), *187*
MFA Boston Cabinet, 1992 (Gilpin), *160*
Michey MacIntosh Chair, 1980 (Maruyama), *222*
Milliken, Alexander, 47
Mirror with Birds, 1994 (McKie), *20*
mirrors, 180
Mr. Potatohead, 1984 (Mattia), *178*
model airplanes, 55
Monique (Jean-Louis's partner), 319
Monkey Chair, 1994 (McKie), *102*
Moos, Peder
Occasional Table, 1948, *74*
Jere Osgood on, 74
More Is More, 2011 (Castle), *48*
Morris, William, 24–25, 96
Music Cabinet, 1975 (Mattia), *172*
Music Rack, 1964 (Castle), *53*
Music Stand, 1963 (Krenov), *32*

N

Nail Cabinet, 1979 (Bennett), 220, *220*
Nakashima, George, 13, 323, 324, 326–327
National Technical Institute for the Deaf, 219
neon series, 227
Never Complain, Never Explain (Castle), *65*
New American Furniture (Cooke), 191, 233, 253
New American Furniture (exhibition), 56–57, 89, 149, 273

334

New Furniture, The (Dormer), 47, 233, 273
New Hamburger Cabinetworks Collective, 93, 94–95, 236, 278, 327
Newman, Richard Scott
awards/honors, 127
Banjo, 2012, *146*
banjos, 127, 132, 135–137, *147*
Bedside Table, 1988, *140*
birth, 127
Blanket Chest, 1981, *135*
boxes, 135
career, 127, 130–131, *147*
Chair, 1967, *131*
Chairs, 1984, *136*
Chest of Drawers, 1990, *144*
Coffee Table, 1971, *132*
commissions, 137
Commode, 1989, *143*
dance, 127, *147*
Demilune, 1983, *130*
demilune tables, 129
Desk and Chair, 1985, *128*
Dining Table and Chair, 1982, *137*, 137–138
David Ebner on, 122
education, 127, 129–130, 131, 132–135, *147*
End Table, 1988, *142*
exhibitions, 127, 136
family, 129, *147*
Fluted Box, 1987 (Newman), *136*
Fluted Cabinet, 1988, *141*, *141*
Warren Eames Johnson on, 326
on James Krenov, 133–134
on music, 132
Newman Banjo, 1975, *134*
on Jere Osgood, 134
on pearwood, 144
pictured, *126*
Ruff Alley Works, 127
Scalloped End Table, 1980, *132*
Spiral Coffee Table, 1980, *132*
Ten-Foot Demilune, 1989, 129, *130*
Umbrella Stand, 1984, *140*, *140*
Vessel, 2003, *145*
on Wendell Castle, 132–133
Writing Table, 1988, *139*
Newman Banjo, 1975, *134*
Newson, Marc, 67
Nightstand, 1988 (Philbrick), *262*
Noguchi, Isamu
Chess Table, 1944, *300*, *301*
discussed, 301
Northup, John C., 253, 256

O

Occasional Table, 1948 (Moos), *74*
One Day in Color, 323
Onion Blanket Chest, 1982 (Ebner), *120*
Onn, Cecelia, 35
Oppressed Man, 1960 (Baskin), *55*
Osgood, Jere
and America House, 72, 74
awards/honors, 69
birth, 69
on Alexander Calder, 71
career, 69, 71, 76–77
Chest of Chair, 1971, *75*
Chest of Drawers, 1969, 78, *78*
Chest of Drawers, 1984, *11*
collections, 69
in Denmark, 74–75
Desk, 1987, *81*, 82
Desk Chair, 76
Dining Chair, 1962, *73*
Easy Chair, 1965, *72*
Easy Chair, 1994, *82*
Ebony Desk, 1989, *80*

education, 69, 71–72, 73, 74
Elliptical Shell Desk, 1970, 78, *79*
Elliptical Shell Desk, 1993, *82*
on Wharton Esherick, 13, 71
exhibitions, 69, 73–74
family, 71, 76, 78
Fine Woodworking articles, 69
on Tage Frid, 71
Thomas Hucker on, 298
Michael Hurwitz on, 276, 289
Layton Table, 2000, *85*
mahogany box, 82
Wendy Maruyama on, 217
on mathematical formulas, 72–73
Alphonse Mattia on, 176–177, 181
on nature, 69, 79
Richard Scott Newman on, 134
Timothy Philbrick on, 259
pictured, *68*, 257, *327*
publications, 69
Rosewood Desk, 1985, 80, *80*
Shell Desk, 2001, *70*, 86
Side Chairs, 2003, *83*
small wooden objects for America House, 72
on studio furniture movement, 13
Summer Chest, 1994, *83*
Tall Desk with Pocket Doors, 1995, *84*
on tapered laminations, 78
Wave Table, 1999, *85*
Osgood, Mark, 77
Ott, Jackie, 175

P

Padula, Warren, 325
Pagoda Cabinet, 1973 (Krenov), *33*
Panther Table, 1988 (McKie), 102–103, *103*
Parker, Ken, 136
Patterson, Mac, 238, 242
Patterson, Neal, 264
Pearson, Katherine
American Crafts, 253
pearwood, 144
Peking, 1994 (Maruyama), *226*
Pencil Post Bed, 1991 (Schriber), *249*, 249
Penland Book of Woodworking, The, 69
Penland School of Crafts, 136
Pesce, Gaetano, 306
Peter Joseph Gallery, 10, 47
Philbrick, Ben, 255
Philbrick, Harry, 255
Philbrick, Steve, 255
Philbrick, Timothy, 325
Arm Chair, 2004, *269*
on assistants, 269
Asymmetrical Pier Tables, 1991, *269*
awards/honors, 253
Club Chairs, 1992, *265*
collections, 253
commissions, 253
on drawing, 263
Dressing Table, 1989, *263*
John Dunnigan on, 199
family, 255, 289
Fine Woodworking article, 261
Grecian Sofa, 1984, *258*
Grecian Sofa, 1994, *254*, 266
headboard, 1970s, *257*
Lady's Dressing Table and Mirror, 1977, *260*
Wendy Maruyama on, 221
Nightstand, 1988, *262*
pictured, *218*, *252*, 257
on proportion, 262–263
publications, 253
Rosewood Sideboard, 1979, *264*, 264
James Schriber on, 238–239, 246, 247
Secretary, 2003, *268*

Steinway Piano Commission, 2001, *267*
Tambour Liquor Cabinet, 1976, *260*, 260
Upholstered Settee, 1977, *258*
Vide Poche Table, 1989, *263*
Please Be Seated (exhibition), 89, 104
Poplar Culture (exhibition), 188
Powell, David, 180–181
"Practical Genius" (Binzen), 149
Practice Chair, 1975 (Mattia), *172*
Primary Chairs, 1982 (Maruyama), *223*
Primates (valets), 1986 (Mattia), *177*
Pritam & Eames
discussed, 10, 18, 317, 326, 328
pictured, *316*, *317*, *327*
proportion, 262–263
Puckett, Ronnie, 176
Pye, David, 144
Pylon Table, 1984 (Dunnigan), *205*, 207

R

Raccoon Bench, 1993 (Mattia), *179*
Ramljak, Suzanne
Crafting a Legacy, 253
Reading/Desk Chairs, 1986 (Dunnigan), *202*, 202
Reboli, Joseph, 116
Room, The, 1986, *121*
Red Mirror, 1979 (Mattia), *180*
Renais, Alain, 319
Renwick Stool, 1974 (Ebner), *123*, 123
Retallack, Joan, 13
Risa (Hank Gilpin's wife), 154
Rocker, 2007 (Hucker), *292*, 307
Rocker, The (Steinbaum), 273
Rocking Chair, 1995 (Hurwitz), *286*
Rocking Chaise, 1989 (Hurwitz), *281*
"Room, The," 1986 (Ebner and Reboli), *121*
Rosalie (Tally's dog), 196
Rosewood Desk, 1985 (Osgood), *80*
Rosewood Sideboard, 1979 (Philbrick), *264*, 264
Ross, Karen, 233
Ruff Alley Works, 127, 133
Ruhlmann, Jacques-Émile, 137
Russell, John, 47
Ryerson, Mitch, 244, 278, 327

S

Saatchi, Doris, 255
Saddle Bench, 1995 (Gilpin), *159*
Sagarra Cabinet, 1999 (Hucker), *305*
Salami Tray, 1980 (Maruyama), *216*
Sam (Thomas Hucker's friend), 293
Savage, David
Furniture with Soul, 89, 273
Scale of Things to Come, The (exhibition), 89
Scallion Coat Rack, 2005 (Ebner), *121*
Scalloped End Table, 1980 (Newman), *132*
Scandinavian Seminar, 69, 74
Schriber, A. Max, 236
Schriber, James, 260
Armoires, 1999, *245*
Bed, 1984, *238*
Bench, 2010, *248*
Big Chair with Ottoman, 2005, *248*
birth, 233
Blanket Chests, 1997, *246*
career, 233, 242
collections, 233
Cupboard, 1989, *241*
Desk, 1981, *238*
Dining Room Extension Table, 2008, *250*
Double Chest with Stand, 2000, *247*
education, 233, 235–236, 237, 238–239
exhibitions, 233
family, 235, 236

Game Table, 1984, 249
influences, 239
interiors, *242, 243*
on Daniel Jackson, 240
Pencil Post Bed, 1991, 249, *249*
pictured, *232, 236, 237*
publications, 233
Side Cabinets, 1996, *241*
Side Cabinets, 1999, *241*
Sleigh Bed, 1987, *239*
Steinway Piano and Bench, 2001, *247*
Swag Bench, 1988, *244*
Table, 1987, *241*
Table, 1993, *234, 246*
Tall Cupboard, 1984, *240*
2-Door Cabinet, 2006, *312*
Wooden Toilet Plunger, 1975, *217*
Scoonover, Eric, 195
Screen, 2009 (Gilpin), *163*
Scribe Stool, 1962 (Castle), *57, 58*
Secretary, 2003 (Philbrick), *268*
Seeger, Mike, 136
Sellers, Dave, *236, 237*, 239
Sert, José Luis, 319
Settee, 1990 (Dunnigan), *192, 207*
Settee, 2011 (Hucker), *8, 307*
Seven Percent Chair, 1976 (Hucker), *297*
Seven Percent Chair, 1976 (Hurwitz), *277, 289*
Seven Roses Plant Stand, 1993 (Hurwitz), *284*
Seven-Drawer Chest, 1989 (Gilpin), *164*, 165
Shell Desk, 2001 (Osgood), *70, 86*
Shield Back Chairs, 1985 (Hucker), *299*
Shy Boy, She Devil, and Isis (exhibition), 89
Side Cabinets, 1996 (Schriber), *241*
Side Cabinets, 1999 (Schriber), *241*
Side Chair, 2011 (Hucker), *307*
Side Chairs, 2003 (Osgood), *83*
Side Table, 1994 (Gilpin), *158*
Side Table with Drawer, 1980 (Hurwitz), *277*
Sideboard, 1983 (Mattia), *182*
Sideboard, 1995 (Gilpin), *161*
Sideboard, 1998 (Gilpin), *161*
Silber, John, 176
Silver Chest, 1990 (Hurwitz), *283*
Silver Leaf Desk, 1967 (Castle), *23*
Simpson, Thomas
Fantasy Furniture, 215
James Schriber on, 243
Skirt Table, 1989 (Dunnigan), *200, 201*
Slatted Bench, 1986 (Hurwitz), *280*
Slatted Table, 1982 (Hucker), *308, 309*
Sleigh Bed, 1987 (Schriber), *239*
Slipper Chairs, 1990 (Dunnigan), *205*
Slivka, Rose, 11
Small Cabinet, 1990 (Dunnigan), *202*
Smith, Paul, 76
Snake Table, 1987 (McKie), *103*, 103
Snyderman, Rick, 174
Snyderman, Ruth, 174
soccer, 112, 113
Somerson, Rosanne
discussed, 176, 199, 209, 243
"Perfect Sweep," 69
Sottile, Don, 63
Sottsass, Ettore, 301, 304
Spice Cabinet, 1976 (Hucker), *302*
spider chair (Mattia), 175–176

Spiral Coffee Table, 1980 (Newman), *132*
Stacked Table, 1969 (Ebner), *113*
stack-lamination process, 47
Stand Up Desk, 1968 (Ebner), *112*
Mrs. Standish, 256
Steinbaum, Bernice
Rocker, The, 273
Steinway Piano and Bench, 2001 (Schriber), *247*
Steinway Piano Commission, 2001 (Philbrick), *267*
Steppin' Out, 2012 (Mattia), *188*
Steve Fenton
Craft in America, 89
Stiles, Ed, 116
Stone, Michael
Contemporary American Woodworkers, 69
Stool Sculpture, 1959 (Castle), *57*, 58
studio furniture movement, 13
Studio Furniture of the Renwick Gallery (Fitzgerald), 89, 273
Summer Chest, 1994 (Osgood), *83*
Surls, James, 104
Swag Bench, 1988 (Schriber), *244*

T
Table, 1987 (Schriber), *241*
Table, 1993 (Schriber), *234, 246*
Table and Chair, 2006 (Dunnigan), *208*
Table and Mirror, 1980 (Dunnigan), *197*
Table with Birds and Fish, 1979 (McKie), *101*
Table with Cats, 1977 (McKie), *99*
Table with Kissing Fish, 1975 (McKie), *98*
Tablecloth without Table, 1978 (Castle), *60*
Tag Project, The, 211
Tage Frid Teaches Woodworking (Frid), 191
Tall Black Cabinet, 1987 (McKie), *97*
Tall Buffet, 1995 (Mattia), *185*
Tall Cupboard, 1983 (McKie), *96*
Tall Cupboard, 1984 (Schriber), *240*
Tall Desk with Pocket Doors, 1995 (Osgood), *84*
Tally (specialist in ancient art), 195–197
Tambour Liquor Cabinet, 1976 (Philbrick), *260*, 260
Taplin, Randy, 236
Tea Cup Desk, 1994 (Hurwitz), *285*
Tea Table, 1990 (Hurwitz), *274*
Tea Table with Chairs, 1990 (Hurwitz), *281*
technique, 22
techniques/tools
John Dunnigan on, 195
David Ebner on, 111
Judy Kensley McKie on, 93, 96, 99–100
Richard Scott Newman on, 144–145
Jere Osgood on, 69, 75, 79, 87
Timothy Philbrick on, 265–266
Ten-Foot Demilune, 1989 (Newman), *129*, 130
Terkal, Alice, 244
Tierney, John, 77
Tiger Table, 2010 (McKie), *106*
Tipsy Osbourne, 2010 (Castle), *64*
trompe l'oeil, 47, 60–62
Turino, Steve, 269
Twelve Leaf Resin Table, 2012 (Hurwitz), *288*
Twin Cabinet, 1997 (Dunnigan), *203*
Twisted Stick Chair, 1990 (Ebner), *123*
2-Door Cabinet, 2006 (Schriber), *312*

U
Umbrella Stand, 1984 (Newman), *140*, 140
Untitled, 1960 (Castle), *56*
Untitled Sculpture, 1974 (Hucker), *294*
Upholstered Settee, 1977 (Philbrick), *258*
Urban Amazon, 1989 (Maruyama), *225*

V
valet, early 1950s (Wegner), *183*, 183
van Lennep, Joel, 275
Vanity, 2006 (Maruyama), *224*
Vanity Suite, 1984 (Dunnigan), *197*
Versailles Table, 1982 (Dunnigan), *201*, 201
Vessel, 1983 (Hurwitz), *279*
Vessel, 2003 (Newman), *145*
Vessel with Lid, 1983 (Hurwitz), *279*
Vide Poche Table, 1989 (Philbrick), *263*
Visiting Artist Exhibition (exhibition), 273

W
Wahl, Wendy, 191
Walkabout Cabinet (Krenov), 38
Walker, Peter, 209
Wall Hanging, 1968 (McKie), *92*
Walter Dyer Is Leather, 31
Ward, Gerald W. R.
Maker's Hand, The, 191, 233, 253
Wardrobe, 1989 (Gilpin), *165*, 165
Warshaw, Steve, 275
Watching Dogs Headboard, 1991 (McKie), *101*
watermelons, 64
Wave Table, 1999 (Osgood), *85*
Wave Table, 2009 (Ebner), *122*
Webb, Aileen Osborn, 74
Weed, Walker, 13
Wegner, Hans
valet, early 1950s, *183*, 183
Wendell Castle Studio School, The, 47
White, Newell, 326
White Sideboard, 1983 (Maruyama), *227*
whittling soirée, 231
Wilheim, Franz, 111
William and Mary High Chest of Drawers, 1700–1720, 306
Wingback Chair and Ottoman, 1974 (Mattia), *173*
Wishbone Rocker, 1980 (Ebner), *117*, 117–118
Women Artists at the Laundry (exhibition), 326
Women Designers in the USA 1900–2000 (Kirkham), 89
Wooden Toilet Plunger, 1975 (Schriber), *217*
Woodenworks (exhibition), 52, 111, 120–121, 275, 276
Wright, Jonathan, 278
Writing Desk, 1980 (Maruyama), *219*, 219, 220–221, 226
Writing Table, 1988 (Newman), *139*

Y
Young Americans (exhibition), 73

Z
Zeisel, Eva, 37
Zucca, Ed, 173, 174, 244, 246